The ANTIQUES TREASURY

The ANTIQUES TREASURY

TREASURY

OF FURNITURE AND OTHER DECORATIVE ARTS AT

WINTERTHUR

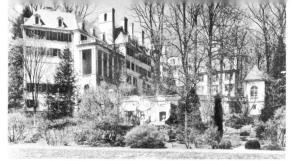

LLIAMSBURG

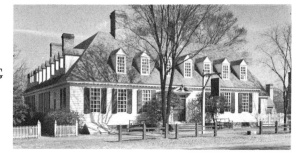

STURBRIDGE

Edited by

ALICE WINCHESTER and the Staff of

ANTIQUES Magazine

Over 800 black and white illustrations

16 pages in full color

RD MUSEUM

OPERSTOWN

DEERFIELD

GARLAND BOOKS

95 MADISON AVENUE

NEW YORK CITY

SHELBURNE

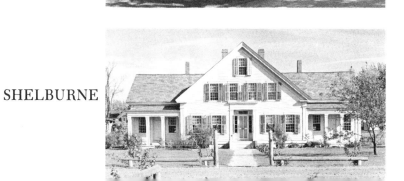

This edition published by arrangement
with E. P. Dutton & Company, Inc.

Library of Congress Catalog Card Number: 59-12514
SBN 0-525-05613-0

Contents

Color plates

For the use of color plates we are grateful to the Henry Ford Museum, the Shelburne Museum, Colonial Williamsburg, and the Winterthur Museum; the Ashley House in Deerfield is shown through the courtesy of *American Heritage,* and the Essex and Marlboro Rooms, Winterthur, through courtesy of The Macmillan Company.

Antiques at seven American museums

BY ALICE WINCHESTER

Editor, ANTIQUES Magazine

SINCE 1922, when ANTIQUES made its first appearance, a new kind of museum has developed in this country. It is difficult to put a name to, for the museums themselves differ in many respects—one is a restoration, one a re-creation, one a preservation—but they have a common aim: to bring American history to life by showing how our people lived. At the seven museums of this kind that are presented in this book, antiques are arranged in appropriate settings to show not only how our ancestors kept house but how they worked and played and thought. At the same time these antiques form splendid collections of the decorative arts produced or adopted in America in past centuries.

Both as history and as art, then, the antiques in these museums are important. That is why in 1951 ANTIQUES launched a series of special issues devoted to them. The seven such issues thus far published promptly became collector's items and now are out of print. What appeared in them is the basis of this book, but we have made many revisions and additions in order to give an up-to-date picture of the museums as they are today. These are all living museums and they are still growing—improving old installations, adding new rooms or galleries or whole buildings, and constantly increasing and enriching their collections.

While it does not pretend to be a comprehensive catalogue, this book may well serve as a guide to the museums, for it is the most complete publication available on any of these great collections of decorative arts. Because, moreover, of the varied nature of the collections the book presents a remarkably thorough survey of the crafts and arts known to early America. Its usefulness as a reference is fortified by the *Chronology of crafts* compiled by Helen Comstock, which enables one to see at a glance the historical relationships among styles, events, and craftsmen in different fields.

Each of the seven museums presented has its own distinctive character. The Henry Francis du Pont Winterthur Museum was originally a private collection. Mr. du Pont began to acquire American antiques in 1918 and ten years later to arrange them in architectural interiors from old houses which he installed in his family home near Wilmington, Delaware. The period rooms grew to number over a hundred, all authentically furnished to the last detail with antiques of the highest quality, and each an artistic composition of exquisite balance and color. The whole is Mr. du Pont's personal creation, expressing his taste and interest as well as his connoisseurship. In 1951 Winterthur was opened to the public as a museum. Our selection of its decorative arts shows them as they are appropriately commingled in settings dating from 1640

to 1840. Many of these interior views appeared in ANTIQUES for November 1951, the first issue in our Museum series, though of these a number have been re-photographed to show subsequent changes, and interiors added since are included to indicate the present scope and quality of the museum.

Colonial Williamsburg, in contrast, is not a single building but a whole town. In the eighteenth century it was the capital of Virginia, the political and cultural center of the Tidewater, but by the twentieth century many of its old buildings had deteriorated or disappeared. In 1926 the Reverend William A. R. Goodwin, rector of Bruton Parish Church, interested John D. Rockefeller, Jr., in undertaking its restoration, and since then it has become the largest and most significant enterprise of its kind. Antiques are to be seen everywhere at Williamsburg, but with few exceptions we have made our selection from the four exhibition buildings furnished with nothing but antiques: the Governor's Palace, the Raleigh Tavern, the Brush-Everard House, and the Wythe House; and we show the pieces individually as well as in their period settings. Each year additions are made to these furnishings, and we include here the most important recent acquisitions, some of which have not yet been placed on exhibition.

Deerfield never knew the prominence of Williamsburg in the eighteenth century, but neither did it suffer such decline in the nineteenth and early twentieth. It remained a quiet village, off the main highway, its broad, elm-shaded street unblemished by neon lights and gasoline pumps. To keep it so was the aim of Mr. and Mrs. Henry N. Flynt who, with deep appreciation of Deerfield's quality, undertook in the late 1940's to preserve it as a living example of an early New England frontier community. In this project they worked closely with two local institutions: Deerfield Academy, a school for boys chartered in 1797, and the Pocumtuck Valley Memorial Association, a historical society founded in 1870. The character of the village has been preserved and eighteenth-century houses have been restored. While all of them are lived in, several are exhibition buildings furnished with antiques. Where possible pieces locally made or owned have been acquired, but the collections comprise as well examples of every type that might have been used in early New England homes. We illustrate, individually and in their settings, items from seven exhibition buildings and from the Brick Church, the Hall Tavern, and Memorial Hall. Again we include recent acquisitions, hitherto unpublished.

At the Henry Ford Museum and Greenfield Village in Dearborn, Michigan, a museum building where decora-

tive arts are displayed in galleries is combined with a "village" made up of old buildings of many types brought from various regions and furnished, most of them, as they were originally. This dual museum was the creation of Henry Ford, who had begun collecting American antiques by 1914 and in the following decade began collecting buildings as well. Most of the decorative arts now to be seen at Dearborn are what he acquired for his project, though significant additions are constantly being made. Our selection for ANTIQUES (February 1958) was made from the museum's Decorative Arts Galleries and Street of Shops; for this book, color plates and a section on Greenfield Village have been added.

Old Sturbridge Village in Massachusetts is again a created, not a restored, community, though it looks today as if it had always been there. And it too came into being as the result of a collecting interest. The brothers Albert B. Wells and J. Cheney Wells had already acquired many American antiques when in the late 1920's they began planning to exhibit them. Gradually they evolved the idea of a typical New England farm village of a century and a half ago, authentic in architecture, furnishings, even in the natural setting. Old buildings were brought from various parts of New England and centered around the village green, the Wells collections were installed in them, and in 1946 this museum was opened to the public. Illustrating the resourcefulness and skill of the New England country craftsman, its decorative arts are exhibited both as furnishings of the houses and as specialized collections. Our selection has been made from both groups, and includes the most recently opened exhibition building, the Salem Towne House.

A somewhat similar concept lies behind the museums of the New York State Historical Association at Cooperstown. There the Village Crossroads of the Farmers' Museum has been built up of architectural elements from New York State to re-create a typical rural community of the region of more than a century ago. The buildings are appropriately furnished, and specialized collections are shown in the Farmers' Museum Main Building and at Fenimore House. Here, too, the museum owes much to the vision of an individual, Stephen C. Clark. The items and views selected for this book emphasize the rural character of the collections, and also represent the paintings and folk sculpture for which Cooperstown is well known.

The Shelburne Museum appears at first to be another village, this one representing rural Vermont—though such elements as the sidewheeler, lighthouse, and hunting camp are scarcely typical of Green Mountain communities. But even more than the other museums of which the same may be said, Shelburne is actually a collection of collections. It is the creation of Mrs. J. Watson Webb, a lifelong collector of American antiques, and in the old buildings she has moved to Shelburne are displayed not only the decorative arts that she has assembled but also such varied collections as dolls, tools, paintings, wild life, and carriages. For this book we have made a sampling from these collections, including numerous items not published before and some not yet on exhibition.

We are immensely indebted to the directors and staffs of all the museums represented in this volume for their encouragement and generous cooperation. We gratefully acknowledge the invaluable assistance particularly of Charles F. Montgomery, director, John A. H. Sweeney, and the late Joseph Downs of Winterthur; of Edward P. Alexander, John M. Graham II, Eleanor L. Duncan, and James R. Short at Williamsburg; of Donald A. Shelley, director, Minor Wine Thomas, Jr., George O. Bird, Gerald S. Gibson, and Katharine Bryant Hagler, at the Henry Ford Museum; of Frank O. Spinney, director, Herbert C. Darbee, Catherine Fennelly, Helen G. Holley, and Margaret B. Munier, at Old Sturbridge Village; of Mr. and Mrs. Henry N. Flynt, leaders in the work of preservation at Deerfield; of Mrs. J. Watson Webb, founder, Sterling Emerson, director, and Lilian Baker Carlisle of Shelburne; and of Louis C. Jones, director, Virginia D. Parslow, Frederick L. Rath, Jr., and Per Gulbek at Cooperstown. We wish to express our thanks also to the specialized authorities who contributed signed articles to the museum issues of ANTIQUES and have graciously permitted us to include them in this volume. The members of ANTIQUES' staff who participated in preparation of this book are Helen Comstock, Barbara Snow, Edith Gaines, Ruth Davidson, Dorothy Baltar, Joan Phillips, and Katrina Seipp. The book was designed by Milton H. Glover.

The photographs of Winterthur were taken by Gilbert Ask and Gottscho-Schleisner; of Williamsburg, by John Crane, Delmore A. Wenzel, and Thomas L. Williams; of Sturbridge, by Samuel Chamberlain, Dick Hanley, Maury LaReau, James Ward, and Frank O. Spinney; of the Ford Museum, by Charles T. Miller; of Cooperstown, by LeBel Studio and Franklyn Rollins; of Deerfield, by Taylor & Dull and Samuel Chamberlain; of Shelburne, by Taylor & Dull and Einars J. Mengis.

The Henry Francis du Pont Winterthur Museum near Wilmington, Delaware

FIVE MILES NORTHWEST OF WILMINGTON, DELAWARE, lies the twelve-hundred-acre farm known as Winterthur. From the gatehouse, the main drive winds for a mile over gently rolling crop land, meadow, and woodland to the slope where, half concealed by lofty oaks and tulip poplars and surrounded by azalea plantations and woodland gardens, its walls and rooftops rising like those of an old French château, stands the Henry Francis du Pont Winterthur Museum. The collections of American arts therein, along with gardening, horticulture, farming, and particularly the breeding of pure-bred cattle, have been the passionate interests of Henry Francis du Pont since early manhood. For his achievements in each he has received widespread recognition.

The Museum has grown out of Mr. du Pont's lifelong devotion to American antiques. As early as 1923 he began acquiring outstanding examples of the objects which American craftsmen fashioned for the early American home, as well as those imported from Europe and Asia. In 1927 he inherited the family residence his great-uncle and great-aunt, James Antoine and Evelina Gabrielle du Pont Bidermann, had built in 1827 and named Winterthur for Bidermann's ancestral city in Switzerland. Almost immediately he began to enlarge it to accommodate some eighty rooms and forty-five alcoves and corridors which, in accordance with a careful plan, were eventually to become a museum open to the public. Here was painstakingly installed interior woodwork from old houses as far apart as North Carolina and New Hampshire, with furnishings which might have been chosen and used by the original occupants.

By the mid-1930's Mr. du Pont was recognized as America's foremost collector of antiques. In 1950 his collection was characterized by the late Joseph Downs former curator of the American Wing of the Metropolitan Museum of Art and first curator of Winterthur, as "the largest and richest assemblage of American decorative arts ever brought together." Mr. Downs further evaluated its significance: "The vast scope of the collections, particularly of the eighteenth century, gives a new understanding of and respect for the integrity of American craftsmanship, an inheritance from medieval times that disappeared in the machine age. . . .To all Americans this overwhelming art collection offers a source of cultural richness, un-equaled anywhere for a better understanding of our history, giving a broader meaning to early life at its best, and offering a greater scope for its enjoyment today."

The time had now come for the second step in Mr. du Pont's plan. During 1950-1951 he moved his family to a new home nearby, conveyed his private museum to the Winterthur Corporation (an educational and charitable foundation which he had established in 1940), provided endowment for its operation, and opened its doors to the public. During the next seven years annual visitor attendance grew from 16,500 to 31,800, the staff from 15 to 106 full- or part-time employees, the library from 5,000 to 12,000 volumes; one by one were added such new facilities as textile-storage rooms, technical laboratory, offices, and classrooms. The final step in the transformation of Winterthur from a private residence to a modern, stream-lined museum plant was accomplished in 1959, when a five-story wing was completed at the south end of the building to provide an enlarged visitors' entrance and dining room; a rotunda for lectures and special exhibitions; a new group of period rooms to be used by school children and to be shown to visitors without advance reservation; and completely up-to-date facilities for library, research, education, and administration.

Displayed along with the early American fine and decorative arts is a representative cross section of imports from Europe and Asia used in early American homes. Geographically, the collection includes interiors from ten of the original Colonies; chronologically, it ranges from 1640 to 1840. For this period, it includes excellent examples of all the important regional schools of craftsmanship; labeled, marked, or otherwise documented specimens of American work; and six major styles of interior design. The collection's greatest strength is in the decorative arts, with major emphasis on pieces illustrating the highest standards of the American craftsman: unmatched in range and depth are the furniture, lighting fixtures and devices, China-trade porcelain for the American market, and fabrics made after 1640; outstanding are the American silver, pewter and other metal work, Pennsylvania folk art, pottery and glass, English delft, and the Oriental rugs known to the colonists as Turkey carpets. The Museum also has an extensive collection of country and folk art, miniature objects, and toys.

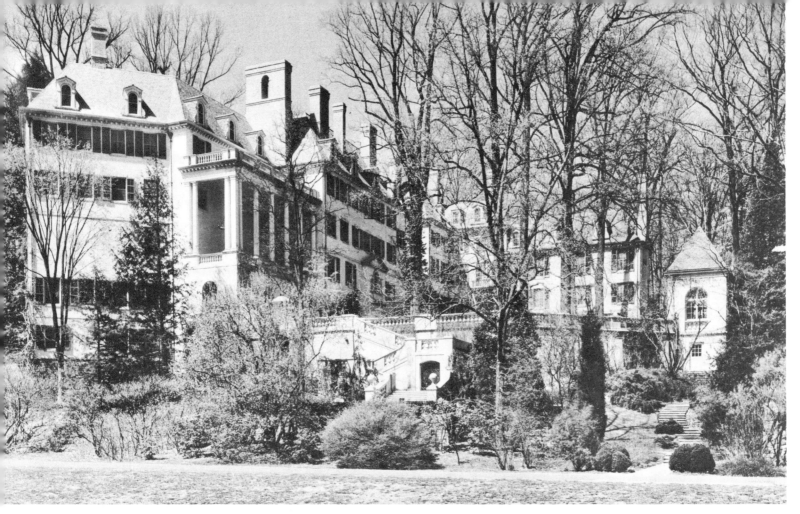

THE HENRY FRANCIS DU PONT WINTERTHUR MUSEUM, south elevation, as it appears today, with the recent additions to the original building of about 1838.

Because Winterthur was originally a private home, each room retains a quality of intimacy; and the visitor seeing the collection, as he does, in a group of not more than four with a guide enjoys a highly personal experience. These period rooms represent a summation of the taste, the standards of living, and the social ideals of a people. Regarding itself as both an art and a history museum, Winterthur endeavors to foster an understanding of American culture by studying and encouraging others to study the early American arts as a chapter in the development of the West's artistic tradition; as an embodiment of the ideals, values, and techniques of American craftsmanship; and as social documents throwing important light on the history of the American people. For the daily visitor or the college class, attention is focused on esthetic quality, design and construction, historical antecedents of style, contrasts between country and urban forms, distinctive contributions of different regions and nationalities, and the influence of imports from abroad.

In addition to the custodianship of its collection, the staff at Winterthur is engaged in research and the creation of research facilities, in publication, and in teaching. Guided tours of varying length and scope are offered to meet the needs and interests of varied groups of visitors. The gathering and classification of information for the interpretation of the objects in the collection and for the determination of the socio-cultural context in which these objects were made and used is advanced with the help of three libraries: the Museum Library, the Joseph Downs Manuscript Library, and the Waldron Phoenix Belknap, Jr., Research Library of American Painting; and three re-

search and study resources: the Index of American Cultures, the Decorative Arts Reference Library, and the Primary Source Quotation File. One of the most significant educational undertakings is the Winterthur Program in Early American Culture sponsored and carried on jointly by the Museum and the University of Delaware. Inaugurated in 1952, this two-year master-of-arts program combines course work in American history, art history, and literature with practical experience and training in connoisseurship and museology.

In summary, at Winterthur the sheer size, magnitude, and scope of the collection, housed under one roof, provide an unparalleled opportunity for the study of the broad panorama of American arts. This great collection bears the unmistakable impress of Henry Francis du Pont in the quality of line and proportion of the individual piece, in the harmony of color and scale, and in the beauty of arrangement of the whole. Mirrored in the collection is his conviction that the arts of earlier Americans reveal their life and manner of living. Another deep imprint on Winterthur was made by Joseph Downs. His high scholarship is memorialized in the standards he set for his followers as well as in the manuscript library that bears his name.

This happy union of collections, tradition of scholarship, and varied resources has made possible the development of a broad program in which every effort is made not only to give enjoyment to the visitor, but also to study, to teach, and to publish.

CHARLES F. MONTGOMERY, *Director*

10

The first colonial century

EXCEPT FOR THE SPORADIC IMPRESS made by the Swedish, Dutch, and Huguenot settlers in America before 1700, the customs of living from old England were strongly implanted in the domestic arts along the Atlantic seaboard throughout the colonial period. Up to nearly 1700 they perpetuated many of the medieval traditions which England herself had not yet fully discarded, though the new fashions that appeared in England were also adopted here. With the first quarter of the eighteenth century the William and Mary style, which had developed in the mother country in the late 1600's, influenced the design of furniture and the related arts in America.

Several rooms at Winterthur re-create American homes of the first colonial century with striking verisimilitude. In these, and the rooms of later periods, the architectural setting and furniture are all American-made. The accessory decorations include objects of the sorts imported here from earliest days to satisfy the insatiable appetite for foreign treasures.

THE HART ROOM, a second-floor room in the house built by Thomas Hart before 1670 at Ipswich, Massachusetts, is arranged to show its original function as a sitting-bedroom. With the exception of the late seventeenth-century gateleg table from Pennsylvania, all the furniture here is of New England origin. The most important piece is the court cupboard, which bears the date 1684 and the initials of its original owners, Ephraim and Hannah Foster, and is attributed to Thomas Dennis, the master joiner of Ipswich. Also considered the work of Dennis is the spice chest marked *T H 1679*, for Thomas Hart, son of the builder of the Hart House. The carved wainscot chair is another piece with an Ipswich history. The silver and pewter in the court cupboard represent other New England crafts, while the fact that settlers cherished possessions from England is shown by the sealtop silver spoon on the center table, owned by Elder William Brewster, for whom the type of chair beside the court cupboard is named. The efforts of the colonists to achieve the com-

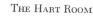

THE HART ROOM

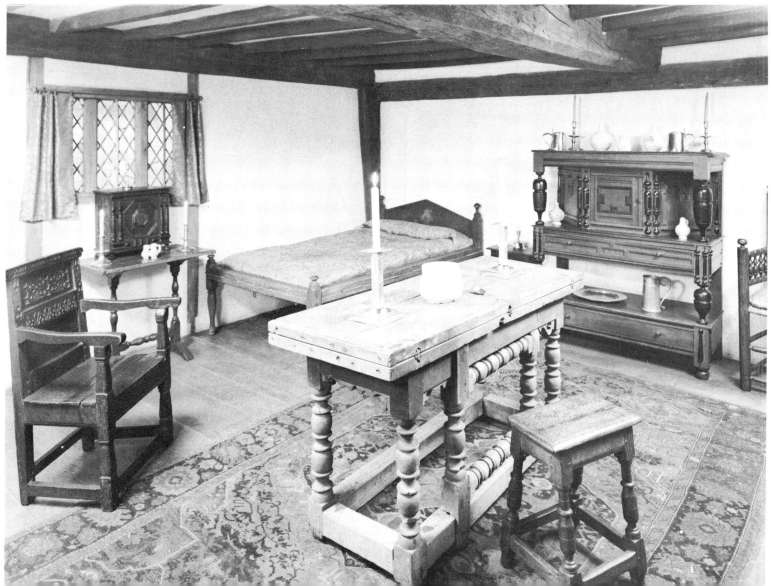

forts of home with imported luxuries are further reflected in the use of Delft pottery, brass candlesticks, Italian brocatelle at the windows and on the seventeenth-century low-post bed, and an Ushak, or "Turkey," carpet on the floor.

The OYSTER BAY ROOM, originally in the Job Wright house built soon after 1667 on Long Island, New York, shows the Dutch and Flemish treatment of ceiling beams and framing, with supporting posts for the narrow, deep summer beam. The fireplace lintel, from a contemporary house in Milford, Connecticut, is the only known American example with carved ornament; this consists of a single row of diamond-shape points. The turned chairs include, along with the Carver at the gateleg center table, contemporary turned slat-backs and severe low-backed Cromwellian chairs; the one in the foreground has its original upholstery of Turkey work, a domestic imitation of the knotted carpets from the East. The long bench with sausage turnings is a New England piece. On the paneled chest stands a Bible box carved with the initials *I H* and the date *1664*. Contemporary maps and books are lighted by candles in brass sticks from England or Holland.

In the late seventeenth century American rooms began to acquire an elegance that echoed the frivolous extravagance and gaiety of Restoration England. The FLOCK ROOM takes its name from the flock covering on the walls, that ingenious substitute for cut velvet, made of chopped wool applied to a glued pattern on canvas or paper, which serves to relieve the oystershell or clay-plastered walls. The hangings here are in a rich pattern of green, orange, and cream, and date between 1720 and 1750. Architecturally this room is one of the outstanding examples of its period in America. The woodwork came from Morattico, built in Richmond County, Virginia, about 1700. On the fireplace wall are painted and marbleized panels. The two paintings over the cupboards show exotic birds, while the overmantel displays a fabulous house and a garden, where the artist has depicted a stag hunt taking place. These paintings are lighted by candles in brass branches on the chimney breast, and an English brass chandelier hangs from the ceiling. Tall-back chairs with turned legs, crested with open carving, are caned or leather-covered. The great gateleg table in the center of the room is covered with a fringed yellow Italian velvet cloth and set with huge brass candlesticks, a seventeenth-century English glass loving cup, and a Bible. The ambitious candytwist turned legs on the high chest are evidence of Carolean design, rare in America. The high-back wing chair with horizontally rolled arms and turned legs and stretchers is upholstered in gold silk brocatelle, matching the curtains at the window.

The woodwork of MORATTICO HALL is from the same Virginia house as the adjoining Flock Room. The charming portrait of Magdalena Douw, an antiquarian document in its details of costume and furniture, was painted in the

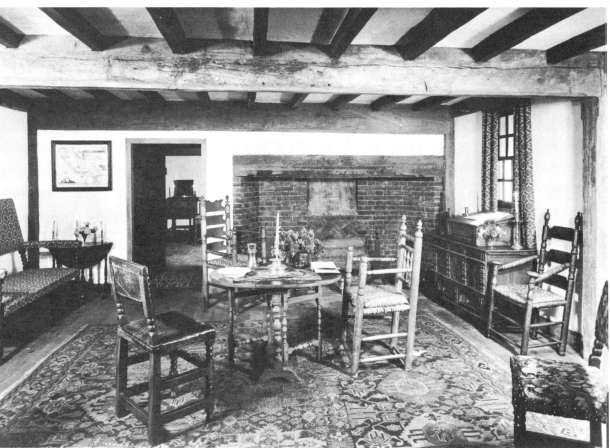

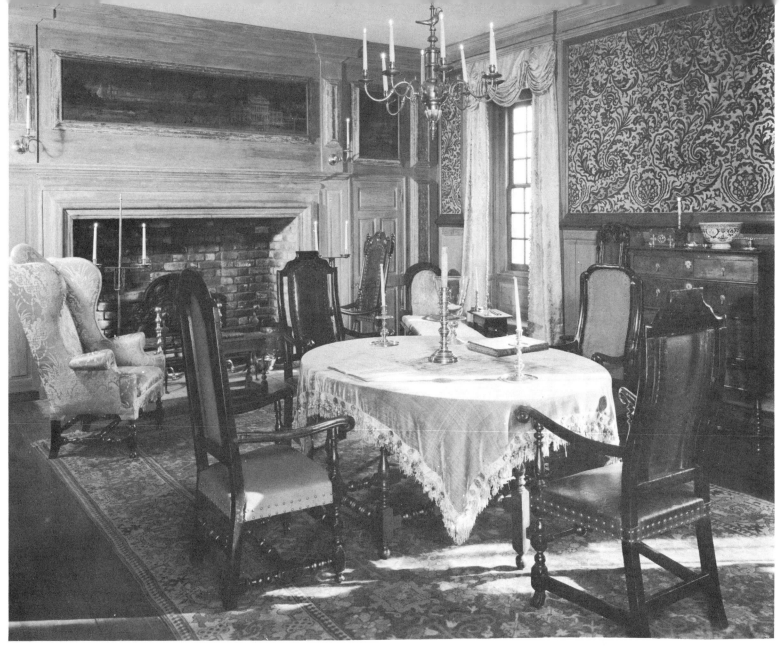

The Flock Room

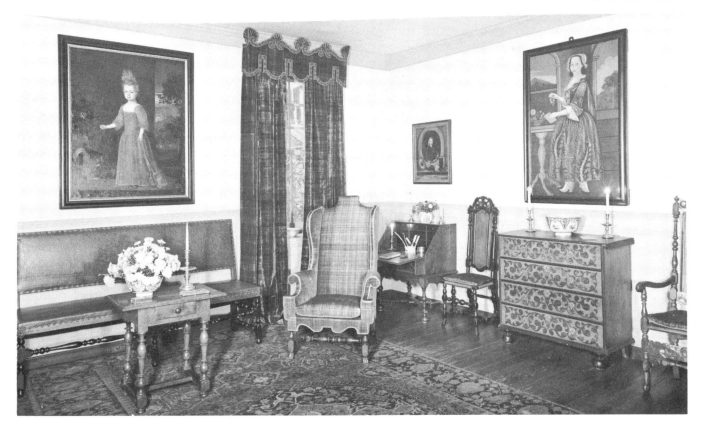

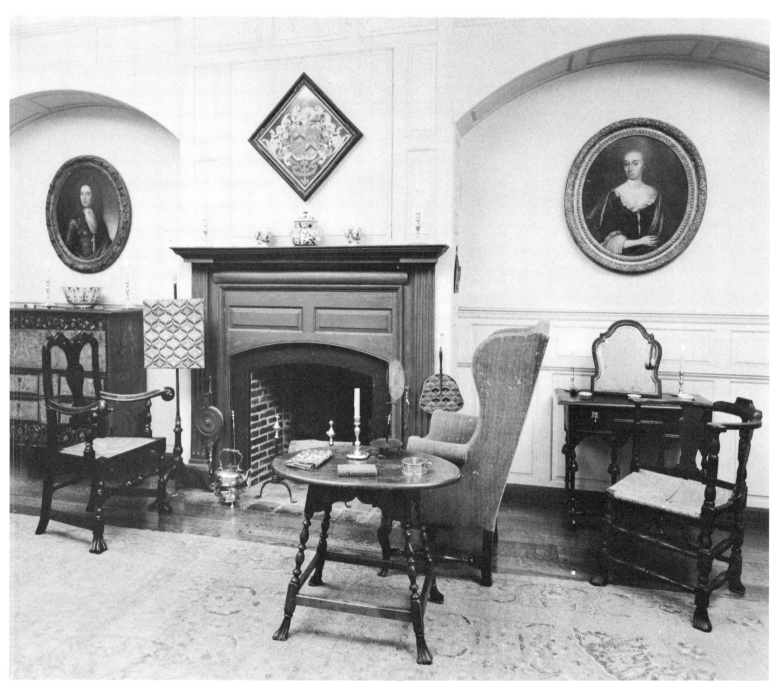

THE BELLE ISLE ROOM

Hudson Valley in the early eighteenth century. The full-length portrait of a child is attributed to Justus Engelhardt Kühn, a German early settled in Maryland. Her red velvet dress matches the old fabric of the window hangings and of the coverings on the Spanish-foot wing chair and the carved and crested caned chairs. The turned bench and table perpetuate seventeenth-century modes, while the ball-foot desk-on-frame has shaped cross stretchers in the William and Mary style of the early 1700's. Painted decoration covers the front of the ball-foot chest, in imitation, no doubt, of the elaborate marquetry fashionable in Europe at the time.

THE BELLE ISLE ROOM is from Belle Isle, a house built by William Bertrand before 1760 at Bocr, Lancaster County, Virginia. Its fireplace with high, richly molded mantelpiece is flanked with paneled and arched bays painted buff. The armchair with carved cresting and bold Spanish feet is one of a pair here, attributed to John Gaines of New Hampshire. The William and Mary scrolled frame of the tall easy chair beside the trestle-base gateleg table is covered with pale red moquette, a seventeenth-century wool pile fabric. The four pad feet of the early turned corner chair presage the typical form of the coming Queen Anne style, while the turnings and flat stretchers of the lowboy or dressing table, which supports a scroll-frame looking glass, are in the William and Mary style. The

painted Guilford chest is one of four in the room, dating soon after 1700; their painted decoration harks back to Restoration England in the use of crown, thistle, rose, and fleur-de-lis. Of equal beauty and rarity is the embroidered hatchment over the mantel; these diamond-shape devices, painted or worked in embroidery with the coat of arms of a deceased person, were hung on the house or placed on the hearse at a time of death, and later often hung in the church as a memorial. The early eighteenth-century New England portraits are by unidentified artists; the man, at the left, is thought to be John Briggs, Jr., who died in Boston in 1721. Bargello embroidery, descriptively called flame stitch— a popular stitch throughout the seventeenth and eighteenth centuries—covers the fire-screen panel. Bristol and Wincanton delft bowls and covered posset pot that dress the mantel and chest suggest the imported wares of the day.

Small-paneled wainscoting of oak covered the walls of many Jacobean houses in England. Here the WALNUT ROOM from the Belle Isle house carries out the same pattern in gray-stained hard pine. The room is named for its furniture—trumpet-legged high chest and tables, and crested chair. The hangings on the folding trestle bed are English cotton printed in red. The portraits of Benjamin Austin of Boston (1716-1806) and his wife, Elizabeth Waldo, were painted by John Greenwood about 1747.

THE WALNUT ROOM

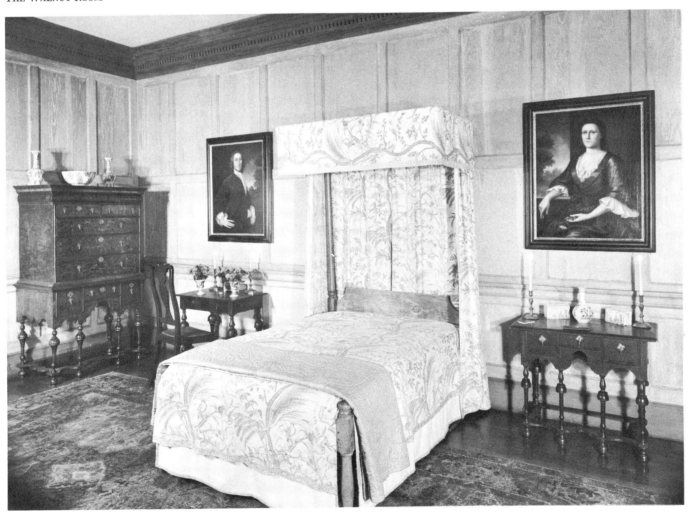

15

"They always contrive to have large Rooms that they may be cool in summer. Of late they have made their stories much higher than formerly, and their windows large, and sasht with Cristal Glass; and with in they adorn their Apartments with rich Furniture . . ." These words of Robert Beverly (*History and Present State of Virginia,* 1705) come to mind in the TAPPAHANNOCK ROOM from the Ritchie house built at Tappahannock, Virginia, about 1725. Its leaf-green painted paneling serves as a foil for the William and Mary furniture in walnut and gumwood. Beside the caned chair an unusual stand on turned feet has candle arms and table that revolve on a screw-turned standard to adjust their height. From Pennsylvania are the wood-bottom turned chair beside the early desk-on-frame, and the early wing chair in the German style, which has flat shaped arm supports. The ball-foot chest dated 1737 was the first piece acquired for the Winterthur Museum. Above it hangs a mirror in walnut veneered frame, and on the other wall a framed crewel-work picture on silk inscribed by *Mary King 1745* of Philadelphia. Here, as in other rooms of the first colonial century, the rug on the floor is one of those Near Eastern weaves known as Turkey carpets because of the source of their shipment to England, and thence to America, before the Revolution.

The WENTWORTH ROOM (*Color plate page 32*) is from a fine seventeenth-century house at Portsmouth, New Hampshire, in which the paneling was installed about 1710. This was originally a bedroom; another bedroom and stair hall from the same house are now in the American Wing of the Metropolitan Museum. Samuel Wentworth, its first owner, was the son of one of the few representatives of aristocratic families to settle in New England in the early 1600's.

The paneled woodwork, mounted with virile bolection moldings, follows a palace style that Louis XIV's architects created; it appeared, too, at Kensington Palace and Hampton Court in England in the reign of William and Mary. Sometimes in the Colonies the paneling was stained in dark colors, as here; sometimes it was left to ripen in sunlight and woodsmoke. Banister-back, crested chairs, joint stool and low-back chair, and Spanish-foot gateleg table are fine examples of turned furniture types. The William and Mary high chest has trumpet-shape legs painted to match the grain of the burl walnut veneer decorating its case. The dark blue and white enameled delft on top of it is among the rarest of English pottery, patterned on Nevers faïence from France. Other English delft here is decorated in polychrome or blue. Rare New England silver in this room includes a double-handled cup marked by Hull and Sanderson, who were in partnership from 1652 on, the first silversmiths and mint masters in the American Colonies. Tankards, caudle cups, a sugar box, and porringers by Jeremiah Dummer, the first American-trained silversmith, and by Edward Winslow, also of Boston, are arresting for their high quality and subtle design. The framed hatchment over the high chest of drawers and the sconces today are known as quillwork, for their elaborate compositions of rolled paper quills, painted or gilded; however, they also contained shellwork, wax figures, and sparkling bits of mica and were made by schoolgirls as part of their education as described in the following advertisement from the Boston *Gazette* of May 26, 1755:

This is to give notice, That Mrs. Hiller still continues to Keep School in Hannover-Street . . . where young Ladies may be taught Wax work, Transparent and Filligree, painting on Glass, Quill work and Feather work, Japanning, Embroidering with Silver and Gold, Tentstitch &c . . .

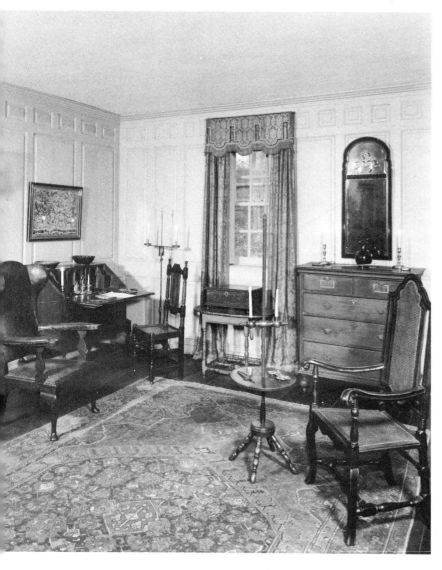

THE TAPPAHANNOCK ROOM

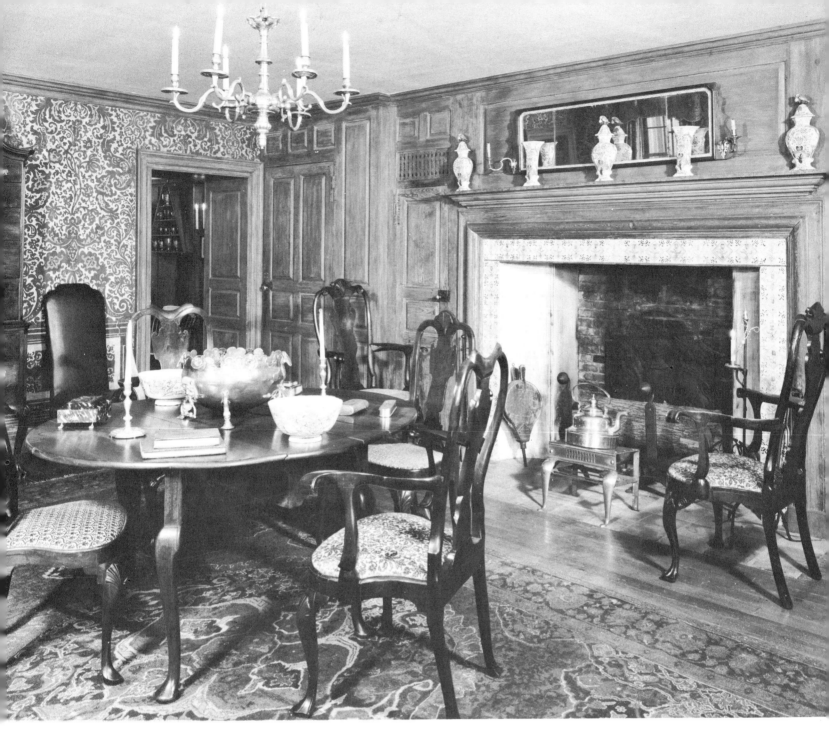

The Queen Anne period

THE QUEEN ANNE STYLE marked a definite trend away from the rectangular and often heavy styles of the seventeenth century, towards curves and greater lightness. There was a new concern for comfort. Domestic interiors became more spacious; cabriole-leg furniture made them more graceful, and exotic treasures brightened them with gay and whimsical ornaments. The foreign ingredients that contributed to the Queen Anne style in England showed the effect of the growing communication that was developing with the Continent, the Near East, and the Orient. In America the new style lagged behind its

development in England; its period here was, roughly, the second quarter of the 1700's. Always, however, an old style persisted into the period of a new one; the period rooms at Winterthur show this overlapping of styles, and also include pieces that are in themselves transitional.

The walls of the VAUXHALL ROOM are covered with hangings of the same type as are in the Flock Room, probably slightly later in design. Here, since there is no wainscoting,

17

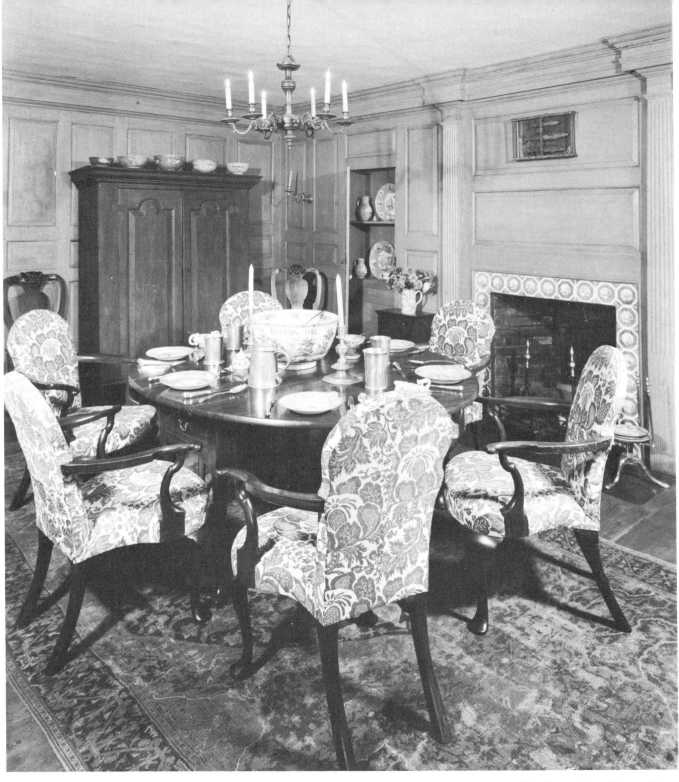

the canvas comes to the floor and the lower part is designed to simulate a dado—an extremely rare feature. The woodwork here is from Vauxhall Gardens, the home of Thomas Maskell in Greenwich Township, Cumberland County, New Jersey. The earliest part of the house was built about 1700; this room is from a section added about 1725. The huge, bolection-framed fire opening is faced with seventeenth-century Dutch polychrome tiles. The furniture here is considered, for its variety and quality, a study collection of Philadelphia Queen Anne. The chairs drawn around the large center drop-leaf table and grouped about the room represent the typical shell carving, the trifid and pad front feet, the plain and molded rear stump legs, and the various types of back splats with volutes and scallops that distinguish Philadelphia work in this period. Contemporary are the scroll-pedimented walnut highboy, and the horizontal looking glass over the mantel, in molded walnut frame with attached candle branches of brass. The mantel is enriched with a garniture of polychrome delft with bird finials. A convivial note is given by the great brass monteith with wineglasses hung over its scalloped rim. Also of brass is the chandelier, decorated with a ring of little birds around the top of the shaft. A capacious brass kettle rests on a high brass stand in front of the fireplace, which is equipped with an iron fireback and tall wrought-iron andirons.

The QUEEN ANNE DINING ROOM is a symphony in color—the strong blue and white of resist-dyed upholstery, the subtle blue and purple of delft pottery, against soft green woodwork. While the woodwork came from New Hampshire, most of the furniture is from New York. The stuffed-back armchairs circling the six-legged table are from a set of seven. The superb walnut side chairs, and two others with eaglehead arms, are from a set which first belonged to Stephanus van Cortlandt in Manhattan. The large green-painted cupboard or kas with heavy cornice and arched-panel doors is from Dutchess County. Tankard and beakers constitute in themselves a collection of eighteenth-century American pewter. The colorful delftware, mostly English and Dutch, includes two rare sauceboats of Irish make, and the great Bristol punchbowl with landscape decoration inscribed *George Skinner, Boston, 1732.*

The impact of Dutch culture in the Hudson Valley is shown in two rooms from the Hardenbergh house in Ulster County, New York, built in 1762. The multiple-beamed, low wooden ceilings, deep windows, and flat-cupboarded walls seem like many Old World interiors painted by the Little Masters. In the furnishings, as in the architecture of these rural rooms, early eighteenth-century features persist at a time when sophisticated centers had adopted the Chippendale style. In the HARDENBERGH PARLOR a New York Queen Anne wing chair is drawn up before the fireplace, beside a black-painted trestle stand where an American pewter tea set and cups of scratch-blue salt glaze are laid out for tea. Similar English salt glaze fills the cupboard. Candles in tall wrought-iron stands augment the light from fat lamps. Flintlock rifle, powder horn, knife, and game bag hang above the fireplace, framing the sampler worked in 1760.

THE HARDENBERGH PARLOR

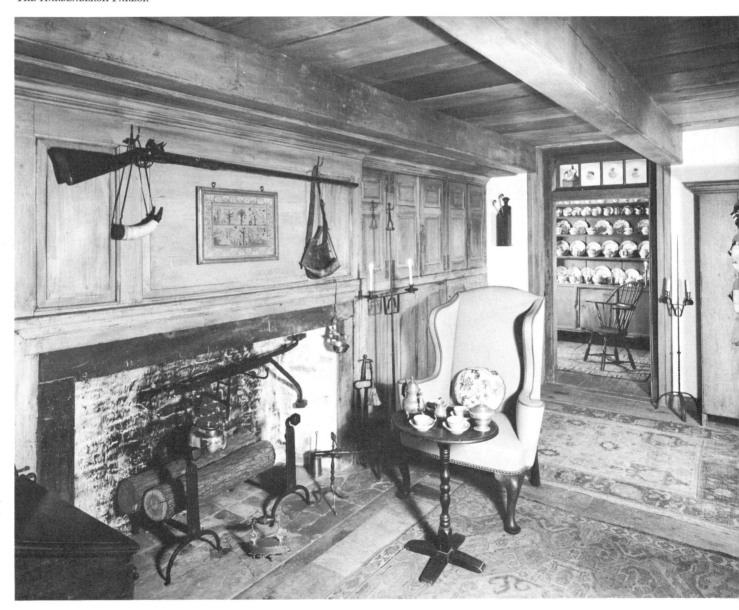

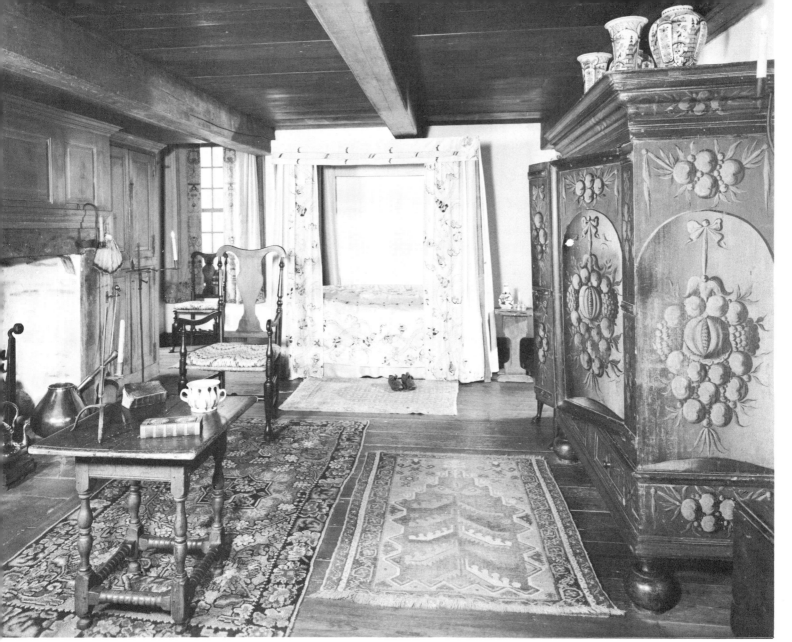

THE HARDENBERGH BEDROOM

In the HARDENBERGH BEDROOM the bed, hung with crewel-work of unusual design, is placed along the wall in Continental fashion. New York Dutch tradition is apparent in the rush-seated chairs painted red and black, the sausage-turned stretcher table, the garniture in Dutch blue and white Delft on the kas, and in the great kas itself. This piece with its heavy cornice and large ball feet is typical of a Continental form made all through the Hudson Valley and also in Pennsylvania and New Jersey; it is rare, however, in its decoration painted in grisaille with fruits and swags.

In the WYNKOOP ROOM, the rich blue tones of silk bed hangings and a Chinese Ch'ien Lung rug complement the color of the woodwork, a deep blue-green shade copied from the house built by Cornelius Wynkoop about 1772 at Stone Ridge, Ulster County, New York. All the furniture in this room is related through the use of the Spanish foot, a holdover from the William and Mary period which is here incorporated with features of the Queen Anne and Chippendale styles on provincial furniture dating as late as the mid-1700's. The cabriole legs of the unusual Connecticut field bed (1725-1750) end in graceful Spanish feet, as do the turned legs of the early eighteenth-century

20

Connecticut corner chair facing the dressing table. The Connecticut kneehole chest of drawers is perhaps unique in its combination of this earlier type of foot with the block front generally associated with Rhode Island and Massachusetts furniture of the Chippendale period. The garniture on the chest bears the mark of Justus Brouwer, who worked at Delft between 1739 and 1770. Above, a New York looking glass is flanked by English delft wall pockets.

The tall dignity of Southern plantation houses is evident in a room and adjacent stair hall from Readbourne, a house built in Queen Anne's County, Maryland, about 1733. Here, in the READBOURNE PARLOR, are splendid Philadelphia Queen Anne chairs with trifid, web, and claw-and-ball feet. The sofa, also a Philadelphia piece, has horizontally rolled arms and web-foot cabriole legs like the compact little easy chair that turns its back to the window (center). The tea table in the center of the room is a reminder that tea, introduced in Europe in the early 1600's,

came to real popularity in the Queen Anne period, bringing with it new social customs that called for new forms in furniture, ceramics, and metals. Here the dish-top rectangular table is set with an English salt-glaze tea and coffee service whose polychrome decoration is one of those charming adaptions of Chinese design called chinoiserie. The East also influenced the lavish decoration of a highboy in this room, which is an outstanding example of the japanned work done in New England in imitation of Oriental lacquer. This rare high chest of drawers was made in Boston for Commodore Joshua Loring between 1740 and 1752 by the cabinetmaker John Pimm, whose name is written in chalk on the drawers; it was decorated probably by William Johnson, the leading japanner of Boston. Three glittering sconces on the wall are of New England quillwork. The matching two are the only known examples retaining their original silver candle branches, which are marked by Jacob Hurd of Boston (1702-1758). The branches on the double sconce, the only other American silver candle arms known, were made by Knight Leverett of Boston (1703-1753). The sil-

THE READBOURNE PARLOR

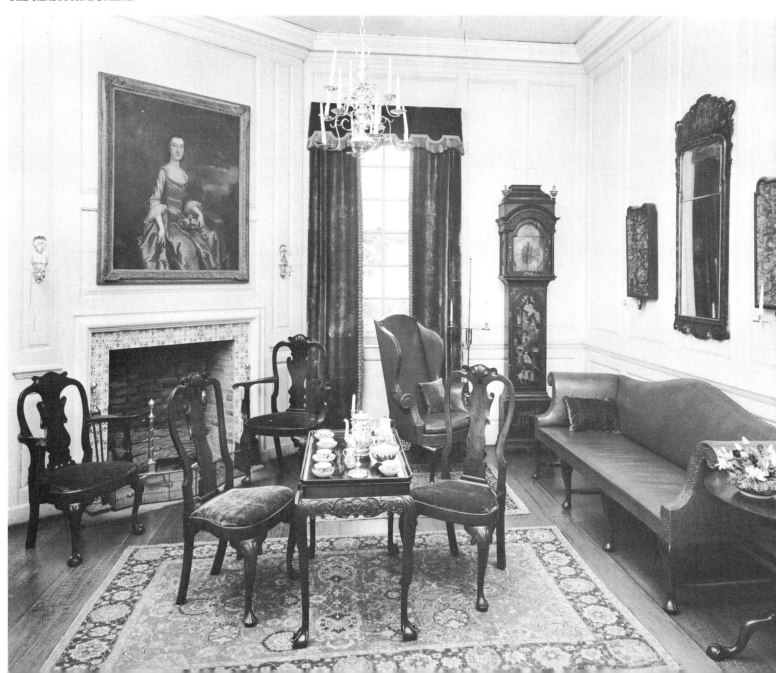

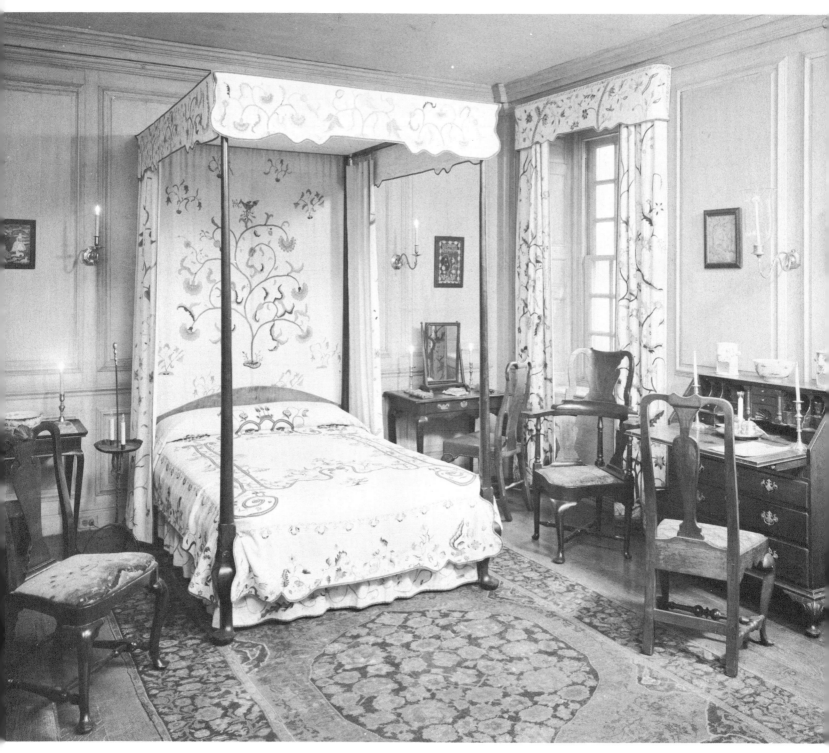

THE CECIL BEDROOM

ver chandelier, according to an engraved inscription on the base, was given to a church in Galway in 1742; the silver sconces on the chimneybreast were made in London by John Sanders in 1718. John Wollaston painted the portrait of Experience Johnston Gouverneur of Newark, New Jersey, which hangs above the fireplace. The rich blue of her gown is repeated in the lustrous velvet window hangings and Ispahan carpets, which suggest the luxury of colonial mansions adjacent to the sea lanes of commerce.

The CECIL BEDROOM is from the Pickard house, Cecil County, Maryland. Here stands a unique early maple bed, its towering posts supported on pad feet; the hangings are rare New England crewelwork embroidered in gay flowers and strapwork bands. The bedspread was originally owned by Thomas Hancock in Boston, ship owner and merchant, and later by his nephew and heir, John, the Signer and governor. Crewelwork pictures signed by their makers hang against the paneled, blue-painted walls. The furniture is all of the Queen Anne period.

22

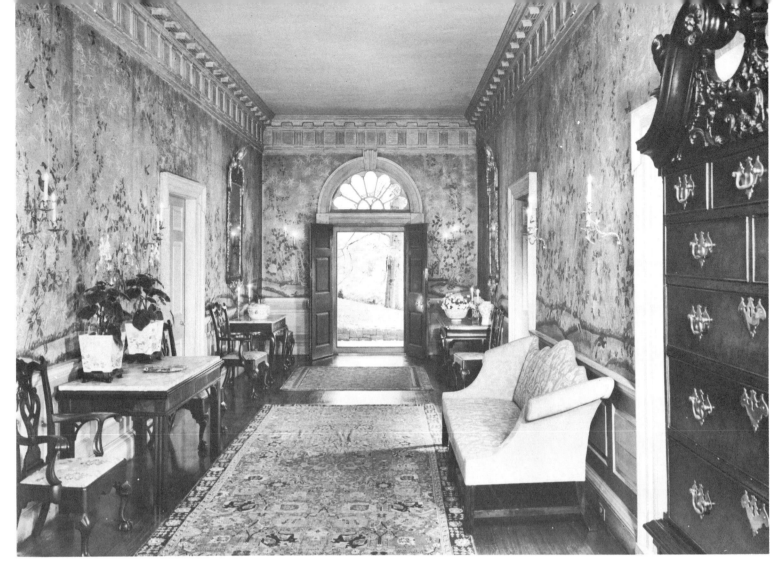

The Chippendale period

THE CHIPPENDALE STYLE makes an incomparable display at Winterthur. This anglicized version of the French rococo, "all twisted as though by a rogue," in Cochin's words, was sobered in its colonial interpretation, yet its Chinese, French, and Gothic phases were handled with astonishing ability and variety in New England, the Middle Colonies, and the South, from the mid-eighteenth century until after the Revolution. At the same time an ever-increasing wealth of decorations from other parts of the world was enriching the homes of the colonists and broadening their horizons. Though Jefferson complained of "that burden of barbarous ornaments" during this period, the Chippendale rooms at Winterthur give evidence of the elegance and grace the style achieved in the American Colonies.

The spacious PORT ROYAL ENTRANCE HALL, which served as the entrance to Winterthur during the years it was a home, sets the mood for the Chippendale rooms with an early painted Chinese wallpaper; pale bamboo branches and tree peonies, birds and butterflies form a graceful pattern on a muted green surface. The woodwork was taken from Port Royal, a house built in 1762 in Frankford, near Philadelphia, by Edward Stiles, a prosperous West India merchant. The original gray paint is a valuable document: the bevels and fields of the panels are in lighter shades than the rest of the woodwork. The double doors at either end of the hall have broad architraves in keeping with the deep Doric cornice and paneled dado; the motif of the fanlights above them suggests the cockleshell often seen in furniture carving of the time. Besides the painted paper, the ornaments on the walls are eight rococo gilt-bronze candle branches of delicate leaflike form, and a matched pair of mahogany and gilt looking glasses of great size. These once hung in the Bromfield-Phillips house on Beacon Street in Boston, where Abigail Phillips and Josiah Quincy were married in 1769. The other Chippendale furniture ranged along the walls includes Philadelphia chairs, sofa, and scroll-top double chest with pediment carved in a bucolic scene. One of the three

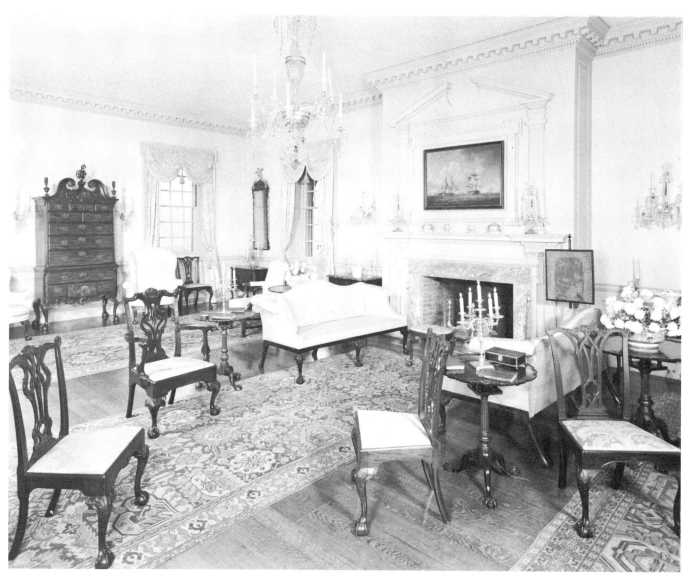

THE PORT ROYAL PARLOR

marble-slab tables has great molded straight legs joined to the frame with fretted corner brackets; the top is partially recessed and framed by moldings. Jardinieres, bowls, and vases are of China-trade porcelain.

Like that of the Entrance Hall, the woodwork of the PORT ROYAL PARLOR, painted a warm cream, is from Port Royal. This room is skillfully arranged for one so large, its symmetrical treatment and use of matched pairs recapturing the balanced effect achieved in formal rooms of the eighteenth century. Here are gathered some of the choicest examples of Philadelphia Chippendale furniture known. The sofas before the fireplace are a matched pair, once owned by the statesman John Dickinson of Pennsylvania and Delaware (1732-1808). They are upholstered to match the chairs and window hangings, in yellow Italian silk damask of the early eighteenth century. Matched pier tables with marble tops flank the fireplace. Side chairs by Thomas Tufft, four piecrust tables, an oval stool, two pembroke tables with Marlborough legs and saltire stretchers, the Van Pelt highboy, and the matching highboy and lowboy from the Gratz family

are among the other rarities in the room. Opposite the fireplace stands an imposing desk and bookcase, its elaborate top composed of a flaring molded cornice, pierced pediment, and fretwork frieze. The carved basket of flowers forming the center finial is an outstanding document of the Philadelphia carver's skill. Ten brilliant wall branches match the eighteenth-century cut-glass and ormolu chandelier; the room is further lighted by candlesticks and candelabra of English cut glass and silver. The overmantel picture, *American Ships Off Dover*, was painted about 1785 by the émigré artist Dominique Serrès. Pieces of China-trade porcelain garnish the mantel and tables, along with Bristol pottery and Chelsea porcelain figures. The three seventeenth-century Kuba carpets are blue and rose.

The paneled walls and ornate chimney piece of the CHESTERTOWN ROOM came from a house built at Chestertown, Maryland, about 1732. The rich ceiling decoration in stucco was originally in the hallway of Port Royal, the house from which the Entrance Hall and Parlor woodwork were taken. Such work, a pure expression of rococo taste, was extremely rare in American houses. Framing

24

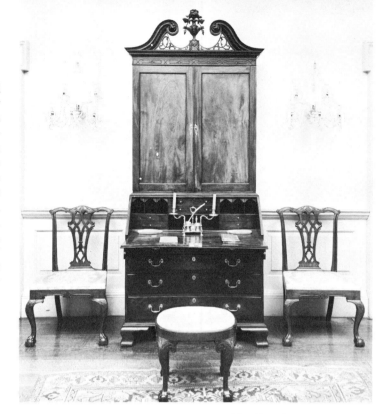

the fireplace opening, the tiles by Sadler of Liverpool are black-printed with pictures of ships and sailors, many of them amusing designs. Superb New England furniture here is the equal of its setting in quality. The shell-carved bureau desk, a pair of china tables, and the urn stand are products of the Goddard-Townsend cabinet-makers of Newport. The tea table, its top and skirt scalloped in twelve lobes, is from Massachusetts, as are the armchair and pole screen. The walnut-veneered and gilded looking-glass frame has a fret-pierced veneer panel in the frieze. The tea table is set with transfer-printed cups and saucers of Worcester porcelain, and a New England silver tea service of the third quarter of the eighteenth century. The coffee urn on the little mahogany stand is early Sheffield plate, about 1760. Ornaments on the tops of the furniture and the mantel are of Meissen and Chelsea porcelain and Battersea enamel. The mid-eighteenth-century cut-glass chandelier has a crown or corona at the top hung with glass beads, and icicle-like shafts on its glass arms. The design of the pale yellow damask window hangings was taken from Chippendale's *Director*. The early carpet is an Ushak weave.

THE PORT ROYAL PARLOR

THE CHESTERTOWN ROOM

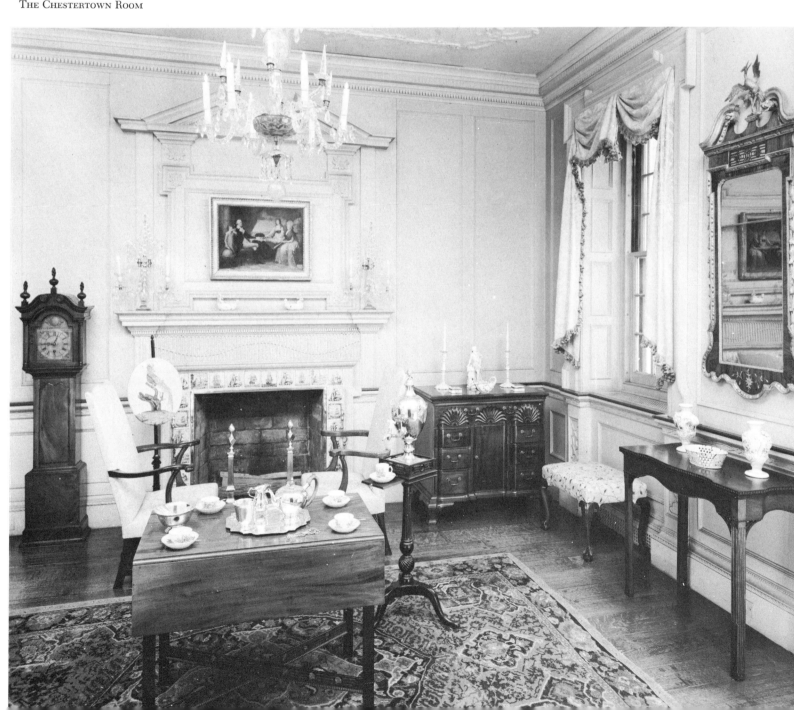

IN the STAMPER-BLACKWELL PARLOR the quintessence of the American Chippendale style is concentrated in every detail of woodwork, furniture, and decorations. Here we see the American colonial reaching its closest approach to its English prototype, yet tinged with that indefinable quality which marks it with its native origin. Architecturally the room is among the most elaborate expressions of the colonial rococo that have survived. The woodwork is from a Philadelphia town house built in 1762 by John Stamper, mayor of the city in 1759. The house followed designs by Abraham Swan, an English architect whose books were well known in the Colonies from 1750 on. Fireplace wall, cornice, and doorways are richly carved. The mantel shelf is mahogany, like the doors and chair rail. The frieze below it is ornamented with bucolic scenes, and here particularly the carving shows great virtuosity, with high relief and deep undercutting. An overmantel panel is framed in carved festoons of leaves and flowers, and itself frames a view of Perry Hall by Francis Guy, who painted views of a number of gentlemen's

estates near Baltimore in the late eighteenth century and later worked in New York. Gilt-bronze candle branches on the paneled chimney wall are in keeping with the rococo character of the carving. So too are the bowls of China-trade porcelain that garnish the mantel; they are decorated with *The Cherry Pickers* design. All the furnishings are on a level with the sumptuousness of the architectural background, representing the ultimate in refinement and elegance achieved during the Chippendale period in Philadelphia. The furniture is all of Philadelphia make, shapely and ornamented with carving. Philadelphia carvers reserved the hairy-paw foot for their finest furniture, and it is represented on eight examples in this room: five side chairs, a wing chair, a card table, and a pole screen. Of the side chairs, that with carved seat rail is one of the six sample chairs attributed to Benjamin Randolph; the other four are a matching set, closely similar to the Randolph sample chair now at Colonial Williamsburg. No less distinguished are the claw-and-ball-foot pieces in the room: the tripod tea table, the marble-top pier table, the wing

THE STAMPER-BLACKWELL PARLOR

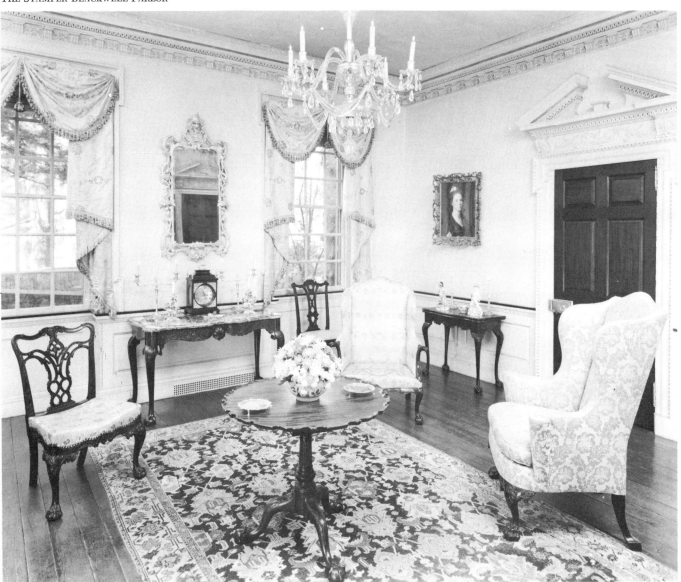

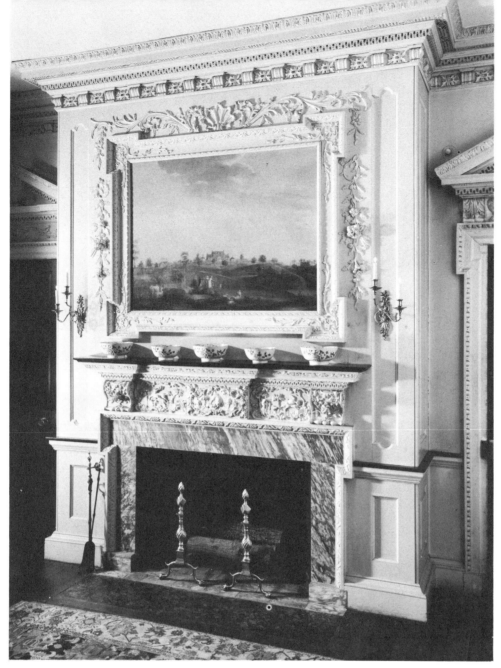

THE STAMPER-BLACKWELL PARLOR

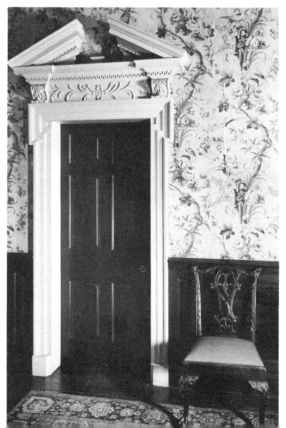

chair with carved arms and seat rail, and the daintily pro-portioned card table. An airy pierced looking-glass frame in white and gold, made in Philadelphia, is a great rarity. Other ornaments in the room are of "burnt china" from the Orient and from the English factories of Chelsea and Bow. On the wall hangs one of the rare early pastels by the Boston painter John Singleton Copley (1739-1815). It por-trays his wife, Susanna Clarke, and is a companion to a self-portrait in the room. The Kuba carpet from Asia Minor glows with color. The long curtains of Louis XV silk in a clear salmon shade are trimmed with bands of contemporary needlework.

The STAMPER-BLACKWELL VESTIBULE, a small hall adjacent to the Stamper-Blackwell Parlor, has a mahogany dado around walls covered with an eighteenth-century Chinese painted paper. The mahogany chair (one of a set of four here) is one of the most sensitive American interpretations of the Chippendale style.

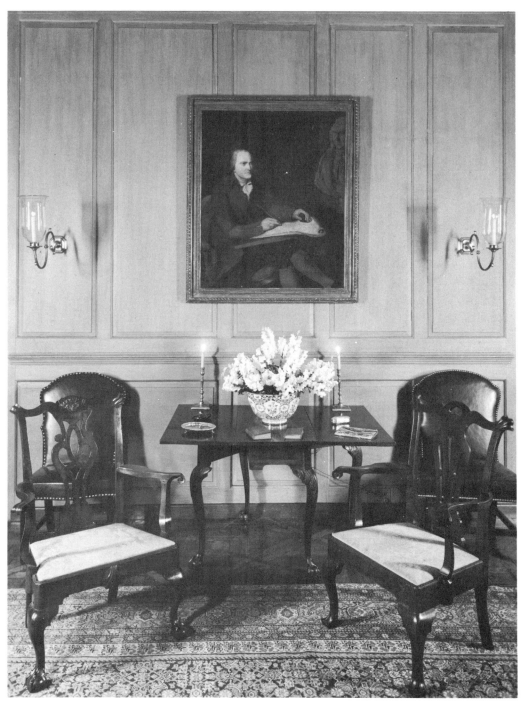

THE MARLBORO ROOM

In the MARLBORO ROOM *(Color plate page 33)* hangs the portrait of Pierre Samuel du Pont de Nemours, first of the name to settle in the United States in 1800. Painted in France by an unidentified artist, it shows Du Pont seated beside Houdon's bust of his friend Turgot, Louis XVI's minister of finance. Portraits of his parents, Samuel du Pont and Anne de Nontchanin, also hang in this room, and those of Richard Bennett Lloyd of Wye, by Charles Willson Peale, and of General Washington by Charles Peale Polk. The lofty walls themselves, fully paneled and painted gray green, are from Patuxent Manor, a brick house in Lower Marlboro, Maryland, built for Charles Grahame in 1744. An immense eighteenth-century Fera-

ghan carpet covers the old pine floor, and the curtains are of early Italian red brocatelle. The gilded chandeliers are a rarely graceful pair, their tin branches spreading from a turned wood shaft. The room is also lighted by candles in glass-shaded branches of heavy English brass on the walls, in American iron and brass candlestands, and in the sconces of a handsome gilt mirror of the early 1700's. On the hearth a brass teakettle rests on a high stand. Above the fireplace hangs the earliest (1746) of the dozen or more needlework pictures known as The Fishing Lady on Boston Common. Delft bowls from the Lambeth, Brislington, and Bristol potteries in England have deep, slanted sides indicative of the early period. The room is furnished largely

with Philadelphia walnut. Queen Anne chairs and Chippendale sofas, covered in leather or damask, are arranged in informal groups with tripod, gateleg, and simple claw-and-ball-foot tables. An armchair labeled by William Savery stands at the window to the right, and a set of four stools with shell-carved knees was made by John Elliott in 1756 for Stenton, in Germantown.

The PATUXENT ROOM came from the same Maryland house as the Marlboro Room, and has the same airy proportions. Tea table and easy chairs recall the eighteenth-century custom of using a bedroom frequently as a sitting room. The tea set here is of Worcester porcelain, transfer-printed with designs signed by Hancock. A great bed is hung with a unique set of crewelwork linen curtains which were worked by ladies of the Penn family. Sea-green Italian brocatelle at the windows is matched by the upholstery of the Philadelphia Chippendale chairs. From Philadelphia likewise are the chest-on-chest, or double chest as it was called in the 1700's, and the unusual slant-top desk with finely detailed interior, on a low scrolled frame. On the walls are engravings by the patriot and silversmith Paul Revere, the *Landing of British Troops on Long Wharf* in 1768 and *The Boston Massacre* of 1770.

The CHINESE PARLOR takes its name from the wallpaper, printed in China about 1770 with scenes of Chinese life in bright, clear colors, which makes an exotic setting for the Chippendale furniture. A pair of Chinese lacquer screens in black and gold, from the Elias Hasket Derby mansion in Salem, repeats the Oriental note. So do the varied pieces of Chinese porcelain, which include a pair of large green and gold vases decorated with plum blossoms. And, in the

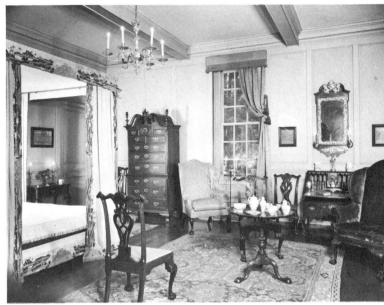

THE PATUXENT ROOM

shell-carved open cupboard, is a tea service of the rare "Jesuit" china, China-trade porcelain decorated in black, with Biblical and other scenes copied from European engravings. On the carved, gray-painted mantel, which came from the Stamper-Blackwell house in Philadelphia, is a garniture of Derbyshire spar, its crystalline depths shading from violet to chrome yellow. The English glass chandelier of about 1770 has sparkling sunbursts and beads and is equipped with engraved hurricane shades. The sofa before the fireplace is inscribed *Made by Adam S. Coe April 1812*

THE CHINESE PARLOR

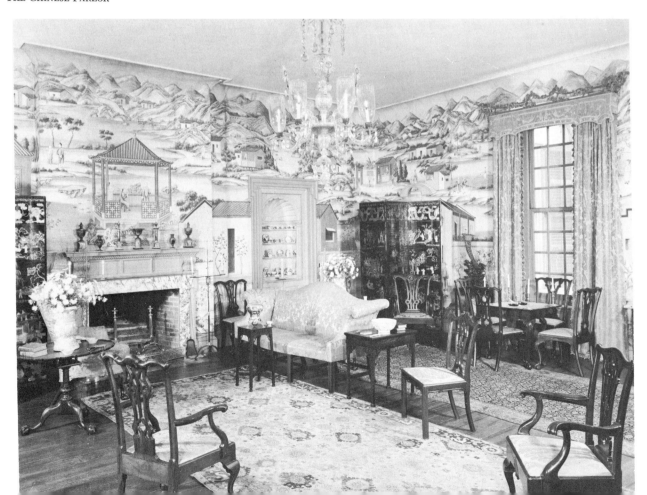

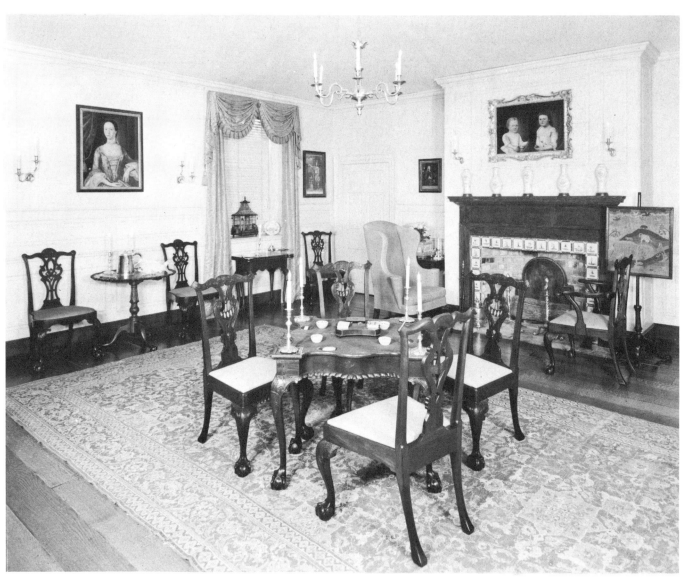

The Bertrand Room

for Edw. Lawton, indicating that such an agreeable style as the Chinese Chippendale retained its popularity for many years. The richly carved urn stand and the tea table nearby, both showing intricate fretwork designs, are probably from the Carolinas. The silver teakettle and stand, by Edward Lownes of Philadelphia, were made about 1815 in the lingering rococo style. Nearby, a Philadelphia side chair exhibits Chinese pretensions in its straight legs, rail below the seat, and pagoda-like terminals to the posts. Other Philadelphia Chippendale chairs include a set of five matching a labeled Benjamin Randolph example in the Boston Museum of Fine Arts.

The Bertrand Room is notable for its excellent examples of Chippendale furniture of New York origin. The woodwork here came from Belle Isle, a house built by William Bertrand in Lancaster County, Virginia, before 1760. The English delft tiles are decorated with chinoiserie figures, and the mantel garniture is of China-trade porcelain. The tassel-and-ruffle chairs grouped around the New York card table are part of a set of seven in the room, made for the Van Rensselaer family in Albany about 1765. The card table, matching the chairs in gadrooning and carving, is set out with eighteenth-century gaming equipment and four brass candlesticks. A pair of chairs with interlaced scroll-and-diamond splats belonged to Sir William Johnson. To the right of this pair is a chair similar in design, and signed by the chairmaker Gilbert Ash, of New York. The easy chair beside the fireplace is covered in contemporary red moreen, a watered wool fabric. Red Italian damask hangs at the windows. On the richly carved New York tea table with piecrust top are a mammoth silver tankard by Benjamin Hiller of Boston (1687-1745), and a large fish in China-trade porcelain. The portrait of Ann Farmer above the table is by John Durand, who also painted the likeness of her aunt, Mrs. Benjamin Peck, which hangs on the opposite wall. The painting of two children, over the fireplace, is attributed to Thomas McIlworth. The carpet here is an eighteenth-century example from Asia Minor.

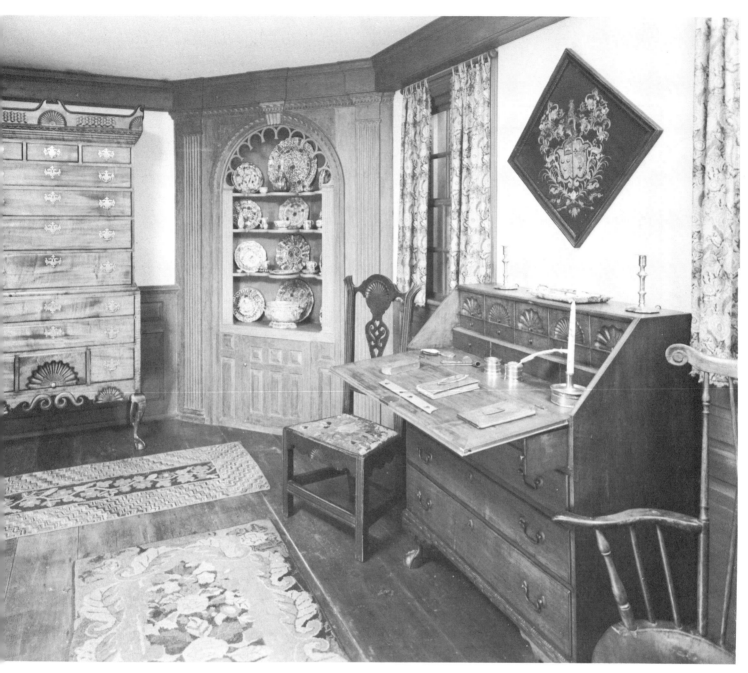

THE DUNLAP ROOM

From the Thomas Chandler house in Bedford, New Hampshire, comes the paneling of the DUNLAP ROOM. (Until recently, the source of this woodwork was thought to be the Zachary Taylor house, but through the studies of Mrs. Gordon Woodbury of Bedford, New Hampshire, it has been correctly identified.) The woodwork, in the original brick red and deep blue revealed by the removal of eight coats of paint, forms an appropriate background for furniture attributed to the Dunlap family, who lived in nearby Chester and Salisbury at the end of the eighteenth century. A stylized egg-and-dart molding in the cornice of the room matches that on the maple high chest of drawers, which is probably the work of Samuel Dunlap II; and it is assumed that the paneling and chest are the products of the same hand. Also thought to be a Dunlap piece is the blue-painted maple chair, which has in its cresting a carved

shell similar to those in the pediment of the high chest. The maple desk has the short cabriole legs and sharply cut claw feet typical of Dunlap work, and the same molding seen on the high chest and paneling. While the tortoise-shell pottery displayed in the corner cupboard is the English variety attributed to Whieldon, it is interesting to note that a similar type of ware was made in America as early as 1769, when an advertisement in the Boston *Evening Post* mentioned "... tortoise shell cream and green colour plates ... equal to any imported from England." With a family hatchment on the walls, chintz at the windows, and hooked rugs on the floor, this room illustrates both the home background of a New Hampshire townsman and the regional character of American furniture as it is expressed in the distinctive work of one New Hampshire family.

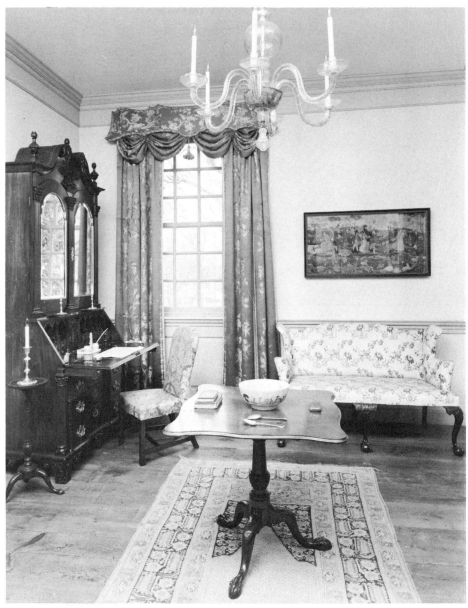

In recent years collectors have recognized the quality of Massachusetts furniture; and, in keeping with this interest, the MASSACHUSETTS HALL provides a setting for the product of master cabinetmakers who worked in that colony during the Chippendale period. Superb carving of architectural detail in the Corinthian capitals of the pilasters and quarter-columns and in the rosettes of the broken pediment establishes the importance of the mirrored desk and bookcase, purchased by Josiah Quincy of Braintree, Massachusetts, in 1778. Flanking the desk are intricately carved candlestands made, according to an old inscription, in Massachusetts in that same year. Also a tribute to the skill of Boston craftsmen is the settee, which, upholstered in French silk brocade, captures the spirit of the rococo in its graceful outline and delicate cabriole legs. Under an English glass chandelier stands a serpentine-topped tea table with rat-claw-and-egg feet; and on the table lies a spoon by Boston silversmith William Simpkins. The so-called Fishing Lady on Boston Common surveys the scene from a large needlework picture, which was probably worked by a schoolgirl in the mid-1700's; and the crimson silk curtains and a Ghiordes carpet add to the atmosphere of prosperity.

The high-ceiled ESSEX ROOM *(Color plate page 64)* has an arched fireplace opening flanked by tall pilasters, and a heavy chair rail which is carried around the fully paneled walls. This paneling was originally installed about 1740 in the plantation house of the Ritchie family at Tappahannock, in Essex County, Virginia. The furniture shows all the variety produced by Connecticut cabinetmakers of the Revolutionary era in the cherry wood they favored. The bed has the turned and square fluted posts that mark the peak of elegance in this period; the desk and bookcase has the multiple-arch paneled doors characteristic of Connecticut. A carved easy chair and an armchair in dark mahogany by the fireplace represent the quiet perfection of Massachusetts Chippendale furniture. On the blockfront chest by the bed is one of three bombé or serpentine dressing stands in the collection, made in New England in the Chippendale period. The window curtains are of printed linen, of which a selvage is marked *Soehnée L'Aîné & Cie à Munster près Colman*, naming a textile-manufacturing partnership formed in 1799. The luxurious carpet is an eighteenth-century Ushak. On the chimney breast is a portrait of William Verstille (b. 1757) by William Johnston, of Boston and Hartford.

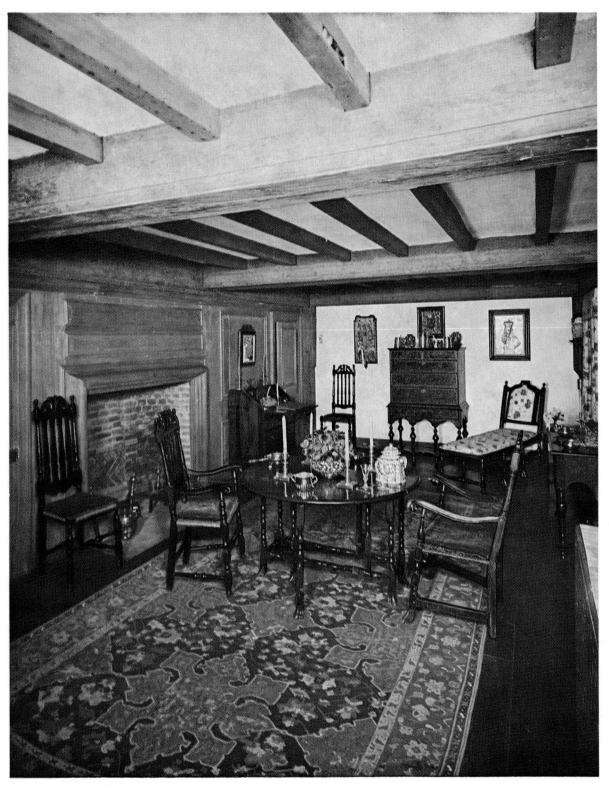

THE WENTWORTH ROOM, WINTERTHUR MUSEUM

(See page 16)

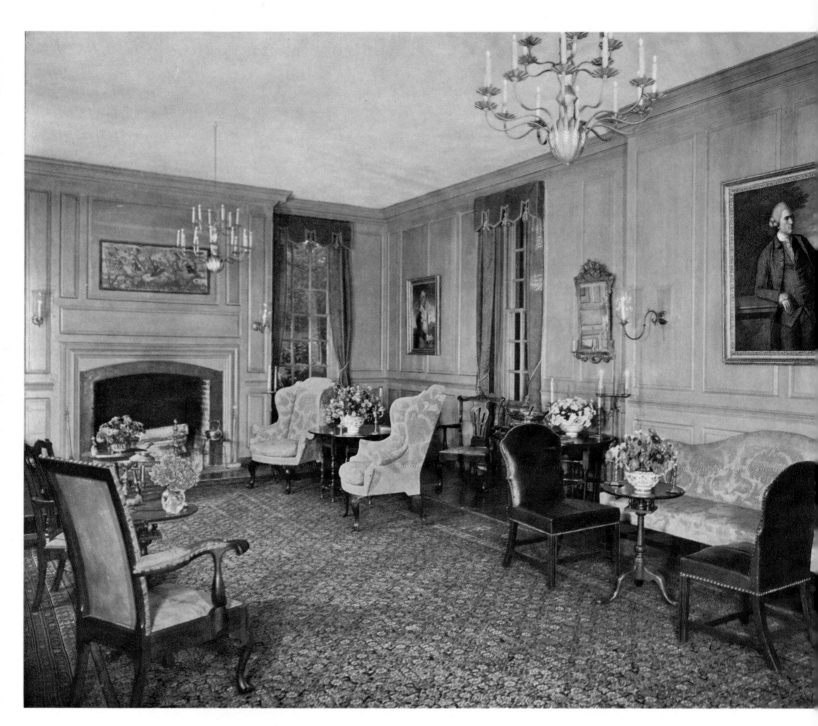

THE MARLBORO ROOM, WINTERTHUR MUSEUM

(See page 28)

The Federal period

AFTER THE REVOLUTION the classic revival, introduced into England by the brothers Adam as early as 1759, swept aside the taste for the rococo in America. Before 1800 it had affected the architecture of houses and everything that went into them. Direct communication established for the first time between the new nation and other parts of the world introduced American craftsmen to varied influences. The style of the early Federal period reflected the contemporary taste of France as well as of England, and was garnished with decorative accessories brought from Europe and the Orient. The new classicism was at first light and graceful, accented with motifs borrowed from ancient Herculaneum and Pompeii. Gradually it became more pretentious and less subtle, until by the late 1830's its inspiration was spent. Thereafter, artists borrowed from many sources to satisfy Victorian taste.

The MONTMORENCI STAIR HALL replaces the old entrance hall of the Winterthur house completed in 1839. Now a miraculously graceful spiral staircase rises from it to the third story. This came from Montmorenci, a house built near Warrenton, North Carolina, in 1822. The lightness and finesse of the American classic style, so superbly embodied in the architectural features here, are repeated in the furniture. The rare mahogany and satinwood settee and chairs were made by John Seymour and son, English-trained craftsmen who worked in Portland and Boston. The pier table under the gilded mirror bears the label of Charles Honoré Lannuier, a French émigré cabinetmaker active in New York in the early nineteenth century. Classic motifs are apparent in the great covered urns of China-trade porcelain and in the enameled bronze bases of the cut-glass candelabra.

THE MONTMORENCI STAIR HALL

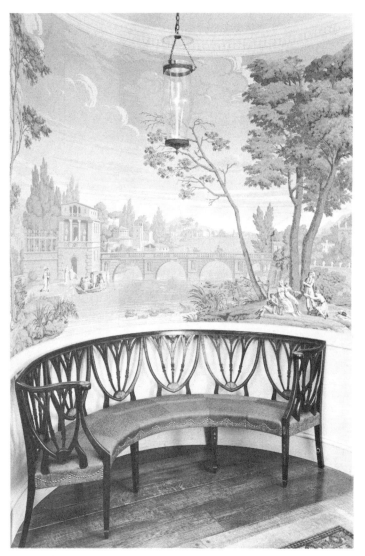

In the SECOND FLOOR HALL a semicircular niche frames a unique piece of furniture. This curved Hepplewhite settee, with six engaged shield backs and a return at each end, came from the Pierce house in Portsmouth, New Hampshire, for which it was undoubtedly built to special order since it fitted perfectly there under the curving stairs. It is carved and inlaid, and covered in contemporary brown horsehair. By this period block-printed wallpapers had replaced the hand-painted Chinese papers in fashionable taste. This one was made in France, with a broad scenic design in blue and gray.

The DU PONT DINING ROOM *(Color plate page 65)* has all the elegance of the classic style of the early Federal period in America. It contains a wealth of silver and ceramics, as well as some of the finest fabrics, paintings, and furniture of this period in the Museum. The paneling is from the Readbourne house at Centreville, Maryland; the chimney breast, from Kernstown, Virginia, is a charming interpretation of the classic style, reminiscent of Louis XVI design in its detail. A portrait of George Washington by Gilbert Stuart, painted in 1796, hangs in the center panel. This is the Bingham-Kitchen-Hart-Perry-Brady likeness, closely related to Stuart's equally famous Vaughan portrait of Washington. Cabinets on either side are filled with services of China-trade porcelain decorated with eagle designs. The furniture in Hepplewhite and Sheraton styles shows the slim elegance and fine veneers that characterize furniture after 1790. Twelve of a large set of square-back Sheraton chairs are heirlooms of the Du Pont family. The long Hepplewhite table is inlaid on the skirt with eagle medallions. It is set with Wedgwood plates and dishes, paneled amber glass tumblers,

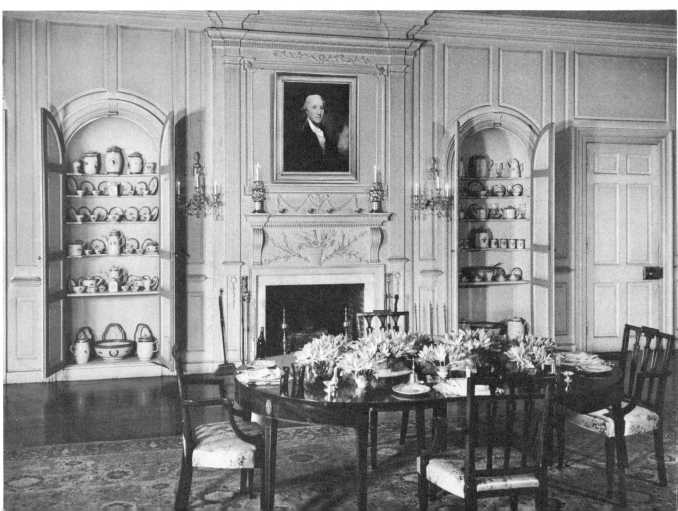

THE BALTIMORE DRAWING ROOM

and a remarkable set of American flat silver bearing Washington's portrait medallion, made by Thomas Harland, of Norwich, Connecticut. In the colored illustration there is to be seen between the windows a china cabinet with butler's desk, its upper shelves filled with rare and colorful pieces of canary and silver lusterware. Covered urns and tureens in China-trade porcelain dress the sideboards. In front of the urn-shape knife boxes on the long serpentine sideboard stand six matched silver tankards by Paul Revere. Each is inscribed *The Gift of Mary Bartlett Widow of Ephm Bartlett to the Third Church in Brookfield 1768.* Above hangs the well-known *Conference of the Treaty of Peace* in 1783, an unfinished sketch by Benjamin West, in which only the American delegation is shown, portraying John Jay, John Adams, Benjamin Franklin, Henry Laurens, and William Temple Franklin; Lord Oswald and his staff are omitted. The window hangings epitomize the glory achieved by French looms, which led the world in textile weaving in the eighteenth century. The exquisitely drawn figures in vignettes, in pastel colors on a buff satin ground, are probably from cartoons by Philippe de Lassalle, a pupil of Boucher and designer to the court of Louis XVI. Three-branch candle sconces festooned with cut-glass beads light the room, and a large and colorful Herat-Ispahan carpet, woven between 1550 and 1600, fills the center of the floor.

The focal point of the BALTIMORE DRAWING ROOM is the mantel, whose frieze is ornamented in plaster composition; the relief in the center panel portrays the Battle of Lake Erie in 1813. This stuccowork in the Adam manner was done by Robert Wellford, who worked in Philadelphia between 1801 and 1839. A low brass fender pierced in classic motifs takes the place of the wire fenders of the Chippendale period. The painting above the French bronze mantel clock with its modeled figure of Washington is a view of American ships anchored at Marseilles, by Anton Roux. The velours carpet, woven in the Low Countries for the Spanish market, sets the color scheme of blue and cream for lampas curtains and upholstery. Illustrative of the skill of Baltimore cabinetmakers between 1790 and 1810 is the furniture in this room, including a graceful sofa upholstered in eighteenth-century French silk; a set of two inlaid and painted marble-top corner tables which, with their matching pier tables, are enhanced by *églomisé* panels; and a pair of side chairs originally owned by Charles Carroll of Carrollton. These chairs are enriched with beautifully carved pendent bellflowers similar to the characteristic inlaid bellflowers frequently found in Baltimore furniture. From England came the glass candelabra, one of a pair, with Wedgwood jasperware base. New developments in lighting are apparent in the Argand lamps on the mantel.

THE McIntire Room

In the McIntire Room, Philadelphia woodwork, intricately modeled in stucco, is painted dove gray. This composition ornament on door frames, mantel, and cornice was probably done, like that in the Baltimore Drawing Room, by Robert Wellford. Here again the central design on the mantel frieze is a naval battle scene. And here again the French gilt mantel clock carries a figure of Washington holding an eagle. A landscape on the Schuylkill River painted by William Birch hangs above the mantel. Two armchairs, their upholstered backs crested with carving and punchwork, are probably the work of Samuel McIntire of Salem, as is also the shield-back chair beside the small Hepplewhite desk. A dainty sewing table is inlaid with satinwood. A Bilbao mirror in the alcove is framed with marble and gilt.

Gathered together in the Franklin Room are paintings and drawings of Benjamin Franklin, ceramic statues, bronze and marble busts, along with a variety of plaques, medallions, paperweights, and even small boxes showing representations of Franklin, all testifying to the widespread popularity of Philadelphia's first citizen. Displayed with them is furniture in the neoclassical style, a style with which Franklin was familiar during the latter years of his life. The Sheraton bed has delicately reeded posts; the small Sheraton tables are inlaid with satinwood. Martha Washington chair, shield-back armchairs, and small sofa are in Hepplewhite design. In the Federal period souvenirs of famous men in all sorts of media became popular decorations for the home. The artists of the day, such as Benjamin West, John Trumbull, Houdon, and many others, were creating imposing historical paintings and sculptured busts of important personages, frequently in the guise of ancient Romans. More informal representations of contemporary statesmen, military heroes, literary figures, and philosophers, were produced by designers of ceramics, fabrics, metalwork, and the other decorative arts, not to mention engravings after the major works of art. At one season of the year the fabric of bed and window curtains and upholstery is the famous copper-plate-printed toile called *Apotheosis of Franklin;* its design includes a full-length portrait of Franklin acclaimed by Liberty, Columbia, and Fame. The fabrics shown here are a set of English cotton printed in red with a pleasing design of birds, fruits, and flowers.

The contrast between the delicate restraint of the neo-classical style and the rich profusion of the Chippendale is sharply shown by comparison of the IMLAY ROOM with, for example, the Chinese Parlor. Both rooms are full of pattern and color, but the effect here is of lightness and fine detail; there it is of balanced mass and luxurious sweep. The woodwork here is from a house built at Allentown, New Jersey, in 1790-1791 by John Imlay. So too are the floral paper on the walls and the Venetian blinds with their wallpaper-covered valances. The bill for this paper is in the Metropolitan Museum; it is dated 1794, and enumerates the yardage of "Elegant paper" and borders. The composition ornament of the mantel shows profile busts of Washington and Franklin above the pilasters; the Liverpool tiles around the fireplace opening are decorated in green with classic urns and vases. The dainty floral motifs of the wallpaper are repeated in the mantel garniture of China-trade porcelain, in the embroidered panel of the pole screen, in the tapestry-woven rug on the floor, and on the painted furniture. Most of this was made in Baltimore, which distinguished itself for fine painted furniture in the Federal period as well as for the decorative veneered pieces which were its typical cabinetwork.

THE FRANKLIN ROOM

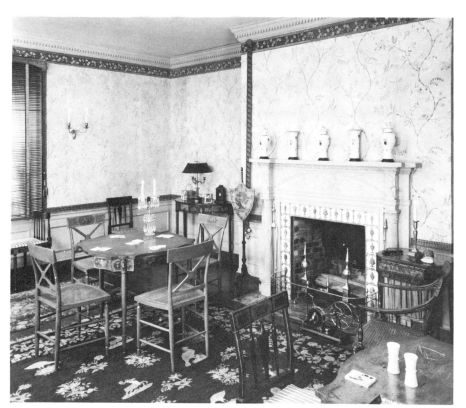

THE IMLAY ROOM

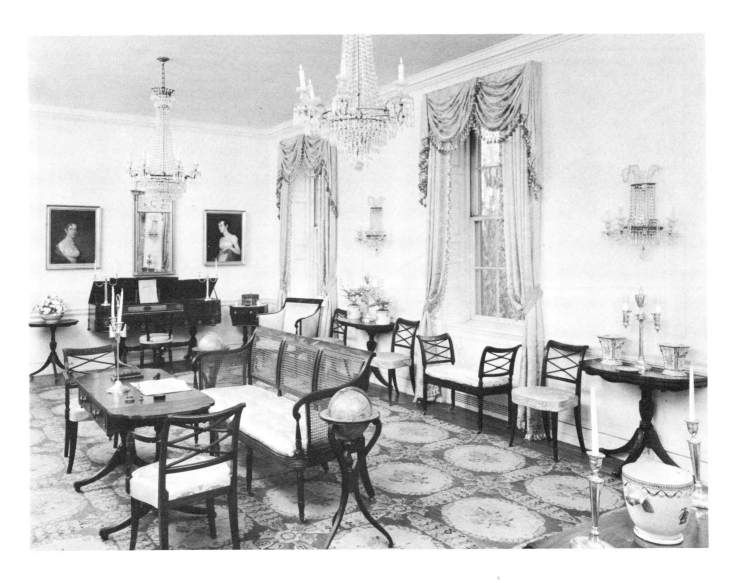

THE PHYFE ROOM

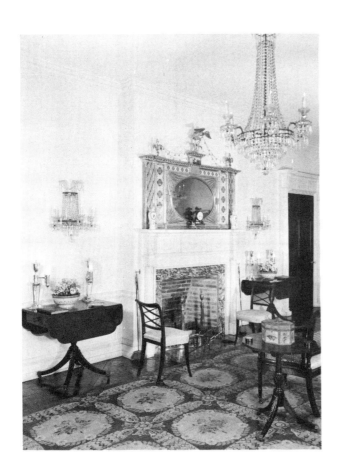

The PHYFE ROOM contains as fine an array of furniture by the New York cabinetmaker Duncan Phyfe as one could wish to see. Here are clearly displayed the classic line, the suave proportions, the crisp carving that are typical of Phyfe's earlier, finer period and that have made his name one of the most famous in American craftsmanship. The sewing table carries Phyfe's label, and the original bill of sale for the settee, chairs, and long table, signed by Duncan Phyfe in 1807, is in the room. The kind of setting in which Phyfe's customers lived is typified by the delicately modeled white woodwork and mahogany doors, which came from the Rogers house on State Street, facing the Battery, in New York. The overmantel mirror, from Albany, is an ambitious design of carved and gilded fans and decorated glass panels. The chandeliers and wall lights, composed of glass beads and prisms with ormolu, show the new severity in design of the period. The classic taste even in dress is revealed in the two ingratiating portraits above the piano, whose case is attributed to Phyfe, but bears the label of the New York instrument maker John Geib. The portraits are of Mrs. Whittier, by James Frothingham, and Mme. Bauduy, née Victorine du Pont, by Rembrandt Peale (1813). The curtains and

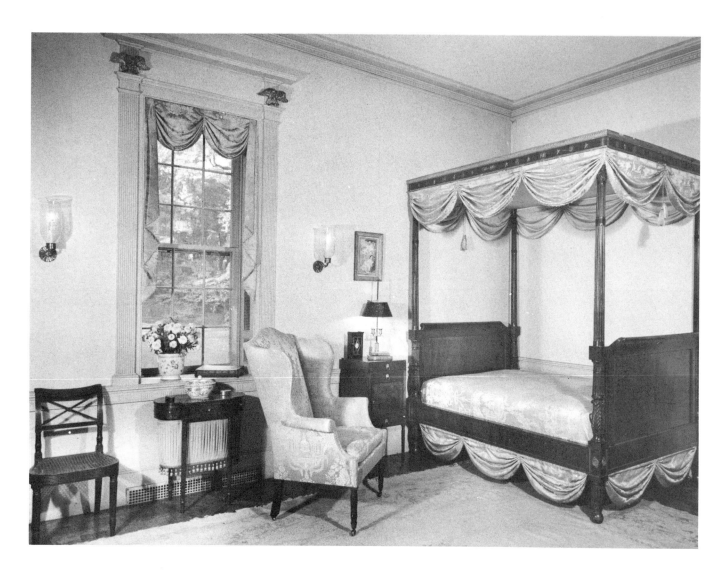

THE NEMOURS ROOM

upholstery are of superb French satin lampas in a pale yellow and blue classic pattern; classic too is the floral medallion pattern of the large Aubusson carpet of about 1805.

The French taste is apparent in the NEMOURS ROOM, where the pale apricot-colored woodwork, from Montmorenci, is reeded to form pilasters at the window, doorways, and mantel. In this room are many Du Pont family heirlooms, including framed documents in French, dating from the late eighteenth century. The furniture is New York Sheraton; chairs, small tables, and a sofa are representative of the work of Phyfe and his contemporaries. The tall-post bed with carved and reeded posts and high head and foot was probably made by the French cabinetmaker Lannuier, who worked in New York from 1805 to 1819. A festooned damask canopy trims its mahogany and gilt cornice, and swags of the same material hang within the window frame, following a design of Jefferson's for window curtains at Monticello. The portrait above the mantel is of Gunning Bedford, Sr. (1742-1797), who was an officer in the Revolutionary army, and a governor of Delaware.

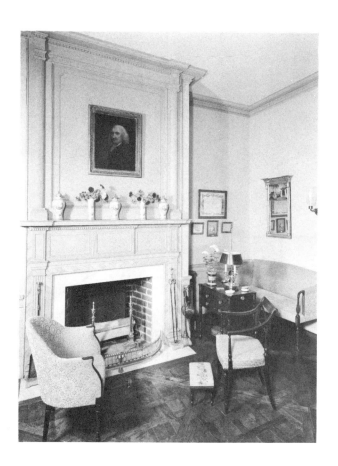

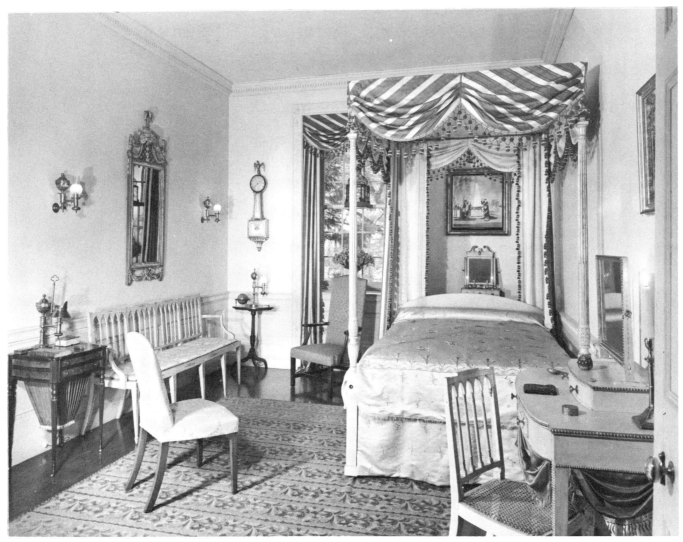

THE GOLD AND WHITE ROOM

THE BALTIMORE ROOM

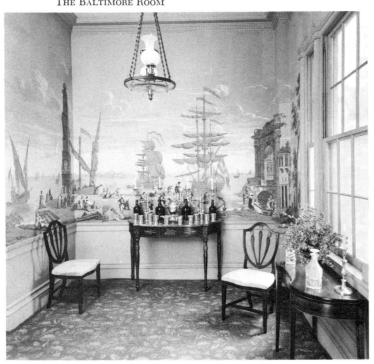

Striking green and white satin stripes in bed canopy and window curtains set off the elegant furniture in the GOLD AND WHITE ROOM. The bed, settee, and chairs here are all gold and white, of great refinement and style. They and the white mirror originally belonged to Governor Joseph C. Yates of Albany (1768-1837). Gold and white also are two dressing tables in the room, and the banjo "presentation" clock by Simon Willard. The satin needlework picture of mourning figures beside a tomb and weeping willow, typical of the period, was worked by Margaret Bleecker Ten Eyck, an ancestor of H. F. du Pont. Wall and table lights here are Argand lamps of various kinds.

In the elegant BALTIMORE ROOM, the furniture represents the fine craftsmanship for which that city became noted in the classical period. Here, against a blue and gray background of the *Bay of Naples* wallpaper, printed by Dufour of Paris about 1820, is a small group of Baltimore furniture in the styles of Sheraton and Hepplewhite. The legs of the kidney-shape card table show the intricate bow-and-tassel inlay found in Baltimore; and on the table are two glass decanters made at the Gallatin Glass Fac-

tory about 1830 and given by Albert Gallatin to E. I. du Pont. The matching shield-back chairs display molded and petal-inlaid splats, as well as the half-upholstered seat rails often associated with Baltimore. Against the wall stands a mixing table, painted black with gilt decoration; and an atmosphere of hospitality is created by the arrangement on the table's marble top. Dark green whiskey bottles, bearing the names of their original owners, are flanked by Sheffield candelabra. The julep cups are the work of such noted silversmiths as Myer Myers, of New York; John Lynch and Samuel Kirk, of Baltimore; and John Akin, of Danville, Kentucky. The tall ewer, by Gale and Hughes, was awarded to Herman Ten Eyck

Foster, the grandfather of Henry Francis du Pont, as "first premium on farms" in New York.

The Greek Revival style which adopted the classic temple as the ideal for public buildings and domestic dwellings finds a perfect expression in the EMPIRE PARLOR from an Albany house of about 1830. High ceilings, long windows, a marble mantel flanked with carved caryatids, Greek honeysuckle pilaster capitals on windows and doorways, bring a new formality into the American home. The furniture is large-scale to suit the spaciousness of its surroundings. Designs of columns for pier tables, gilt-bronze appliques, and oversize lion-paw feet were borrowed literally

THE EMPIRE PARLOR

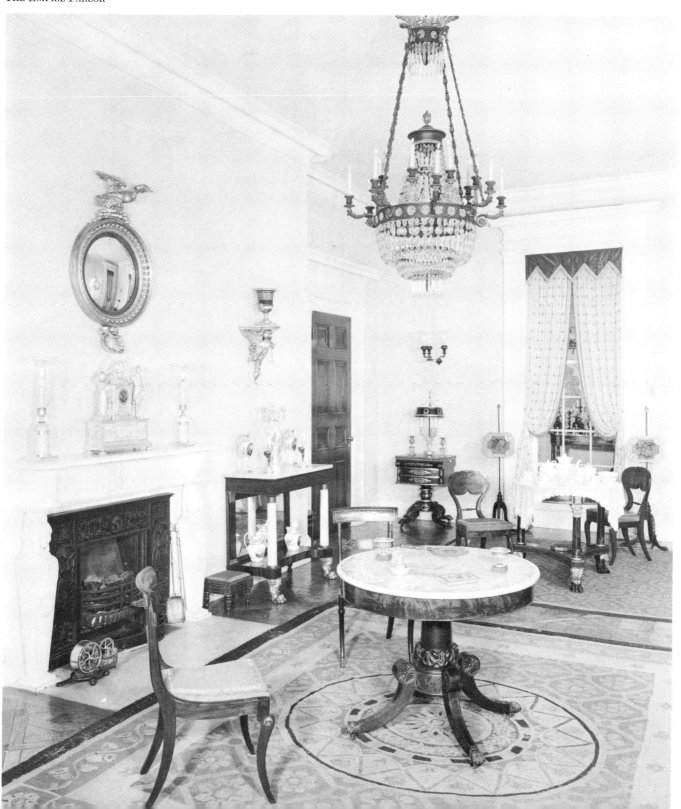

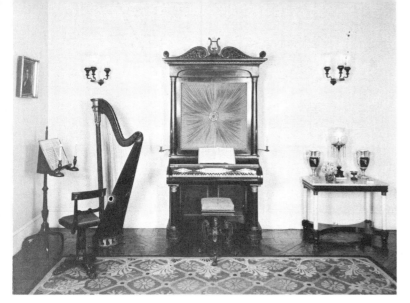

THE EMPIRE PARLOR

gilded carving and gilt stenciling. Several pairs of marble-top tables with marble columns are like those known to have been made by Lannuier and his successor, John Gruez, in New York. The marble top of the round pedestal table is painted with a scene of the battle between the pirate ship *La Gloria* and the packet *Cornwallis* in 1800; the painting was done by an eyewitness, Lewis Brantz. French porcelains in this room, painted with portraits of American heroes, are noteworthy. The room is lighted by a cut-glass and bronze chandelier, bronze *torchères*, and lamps of various metals. The designs of the Aubusson carpets repeat the Greek motifs. The richness of the fabric of the window hangings offsets the simplicity of their treatment: the valance is green and gold satin; the curtains are white mull embroidered in gold.

The EMPIRE BEDROOM, furnished with New York pieces, is also French in feeling. The low bed set along the wall and its crown, from which the printed linen cascades to head and footboards, are of matching mahogany. A needlepoint carpet in a floral pattern covers the floor. The circular dressing table is hung with deep ruffles of patterned India cotton, following a fashion practiced as early as the eighteenth century and as late as today.

from ancient Greece. This severe and masculine expression of decoration, first created for Napoleon, found many fainter and more pleasing echoes through the United States until the Victorian era. In this room a tall piano made in New York and a harp show the style adapted even to musical instruments. Most of the other pieces are also of New York make, of mahogany, with

THE EMPIRE BEDROOM

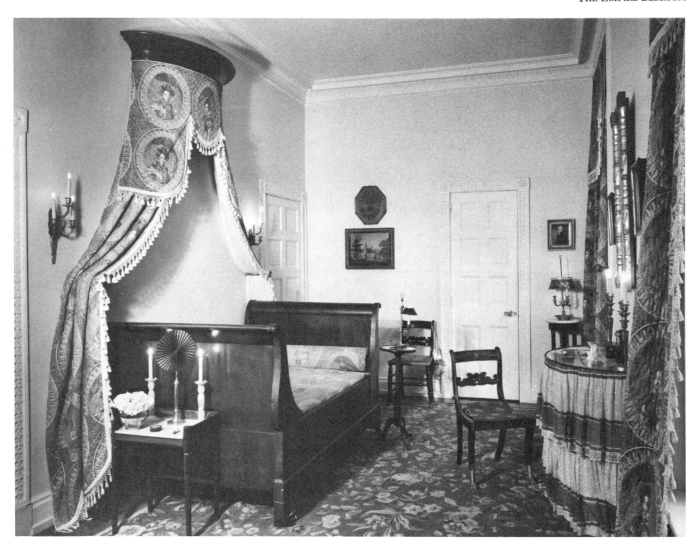

42

THE PENNSYLVANIA FOLK ART ROOM

Folk art

FOLK ART has contributed to the American scene a rich variety of native expression. Although invariably dependent upon traditional sources, the product of the folk artist often appears to be spontaneous and original in its interpretation. Frequently it is humorous and ruggedly independent. These qualities appear in some of the unsophisticated American craftsmanship of various localities, but the region with which the name is most readily associated is Pennsylvania. There in the eighteenth century and the first half of the nineteenth the folk-art traditions brought by settlers from the continent of Europe

were perpetuated or reinterpreted in a variety of decorative media. New England also had its folk art, however, and indeed most rural regions of America, both before and after the Revolution. At Winterthur there are impressive collections of this American folk art, arranged in rooms less formal than those with mahogany and satinwood, but rich in vigorous color and vital design.

In the PENNSYLVANIA FOLK ART ROOM, a low-ceilinged interior with white plaster walls, color and design are shown to full advantage. The tawny brown of faded wal-

nut furniture is set off by painted decoration in typical floral designs on chests and boxes. Hanging shelves and dressers with decorative scrolled contours are bright with Pennsylvania-German sgraffito and slipware pottery by Joseph Spinner, George Hübener, and other artists in clay. Great cupboards with deep cornices and paneled doors show local versions of a form inherited from Germany and Holland. Tall slat-backs with gracefully curved slats and wainscot chairs with solid back and seat contrast with spindle-leg chairs having flat seats and shaped backs, a medieval type inherited from Continental Europe. The walls are brightened by framed *frakturschriften,* the illuminated certificates of birth or baptism. Homespun checks hang at the small windows, and other native fabrics are piled on shelves in the cupboards. A shapely pewter communion set on the early turned table is marked by the Lancaster pewterer Johann Christoph Heyne. Above the tall inlaid chest of drawers from Chester County, near the window, is a portrait on wood of Johann Arndt, the disciple of Luther, an extraordinary rendering done two centuries ago which suggests the free style of

Van Gogh. The room is lighted by candles in wrought-iron chandeliers, candlesticks and stands, and wall sconces with shining tin reflectors.

In the RED LION HALL are painted windsor chairs from New England and Pennsylvania and a hexagonal table, set off by a minutely hooked floral rug of large size. Open shelves are gay with painted tinware of all shapes and sizes. The picture of *Penn's Treaty with the Indians* is a nineteenth-century copy of Benjamin West's famous painting. Hanging from the molded top of the painted paneled settle is a double-pan betty lamp, whose light is supplemented by candles in wrought-iron standards and pierced tin lanterns. The room is named for the Red Lion Inn, at Red Lion, Delaware, an early nineteenth-century building from which the woodwork was taken.

The PENNSYLVANIA-GERMAN BEDROOM is resplendent with painted furniture where birds and horses, trees, flowers and hearts, convert plane surfaces into lively patterns. A slant-top desk is painted green and ornamented with

THE PENNSYLVANIA FOLK ART ROOM

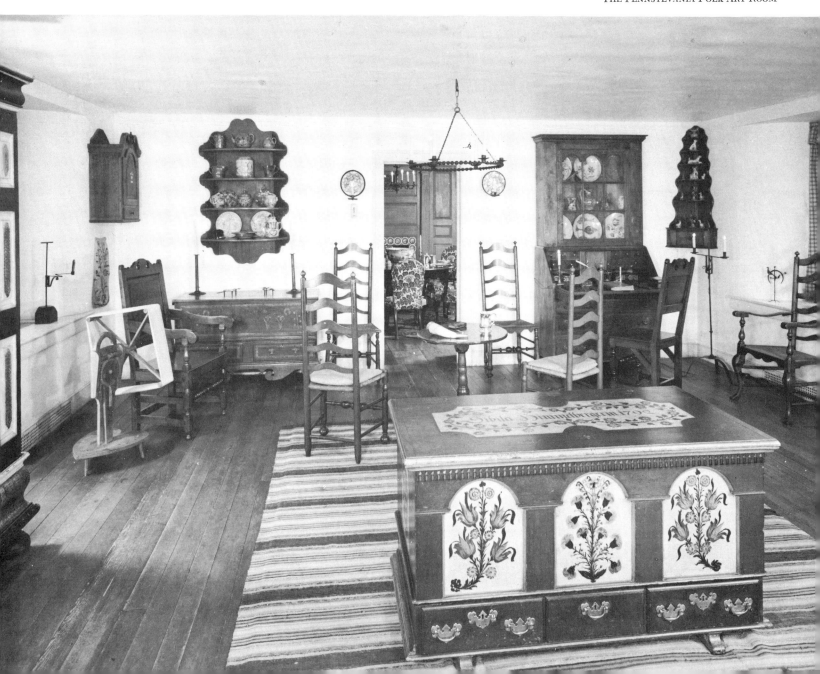

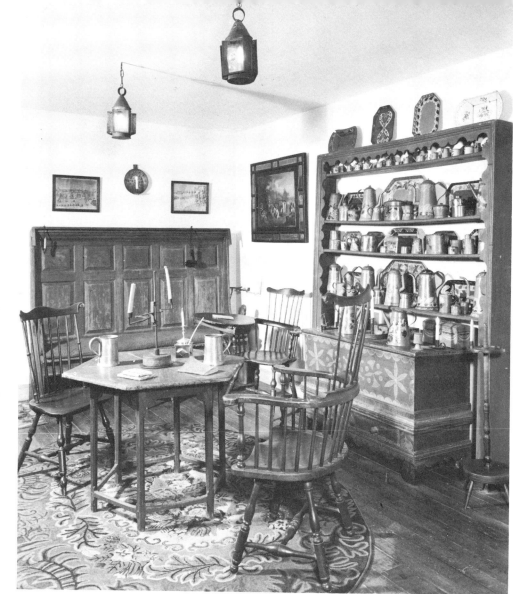

THE RED LION HALL

THE PENNSYLVANIA-GERMAN BEDROOM

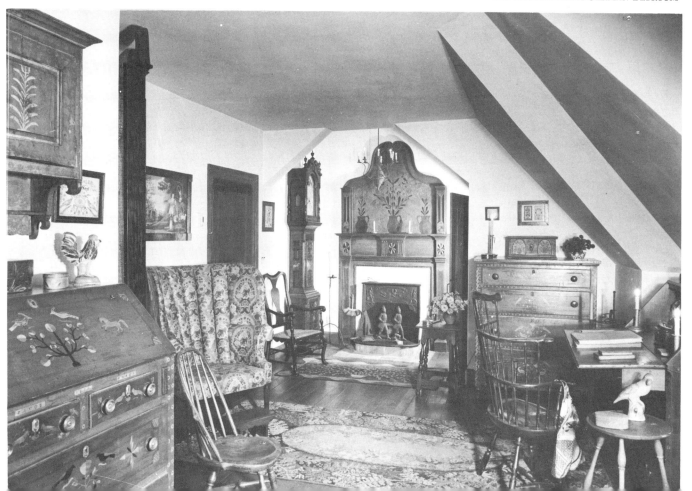

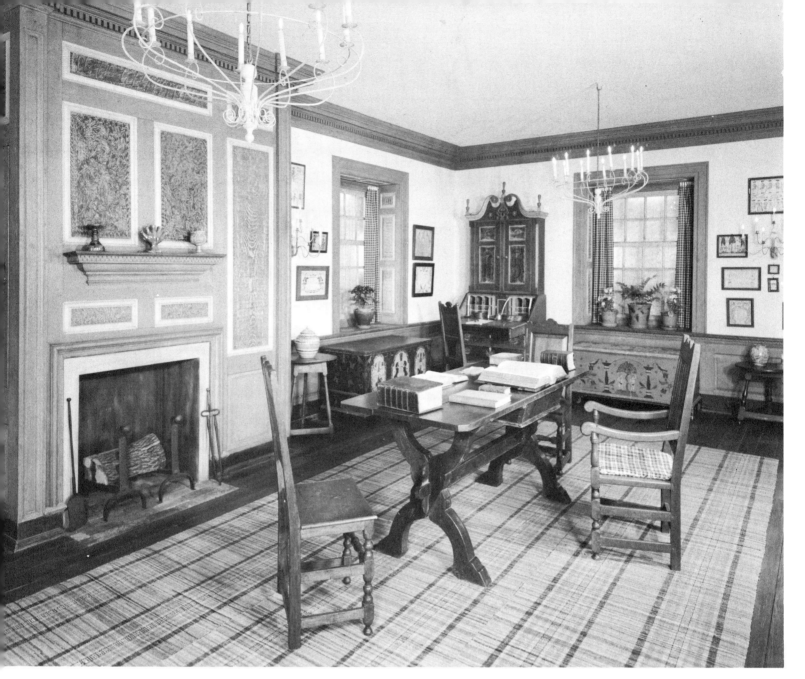

THE FRACTUR ROOM

birds and horses, geometric motifs, and borders of many-petaled flowers. This is the characteristic decoration of the Pennsylvania painter Jacob Maser, who signed this desk with his name and the date *1834*. A green chest of drawers, also dated in the same year, is similarly decorated. The maple case of the tall clock is paneled and elaborately inlaid with eagles, plows, barnyard animals, and the word *Liberty*, with the date *1815*. On the frame of the glass door is inscribed the name of the maker, Johanes Haus of Dauphin County. The fireplace is fitted with a cast-iron Franklin stove and "Hessian soldier" andirons. Above the carved and fluted mantel, from Lancaster County, the carved double-scroll top of an extraordinary overmantel frames a design of flowers in three stocky pitchers, painted on the plaster. Chalkware birds on table and desk are only part of a large collection here. On the wall is a *Peaceable Kingdom* painted by the Bucks County Quaker Edward Hicks, with framed certificates and water-color drawings. Floral hooked rugs add to the profusion of color in the room.

The walls of the FRACTUR ROOM are lined with important examples of fractur, the lingering medieval German art of illuminated writing, which reflects the impact of the German immigrants to Pennsylvania upon American culture. The original mottled blue paint has been preserved on the woodwork from a large stone farmhouse built in 1783 near Kutztown, Berks County, Pennsylvania. Spread out on the early walnut table are illuminated hymnals and exercise books; the large open volume in the center is the *Book of Martyrs*, printed at the Ephrata Cloisters in 1748. Grouped around the table are walnut wainscot chairs made in Chester County before 1750; and dower chests by various Pennsylvania artisans stand in front of the windows. Another Pennsylvania craft is represented by the slipware pottery on the mantelpiece and windowsills. Blue and white "furniture check" hangs at the windows, and American striped rugs are used on the floor. Candles in painted iron sconces and chandeliers of the type used in America at the end of the 1700's cast a soft light over this great room.

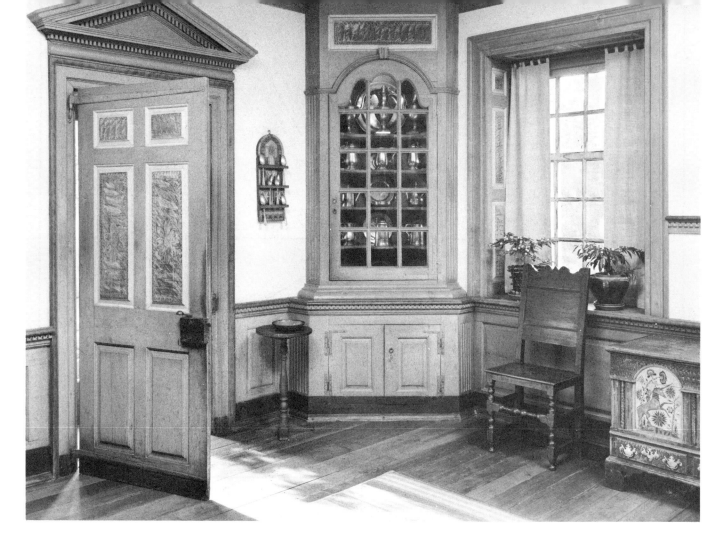

THE FRACTUR ROOM

Outstanding among the painted furniture in the FRACTUR ROOM is a Lancaster County dower chest which stands between the windows. Inscribed *Margaret Kernen 1788*, this chest shows the combination of skillfully executed folk decoration with elements of the fashionable Chippendale style. Arched panels, set within molded architectural frames, are decorated with painted flowers and unicorns, medieval symbols of Christ. Above the chest hang drawings of unicorns, an illustrated verse about Adam and Eve, and a fractur baptismal certificate illustrating the constant use of these symbolic devices, which not only add ornament to their work, but reveal the spiritual background of the Pennsylvania-German craftsmen.

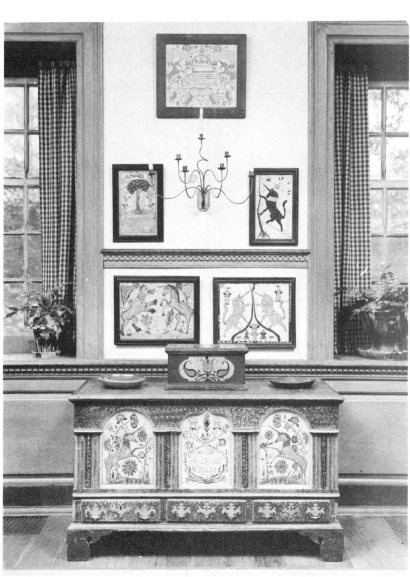

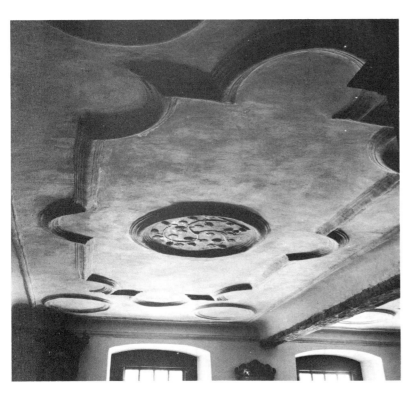

THE KERSHNER PARLOR

Two rooms recently installed at Winterthur came from a simple farmhouse of local limestone near Wernersville, Pennsylvania, built about 1755 by George Hehn, Jr., and occupied from 1772 to 1803 by Conrad Kershner and his family. The KERSHNER PARLOR is distinguished by applied plaster ceiling decoration that represents the transferal to America of the German Renaissance style. A boldly molded cartouche frames a center medallion, in which a stylized grapevine shows traces of the original copper-red paint on the leaves and a deep purple on the bunches of grapes. The molded cove joining ceiling and wall is carried along the summer beam. The other half of the room has a balancing decoration.

Furnishings for the room were selected in the light of a survey made of Berks County inventories, including that taken at the time of Kershner's death. Between the windows hangs a Philadelphia looking glass by John Elliott, its bilingual label indicating that it was intended for sale to German-speaking Pennsylvanians. The tall clock in the corner is inscribed by Jacob Graff, who worked in Lebanon as early as 1750. In the other corner stands a great walnut *schrank* made in 1768, perhaps in Lancaster, for Emanuel Herr. In front of it is an extraordinary armchair owned, according to tradition, by Baron Stiegel. The sawbuck table is set with wooden plates

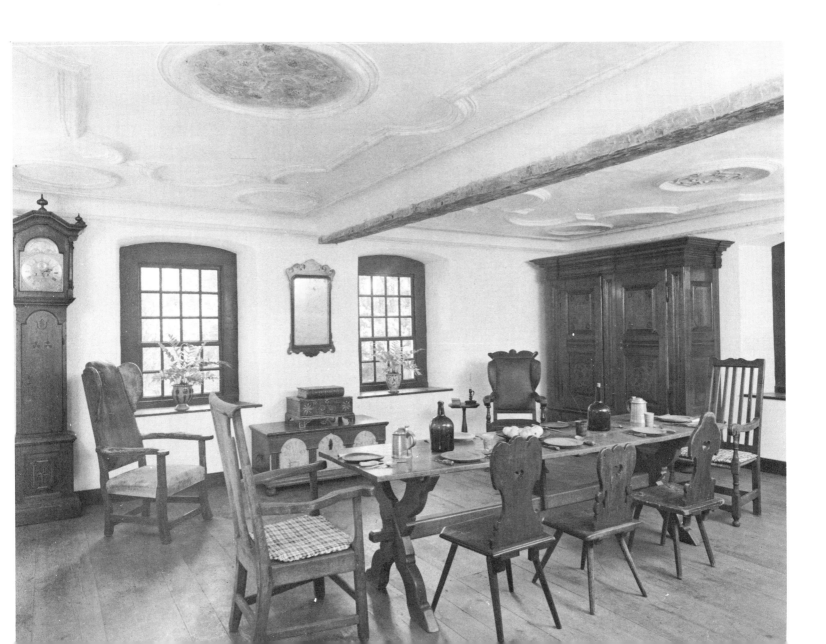

and Pennsylvania pewter tankards. The side chairs here are American, but made in the style of the German colonists' homeland. Between the dresser and a Pennsylvania walnut cradle is the iron five-plate stove, the sides of which bear the inscription of the Mary Ann Furnace in York County; the stone used as a base is from the Kershner farm. On the shelves of the dresser, a form often mentioned in inventories, is arranged a group of eighteenth-century sgraffito plates and jars, most of the pieces dated and representative of the pottery used in Pennsylvania-German homes. The openings in the wall are part of an auxiliary lighting system designed especially for this installation.

The KERSHNER KITCHEN is dominated by a mammoth stone fireplace. Still showing traces of the original whitewash, the stones of the jambs support a twelve-foot lintel of white oak. At left hangs a "Kentucky" rifle marked by N. Beyer of Lebanon; and on the trivet in front of the fire is a copper teakettle by an eighteenth-century Lancaster craftsman, Robert Reed. At right can be seen the opening for the five-plate stove which stands in the adjoining room and is fed by logs or coals from the fireplace. A painted wall cupboard, each drawer decorated with red tulips, hangs above a Pennsylvania walnut table, before which is a windsor chair branded by Gilbert Gaw, of Philadelphia, who sold windsors to Mount Vernon in 1796.

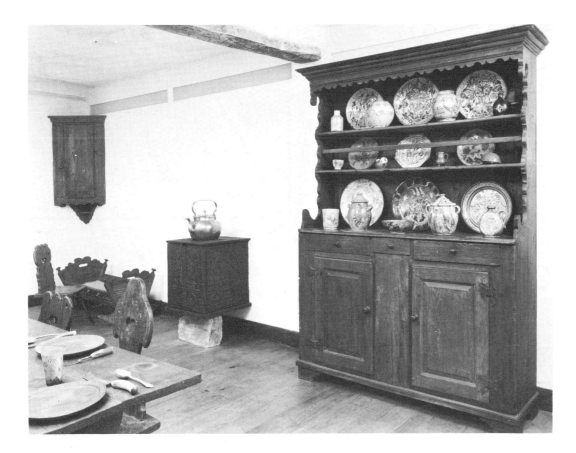

THE KERSHNER PARLOR

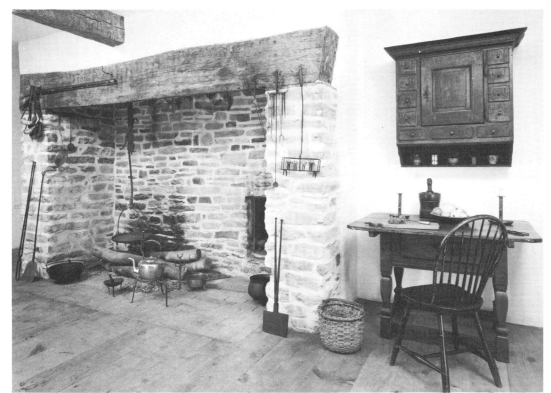

THE KERSHNER KITCHEN

Specialized collections

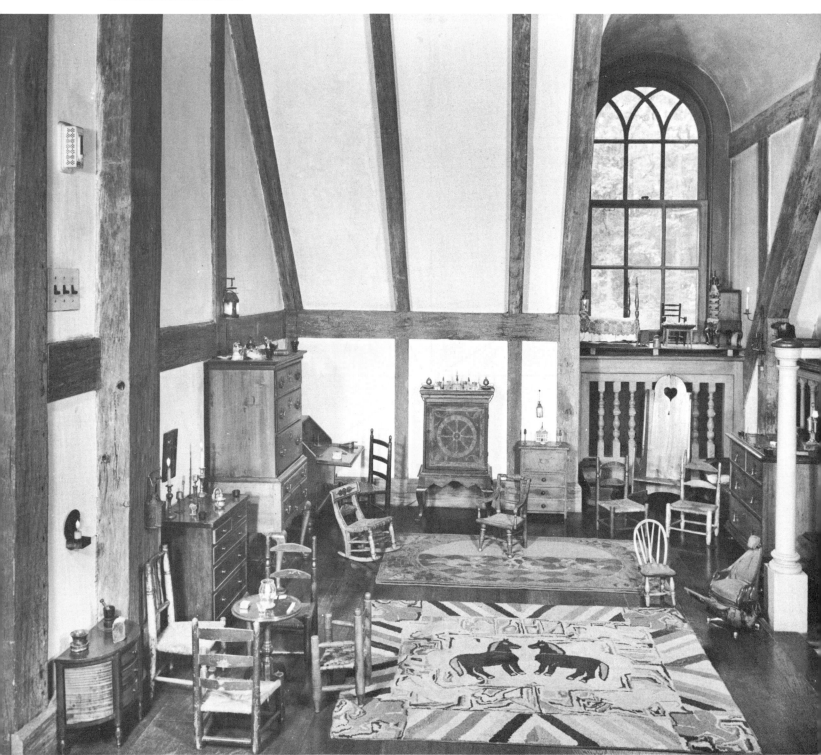

ALL WINTERTHUR IS, of course, a specialized collection, composed of many smaller collections. For the most part these are so combined and arranged that one sees them not as collections but as the appropriate furnishings of rooms. There are, however, several collections that are arranged as such; among these are the American glass, the China-trade porcelain, and the spatterware, which each fill a whole room, and the child's furniture.

The extraordinary array under the sloping roof of the MINIATURE STAIR HALL has the irresistible appeal of all tiny things, and deserves minute attention. Here is child's furniture from the walnut and marquetry of the William and Mary period to the inlay and stenciling of the early nineteenth century. Some of the larger furniture pieces, such as the Queen Anne maple highboy, may have been made not as playthings but as samples of a freeman cabinetmaker's skill. Complete ensembles

for living, even to the minikin cutlery and glassware, are set out. The infinitesimal lighting devices include whale-oil lamps, tin lanterns, candlesticks, even a hurricane shade.

In the SPATTERWARE HALL a vast collection of spatterware fills painted dressers and cupboards to overflowing, and a row of saucers, of which no two are exactly alike, makes a frieze around the top of the room. Spatterware, made in Staffordshire for the Pennsylvania market in the 1820's and 1830's, has the color and decorative motifs that were bound to appeal to its purchasers. Against its "spattered" or sponged background of color the central design of peafowl, cottage, flower, or star was drawn with a freedom and dash to rival that of the Pennsylvania folk artist. This collection is particularly rich in examples of the peacock pattern, but virtually every known design, shape, size, and color is represented.

THE SPATTERWARE HALL

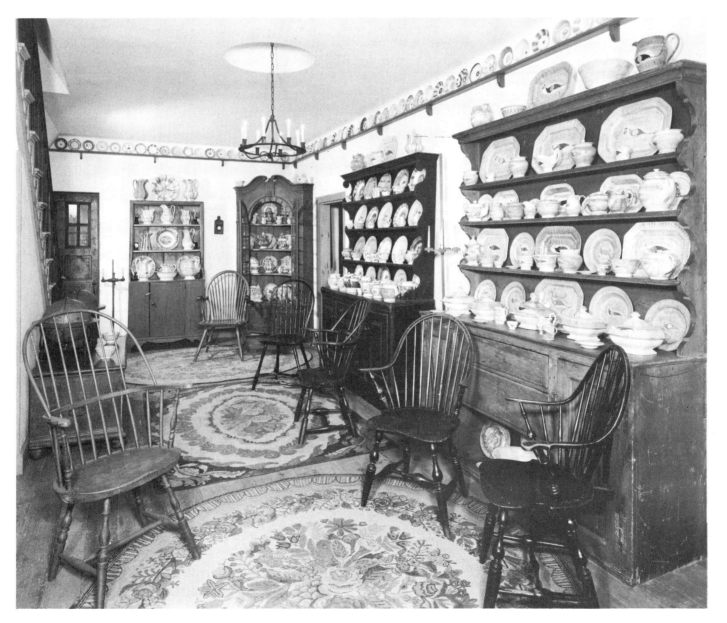

The woodwork of the GLASS ROOM is from an early nineteenth-century store at Chelsea, Delaware County, Pennsylvania, and lighted cupboards display American glass of the eighteenth and nineteenth centuries. There are a number of the large molded vases, emerald-green and amethyst in color, which were formerly called Stiegel but are more likely of New England origin: vases of this type were made at the Boston and Sandwich Glass Company in the nineteenth century. Complementing them in color is a large collection of blown-glass flasks, scent bottles, sugar bowls, and salts attributed to the Stiegel factory, which flourished at Manheim, Pennsylvania, from 1764 until 1774. Painted furniture in the room includes a pair of unusual windsor chairs with upholstered seats, probably made in Philadelphia, and a decorated chest of drawers dated 1830 and made by Jacob Maser, who worked in the Mahantongo Valley of Pennsylvania.

Another cupboard in the GLASS ROOM is dominated by the product of John Frederick Amelung at Frederick, Maryland. Outstanding are the blown-glass sugar bowls— one in clear glass with an elaborate swan finial; and a deep-amethyst example, also with swan finial and engraved *To Mis. C. G. In Washington Cty* in honor of Catherine Geeting, who lived near Amelung's New Bremen Glass-manufactory. A large covered flip glass is engraved *Floriat Commercium . . . Charles Ghequiere . . . New Bremen Glassmanufactory the 20th of June 1788* and was a presentation piece to Ghequiere, an investor in Amelung's enterprise. Other types of American blown glass as well as pattern-molded, blown-three-mold, and pressed techniques are well exemplified in the collection.

THE GLASS ROOM

THE SHOP LANE

The Shop Lane and the Court

WHILE THE EMPHASIS at the Winterthur Museum is on domestic interiors and their furnishings up to 1840, the Shop Lane and the Court round out the picture with architectural exteriors, and with varied collections displayed in shops as they might have been before they found their way into early American homes. The architectural elements, which came from various parts of the country, are skillfully combined to create with telling effect the illusion of an old village street and lane where buildings of different types and ages have grown up together. Even the great slate slabs and cobblestones underfoot are old. Old lanterns and street lamps shed soft light on the exteriors.

Along the SHOP LANE, six old shop fronts show a full range of fenestration and architectural style from the late eighteenth century to about 1840. The earliest is composed of fragments from a shop in Alexandria, Vir-

ginia, built about 1795; it follows traditional Georgian style, with double center doors and a transom above, flanked by bow windows. It is now the exterior of the China Shop; the arcaded trim of the interior is from an apothecary shop of about 1800 in Fredericksburg, Virginia. The other shop fronts include a window from Middleburg, Virginia, and a door from Chadd's Ford, Pennsylvania; a bay and its accompanying shop and dwelling doors, of about 1800, from Peck's Slip, New York City; a shop front of about 1840 from Baltimore; bays and a doorway from a Connecticut shop of about 1805; and a remarkable shop front of 1830-1840 from Kingston, New York. An old shop sign in the form of a fist wielding a mallet came from a mechanic's shop on Cornhill, Boston, Massachusetts. Through the narrow panes of the shop windows are tempting glimpses of printed Staffordshire pottery, white salt-glaze stoneware, a silver tea set, and early books printed in America.

Two interiors of old shops are reminders of more leisurely days. The CHINA SHOP displays the wares of a Chinese merchant. Here are complete dinner services, mantel garnitures, boar-head tureens, life-size figures of dog and geese, all in China-trade porcelain. All are seemingly arrayed for the Yankee sea captain who, a century and a half ago, ballasted his top-heavy sailing ships with tons of this Oriental ware. There are many rarities of enameled decoration here, and also in China Hall near the Chinese Parlor. Together these rooms contain undoubtedly the most important group in existence of Chinese porcelain made for the American market. Parts of Washington's own dinner service painted with the Order of the Cincinnati, Martha Washington's cake plate with her monogram and fifteen state names in a chained border, and one of Edward Tilghman's four toddy pitchers are some of the historic items. Among pieces notable for their decoration are items with the arms of New York State, and with the *Signing of the Declaration of Independence* after the painting by Robert Edge Pine.

The END SHOP, opposite, represents a country store, its shelves teeming with painted tin, pewter, candy jars, brass candlesticks, and other alluring merchandise. Its long balustraded counter is covered with such a variety of novelties as a bird cage in the shape of a church, a French peep show, a plate with sample borders of Davenport creamware, clay pipes, carved figures and other old-time playthings, maps and books, and the shopkeeper's scales and weights.

The cobblestone COURT is enclosed by the façades of old buildings. One from a Connecticut Valley house of the mid-eighteenth century shows the carved arched

THE CHINA SHOP

THE END SHOP

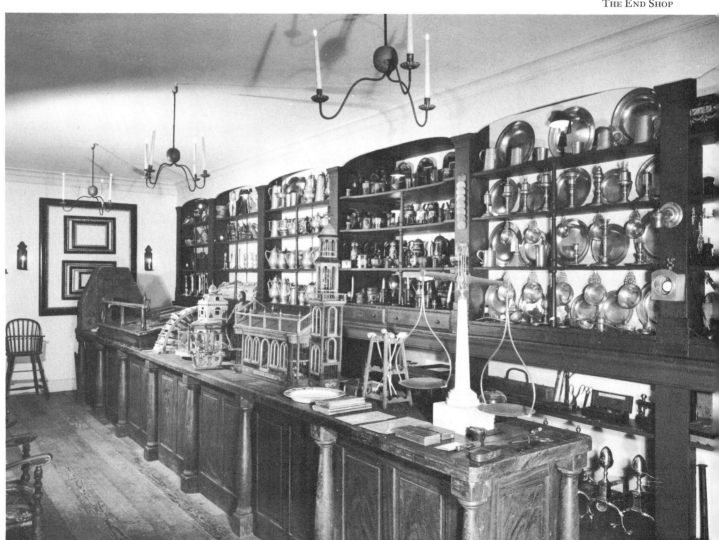

THE COURT: FACADE OF THE RED LION INN

doorway typical of the region against old weather-beaten clapboards. The façade from MONTMORENCI shows the gray-painted center block of the North Carolina house built in 1822 from which the circular staircase at Winterthur came, a fine carved cornice, a triple window with carved scroll pediment, and a double entrance door framed in reeded pilasters, with lights at either side and an arched transom above. The old wooden pump in the door-yard came from the Nathaniel Bowditch house in

Salem, Massachusetts. The RED LION INN, from which the Red Lion Hall came, has a three-story front of brick with shuttered windows and two fanlighted doors; the building stood at Red Lion, Delaware, from the early nineteenth century on. The early octagonal table and bench are set up around an old painted inn sign embellished with the American eagle, the most popular device in the American decorative arts and virtually the symbol of early America.

55

The Court: Facade of Montmorenci

Colonial Williamsburg at Williamsburg, Virginia

LATE IN 1926 Williamsburg was brought down from the attic of Virginia history to be dusted off and restored. Joining concept to opportunity, Dr. W.A.R. Goodwin and John D. Rockefeller, Jr., began the renaissance of a small colonial town. Williamsburg rising again on its old foundations came to symbolize the birth of a spectacular new interest in preservation. Hundreds of Americans set to work patching and painting, renovating and shoring up, scraping off the crust of years from landmarks that remained of a past all but erased.

Williamsburg alone has not aroused the interest in preservation, but it would be idle to discount its influence, for it has provided example and direction (if not also momentum) to the trend. And Williamsburg is unique; its very uniqueness in 1926—a colonial capital still largely intact and in protective isolation—was the keystone of Dr. Goodwin's vision, and of Mr. Rockefeller's interest. The town *could* be brought back to life.

At the core of the eighteenth-century life that Williamsburg reflected was, said Francis Parkman, "a proud little provincial society which might seem absurd in its lofty self-appreciation, had it not soon proved itself so prolific in ability and worth." That society lived in the Tidewater region of Virginia, a flat country penetrated by broad rivers and dotted with small farms and sprawling plantations. Great planters' estates represented the ultimate in affluence and colonial culture. From such self-contained social and economic units grew an orderly way of life dominated by the working aristocrats of the plantations and accepted by farmers, townsmen, craftsmen, servants, and slaves. It was a pattern whose characteristics sprang from the land and were expressed in the simplicity of buildings, customs, and political systems.

Williamsburg, the capital, was the focal point of this pattern. Political life centered there in the sessions of the General Court and General Assembly held in "Publick Times." In his Palace, the royal governor lived and entertained with lavish formality. Intellectual life was stimulated by the College of William and Mary; Bruton Parish Church was a symbol of the Established Church of England which directed religious life. In the details of Williamsburg's architecture and the orientation of its society stood evidence of a practical and affectionate kinship between England and her oldest and largest colony.

But it was a kinship that faded with the growth of a feeling that only a single logical step separated a system of self-sufficient plantations from becoming an independent colony. And from Williamsburg in May 1776 came the call for united colonial action that was the fundamental fact of revolution.

A few years later Richmond became the capital of Virginia and the curtain fell on Williamsburg. A century and a half passed, and even at its end a man standing on Market Square could have spotted vestiges of more than eighty surviving colonial structures. They were in curious states of alteration and disrepair, set among the intrusions of the twentieth century that Williamsburg had entered as quietly as it had lived the nineteenth. Yet ready to hand in 1926 was a conventional architectural form whose repetitive details had been copied in the great country houses of the Tidewater and recopied in newer Williamsburg dwellings. A billeting map, presumably drawn by one of Rochambeau's engineering officers, located missing structures, confirmed the original sites of those that remained; an abundance of data from deeds and wills, letters and newspapers, insurance policies, court records, and even the ground itself pieced out the picture of old Williamsburg.

Furnishing the major buildings of an entire eighteenth-century town has been a complex and exacting assignment. The Queen Anne Speaker's chair that has been returned to the Capitol is the lone survivor of the furniture that once stood in the building—a measure of the task of replacing lost furniture at the Capitol and throughout the town.

Scattered inventories gave clues; other leads came from merchants' accounts, from archeological excavations, from auction records, and from wills. Constant research supplemented by patient deduction has been the practical technique. But that technique is part of a more fundamental hypothesis: while research may identify kinds of furnishings—even individual items—it can seldom describe their quality. And the eighteenth century recognized quality. In an age of fine craftsmanship, based upon a long-established apprentice system, they were surrounded by it. So authenticity and quality determine the selection of the furnishings seen by the millions of Americans who visit restored Williamsburg.

It is an ancient heritage they see in the strange flag, the Hogarth prints, a royal coat of arms, or a Cromwellian chair. But on the palimpsest of England they trace a newer heritage, which is but the old "adapted to the nature of the country by the gentlemen there." English rule was renounced, nothing more. Williamsburg relives as evidence of that, and as witness, through the thousands of impressions it creates for the visitor, that the past can be an emotional as well as an intellectual experience.

JOHN M. GRAHAM, II, *Director and Curator of Collections*

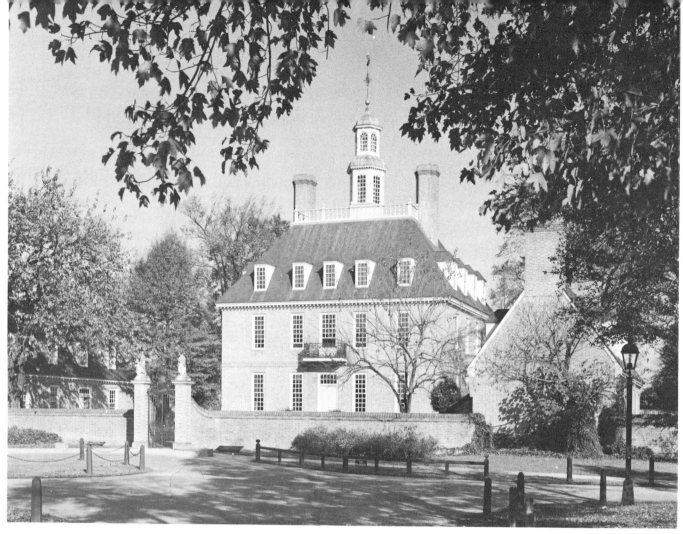

GOVERNOR'S PALACE

The antiques at Williamsburg

FURNISHING THE EXHIBITION BUILDINGS at Williamsburg has required a vast amount of detective work. The initial step was to find out what must have been in the buildings originally, which meant first of all tracking down and studying the available documentary sources of information—inventories, wills, auction accounts, letters, and copies of orders sent to England.

The earliest mention of Palace furnishings appeared in the Council *Journals* for 1710. Among other things a "great Lanthorn" for the hall was specified, and "gilt Leather Hangings" for the "great Room in the second Story." Most important were the inventories of Palace furnishings taken after the death of Governor Fauquier in 1768 and by his successor, Lord Botetourt, in 1770. In the case of the Raleigh Tavern, inventories were available made by two of the proprietors, Henry Wetherburn (1760) and Anthony Hay (1770). No inventories were found for the Wythe House or the Brush-Everard House, so it was necessary to rely on knowledge of contemporary usage, inventories of similar houses, and what could be learned of the circumstances of the owners—all of which was necessary in furnishing the other buildings too.

Important data were provided by the excavations which were made to locate original foundations. A crew of workmen would descend on a site and start digging cross trenches 18 to 24 inches deep, removing a foot or two of soil at a time so that it could be carefully sifted. A ton or more of artifacts might be accumulated from one excavation—bits of clay pipes, broken wine bottles, fragments of porcelain and earthenware, rusted bits of ironwork. When this enormous mass of fragments was sorted and catalogued, sound archeological evidence was available as to what had been used and in what ratio.

With furniture, of course, archeological evidence was not of much help. Inventories and records were searched. It was found that an appropriation of £250 was made in 1710 for Palace furniture to be "provided for in this country or sent for from Great Britain." Some at least of the Palace furniture may therefore have been made by the dozen or so Williamsburg cabinetmakers who were advertising in the *Virginia Gazette* prior to the Revolution. These included Benjamin Bucktrout, whose restored house on Francis Street one may see today, and Anthony Hay, later proprietor of the Raleigh Tavern. Some furniture may even have been made on the grounds of the Palace itself, for the Statement of

58

Losses filed by Lord Dunmore in 1784 included cabinet-makers' tools and a quantity of mahogany. Undoubtedly a good deal of furniture in local walnut and cherry was produced by the cabinetmakers of Tidewater Virginia.

Various other kinds of craftsmen were also at work in the area. Local blacksmiths were at hand to repair items of ironwork and to make such things as pots, shovels, spits, and simple hardware. A number of local brass and copper founders offered wares for sale. In the *Virginia Gazette* of March 1772 James Haldane of Williamsburg advertised that he made copper and brass stills, plate warmers, tea kitchens, stew pans, and dutch ovens. The number of local pewterers was small, but silversmiths were more numerous. In eighteenth-century Williamsburg, Alexander Kerr, James Galt, James Geddy, William Waddell, James Craig, and others had for sale silver porringers, bowls, spoons, tankards, teapots, snuffers, and candlesticks, though many of these items were imported.

Southern craftsmen had competition from the more industrial North. Ships were making the coastwise journey from the early eighteenth century. Between May 1704 and May 1705 fourteen ships from Virginia were among the 259 vessels entering Boston harbor from coast towns. A report made by Governor Gooch establishes a date of about 1730 as the time when New England furniture began to be conspicuous in the coastwise trade, and furniture was also shipped south from other northern centers.

But the greatest competition came from the mother country. The steady flow of ships carrying tobacco to England brought back all the English goods they could carry. The owners of the great plantations felt themselves one with the landed gentry of England and followed their pattern of living as closely as possible. The royal governor, a British gentleman and often a member of the nobility, denied himself no luxury in his tem-porary home across the sea, and could demand and get the most sophisticated products of the London shops.

The Palace was the residence of seven royal governors between 1710 and 1775 when the last one fled: Spotswood, Drysdale, Gooch, Dinwiddie, Fauquier, Botetourt, and Dunmore. Each one brought his own household goods to add to the standing furniture, of which there was always a certain amount. The furnishings now seen in the Palace range in style from the William and Mary, and still earlier, to the fully developed Chippendale, and are predominantly English though they include American pieces.

In the case of the Wythe House, while there was no inventory of the furnishings, a good deal was known about the owner. George Wythe, who lived there from

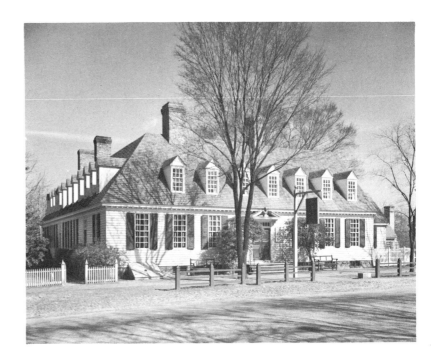

RALEIGH TAVERN

WYTHE HOUSE

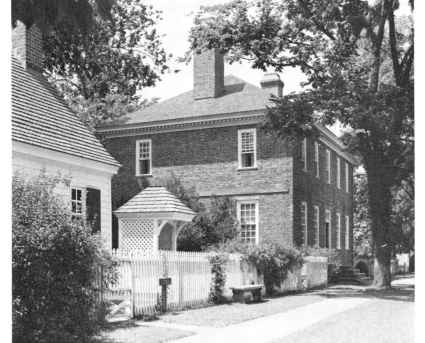

59

1754 to 1789, was one of the most influential men of his day, a neighbor and friend of Governors Fauquier and Botetourt. For years he was a member of the House of Burgesses; he was a signer of the Declaration of Independence, the first professor of law in an American college, and the foremost classical scholar in Virginia. His estate was a plantation in miniature, and his home may be assumed to have shown taste and luxury, though not the magnificence of the Palace.

The Raleigh Tavern was a luxurious inn frequented by Washington, Jefferson, and Patrick Henry, and by members of prominent Virginia families like the Lees, the Harrisons, and the Randolphs. It was in use throughout the Revolution and even after the removal of the capital to Richmond—the time when the Hepplewhite and Sheraton styles were appearing in America.

Completed more recently than the other exhibition buildings, the Brush-Everard House shows especially fine consideration not only of the furniture but of the treatment of walls, fabrics, floor coverings, and decorative objects. These represent the period of occupancy of Thomas Everard, a wealthy tobacco planter, who purchased the house about 1751 and remodeled and enlarged it. Built by Spotswood's gunsmith, John Brush, in 1717, it had had several occupants in the interim, notably the painter William Dering. In Everard's time it took on a more pretentious appearance, and the gardens were laid out.

After determining the types of furnishings that belonged in these exhibition buildings at Williamsburg, the next step was to find actual objects that corresponded to inventory descriptions, excavated fragments, and other evidence. This also demanded detective work of a high order, and endless patience, as well as true connoisseurship. The goal was to find not only pieces appropriate in style but genuine antiques of the highest quality. Already it has been impressively achieved, and treasures are constantly being added.

SHOWN IN COLOR are four rooms in the Governor's Palace, two in the Brush-Everard House, and one in the Raleigh Tavern. The colorful setting of the Apollo room of the Tavern is given a convivial air by two great punch bowls on the tables—one of English delft, the other China-trade porcelain—while harpsichord and aeolian harp suggest the tuneful entertainment offered to eighteenth-century guests. More elegant is the supper room of the Palace, where a Chinese painted paper covers the wall, and "Chinese" motifs are repeated in a Chippendale cabinet and pagoda-like pediment. In the Palace dining room, elaborate silver candlesticks and epergne on the great table, silver sconces on the wall, and a Meissen porcelain monkey band on the mantel add to the rich effect of old mahogany and colorful textiles. In the southeast chamber of the Palace, a remarkable set of English crewelwork hangings is shown at the window and on a seventeenth-century oak bed with bulbous posts and paneled back. The Palace parlor shows the famous portrait of Evelyn Byrd, rare Chelsea birds on the mantel, and a fine group of Queen Anne and early Georgian furniture. In the Brush-Everard House, American furniture predominates; chairs in the parlor are upholstered in red moreen, matching the curtains; in the library, two chairs and a fine daybed are covered in colorful flame-stitch embroidery. Many of the objects in these rooms are illustrated in detail in the black-and-white pages. *(See between pages 96-97, 128-129)*

WILLIAMSBURG GARDENS

The English furniture

Tall-case clock made for William III by Thomas Tompion (London, 1699). The elaborate mechanism is in a case of French burl-walnut veneer on oak carcass with gilt-metal mounts, crowned by a gilt figure of Minerva. Owned by the reigning monarchs of England from William III to Queen Victoria. *Palace, upper middle room.*

THE EARLIEST FURNITURE at Williamsburg is of oak and walnut. Since the old inventories contain none of the descriptive terms we employ today, it is necessary to rely on the mere mention of the wood for a clue to style. An oak bed may be assumed to be Jacobean; a walnut piece is probably William and Mary or Queen Anne, although walnut came into widespread use about 1670, some fifteen years before the reign of William and Mary began. Mahogany supplanted walnut about 1720, so that Georgian styles may be assumed where mahogany is mentioned.

Oak pieces are few in the Botetourt inventory of 1770. It lists an oak bed in the "chamber over the dining room" (the northeast bedchamber), and today a Jacobean oak bed stands there. In the dining room a handsome Jacobean oak court cupboard, used for the display of plate, is appropriate. Another important early piece is the oval oak drop-leaf table in the upper middle room, which corresponds to an item in a bill of Richard Price, Charles II's joiner: "For a large oval Table to fall downe all round with strong Ironworke, & the frame to screw together with Ironscrews."

The outstanding walnut piece in the Palace is the great Tompion clock made for William III and bearing his cipher. It is of prime importance for its walnut-veneered case and gilt-metal mounts no less than for its elaborate mechanism.

Oriental lacquer and its English imitation, "japan" work, were introduced as furniture decoration in the reign of Charles II, and continued popular in the Queen Anne and George I periods. Among interesting examples in the Palace are a pair of cabinets japanned in red and gold in the supper room, a pair of candlestands with japanned tops in the little dining room, a tea table in the parlor and a desk in the governor's bedchamber, both in black and gold, and a notable set of green and gold chairs in the upper middle room. This set was once at Ormeley Lodge, Ham Common, Surrey, and is similar to a set at Chequers, the country residence of the prime ministers of Great Britain.

The typical Queen Anne chair with urn-shape splat of conformal type, adapted to the back of the sitter, was an important innovation in furniture design which has affected all chairmaking since. The cabriole leg ending in the claw and ball, which first appeared about the turn of the century, became usual. There are many examples of this popular Queen Anne chair throughout the exhibition buildings; a fine set is in the little dining room at the Palace.

With the emergence of William Kent, who designed not only houses but furniture and gardens, came a more elaborate architectural style in furniture. The broken-arch pediment he favored remained on case pieces for a great part of the Georgian period. About 1735 sinuous lines were introduced, under the influence of the French rococo, but this affected ornament more than structure.

Chair backs became more ornate during the reigns of George I and George II. Of the early Georgian period are the settee and matching set of side chairs in the supper room at the Palace; the inset panels of the backs and cresting are decorated with gilt gesso, the work of a specialized craftsman allied to the engraver and metalworker. A number of fine pre-Chippendale chairs at the Palace show the progression from bow-shape cresting to square, and from the solid urn splat to one pierced, splayed, and carved. The Georgian chair is especially well represented in the dining room, the ballroom, and the bedchambers at the Palace.

Charles II oak stretcher table (late 1600's). Oval when open, rectangular when leaves are dropped; bulbous legs joined by molded stretcher. Four or five such tables survive today. *Palace, upper middle room.*

Jacobean oak cupboard, carved and inlaid, with splay front and melon-bulb supports. Eighteenth-century English silver and slipware. *Palace, dining room.*

Caned, hooded chair with oak frame, the broad front stretcher carved with rosettes and foliage in low relief (late 1600's). The only example of this kind known. *Palace, secretary's office.*

62

Ball-foot cupboard, walnut veneered on oak, with beveled glass panes and brass bosses on doors (late 1600's). One of a pair made during William and Mary's reign for Hampton Court, where the other remains. *Palace, little middle room.*

Secretary-bookcase with looking-glass panels (c. 1715). Oak carcass, veneered in plain and richly figured French walnut with cross banding and herringbone borders. Sliding desk section has original green velvet. Originally at Ashburnham Place. *Palace, upper middle room.*

Chippendale gave the breakfront bookcase its final form and made it the dominant piece of furniture in the Georgian interior. Especially fine is the bookcase in the upper hall of the Palace, and other handsome case pieces of the period include cabinets, secretaries, and chests of drawers. For sheer elegance and richness of style, Chippendale fire screens, on which the full artistry of carving could be lavished, were unsurpassed. One with a needlework panel in the Palace is exceptional in every respect. Mirror frames offered another opportunity for elaborate carving in the rococo manner.

Toward the end of the Chippendale period curves gave place to straight lines. The broad, straight legs that came to be used on tables and chairs were like those known on Chinese furniture. Chinese influence is also expressed in fret carving, as on the handsome side tables at each end of the Palace ballroom and on a cabinet and a commode in the Palace supper room. The last is similar to a plate titled "China Table and Shelf" in Ince and Mayhew's *Universal System of Household Furniture* (London, 1759-1763).

Under the influence of the classic taste in the last quarter of the eighteenth century, furniture took on the lighter forms and more delicate ornament advocated by Adam, Hepplewhite, and Sheraton. Since these styles did not come into vogue until near the close of the period represented at Williamsburg, relatively few examples are to seen there.

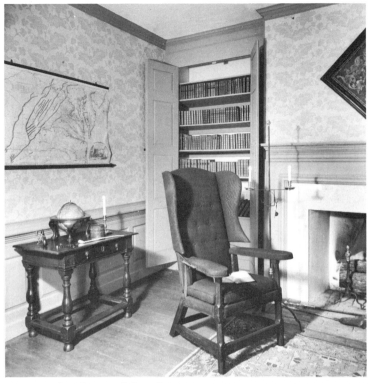

Few examples of an English early eighteenth-century sleeping chair with adjustable back have survived. This one even has its original black moreen covering. The stretcher table with turned legs is of the late 1600's. *Brush-Everàrd House, library.*

Pair of Charles II silver-gilt gesso candlestands (c. 1680). The polygonal tops are japanned with Chinese scenes. Said to have come from Ham House, Surrey, a Jacobean mansion which is now a property of the National Trust. *Palace, little dining room.*

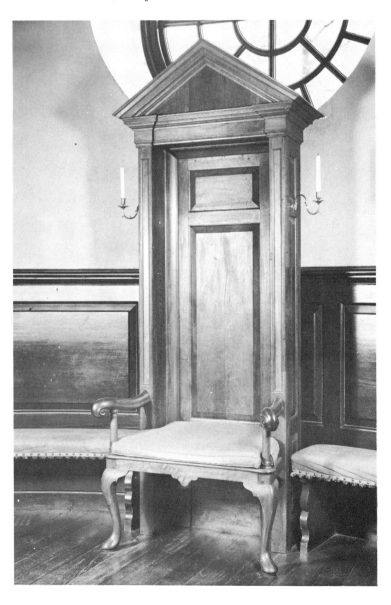

Original Queen Anne Speaker's chair of the House of Burgesses (walnut, early 1700's). Taken to Richmond in 1779 when the capital was moved, and now on loan to Colonial Williamsburg by the General Assembly of Virginia. *The Capitol, House of Burgesses.*

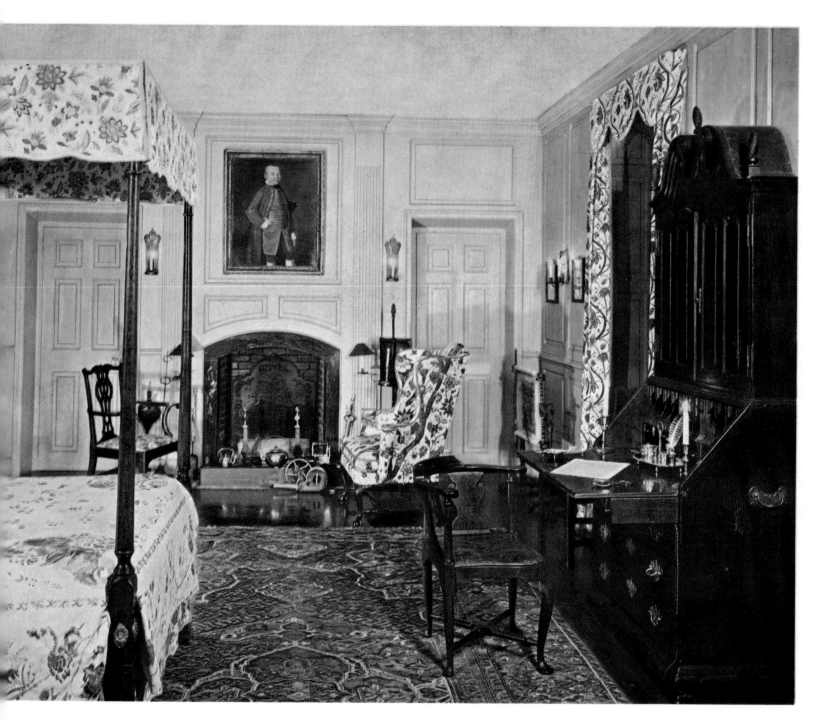

THE ESSEX ROOM, WINTERTHUR MUSEUM

(See page 32)

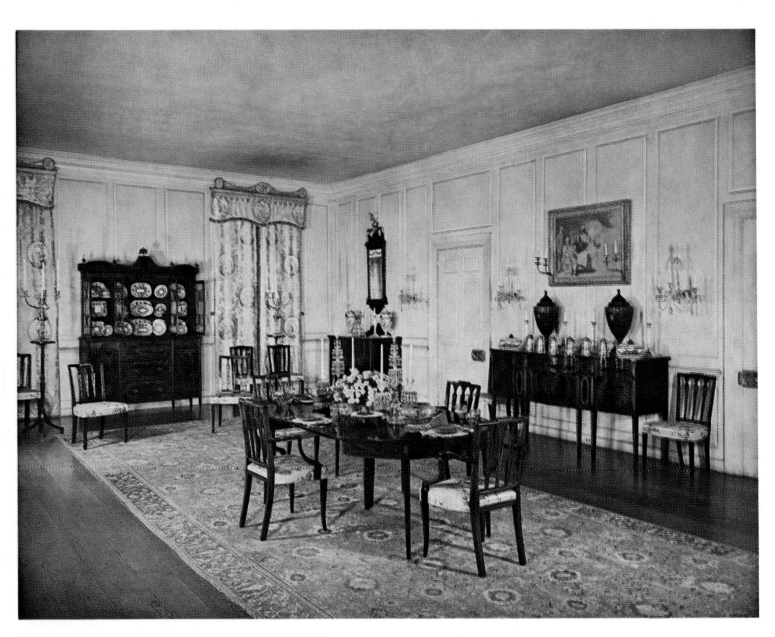

THE DU PONT DINING ROOM, WINTERTHUR MUSEUM

(See page 34)

Long side table, or dresser, oak with mahogany cross-banding on the three drawers (provincial English, c. 1740). *Raleigh Tavern, hall.*

George I beechwood chair japanned in green and gold, one of a set of six with caned seats and backs (c. 1720). Perhaps made by Giles Grendey of London. The quality of the decoration is very fine. From Ormeley Lodge, Ham Common, Surrey. *Palace, upper middle room.*

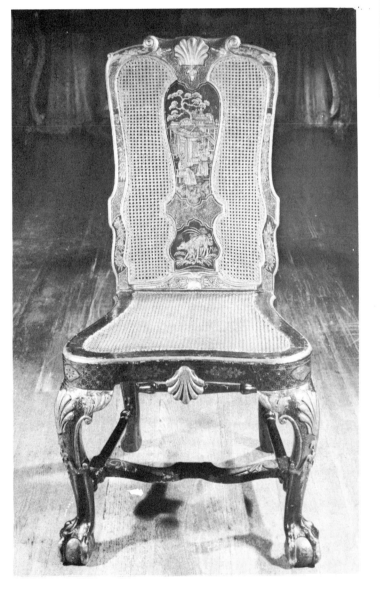

Tilt-top tea table with scalloped top, japanned in black and gold (c. 1750). *Palace, parlor.*

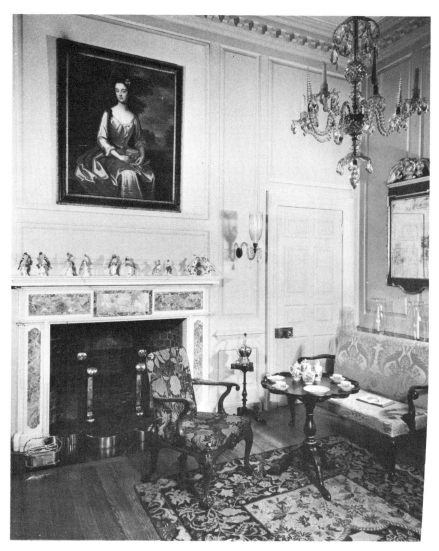

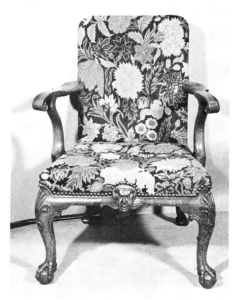

George I walnut armchair with carved winged-satyr's mask on front seat rail (c. 1725). Contemporary needlework. *Palace, parlor.*

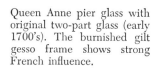

Queen Anne and Georgian furniture are used with an early English chandelier and needlework rug. Five choice pairs of Chelsea birds are arrayed on the mantel, above which hangs the portrait of Evelyn Byrd (see *The paintings*). *Palace, parlor.*

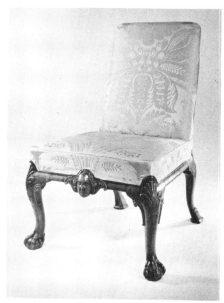

George I walnut side chair with carved female mask on front seat rail (c. 1725). A rare type. *Palace, parlor.*

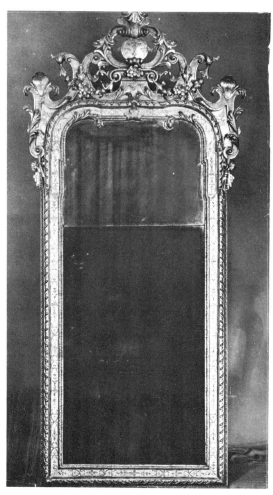

Queen Anne pier glass with original two-part glass (early 1700's). The burnished gilt gesso frame shows strong French influence.

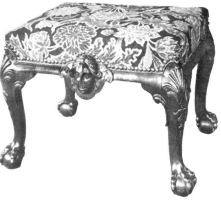

George I walnut stool with carved female mask on front seat rail (c. 1730). Petit-point upholstery. *Palace, parlor.*

66

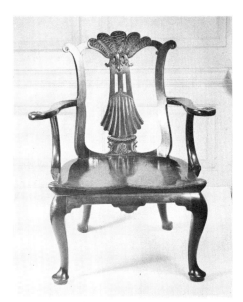

George II mahogany armchair (London, c. 1735). Carved with scaled plume. *Palace, dining room.*

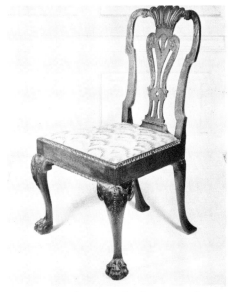

George II mahogany side chair, one of a set of six (English provincial, c. 1730-1740). *Palace, dining room.*

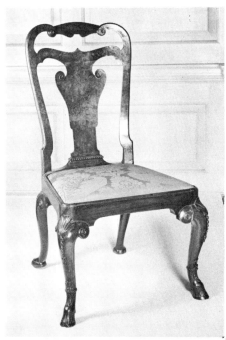

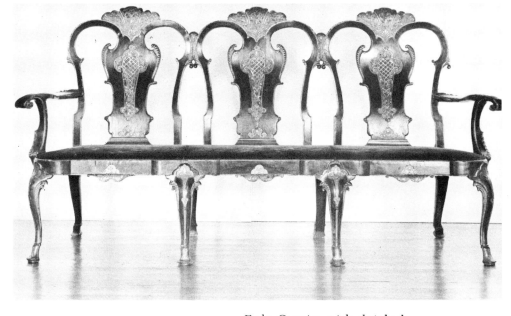

Early Georgian triple-chair-back settee of walnut with gilt-gesso panels, carving, and molded edges (c. 1720). Part of a set of six side chairs. *Palace, supper room.*

Early Georgian walnut side chair with double ox-bow crest rail (c. 1730); cabriole front legs with hoof feet. *Palace, dining room.*

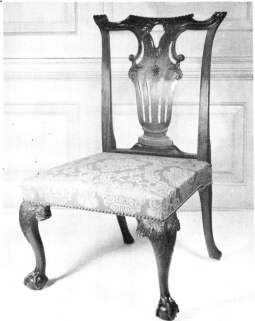

Georgian mahogany side chair, one of a set of six, showing Chippendale influence in proportions and carving (c. 1745). *Palace, dining room.*

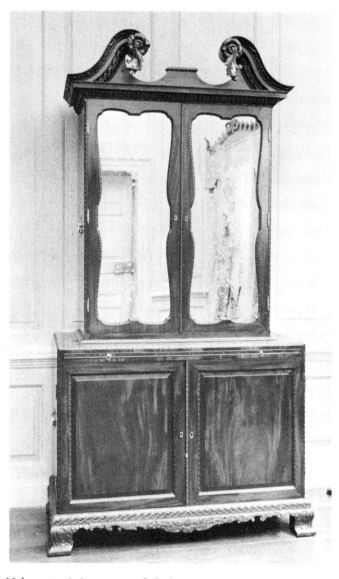

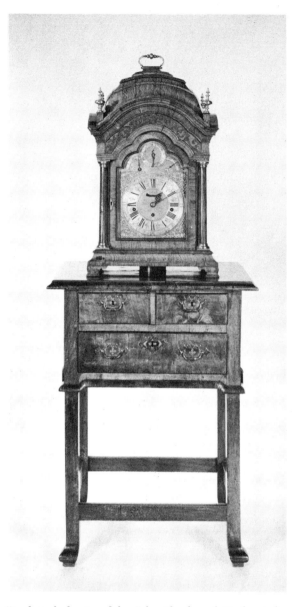

Bracket clock, signed by John Shepley of Stockport (c. 1749). The walnut-veneered case, with brass mounts and fittings, rotates on a walnut veneer table which was undoubtedly made for it—a rare combination.

Mahogany clothes press with looking-glass doors, on a cupboard base containing drawers (c. 1735). Labeled by Giles Grendey of London. A richly carved piece showing transition from Kent to Chippendale. *Palace, governor's bedchamber.*

English mahogany shaving stand and wash stand, with pewter ewer and fitted razor case. The Botetourt inventory lists "Chagrine case of raisers." *Palace, governor's bedchamber.*

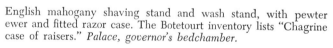

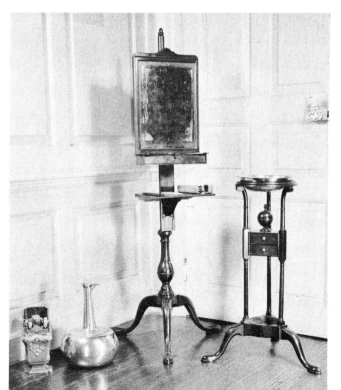

Siphon-wheel (mercurial) barometer in wall case of ebonized pearwood with gilt metal mounts; signed on dial plate *Geo. Graham/London* (c. 1720).

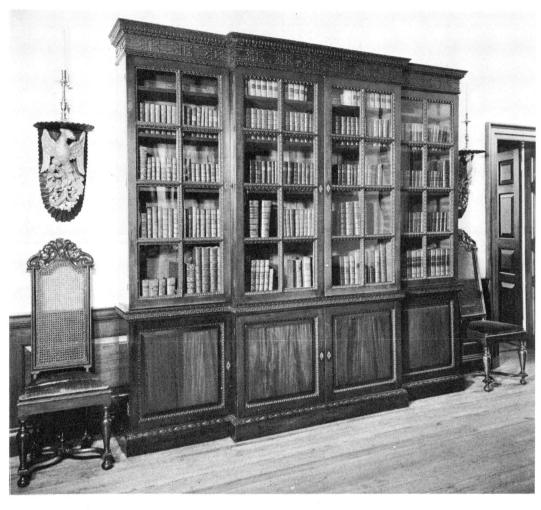

Chippendale mahogany breakfront bookcase with egg-and-dart molding and fret-carved frieze (c.1750). Flemish walnut side chairs from set of four (c. 1700-1710). Pair mahogany wall brackets with gilt-gesso carved eagles (mid-1700's). *Palace, upper hall.*

Irish Chippendale desk with pull-out front, cabinet above (mid-1700's). The punched ground and broad apron are characteristic of Irish work. *Palace, secretary's office.*

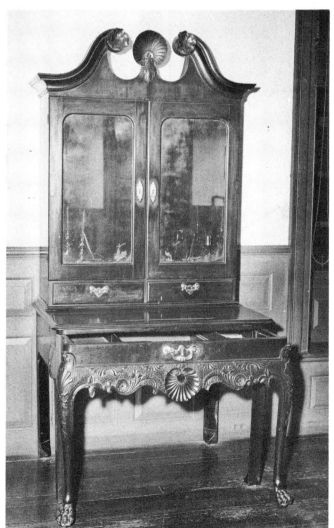

Mahogany tea table, one of a pair (c. 1750). Square, galleried top turns on a bird cage; carved pedestal and tripod base. *Palace, dining room.*

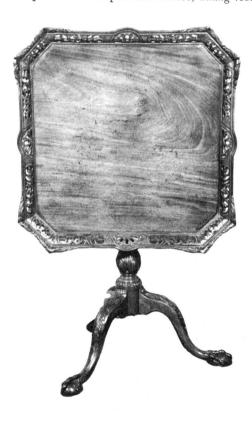

69

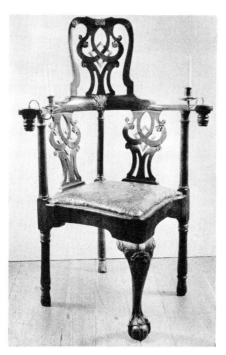

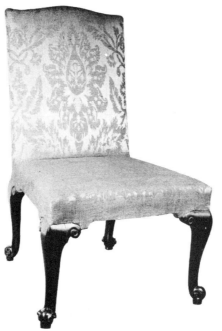

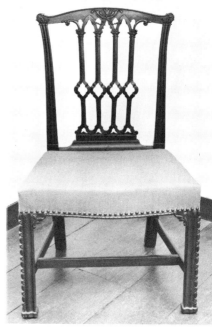

Walnut corner chair (English provincial, mid-1700's), with touches of gilding on the carving; candle arms for reading. *Palace, upper middle room.*

Upholstered side chair or back stool, with scroll toe showing French influence on Chippendale (mid-1700's). *Palace, northeast bedchamber.*

Chippendale side chair, one of a pair, with pierced Gothic splat; straight legs edged with egg-and-dart molding and joined by stretchers. *Brush-Everard House, parlor.*

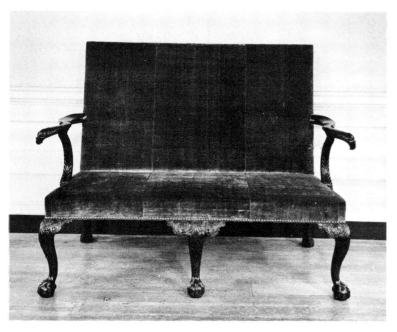

Early Georgian mahogany settee with open arms terminating in carved eagle heads, and carved front legs (c. 1730). *Palace, ballroom.*

Walnut card table, one of a pair (c. 1745). Hinged top with square corners for candlesticks. *Palace, parlor.*

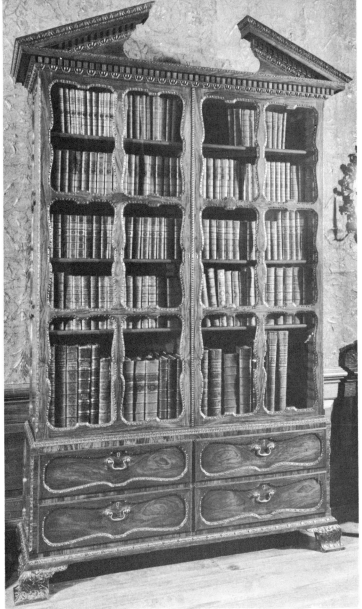

Bookcase of rosewood veneer and mahogany, with broken pediment, shaped glazed panels, and four drawers (c. 1740). Pediment, panel edges, moldings, and feet enriched with carving. Original silver drawer handles. *Palace, upper middle room.*

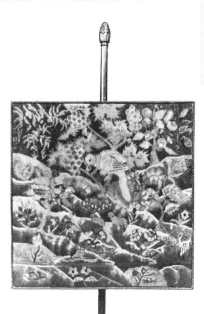

Tilt-top tea table (c. 1775); the top of Pontypool japanned sheet-iron with pierced edge, polychrome and gilt decoration on black ground; the tripod pedestal of japanned beech. *Palace, southwest bedroom.*

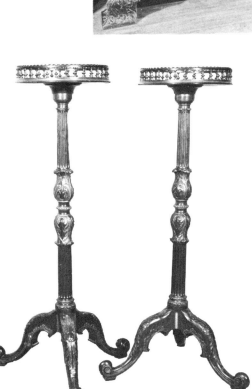

Mahogany *torchères*, a pair, with round galleried tops on fluted and carved columns supported by carved tripod bases (c. 1750); the carving is gilded. *Palace, parlor.*

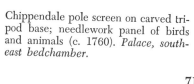

Chippendale pole screen on carved tripod base; needlework panel of birds and animals (c. 1760). *Palace, southeast bedchamber.*

71

Mahogany commode for displaying porcelains (c. 1760); doors, sides, and gallery in "Chinese" open fretwork. Attributed to Ince and Mayhew of London.

Mahogany breakfront china cabinet on fretwork stand, in Chinese Chippendale style (c. 1760); interior fitted with shelves and lined with red velvet. *Palace, supper room.*

One of a pair of Chinese Chippendale mahogany side tables with unusually rich carved ornament (c. 1750). *Palace, ballroom.*

The American furniture

THE EARLIEST AMERICAN furniture known to Williamsburg must have been made locally, for importation from the north was not well established until the second quarter of the 1700's. Southern furniture is very difficult to date, since the early styles were continued over a long period; Queen Anne gate leg tables, for instance, were made even into the 1800's. The William and Mary highboy, a Virginia piece in the Brush-Everard House, was probably made in the first half of the 1700's. Examples of other early types, as well as later southern pieces, have been secured for Williamsburg.

The first furniture to reach Williamsburg from New England, Philadelphia, and other northern centers must have been in the Queen Anne style, such as the Rhode Island daybed in the Brush-Everard library and the Newport drop-leaf table in the Apollo room of the Raleigh Tavern. Chippendale items, both northern and southern, have also been placed in the Brush-Everard House. Northern pieces selected for the Palace are relatively few but represent the finest American craftsmanship in the Chippendale style. Such are the Philadelphia highboy and similar lowboy in the northeast bedchamber, and the New England bombé chest-on-chest in the southeast chamber. Of exceptional interest is the "sample" chair in the former, one of six known which are believed to have been made by the Philadelphia cabinetmaker Benjamin Randolph as samples of his skill. Another outstanding example of Philadelphia work is the elaborate tall case of the clock by Edward Duffield in the little dining room.

While American furniture in the post-Revolutionary styles is not to be seen in the Palace or in the Brush-Everard House, it has been considered appropriate in the Raleigh Tavern and the Wythe House. The Tavern was famous for its sumptuous furnishings, and since one of its proprietors, Anthony Hay, had himself been a cabinetmaker, we can be certain that the furniture was of superior character. The finest pieces are in the Apollo and Daphne rooms, where the gentry were entertained. A handsome southern sideboard with fan inlay, in the Daphne room, represents the late-century additions to the furnishings with which the Raleigh would have begun its existence in the 1740's. In the public dining room and the taproom the furnishings are more utilitarian in character and less up-to-date in style. In the Wythe House are examples of both Hepplewhite and Sheraton furniture, and there are also small pieces of southern origin throughout the house.

Walnut desk-on-frame with slant top and turned legs (southern, c. 1760). *Brush-Everard House, northwest bedchamber.*

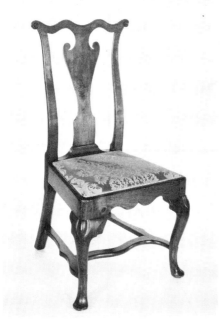

Walnut side chair, one of a pair (Philadelphia, c. 1750-1760), bearing the label of William Savery.

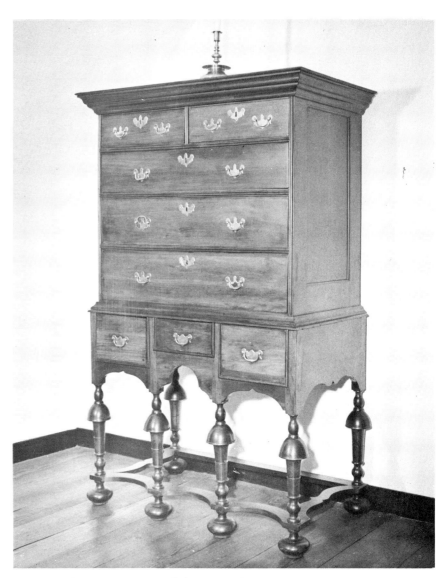

William and Mary high chest of drawers with trumpet-turned legs and paneled ends (probably Virginia eastern shore, first half 1700's). *Brush-Everard House, northwest bedchamber.*

Queen Anne eight-leg splat-back daybed in maple (Rhode Island, c. 1730-1740). Slip seat is covered in eighteenth-century flame stitch. *Brush-Everard House, library.*

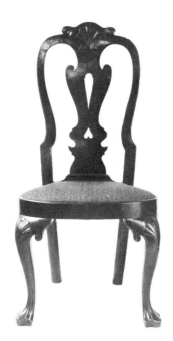

Queen Anne walnut side chair (Philadelphia, second quarter 1700's). *Ex coll.* Luke Vincent Lockwood. *Brush-Everard House, library.*

Important tall-case clock by Edward Duffield (Philadelphia, w. 1756-1775); carved mahogany case. *Palace, little dining room.*

Tall-case clock by Thomas Walker of Fredericksburg (w. 1760-1775). *Brush-Everard House, hall.*

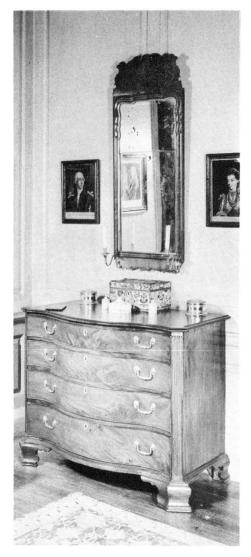

Swell-front mahogany chest of drawers with fluted chamfered corners and ogee bracket feet (Philadelphia, c. 1775). Attributed to Jonathan Gostelowe (1745-1795). *Palace, northeast bedchamber.*

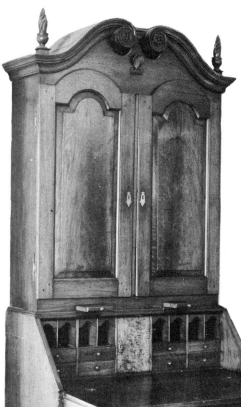

Tidewater Virginia walnut secretary with bonnet top (mid-1700's). *Brush-Everard House, library.*

New England mahogany bombé chest-on-chest with fluted pilasters and scrolled domed top. In the lower section the drawer sides extend to the outside curve, a fine detail. *Palace, southeast bedchamber.*

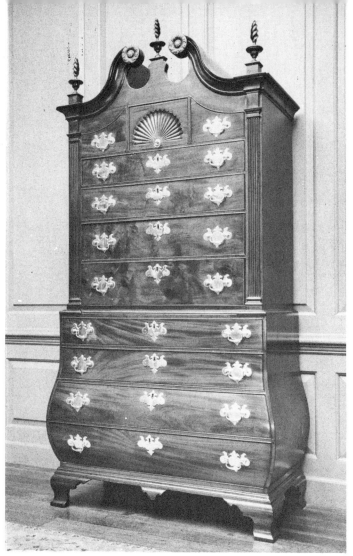

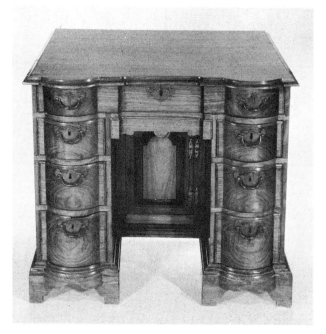

Mahogany kneehole dressing table with round blocked front (Massachusetts, c. 1760-1765). There is a shallow sliding tray below the center of the top drawer.

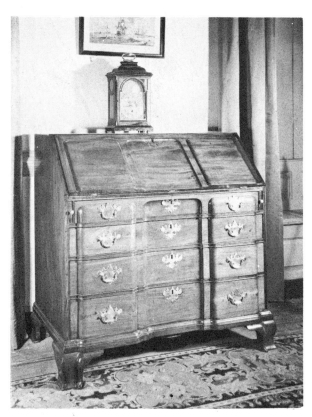

Mahogany blockfront desk of fine type (New England, 1760-1765). Bracket clock by John Newberry (London, c. 1745). *Wythe House, study.*

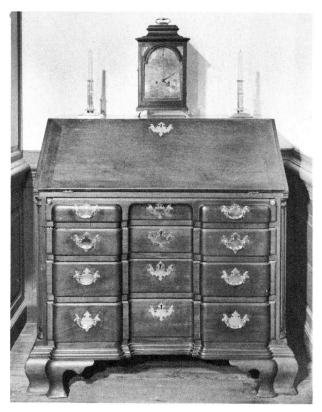

Walnut blockfront desk (possibly southern, 1760-1775). Inset quarter columns; blocking and fluting in the interior. *Brush-Everard House, parlor.*

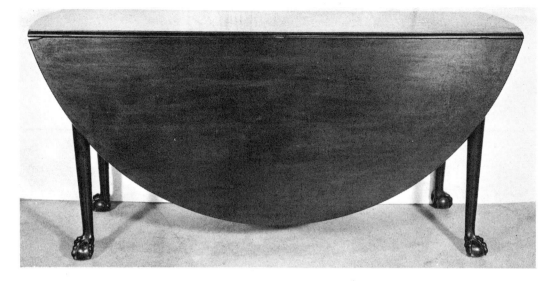

Mahogany drop-leaf dining table, attributed to the Goddard-Townsend cabinetmakers (Newport, c. 1750-1760). One of the largest Rhode Island examples of its type, 68¾ inches wide. *Raleigh Tavern, Apollo room.*

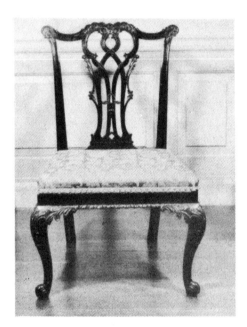

"Sample" chair, one of six now in various collections attributed to Benjamin Randolph of Philadelphia; *ex coll.* Reifsnyder. *Palace, northeast bedchamber.*

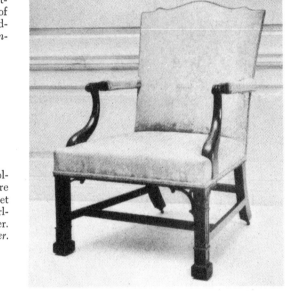

Philadelphia Chippendale upholstered open armchair of rare type (c. 1760). Mahogany; fret carving on straight legs; Marlborough feet. *Ex coll.* Reifsnyder. *Palace, northeast bedchamber.*

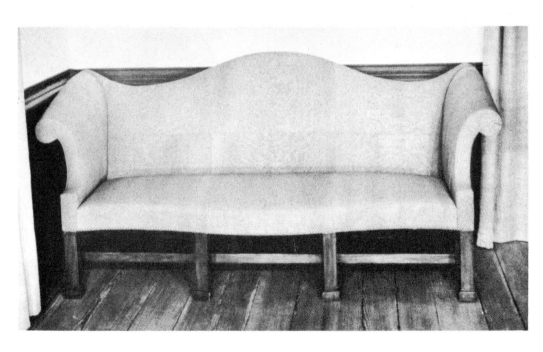

Philadelphia mahogany eight-leg sofa (Philadelphia, c. 1770-1780); serpentine front and back; Marlborough feet. Upholstered in eighteenth-century red moreen. *Brush-Everard House, parlor.*

77

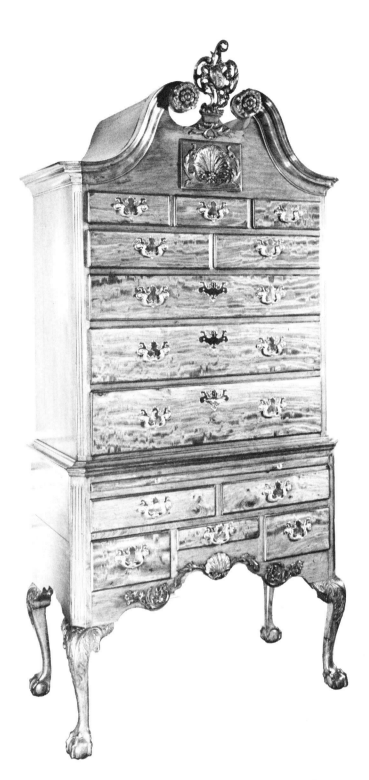

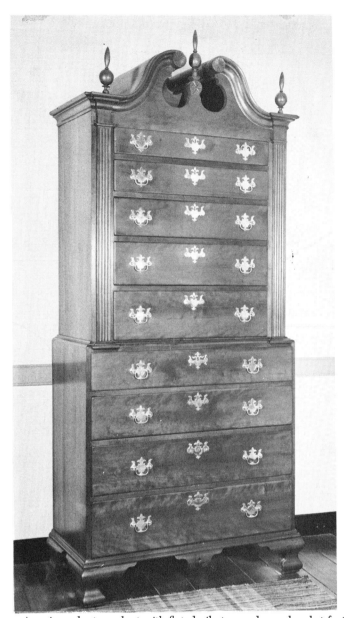

American chest-on-chest with fluted pilasters and ogee bracket feet, domed top, possibly Connecticut (last quarter of 1700's). *Wythe House, southeast bedchamber.*

Philadelphia Chippendale mahogany scroll-top highboy (c. 1760). With pierced finely carved shell and leafage. *Palace, northeast bedchamber.*

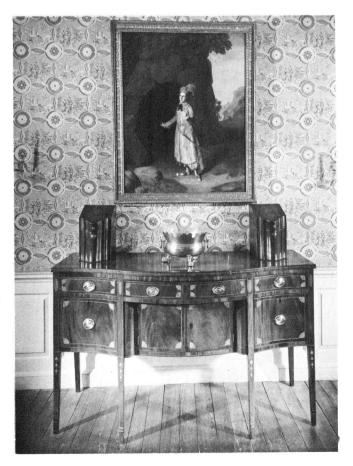

Fine southern sideboard, mahogany with southern pine interior (late 1700's); the lavish use of the inlay is typical of Georgia work. Portrait (1771) by Charles Willson Peale of Nancy Hallam, one of the first stars of the American stage, as Imogen in Shakespeare's *Cymbeline. Raleigh Tavern, Daphne room.*

Slip-decorated candlesticks of dark-brown lead-glazed red earthenware; an almost identical pair, with five candle sockets and molded prunts; one dated 1663, the other 1668. Made at Wrotham, in Kent, possibly by George Richardson. Heights 10⅜ and 10⅞ inches. *Raleigh Tavern, public dining room.*

The ceramics

OF THE VARIOUS TYPES of eighteenth-century material that have been unearthed in excavations at Williamsburg, ceramics are the least susceptible to decomposition. Thus the fragments found have been tremendously helpful in establishing what wares were actually used there, quite aside from the supporting evidence of contemporary records. The Palace inventories are less illuminating—we find, for example, quantities of quite unidentified "dishes"—but many of their references may be interpreted in the light of the fragments.

The fragments make it clear that delftware, both English and Dutch, was well known in Williamsburg. The English learned to make this tin-enameled ware from the Dutch, who had produced it in the attempt to imitate the Chinese blue-and-white porcelain. Dutch delft tiles with designs in blue or purple were a standard article of import in the American Colonies where they were used for framing fireplaces, as in several rooms at Williamsburg. English delftware, in plain white or decorated in colors, is seen in greater variety.

From Germany the English had learned the process of making salt-glazed stoneware, and this "white stone china" was extensively advertised in America. Fragments at Williamsburg indicate its use there. Probably it was the "white china" listed in the Palace inventories. The "coloured china" listed may have been one of the variegated wares associated with the English potters Whieldon, Astbury, and Wedgwood. Some fine examples of these wares, whose characteristic "agate," marbled, and tortoise-shell effects were obtained by colored clays or colored glazes, are in the little dining room of the Palace and the dining room of the Brush-Everard House.

English creamware, which was perfected in the 1760's and eventually supplanted these earlier eighteenth-cen-

Staffordshire hexagonal teapot of unglazed red stoneware (late 1600's); recessed oval panels decorated with chinoiserie motifs on an unfired gilt ground; probably by John Philip Elers. An identical example is in the Victoria and Albert Museum. Height 4⅛ inches.

79

Rare Lambeth delft basket, or layette, dated 1679; initialed *S B*. The ground is the brilliant white of Lambeth, with cobalt blue decoration; sides are pierced in a floral design and the interior of the base shows a vase of flowers, fruit, and butterflies. Apparently only one like it, once in the collection of Lord Revelstoke and now dropped from sight, has been recorded. *Length 13 inches. Palace, northeast bedchamber.*

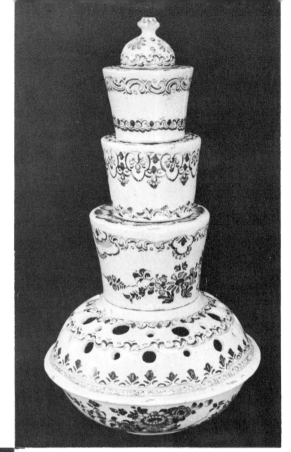

Bristol delft pyramid vase in four tiers (c. 1730); blue and white; height 14¼ inches. A similar but slightly smaller vase in the Fitzwilliam Museum, Cambridge, is the only other example recorded. *Palace, northeast bedchamber.*

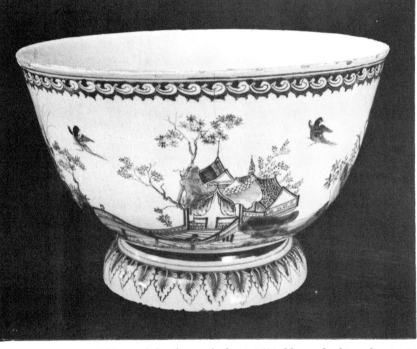

Liverpool delft punch bowl, inscribed *EA 1721;* blue and white; chinoiserie decoration like that on a large covered bowl, dated 1724, in the Glaisher collection, Fitzwilliam Museum. The deep bowl is of the steep-sided early type. Diameter 10 1/16 inches. *Raleigh Tavern, gentlemen's reception room.*

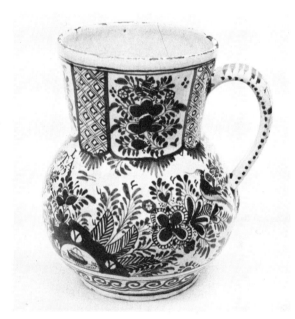

Bristol delft jug, initialed *L/TA* and dated 1709 (numerals transposed as 1079); polychrome decoration in reddish brown, yellow, olive green, and blue; height 6¼ inches. *Raleigh Tavern, public dining room.*

tury wares, has been found in quantity among the fragments. Dishes with a molded or "feathered" edge touched with blue or green were apparently very popular. Possibly this is what is meant by the "Staffordshire Ware" listed in considerable amounts in the inventories, though delft, salt glaze, and the variegated wares were also all made in Staffordshire. So was slip-decorated pottery, the traditional ware of the region, and it too was imported here. The "Staffordshire Ware" includes, besides "dishes," such forms as "mugs, coffee pots, tea pots,

wash hand Bason, cream pails and ladles." It was apparently utilitarian, as contrasted with "16 pieces ornamental china."

Other ornaments were "22 Chelsea china figures" in two rooms at the Palace. These must have been quite a rarity, for not much English porcelain was known in Williamsburg. More usual ornaments would have been earthenware figures made by English potters working in the Whieldon tradition. Some early Worcester tablewares may have been imported, as well as a few items

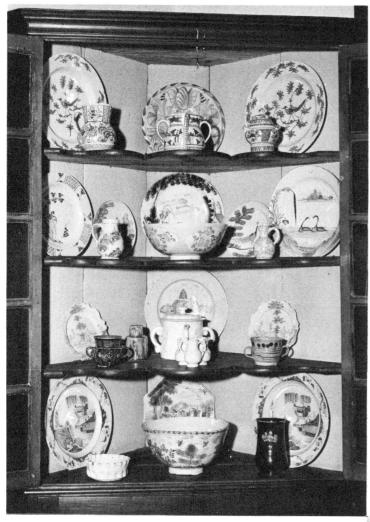

English earthenwares of the late seventeenth and early eighteenth centuries: principally delft in interesting variety. *Raleigh Tavern, public dining room.*

Bristol delft dish decorated in yellow, black, blue, and brown-orange (c. 1730); diameter 13¼ inches. *Raleigh Tavern, public dining room.*

Choice English eighteenth-century earthenware: polychrome delft posset pot; Whieldon bird, cup, and tray; salt glaze, chiefly with molded decoration. *Brush-Everard House, dining room.*

from the other English soft-paste porcelain manufactories, such as Bow and Chelsea, though there is very little record of English porcelain in the American Colonies in the eighteenth century. Still less numerous would have been examples of the first English hard-paste porcelain made at Plymouth and Bristol.

Porcelain from China, however, was familiar. Since the early 1600's the East India Companies had been bringing to Europe the blue-and-white ware called Nankin china, and, in the eighteenth century, the China-trade or export porcelain decorated to special order. These wares also became available in the Colonies. Fragments of this "East India china" found at Williamsburg are numerous, and it is believed that most of it was imported before the Revolution. There were "39 pieces nanken china for tea" at the Palace in 1770, besides many "blue and white china dishes." The "enameled" and "flowered" china there may have been Chinese porcelain, or it may have been delft or salt glaze with painted decoration in imitation of the Chinese.

Besides the considerable variety of imported ceramic wares known to have been used in eighteenth-century Williamsburg, there was the local product. Some of the excavated fragments are of simple, often crude, earthenware which may have been made in the vicinity.

All these wares are represented now in the Williamsburg buildings with examples that are not only characteristic but in many cases outstanding.

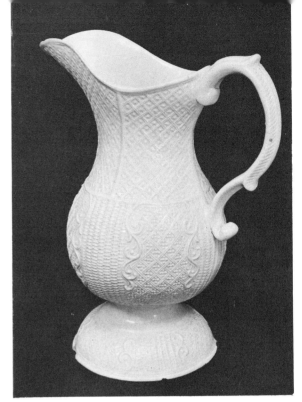

White salt-glazed stoneware ewer with raised decoration simulating wickerwork (Staffordshire, c. 1760); height 9¼ inches. Identical to one in the Schreiber collection, Victoria and Albert Museum. *Brush-Everard House, dining room.*

Staffordshire polychrome salt-glazed pitcher, with pastoral decoration (c. 1760); height 6⅞ inches. *Brush-Everard House, dining room.*

Whieldon-type candlesticks of earthenware molded in naturalistic forms with applied and stamped rosettes and other motifs, and standing Chinese figure; lead-glazed in mottled shades of green, brown, and gray on cream ground; Staffordshire, c. 1745. A pair; heights 11⅜ and 10¾ inches.

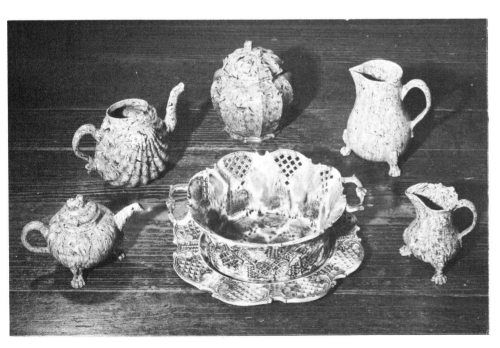

Teapots, faceted sugar bowl, and jugs of agateware, molded of clays in variegated colors; Whieldon-type basket and stand, earthenware glazed in mottled translucent colors. Staffordshire, mid-1700's. *Palace, little dining room.*

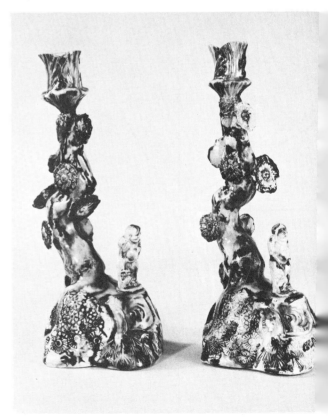

Group of Wheildon-type animals with tortoise-shell decoration. Cat shows accents in green and black; rabbit, leaves, and flowers in green and blue; squirrel, light green collar; bird, cream ground on base, green accents; dog, all tortoise shell. Heights, 3 to 8½ inches. *Brush-Everard House, library.*

Lowdin's Bristol porcelain water bottle and basin, decorated with birds in color in the Chinese manner (c. 1751). *Brush-Everard House, northwest bedchamber.*

Figure of St. George and the Dragon, earthenware with colored glazes, by Ralph Wood, Sr. (English, c. 1760). *Brush-Everard House, parlor.*

Earthenware figures of Venus and Neptune by Ralph Wood, Sr. (c. 1760). *Brush-Everard House, parlor.*

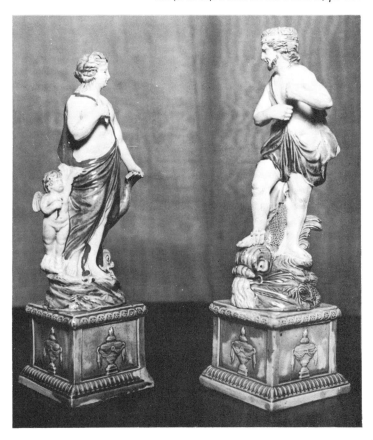

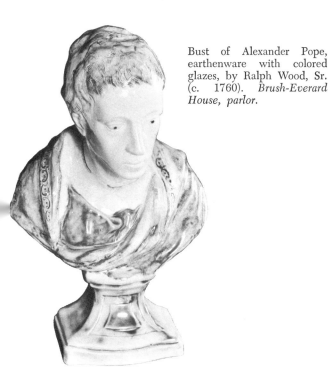

Bust of Alexander Pope, earthenware with colored glazes, by Ralph Wood, Sr. (c. 1760). *Brush-Everard House, parlor.*

83

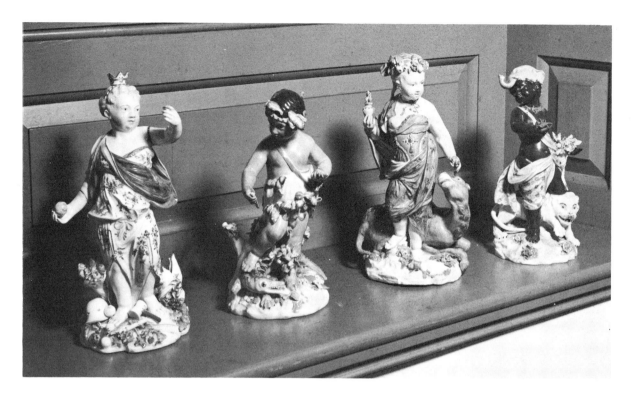

Important set of Chelsea porcelain figures of the Continents, gold-anchor period (c. 1765); the largest type of Chelsea figures made, height 12 inches. *Palace, ballroom.*

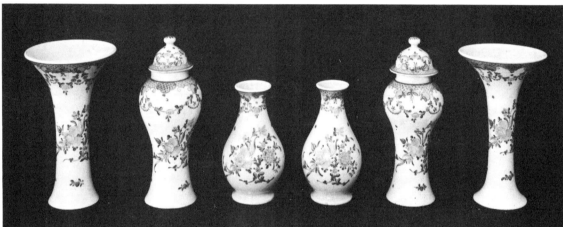

Porcelain garniture of six pieces in miniature; white ground with polychrome floral decoration in green, sepia, carmine, and yellow; Lowestoft, Suffolk (c. 1775). Height 4½ to 6 inches. This factory was known also for miniature tea services. *Brush-Everard House, dining room.*

Cistern and basin in Chinese porcelain with *famille verte* decoration (mid-1700's). *Palace, little dining room.*

China-trade porcelain punch bowl with floral reserves and unusual multicolor lotus-petal background. Diameter 20½ inches. *Raleigh Tavern, Apollo room.*

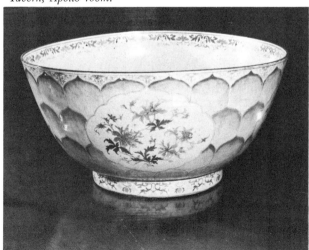

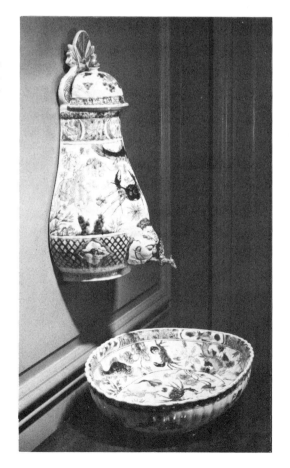

84

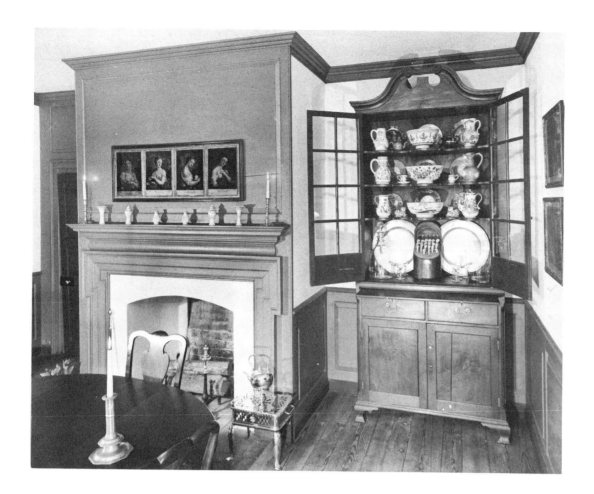

A walnut china cupboard probably made in Virginia in the second half of the 1700's displays English delft and other eighteenth-century earthenware, glassware, and pewter. The Lowestoft porcelain miniature garniture is arrayed on the mantel. *Brush-Everard House, dining room.*

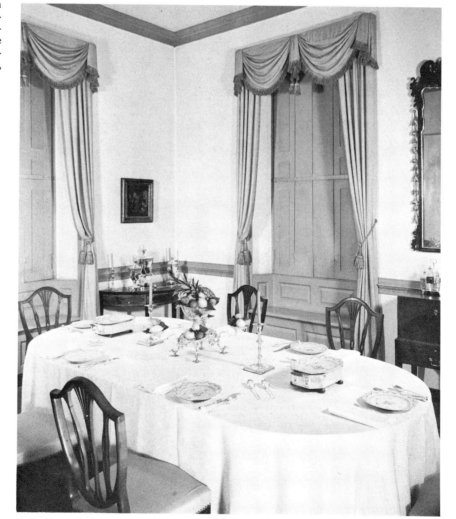

The table is laid with China-trade porcelain, floral-decorated, made for the English market in the late 1700's. *Wythe House, front dining room.*

The silver

SILVER WAS AN ADJUNCT of luxurious living in the eighteenth century. Silver vessels for eating and drinking, silver ornaments, silver lighting devices suited the taste of the time for elegance and refinement, and their forms answered the demands of new customs. New delicacy in table manners was made possible by the use of forks, which became general at the beginning of the century. Like the cabinetmakers and potters, the silversmiths met the introduction of tea, coffee, and chocolate with a variety of new forms. Some of the old forms became obsolete and a wide diversity of new silver utensils reflected the love of rich and graceful ornament—casters for salt, sugar, and spices; sets of plates and flatware; tureens, sauceboats, dish rings, salvers, and condiment stands; culminating in such ornamental masterpieces as the pierced fruit baskets and epergne that may be seen in the Palace dining room.

As might be expected, most of the silver at Williamsburg is in the most luxurious residence, the Governor's Palace, and in the silversmith's shop, the Golden Ball.

It also seems natural that most of that should be of English make; though nearly a score of silversmiths are recorded in Williamsburg before the Revolution, they probably imported as much as they made. There is in the Palace a silver-handled sauce pan attributed to James Geddy (1731-1807) of Williamsburg, and a spoon with the same mark is in the Archaeological Museum. Other American pieces are in the Brush-Everard House, and at the Golden Ball a collection of English and American silver represents what the pre-Revolutionary silversmith might have offered his Virginia clients.

The handsome array of English silver in the Palace dining room includes a number of noteworthy pieces exhibiting fine design and craftsmanship, and several that have the added richness of being gilded. The earliest are two Elizabethan tankards. Others represent what might have been brought by successive royal governors to add luxury and elegance to the Palace. One of the rare sconces on the wall of this room, and various other candle holders in silver, are shown in *Lighting*.

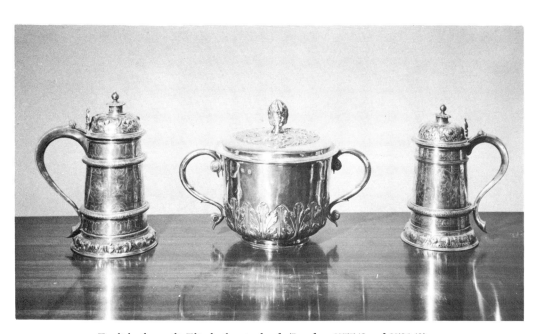

English silver-gilt. Elizabethan tankards (London, 1577/8 and 1591/2); Charles II covered cup (London, 1678/9). *Palace, dining room.*

Charles I bell-shape standing cup on a baluster stem, by an unidentified London maker (1641/2); pricked initials *OH/A* amid leafage, on bowl near lip; height 6 7/16 inches. *Golden Ball, silversmith's shop.*

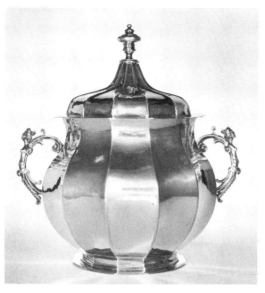

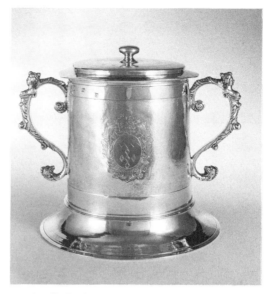

Silver-gilt twelve-sided cup with conforming cover and two finely cast and chased caryatid handles; London, 1649/50; mark of unknown maker, a hound sejant. Height over all 8⅛ inches. *Ex coll.* Lord Swaythling; William Randolph Hearst. *Palace, dining room.*

Two-handled silver cup with cover; London, 1655; maker's mark AF in shaped shield. The plain cylindrical form is typical of the Commonwealth period; on the broad matted band circling the body a coat of arms is engraved; the caryatid handles end in bird heads. Height 7¼ inches. *Ex coll.* William Randolph Hearst. *Palace, dining room.*

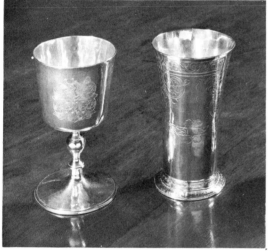

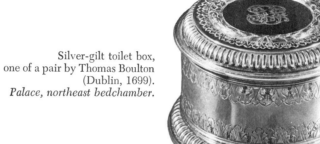

Silver-gilt toilet box, one of a pair by Thomas Boulton (Dublin, 1699). *Palace, northeast bedchamber.*

Silver standing cup with engraved arms (London, 1674/5). Engraved beaker (London, 1601/2). *Palace, dining room.*

Set of octagonal silver casters by Charles Adam (London, 1717/8). *Palace, little dining room.*

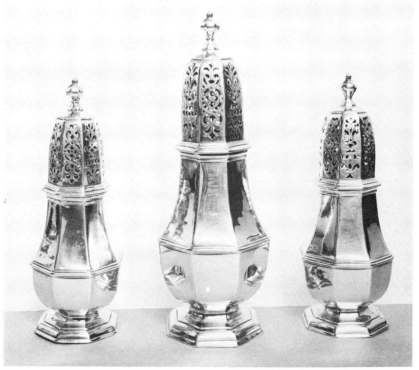

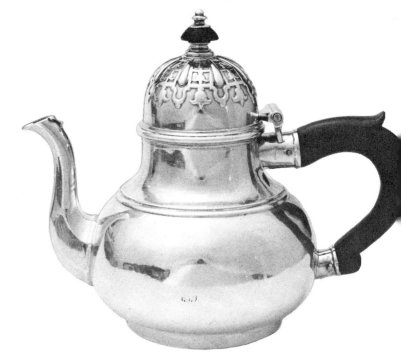

Queen Anne teapot with cut-card decoration on cover; by Pentecost Symonds, Exeter (1714/5). Next to Norwich, Exeter had the oldest provincial assay office. As the date letter changed in May of each year, and Queen Anne died August 1, 1714, this may have been made before her death. Height 6⅛ inches. *Golden Ball.*

Tea party in the time of George I (c. 1725), painter unknown. Of great interest in showing silver types made in the Queen Anne and George I periods, and China-trade porcelain teacups of the early eighteenth century. Apparently by the same artist as *A family taking tea* in the Victoria and Albert Museum, illustrated in Ralph Edwards' *Early Conversation Pictures* (No. 95). *Golden Ball.*

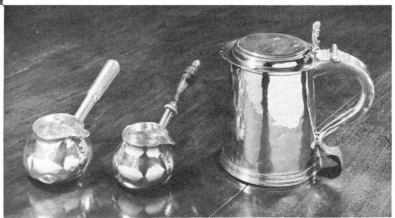

Silver-handled sauce pan attributed to James Geddy (Williamsburg, 1731-1807); silver sauce pan by John Eckford (London, 1723/4); silver tankard (Dublin, 1680/1). *Palace, little dining room.*

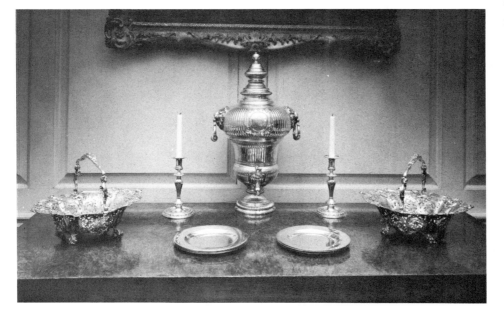

English silver-gilt. Pierced baskets by Paul de Lamerie (1747/8). Urn or wine fountain by Joseph Ward (1702/3), made for the Duke of Newcastle; gadrooned and engraved with arms. Candlesticks (London, 1727/8). Set of eight plates by Lewis Mettayer (1716/7). *Palace, dining room.*

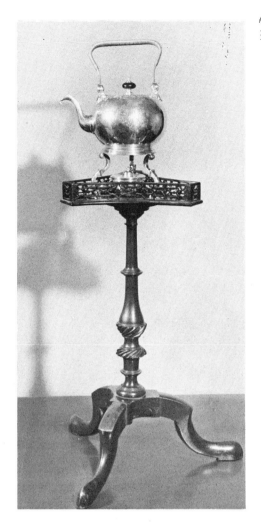

Chippendale kettle stand with triangular pierced fret gallery (c. 1750). Silver teakettle and stand by William Shaw, London (1727/8). *Palace, parlor.*

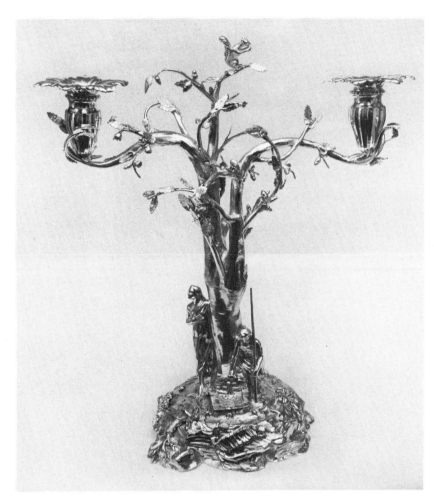

One of a set of four rococo two-light candelabra with allegorical figures which have not been identified. All four candelabra show the mark of Thomas Powell, London, 1759/60. Leafy branches curving from a central trunk support the flower-like sockets, and the base is a mound with insects, snails, and varied flowers in high relief. The finial here is a squirrel. A possible relation to porcelain designs of the period has been suggested but a prototype has not been found. Height 14¾ inches. *Palace, dining room.*

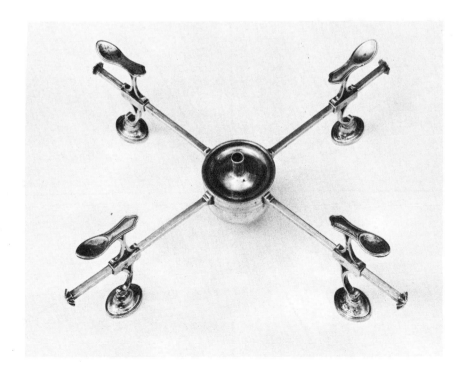

Philadelphia dish cross by Richard Humphreys (c. 1772). Ovoid spirit lamp with revolving cross-arms, each equipped with a sliding, spoon-shape dish rest supported by two C scrolls terminating in an oval foot; height 3⅜ inches. The dish cross is an exceedingly rare form in American silver. *Golden Ball.*

89

Lighting

THE VARIETY OF FORMS provided for holding candles in the late seventeenth and the eighteenth centuries is well illustrated at Williamsburg, as is also the variety of materials in which candle holders were made: wood, iron, brass, pewter, silver, glass, ceramics, enamel. Though eighteenth-century candlelight, often accompanied by dripping tallow and guttering wicks, was not always the romantic glow we know today, it was nevertheless a brighter and pleasanter illumination than that given by rushlight or grease lamp, and craftsmen devoted some of their finest efforts to devices for its use.

Candlesticks of the early, pricket type, rising to a spike on which the candle was impaled, were virtually obsolete by the Williamsburg period except for ceremonial use. The socket holder had become prevalent by the second half of the seventeenth century, when hollow casting made possible metal candlesticks of lighter weight than the preceding solid forms, and opened the way to the wide variety of baluster designs popular through the eighteenth century. Examples in these designs are numerous at Williamsburg, in brass and in other materials (see *The ceramics* and *The silver*).

Wall sconces for candles, or branches as they were called, were commonly made of brass and often had a glass shade to protect the flame. More sumptuous, and far rarer, are the two sets of richly wrought silver sconces and the glittering mirrored girandoles in the Palace. Other treasures there are the chandeliers of silver and of carved and gilded wood.

One of the first references to chandeliers of glass was an announcement in the *London Gazette* in 1714 that John Gumley had for sale "Looking Glasses, Coach Glasses, and Glass Schandeliers." The term *lusters*, used at first to describe cut-glass drops, came later to apply to the whole chandelier. One of the handsomest chandeliers at Williamsburg today is that hanging in the Palace supper room, which is not only a brilliant example of eighteenth-century work but a reminder of the reciprocal trade between East and West at that period. Made in England or Ireland, it was found in Canton, China.

Pewter candlestick, one of a pair by William Allen, London, c. 1675-1680. Columnar form with wide octagonal base and low drip pan. Height 9 inches. *Brush-Everard House, dining room.*

Brass candlestick with narrow socket, drip pan midway of the stem, and domed base (mid-1600's). *Palace, governor's study.*

Silver taperstick, one of a pair, London, 1725/6. Baluster form, hexagonal in section; used for small candles called tapers. *Wythe House, parlor.*

Brass candlestick, one of a pair, English, mid-1700's. Engraved with leafage on socket, baluster stem, and base, and on under side of base with the name *Skinners Company*, referring to one of the great London guilds. Height 8 1/16 inches. *Brush-Everard House, library.*

Brass candlestick, English, c. 1730. Baluster form, with six-lobed lip, knop, and base. *Palace, northeast bedchamber.*

Bilston enamel candlestick, one of a pair (English, c. 1760). Polychrome decoration. *Palace, northeast bedchamber.*

Silver taper lighter by Samuel Wood (English, 1744). *Palace, southeast bedchamber.*

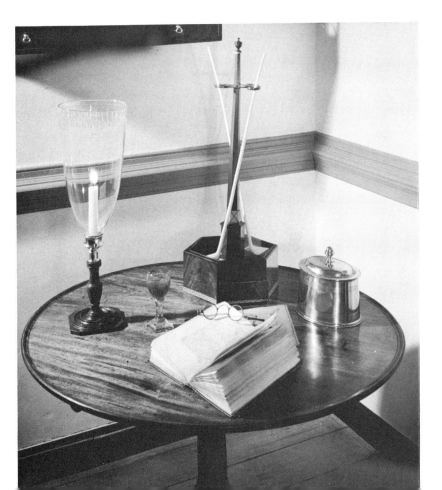

Turned wood candlestick with brass socket and engraved glass shade (late 1700's). Pewter tobacco box; mahogany pipe rack with clay pipes. *Wythe House, parlor.*

Hanging lantern, glass in brass frame with ornamental castings; brass candlestick; mid 1700's. *Brush-Everard House, hall.*

Hexagonal lantern, glass sides in wood frame, metal candleholder and ventilator; c. 1760-1780. *Brush-Everard House, porch.*

Candlestick of iron and brass, adjustable arm with two brass sockets and snuffers; c. 1760-1780. *Brush-Everard House, library.*

Wall lantern for a corner, English, c. 1730. Mahogany frame with two mirror panels and bowed glass panel. Early eighteenth-century brass candlestick. *Palace, upper hall.*

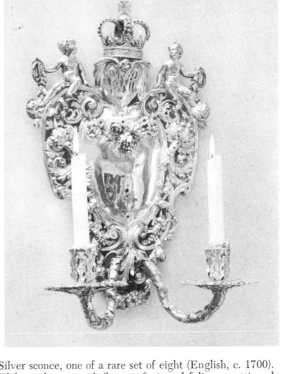

Silver sconce, one of a rare set of eight (English, c. 1700). Elaborately cast with flowers, fruit and foliage, *putti*, and the crown cipher of William and Mary. *Palace, dining room.*

Light from the open fire may be supplemented by candles in tin chandelier, brass sconces with pierced reflectors on the chimney breast, and early brass candlestick at right. On the round table is a betty lamp attached to a scroll-base iron standard. *Raleigh Tavern, taproom.*

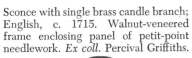

Sconce with single brass candle branch; English, c. 1715. Walnut-veneered frame enclosing panel of petit-point needlework. *Ex coll.* Percival Griffiths.

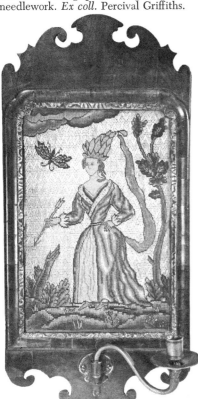

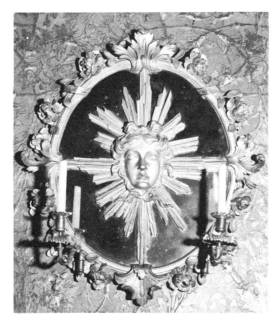

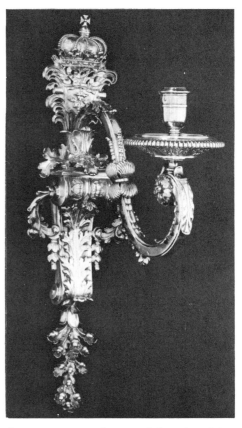

Girandole, one of a pair, with two brass candle arms; English, c. 1740. Oval looking glass in quadrant sections; carved and gilded deal frame and mask of Apollo on sunburst. Height 29½ inches. *Ex coll.* Solomon R. Guggenheim. *Palace, upper middle room.*

Silver sconce, one of a set of four, by Philip Rolles, London, 1700. In the form of a truss enriched with chased leaves and acorns and topped by a crown; the single branch is engraved with the crown cipher of William III. Height 15 inches. *Palace, northeast and southeast bedrooms.*

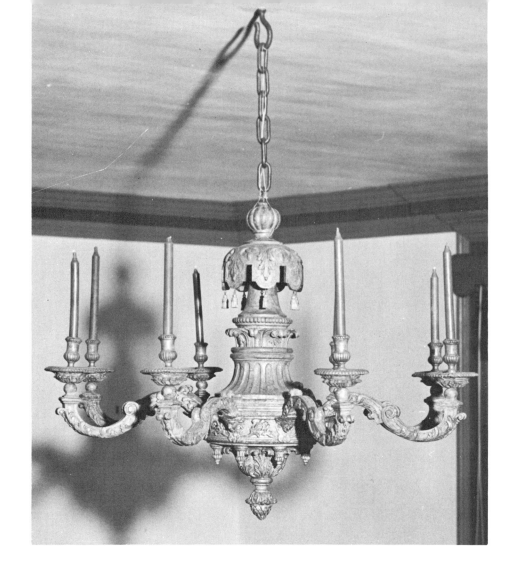

Rare William and Mary chandelier of wood, richly carved and gilded; English, c. 1700. The fluted stem has female masks at the bases of the S-curved branches and carved pendants, and is crowned by a carved lambrequin. Height 27 inches. *Palace, governor's office.*

Silver chandelier (English, c. 1710); ten scrolled branches and gadrooned baluster shaft. A rare and handsome thing. *Palace, little dining room.*

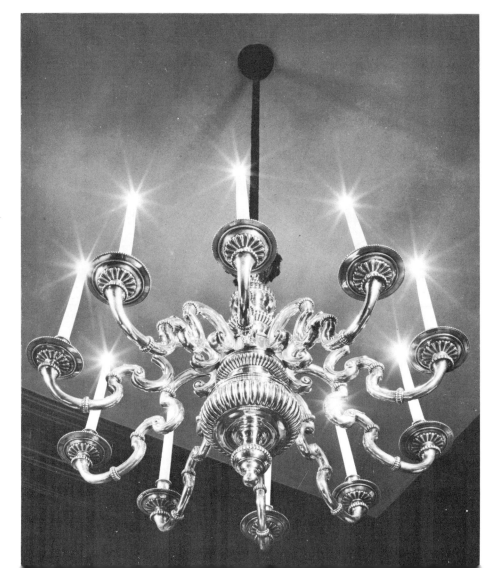

94

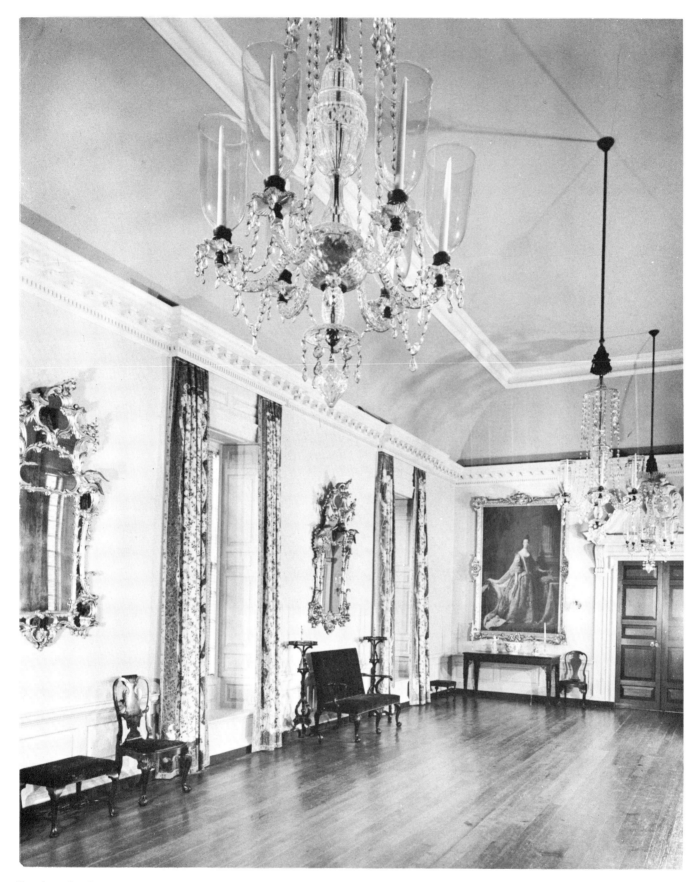

Cut-glass chandeliers of English or Irish origin, augmented by candles in wall sconces and in candlesticks on tables and *torchères*, provided the most brilliant illumination known to eighteenth-century interiors. Here they are reflected in gilt mirrors and shed their light on fine English furniture, paintings, and fabrics. *Palace, ballroom.*

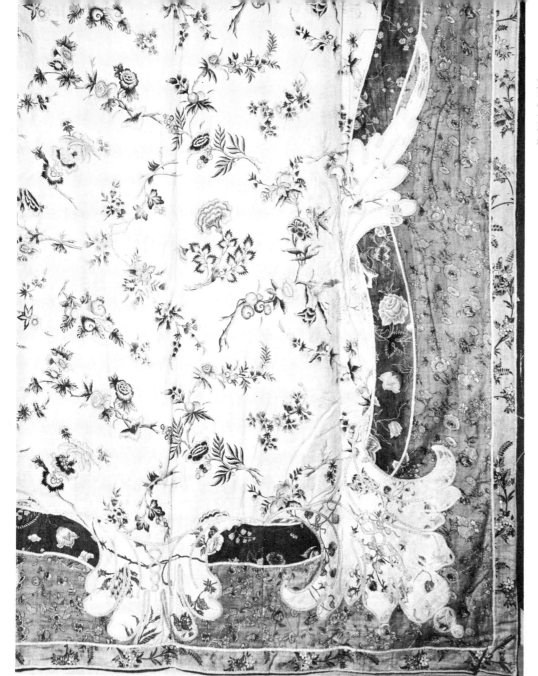

One of the great textile rarities at Williamsburg: India cotton finely painted in polychrome on white ground; appliqué borders printed in black on blue and red grounds, edged with light blue braid. Summer curtains, six matching pairs (detail). *Palace, ballroom.*

The textiles

TEXTILES, WHICH ADD SO MUCH warmth and color—that is to say, so much life—to a room, have come down from earlier periods in much smaller quantities than other furnishings, and those that have survived deserve to be carefully preserved as the valuable documents they are. The antique textiles at Williamsburg represent the chief types known to eighteenth-century American homes, and they are used here just as they might have been used originally, as indicated by engravings and design books of the period.

Most of them came from abroad, chiefly from France and England. The materials made of silk, or of silk reinforced with linen, that are used at Williamsburg include taffeta and velvet and stuffs with woven pattern like lampas, brocatelle, and damask; the last is perhaps the most characteristic silk fabric of the period. Chairs were also covered in haircloth (the 1770 inventory of the Palace furnishings lists "chairs hair bottoms") and with leather.

A woolen fabric popular for upholstery and curtains was moreen, a watered (moiré) stuff which was less expensive than damask and extremely durable. Moreen in a glowing red is used in the parlor of the Brush-Everard House.

Wool, cotton, and flax were spun and woven into cloth on Virginia plantations and it is safe to assume that at least some part of the materials used for window hangings, bed "furniture," and upholstery was home-made. But the printing of cotton and linen in this country before the Revolution was limited to small-patterned dress goods, and most of the printed materials used in furnishings must have been imported. The beautiful printed cottons of India had been coming into England since the seventeenth century and the importation of "India chints" into the Colonies is recorded as early as 1712; the summer curtains of the Palace ballroom are an exceptionally fine example. Textile printing was banned in England in 1721 but was later permitted to develop in competition with the thriving French industry. In 1758 Franklin wrote home from France about the textiles "printed curiously from copper plates, a new invention," which were replacing the old block-printed

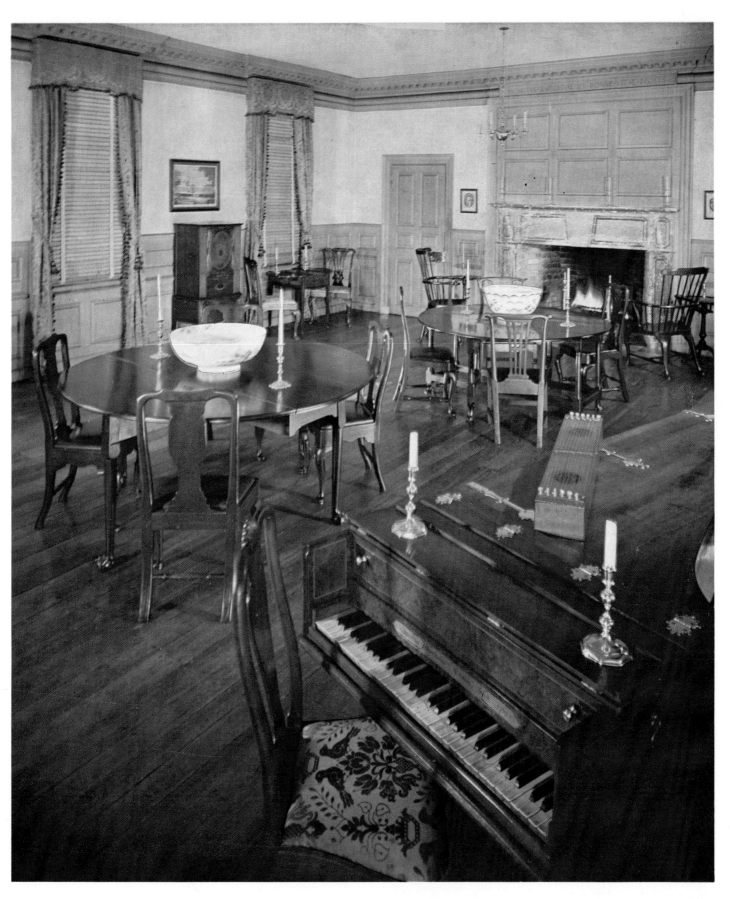

THE APOLLO ROOM, RALEIGH TAVERN, WILLIAMSBURG

(See page 60 for reference to Williamsburg color plates)

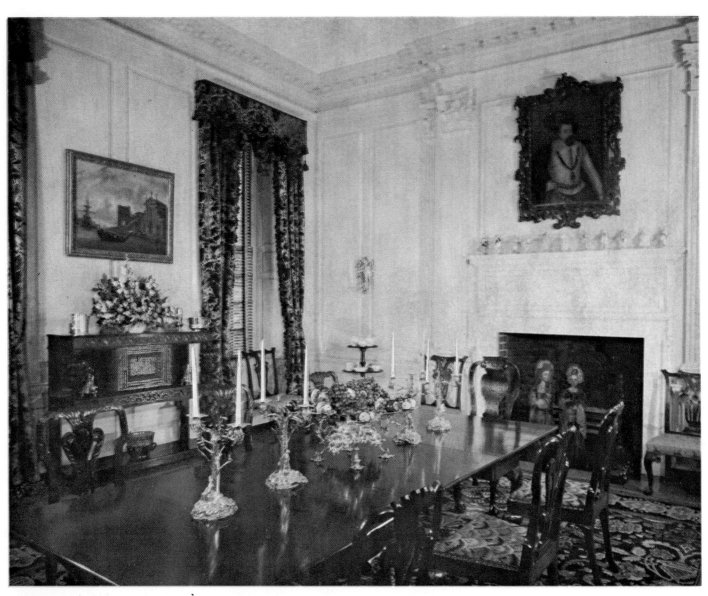

THE DINING ROOM, GOVERNOR'S PALACE, WILLIAMSBURG

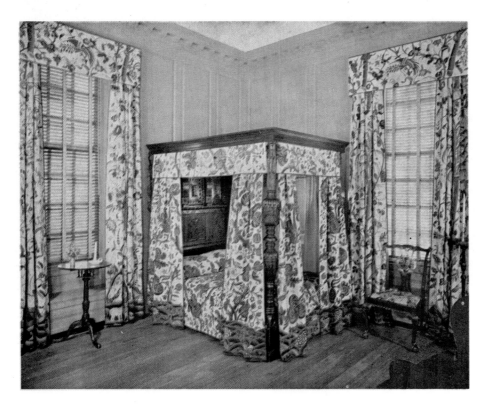

THE SOUTHEAST BEDROOM,

GOVERNOR'S PALACE, WILLIAMSBURG

(See page 60)

Green silk moiré striped with red and gold (1700's),
in a contemporary window treatment.
Brush-Everard House, dining room.

A rather heavy striped cotton fabric, simply draped in a fashion
that was new in the late 1700's; dark red lined with white.
Wythe House, back dining room.

fabric, and the "blew plate cotton furniture" that Washington received in 1759 was undoubtedly one of them.

Countless hours of unstinted labor went to embellish curtains, bed furniture, chair seats, and other useful or decorative objects with needlework. The sprawling naturalistic motifs of the Indian prints were copied on a linen (sometimes cotton) ground in crewel wools—the "Bunches of cruels" mentioned in one of the Palace inventories. Beds in the Palace and elsewhere that are hung with crewel-embroidered curtains and valances give an idea of the large repertory of stitches and designs used in this type of work. In Turkey work, rarely found today, strands of wool were pulled through a canvas foundation and tied in knots, and the trailing ends were sheared to make a pile simulating that of Eastern carpets. Kensington or tent stitch and cross stitch worked in wools on canvas made durable upholstery for chairs, benches, and stools; a letter of 1768 mentions a "worked fire screen" in the Palace. Hungarian stitch, or flame stitch as it is graphically called, was also worked on canvas with wools in such a way as to make zigzag bands of contrasting colors. In finer threads, such stitches were used to embroider pictures in which human and animal figures and landscapes were fashioned with painstaking angularity. Embroidery in silk floss and sometimes with gold or silver threads, on linen or silk, carried out the most ambitious designs.

Floor coverings, like other textiles, were usually imported. The richly colorful "Turkey carpets" which had begun coming into Europe from the Near East in the sixteenth century were highly prized, and the rugs to be seen on the floors of the Williamsburg buildings show what might have been imported not only by the governor for his Palace but by well-to-do colonists for the best rooms of their homes. Actually these so-called Ushaks, Kubas, Agras, and other types came not only from Turkey but also from the Caucasus and India. By about 1760 English carpets from the factories of Wilton and Axminster were also available, and large needlework or "tapestry" rugs were sometimes used. For bedrooms, perhaps, and for ordinary homes, home-woven rugs served the purpose—or the floors went bare.

French blue and white resist-dyed linen in a rich naturalistic design borrowed from the East, on an extraordinary American low-post bed of about 1760. *Brush-Everard House, southwest bedchamber.*

White muslin hangings and all-white quilted bedspread on a tent bed of the late 1700's. Tape loom on table. *Wythe House, southwest bedroom.*

Crewelwork bed and window curtains in brilliant colors on natural cotton and linen ground; English, late 1600's. A luxuriant version of the tree-of-life design which, originated in China, developed as a form of chinoiserie in England in the 1500's and remained popular for two centuries. *Palace, southeast bedchamber.*

Red-printed cotton (probably French, c. 1765), on an American Chippendale wing chair. *Wythe House, northeast bedroom.*

98

Crewelwork bed furniture in a free, open pattern typical of American eighteenth-century work. Bedcover of quilted glazed wool. Ushak rug. *Brush-Everard House, northeast bedchamber.*

Crewelwork bed hangings of white linen embroidered in tan and cream with accents of rose, blue, and black; New England, mid-eighteenth century. The hangings are on a press bed (a press bed was listed in the Raleigh Tavern inventory, 1770). The glazed-wool quilt (c. 1760) is light yellow. *Raleigh Tavern, bedroom 2.*

"Turkey work," the original upholstery of this Cromwellian chair (English, c. 1660). *Palace, east advance building, governor's office.*

Silk petit-point needlework in remarkably fine condition is the original upholstery of an English Queen Anne walnut wing chair, c. 1715. The conventionalized Oriental garden scene with human figures, beasts, and birds is in brilliant colors. *Palace, governor's bedchamber.*

Armorial embroidery in silks
and chenille with beads and
mica, on silk taffeta, makes
an elegant covering for bel-
lows (first half of the 1700's).
Brush-Everard House, parlor.

Needlework picture (English, late 1600's), worked
in wool threads, silk chenille, and metallic purl on
linen canvas. *Brush-Everard House, parlor.*

Original needlework panel in Chippendale fire
screen; fine tent stitch or petit point in a pastoral
design. *Palace, governor's bedchamber.*

Embroidered hatchment, or memorial coat of arms,
worked in silk and metal threads on black silk satin
ground (mid-1700's). The arms are of a branch of
the Porter family. *Brush-Everard House, library.*

100

The paintings and prints

PAINTINGS AND PRINTS take their place so naturally in the decorative scheme at Williamsburg that their quality is sometimes overlooked. From the *Queen Elizabeth* by the elder Marcus Gheerhardt, and the works of such British portraitists as Lely, Kneller, and Allan Ramsay, to the great full-length of George Washington by Charles Willson Peale, the selection of portraits brings together a distinguished group of historical subjects, both English and American.

But it would have been a mistake to overemphasize portraiture at Williamsburg. The taste of the time becomes vivid for us in the charming conversation pieces of Arthur Devis and Charles Philips. The aspect of towns and dwellings in the eighteenth century is seen in the work of Samuel Scott and Thomas Sandby. A painting of a chaise match represents the well-known sporting painter James Seymour. Flemish flower paintings, which were extremely popular in England in the early 1700's, add grace and color to the Queen Anne and early Georgian interiors. American paintings record the stirring events of the Revolution.

Prints in the form of portraits, town views, and maps were widely circulated in the eighteenth century and hung in colonial interiors. Town views by Thomas and Carington Bowles, maps published by Thomas Jeffreys, and A. Drury, sporting prints after John Wootton, George Stubbs, and John Sartorius, and the other prints which have been hung in the exhibition buildings at Williamsburg are such as would have been well known to its colonial residents.

Sir Walter Raleigh.
By Marcus Gheerhardt the younger
(c. 1561-1635).
Raleigh was always
magnificently dressed
in his portraits.
Capitol, conference room.

Queen Elizabeth. By Marcus Gheerhardt the elder (c. 1516-1604). Painted about 1585. Formerly owned by the Earl of Effingham. *Capitol, secretary's office.*

Evelyn Byrd (1707-1737), elder daughter of William Byrd of Westover; shown in blue satin dress, seated out of doors, with a cardinal in a tree at her shoulder. 50 by 40¼ inches. Though long attributed to Charles Bridges who painted in Virginia 1735-1740, this lovely portrait may have been done in England by an artist as yet unidentified when Evelyn Byrd was there in 1717-1726. It hung originally at Westover and remained in the family until acquired for Williamsburg. *Palace, parlor.*

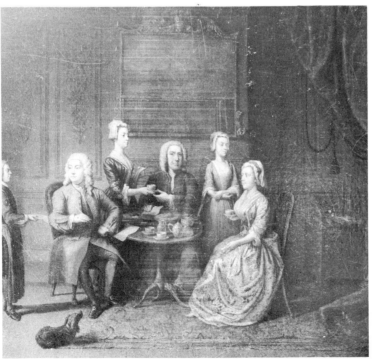

Family Group. By Gawen Hamilton (1697-1737). A family at a tea table with a porcelain tea service, about 1730. Little is known of Hamilton except that he was born in the west of Scotland and is mentioned by George Vertue. *Palace, northeast bedchamber.*

Colonel Thomas Newton, Jr. By John Durand (w. 1766-1782),
c. 1770. Newton was a member of the House of Burgesses for the County of Norfolk
and Mayor of Norfolk. *Wythe House, study.*

Portrait of a lady. By Arthur Devis (1711-1787). Dated
1748. A good example by the best-known of the Devis
family of painters of conversation pieces, it shows a lady
at her table painting water colors. The garniture on the
mantel relates this to two Devis paintings of the Bull
family of Northcourt, Isle of Wight. *Palace, southeast bed-
chamber.*

Mrs. Gavin Lawson, née Susannah Rose, married
January 1769. By John Hesselius (1728-1778). Inscribed
on back . . . *Aetat 20, J. Hesselius pinx 1770.*
Wythe House, parlor.

Gavin Lawson, merchant of Falmouth, Virginia.
Inscribed on back *Gavin Lawson, Aetat 30, J. Hesselius,
pinx 1770, Virginia, June 21st.*
Wythe House, dining room.

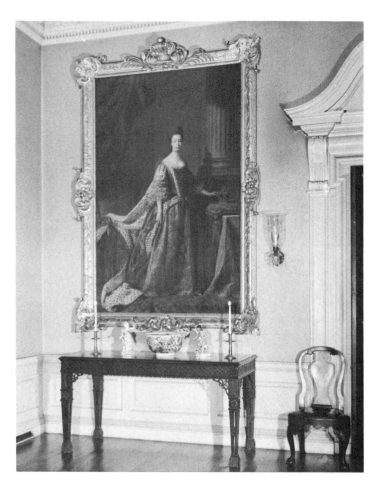

Queen Charlotte. By Allan Ramsay (1713-1784).
Companion to a portrait of George III.
Ramsay became painter-in-ordinary to George III in 1767.
Palace, ballroom.

Portrait of William Randolph of Chitower, son of Thomas Mann Randolph; c. 1773. By Matthew Pratt (1734-1805). Pratt held an exhibition at the King's Arms Tavern in Williamsburg in 1773, in which year he advertised several times in the *Virginia Gazette.* He also executed a portrait of Mrs. William Byrd III of Westover. The subject of the portrait illustrated was the brother of the junior Thomas Mann Randolph, who married Martha Jefferson. In William Sawitzky's *Matthew Pratt* the painting is erroneously identified as of William Randolph of Chellowe. Chellowe belonged to the Bolling family. *Brush-Everard House, parlor.*

George Washington. By Charles Willson Peale (1741-1827). Painted in Philadelphia about 1780, this hung for more than a century at Shirley in the possession of the Carter family. *The Capitol, clerk's office, House of Burgesses.*

Jacob Fox of Port Royal, Virginia.
By William Williams (c. 1710-c. 1790).
Signed, lower left, *Wm. Williams Pinxt. 1774.*

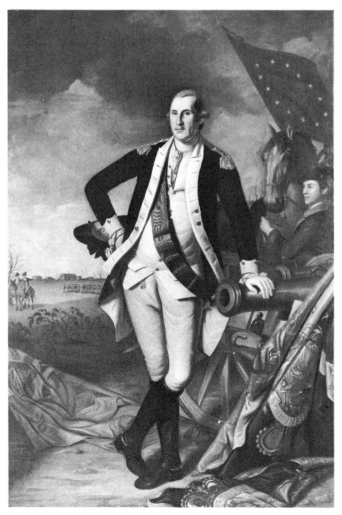

Charleston, S.C., water color on paper (detail). By Bishop Roberts (d. 1739). The only known work by this artist, who was active as a painter and engraver in Charleston, 1735-1739. This view was engraved by W. H. Toms and published in at least two states, one dated *June 9, 1739*, the other *June 9, 1749* (see ANTIQUES, August 1947, p. 100); an example of the second state is at Williamsburg. Size of complete painting, 15 by 43⅝ inches.

The Holbein Gate. By Samuel Scott (w. 1725-1772) and Thomas Sandby (1721-1798). A London street scene, about 1750. At the right is the Banqueting House, Whitehall. *The Palace, east advance building, governor's office.*

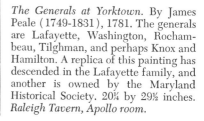

The Generals at Yorktown. By James Peale (1749-1831), 1781. The generals are Lafayette, Washington, Rochambeau, Tilghman, and perhaps Knox and Hamilton. A replica of this painting has descended in the Lafayette family, and another is owned by the Maryland Historical Society. 20¼ by 29½ inches. *Raleigh Tavern, Apollo room.*

Sir Peter Parker's Attack against Fort Moultrie, June 28, 1776. By James Peale (1749-1831), 1782. This and *The Generals at Yorktown* were painted for Francis Bailey of Philadelphia, official printer to the Continental Congress and the Commonwealth of Pennsylvania and, after 1781, editor of *The Freeman's Journal or North American Intelligencer* (see ANTIQUES, December 1954, p. 492). 20¼ by 29⅝ inches.

The South Prospect of the City of New York, in North America. Engraved for the *London Magazine*, 1761; a re-engraving of the Burgis view of 1716-1718. *Palace, east advance building, secretary's office.*

April. One of the special treasures of the Williamsburg collection of prints is Robert Furber's *Twelve Months of Flowers,* published in London in 1730 as an unusually ambitious seedsman's catalogue after original paintings by Pieter Casteels. The keyed plates identify plants "colored to the life." Complete sets are rare, so that the twelve prints that hang along the stair at the Wythe house always attract the eye of the print collector as well as of those who enjoy them solely as superlative decorations.

*The Three Cherokees, came over from the head of the River Savanna to London, 1762...*Line engraving, English. An account of the trip made by these Indians to visit the king is given in the *Memoirs* (1765) of Lieutenant Henry Timberlake who accompanied them to England. 9⅞ by 11¾ inches.

A map of the Province of New York with part of Pennsylvania and New England. Surveyed by John Montresor; published by A. Drury, London, 1775. Line engraving with provincial boundaries and coast lines accented in color, mounted on canvas with original wooden rollers. Length 57 inches. *Brush-Everard House, library.*

Old Sturbridge Village in Sturbridge, Massachusetts

"OLD STURBRIDGE VILLAGE, in Sturbridge, Massachusetts, is a regional museum of rural New England life. Its purposes are historical and educational: to preserve and present the story of New England farm and village life of yesterday, and to impart a knowledge and understanding of that heritage to the citizens of today."

This statement of purpose, quoted from a recent annual report issued by the trustees of Old Sturbridge Village, sums up the ideas and activities of the many different people who, over the last several decades, have had the exciting experience of creating and helping to shape the development of a new institution.

The story of the Village begins in the 1920's with two brothers, Albert B. Wells and J. Cheney Wells, members of a family prominent and active in this vicinity for several generations. As has happened to many individuals before and since, the Wells brothers were smitten—and it usually occurs suddenly and totally—with the collecting urge. Family stories linger from the 1920's and 1930's recounting the adventures and fun the brothers enjoyed as they collected tables, chairs, mirrors, chests, clocks, lighting devices, woodenware, guns, tinware, pottery, glass, china, paperweights, latches, hinges, saws, axes, pewter, copper, brass, and the almost infinite variety of objects found in the homes, barns, sheds, shops, and mills of early America.

As the collections grew in size and scope, so gradually their fame spread. It became apparent to the brothers that their private treasures were of great public interest and importance. From this realization came the decision to establish a museum of some kind. It was but a step to the idea of exhibiting the collections, not in the glass cases of the typical city museum but in a natural setting that would suggest the original locations of the objects and their uses. Thus emerged the concept of a re-created village to be formed by bringing together houses, shops, mills, a store, a tavern, a meeting house, and other characteristic structures. The present Village site was acquired. Through it flows the Quinebaug River to form the ponds for the saw and grist mills. Upon this two-hundred-acre tract of farm land was laid out a typical village plan with its common, roads, and paths, and to it were brought the thirty buildings found here today.

Thus Old Sturbridge Village is not a restoration of an actual historical place, but the re-creation of a representative New England community of the period 1790-1840.

In this first half-century of national independence and experimentation in self-government, agriculture was still the chief occupation of New Englanders. The coastal towns and cities were busy with trade and commerce, and the beginnings of large-scale industry were just appearing in certain strategic water-power spots along the larger rivers, but these towns were few in number and small in total population compared to the farm and village areas.

Throughout New England, back from the coast, up the river valleys, and in the western parts of the states, there flourished hundreds of small communities, each with its outlying farms, the central cluster of houses, shops, mills, taverns, and meeting houses, exercising and refining the New England talent and drive for self-government in town and church affairs. Free public education, humanitarian and reform movements, a passion for work and the insistent spur of the famous New England conscience, a Puritan heritage, are other parts of the civilization developed and cherished in these rural areas and carried by their inhabitants wherever they went—to Ohio, Illinois, Kansas, or California.

Old Sturbridge Village represents just such a New England village in the heyday of its agricultural prosperity, still largely self-sufficient, relying on its local craftsmen and domestic industry for its main requirements, trading occasionally at the store for the few needs and luxuries that could not be obtained by local endeavor, and living close to the soil.

In addition to the Village, in a sense the largest exhibit of this museum of early New England life, Old Sturbridge possesses collections which are shown separately. These clocks, firearms, textiles, tools, ceramics, art, iron- and woodenware, glass, and certain other objects are displayed in more formal and more extensive fashion than they can be in the natural setting of the buildings of a community.

Early in the development of what was to become Old Sturbridge Village, a charter was sought from and granted by the Commonwealth of Massachusetts establishing a non-profit educational and charitable corporation. To this organization and to its board of trustees the two founding brothers gave their collections, the buildings, and the site. The Village is now managed by a professional museum staff appointed by the trustees. Financial support of its operations comes entirely from admission fees, sales, royalties, endowment income, and gifts. The Village receives no public funds. All revenues are used for the support of the Village and its educational program with no part accruing to any private benefit.

The Village was first opened to the public in 1946. Attendance has grown steadily. In 1958 close to two hundred thousand visitors, including twenty thousand children in school classes, entered its buildings, enjoyed its setting, and took away, we hope, some understanding of how New Englanders lived, worked, played, and worshiped a century and a half ago.

FRANK O. SPINNEY, *Director*

The Village Green in late October, showing the Meeting House, Fenno House, and Fitch House.

The buildings

BY ABBOTT L. CUMMINGS

Assistant Director, Society for the
Preservation of New England Antiquities

THE STORY OF ARCHITECTURE in early New England has tended to play up those few towns and cities along the coast which were focal centers of culture and points of dissemination for style. Yet they represented but a fraction of the total population and land area. The majority of people were scattered through what European travelers liked to call "the interior parts" of America, on farms and in farming villages. The character of these American villages forced itself upon the attention of more than one foreign visitor as different from that of the crowded towns of Europe. The Marquis de Chastellux, for example, observed in 1780 that "what is called in America, a *town* or *township,* is only a certain number of houses, dispersed over a great space, but which belong to the same incorporation . . . The centre or headquarters of these towns is the meeting-house or church. This church stands sometimes single, and is sometimes surrounded by four or five houses only . . ."

Such a description sounds as strange to us today as it must have then to its readers in Europe, for this type of early American settlement has pretty much disappeared. Very few villages have not grown up into good-sized towns, or suburban communities, or even cities, in the course of America's change from an agricultural to an industrial economy. Another traveler from Europe, Brissot de Warville, noted in 1788, at a time when the young nation stood upon the very threshold of its industrial revolution, that almost all the houses he saw in Massachusetts and Connecticut were inhabited by men "who are both cultivators and artisans; one is a tanner, another a shoemaker, another sells goods; but all are farmers."

The early New England village was a community of farms, and the story of village architecture is largely a story of farmhouses. So many of these simple dwellings have been engulfed by towns and suburbs growing up around them, so many have been spruced up and urbanized, invested with modern kitchens and bathrooms, stripped of all land but a mere front yard and all outbuildings except a small shed now utilized as a garage, that we scarcely know what a real farmhouse is like.

To realize both the farmhouse and the farming community as they once existed Old Sturbridge Village has re-created such a settlement, bringing together eighteenth- and early nineteenth-century buildings from a variety of places and arranging them in the pattern of an early nineteenth-century town. The legitimacy of such an artificial undertaking is plain when one realizes that the various dwellings and buildings of early New England

108

Solomon Richardson house
from North Brookfield, Massachusetts,
mid-eighteenth century.

Stephen Fitch house
from Windham, Connecticut,
early eighteenth century.

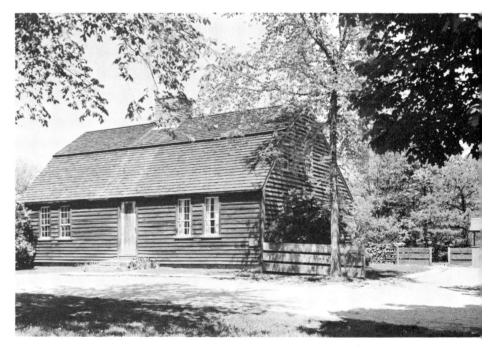

Pliny Freeman farmhouse
from Sturbridge, Massachusetts
(1801), with its outbuildings
and fencing.

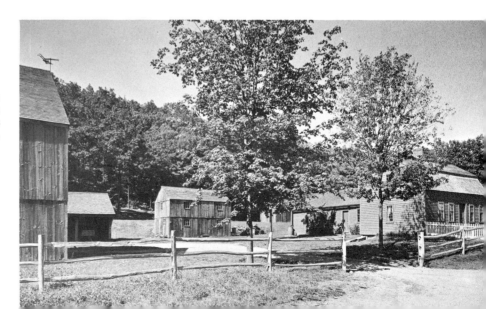

farming communities were, in a sense, "interchangeable parts." Barring some regional variations, a farmhouse with its barns and sheds in one community, and the layout of a whole village in one county, could be duplicated a dozen times in the next, or the next after that. Old Sturbridge Village has worked within a wide margin of safety in this respect, gathering material from towns so nearby that there could be no possible question of regional incongruity. At least two of the most important buildings have come from the township of Sturbridge itself (outside the Village site). Others were found in the neighboring towns of Worcester, Charlton, Bolton, Brookfield, and Stafford Springs, Connecticut, while three come from the somewhat more distant communities of Canton, Massachusetts; Willimantic, Connecticut; and Portsmouth, New Hampshire. Of all these buildings perhaps only the last, the urban Langdon house, is not completely in keeping with the rural character of the Village, but this house

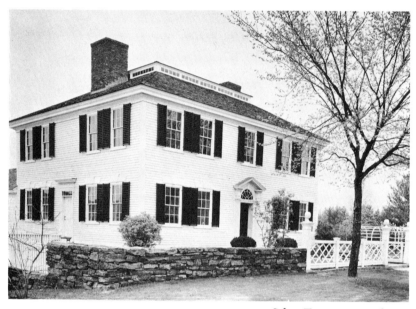

Salem Towne mansion house
from Charlton, Massachusetts, 1796.

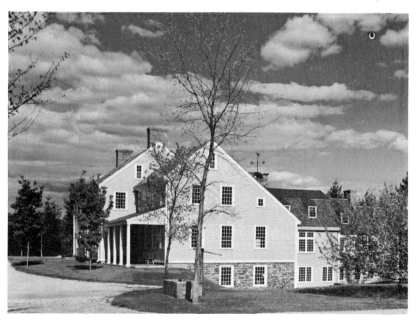

Tavern on the green (a composite
of old and new elements).

has been wisely kept in the background and is now used for administration offices.

Together these buildings tell the story of the farming community, whose homes and shops seldom showed much deviation from an accepted architectural norm. They reflected common sources of inspiration and a relatively common social and economic level. The usual house plan, inherited from the seventeenth century, was that of two rooms around a large central chimney, usually two and a half stories high, with or without the addition of a lean-to. The proportions could be somewhat restricted and the finish utterly sparse as in the Fenno house, or there could be generous proportions and niceties of finish as in the Richardson house, generally reflecting nothing more than the individual owner's tastes and the value put upon his energies. A "poor" house, one with a minimum of finish details, might not reflect a poor farmer so much as one with a crabbed spirit.

There was of course one exception: the village "squire," who in every small community in early New England represented the forward look—the man who by dint of exceptional effort and unusual abilities pulled out ahead of his neighbors materially and socially. His house was never lavish, but it was nevertheless the local "mansion house," reflecting the forward look in style and finish and in appointments which seldom found their way into the simpler farmhouses. Instead of the traditional cluster of rooms around a single functional chimney the squire's house was likely to imitate the more spacious and up-to-date plan of the urban mansions. Whereas a single room in the farmhouse would be set apart as a parlor and reserved for the "best" furniture, the squire's mansion would have several finely finished rooms of academic proportions and detail, opening off a wide central hall with formal staircase. There would be a front and back parlor as well as sitting room and kitchen, and large airy chambers on the second floor. And while the farmhouses were built with traditional building lore, often by the farmer himself with the help of neighbors, the squire's house would very likely draw upon carefully scaled designs from European and, later, American builders' handbooks. These in turn would be interpreted with the professional help of joiners and a master-builder.

The squire loomed large in the community, and his house often overlooked the village green in a way that drew attention to its owner's importance. The Salem Towne house from Charlton which has recently been added to Old Sturbridge Village is a superb, unspoiled example of the late eighteenth-century squire's mansion. It occupies just the position on its new site that such a house should, matched at the other end of the green by the two meeting houses which with their slightly higher elevation symbolize the real focal point of the early New England village. Until well into the nineteenth century the New England meeting house remained primarily just that, even after such churchly trappings as spires and formal porticoes had been added to the exterior. The Baptist meeting house from Sturbridge, a small Greek Revival building of 1832, with its reasoned orders and serene balance between horizontal and vertical lines, very well represents this continuing mood. The Friends', on the other hand, is an eighteenth-century meeting-house in the strictest sense: one almost needs to be told that it is not just a large dwelling.

These two buildings, in addition to their differences in

110

style, point up at least one other contrast between the eighteenth and nineteenth centuries in their color. The Baptist meeting house is quite appropriately painted white, which became an almost uniform finish in the early nineteenth century for all buildings—"so white that it makes one wink to look at them," commented Charles Dickens of the dwellings and meeting houses he saw just outside Boston in 1842. But this had not always been the case. A Captain Daniel Willard of Newington, Connecticut, whose memory extended back to the time of the Revolution, wrote of his boyhood that he could not remember a single white house in the town, and only one house was of "a greenish color, a few Spanish brown [red], all the others of natural wood color." The painted buildings in these farming communities before the nineteenth century got well under way showed a love of rich and even variegated color. One of the popular combinations was gray with white trim, as on the Friends' meeting house; another was Indian red or Spanish brown, which is seen, with white trim, on the Richardson house.

Of the remaining buildings around the green and in outlying parts of the Village, some, like the unpretentious blacksmith's shop, were standard fixtures in the farming community, while others, like the Isaiah Thomas printing office from Worcester, would have been exceptional in the average village. But the tavern was an absolute necessity and usually the most complex building in the town. Starting out often as a dwelling-turned-tavern, and thus likely to be a simple lean-to house at the core, it would have ells and extensions added, and the façade lengthened perhaps along the village street, until through a process of adaptation a comfortable, roomy, and convivial "house" was evolved. Usually there was a ballroom for the more festive community gatherings, which might serve also as meeting place for fraternal organizations. Such a room was set apart in the home of Salem Towne for Masonic meetings—further evidence of the squire's leadership in the community.

Old Sturbridge Village has assumed proportions sufficient to give a correct architectural impression of the early nineteenth-century farming community. It is not as yet complete, and a certain excitement can be felt by staff and public alike in the gradual evolution of plans and details which will bring the picture into sharper focus. There is still to be added a schoolhouse, for example, and more fencing is needed, especially in the area around the common. Outbuildings, wells and pumps, horse sheds and stables, watering troughs, hay scales and liberty pole, horse blocks, and guide- and mileposts will be set up as opportunity permits.

There was no rigidly prescribed arrangement for the average farming community, despite the orderly way in which lots were laid out and apportioned. The township grew about its meeting house and tavern, making convenient use of the land. The straight "highways" designed on paper in so many New England communities when lots were laid out were seldom followed closely in practice, and one senses that expediency often governed the growth of the community plan as much as its first "plats." Old Sturbridge has used successfully a plan centering around a village common with outlying roads which not only approximates that of numberless actual villages, but which in its flexibility permits future growth in just the practical way that has governed the growth of all New England villages.

Moses Wilder blacksmith shop from Bolton, Massachusetts, about 1810.

Isaiah Thomas' printing office from Worcester, Massachusetts, about 1784.

General store from Stafford Springs, Connecticut, about 1790.

111

The interiors

As IN A NEW ENGLAND VILLAGE of the early nineteenth century might have been found a variety of homes, some surviving from a considerably earlier period and others more recently constructed, so at Old Sturbridge Village the houses range in date from the beginning 1700's to a century later. And just as in any house occupied over a period of years by successive generations with different ideas of convenience and comfort, and with a responsive interest in changing fashions of use and decoration, so the different residential structures of this re-created community reflect the accumulations of style, the impulse toward modernization, and the acceptance of varying tastes.

Throughout the Village homes, moreover, runs a major theme or premise that has guided their exhibit development—the typical or representative, not the unique or spectacular; the everyday home, not the "period" room; the house that was lived in, not one designed for display. The visitor to Old Sturbridge Village finds not so much a textbook of style as an anthology of homes with all the contradictions of good and bad, antiquated and modern, neatness and disarray one might expect in any house occupied by a busy family intent on its daily round of domestic activities.

It occasionally disconcerts the ardent antiquarian to discover a Connecticut sunflower chest tucked away inconspicuously in the sparsely furnished work room of a Village house rather than displayed proudly and prominently with all the reverence its rarity seems to deserve. In 1800, however, probably more often than not such an obsolete chest was relegated to the attic or shed chamber as something hopelessly old-fashioned but still usable.

Thus peering into the kitchens, bedrooms, parlors, and other corners of the Village houses shown in the interior scenes that follow, the visitor catches a glimpse of the homes his ancestors may have known—ashes on the hearth, loom in the attic, rooms filled with their furniture, their cooking utensils, all suggestive of the daily routine of thousands of obscure New England families a hundred and fifty years ago.　　　　　　FRANK O. SPINNEY

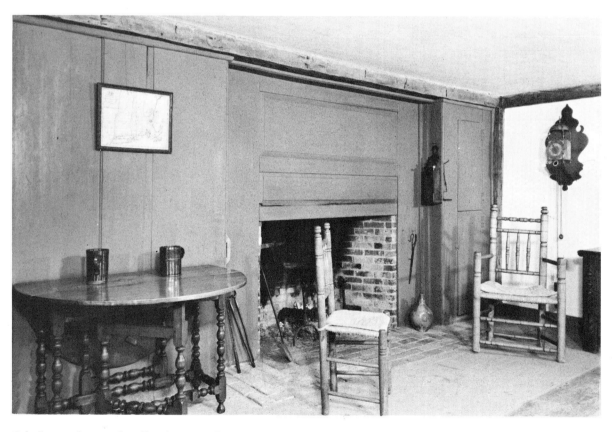

Oak Carver chairs with yellow linen squabs, or cushions, are seen against the gray-blue paneling and whitewashed walls of the parlor of the architecturally plain JOHN FENNO HOUSE. Other seventeenth- and early eighteenth-century furniture includes a gate leg table and paneled chest. To the right of the fireplace hangs an English brass lantern clock, c. 1650. A lamp, a pipe box with heart and swirl-circle motifs, and pipe tongs are convenient to the hearth.

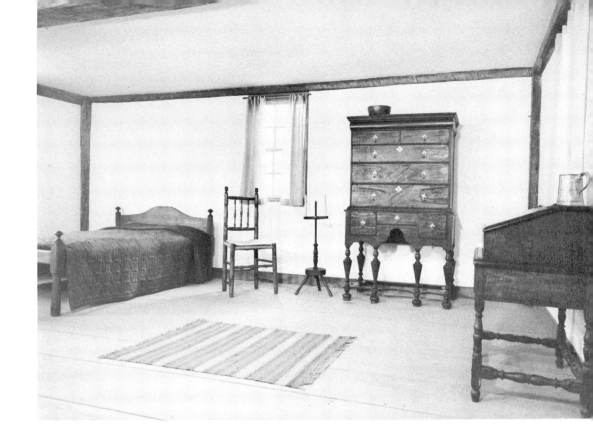

Yellow linen curtains the small windows of the combination bedroom-parlor of the FENNO HOUSE, and a nut-brown quilted coverlet of glazed wool covers the low oak bed. For storage of clothing and linen in households without closets, the high chest was most useful. This one, of the William and Mary period, is of tulip poplar, or whitewood, painted to simulate the grain of walnut. The desk-on-frame, 1700-1725, is of curly maple.

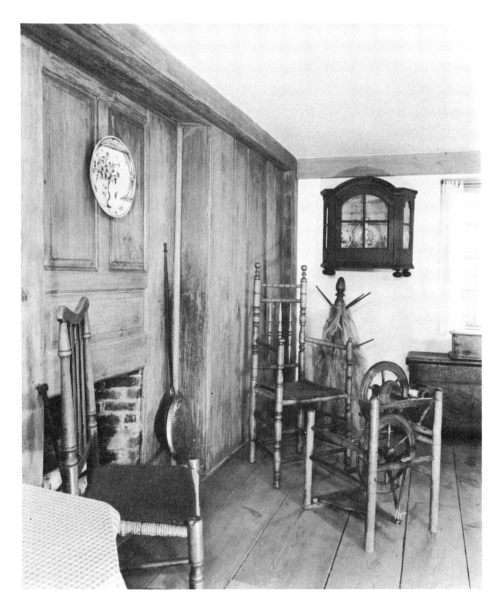

THE FENNO HOUSE (1704) is the oldest structure at Old Sturbridge Village. In this chamber the white-washed walls and ceiling, the wide, untreated floor boards, and a sparseness of furniture recall the austerity of most New England farmhouses of the time. Vertical sheathing covers one wall, with raised panels over the fireplace. The yoke-shape cresting on the banister-back chair in foreground suggests the tentative influence of the Queen Anne style on an older form. In front of the Carver chair stands an unusual spinning wheel supported in a turned frame, and beyond, the flax hangs ready. The small oak cupboard, displaying delftware, was designed either to stand on its own rounded feet or to hang from a wrought-iron strap. White linen hangs at the window; scratch decoration adorns both chest and box under it.

113

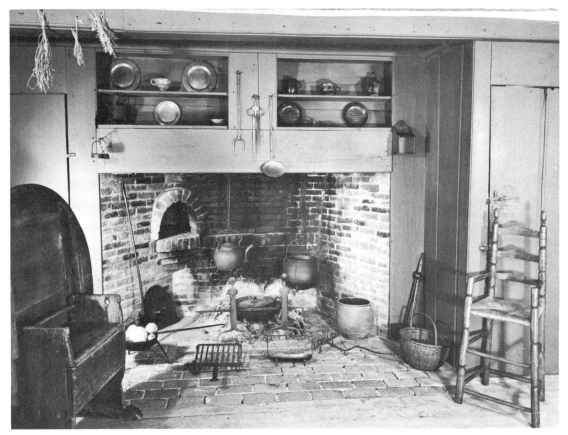

The brick fireplace of the FENNO HOUSE kitchen has a beehive oven opening into the chimney. From the iron chimney-rod iron kettles hang on trammels, and equipment on the hearth includes a gridiron or broiler, toaster, and sausage baker or roaster for small birds or fish. A bake kettle with concave cover rests in the embers. On the fireplace shelves are pewter and redware vessels, with wrought-iron utensils hanging in the center, a betty lamp at the side, and drying herbs above. The pine hutch or chair table, dating from close to 1700, was found in New Hampshire.

Built-in shelves in the FENNO HOUSE kitchen hold a useful array of redware dishes and jars, woodenware, and pewter. The ladder-back high chair is red-painted pine.

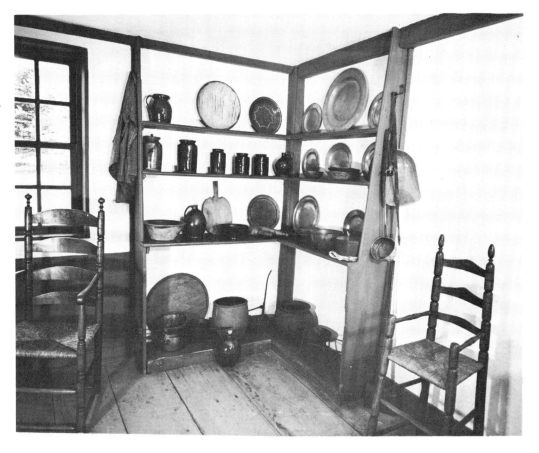

In the upper-floor weaving room of the FENNO HOUSE the itinerant weaver helped the family work up the year's needs in cloth, or rag rugs like that in process here—and seen in use in the Richardson house—were made of otherwise useless scraps. The clock reel for measuring yarn has a dial and indicator hand. Beside it an early three-panel oak chest for storage has shallow tulip carving, pine top, and single drawer. A six-board pine chest opposite is nearly hidden by the large hamper of woven splint.

The soft tones of old pewter, brass, iron, red paint, and wood combine to make the west parlor of the STEPHEN FITCH HOUSE warm and inviting. The fireplace is distinguished by a granite lintel and equipped with andirons of iron with brass finials. Isaac Blaisdell of Chester, New Hampshire, made the tall clock (c. 1760) that stands against the vertical pine sheathing; his name (here spelled "Blasdel") is on the brass dial. Beside the fireplace, two country versions of the Queen Anne chair show the retention of early features in legs and stretchers.

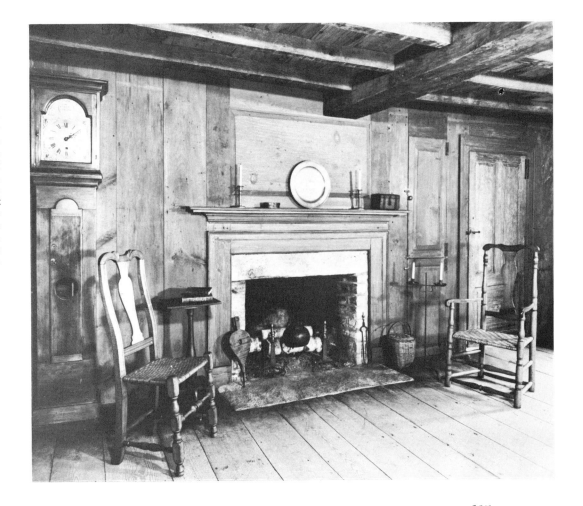

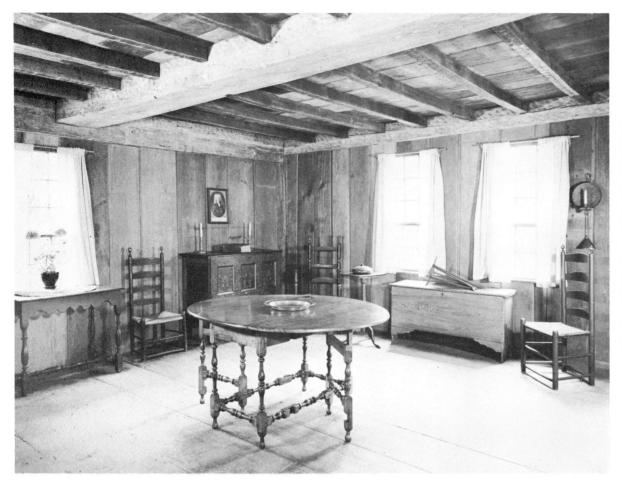

Feather-edge pine sheathing in the FITCH HOUSE east parlor makes a pleasing background for early furnishings. Interesting pattern is provided by the turned legs and stretchers of the maple gate leg, c. 1720, the scalloped apron of the table at the window, and the low relief carving in a stylized tulip-like design which covers the front of the Hadley chest. There is color in the blue six-boarded chest and the red and black ladderback chairs, with touches of gilt in the armchair. The contraption on the chest is a niddy-noddy, used to wind wool into skeins.

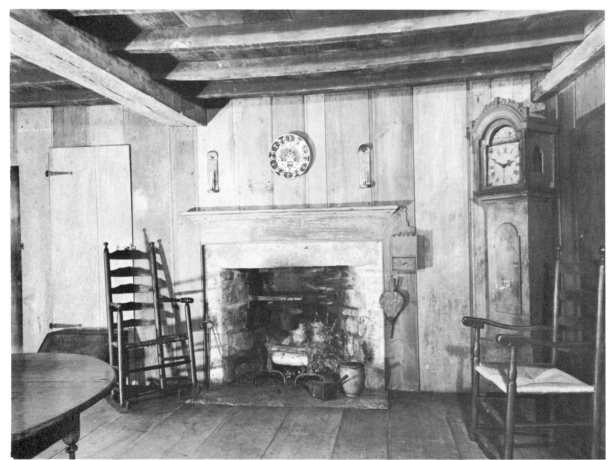

On the fireplace wall of the FITCH HOUSE east parlor hang a colorful Delft wall plate and tin candle sconces, a red-painted pipe box with scalloped edge, and painted bellows. The tall clock was made by a country craftsman about 1790. Its imported dial has been repainted with a stylized landscape, and its weights are carefully shaped and balanced field stones. Here are two versions of the ladder-back chair, one painted red and the other black, with rockers added.

116

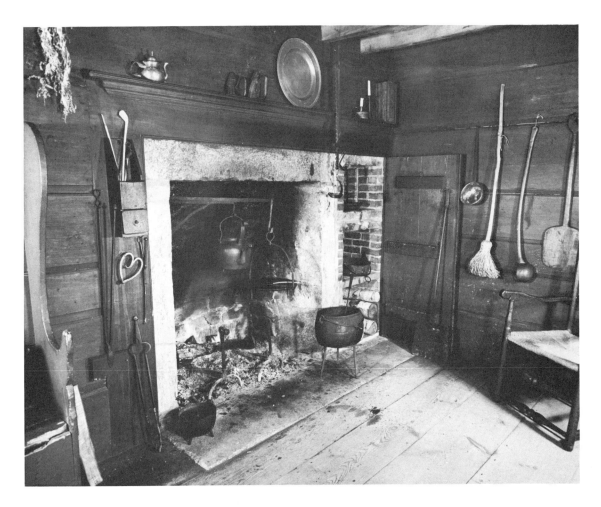

The red kitchen in the FITCH HOUSE has a granite fireplace with two openings below the oven; andirons, kettle, pots, and griddle are of the sort used in the eighteenth century. An early charger and teapot of English pewter stand beside the flatirons on the mantel, and at the left are a pine box for clay pipes, wrought-iron trivet, and tongs. A betty lamp is suspended from a wooden trammel, and against the red-stained horizontal wall boards hang tools of fireplace cookery—wooden peel, strainer, and long-handled ladle.

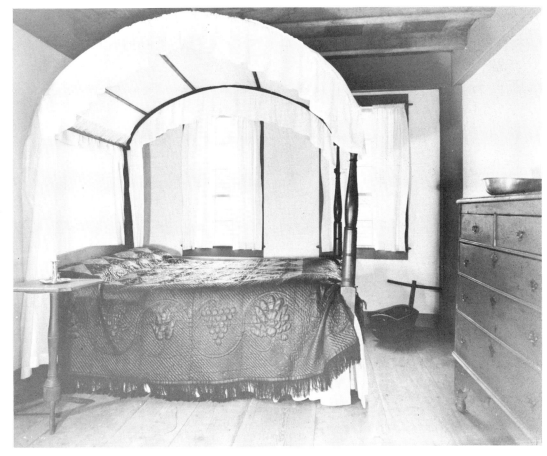

In the FITCH HOUSE bedroom, a beautifully quilted glazed-wool coverlet with patchwork center covers the curtained and canopied field bed. It was made in Northbridge, Massachusetts, about 1800. The chest is red-painted pine, as is the crude country candlestand. A doll's cradle stands at the foot of the bed.

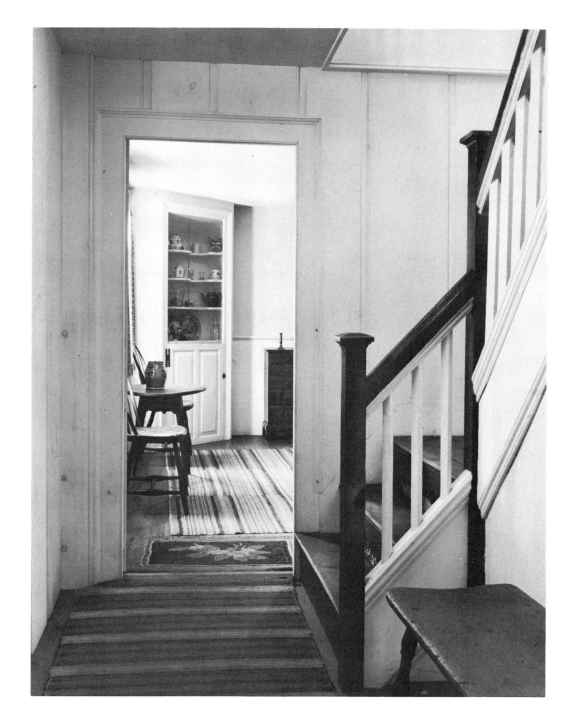

Vertical feather-edge boarding covers the walls of lower hall and stairwell in the SOLOMON RICHARDSON HOUSE, a saltbox of fine proportions dating from the 1740's. In the dining room beyond, the corner cupboard is garnished with colorful English earthenware, China-trade porcelain, and glass of the early 1800's.

Opposite page, top

The parlor of the RICHARDSON HOUSE gains distinction from its paneled wall and dado, painted blue. Resist-dyed cotton (a reproduction) covers the Sheraton easy chair. Over it hangs a portrait inscribed on the back *painted from nature by Wm. M. Prior, Feby 24, 1836, Portland, Maine.* An interesting feature of the Queen Anne maple high chest (c. 1740) is the deep cove molding of its cornice which forms a shallow drawer for papers and documents.

Opposite page, bottom

In the RICHARDSON HOUSE west chamber, the pattern of the red-printed cotton coverlet is a Shakespeare-David Garrick scene; canopy and flounce are reproduction dimity. The oval-top table with its chunky pad feet is pine, painted red; on it a painted towel rack, pewter basin, and brass candlestick await the guest. The tripod candlestand, also pine, has a square molded top.

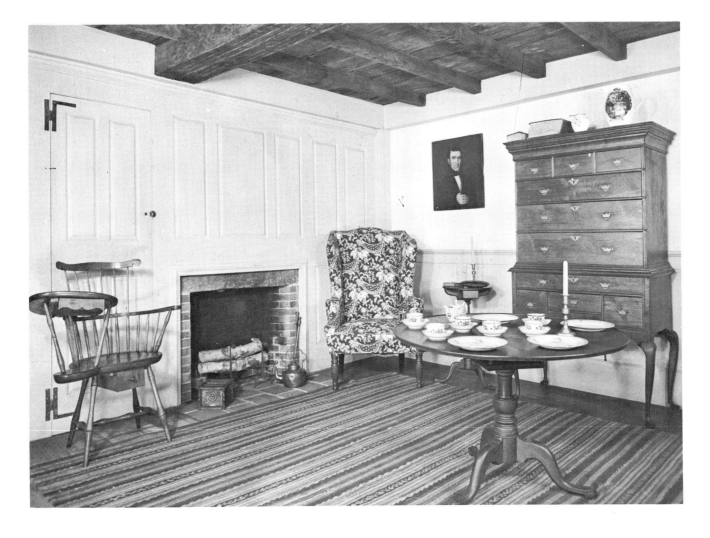

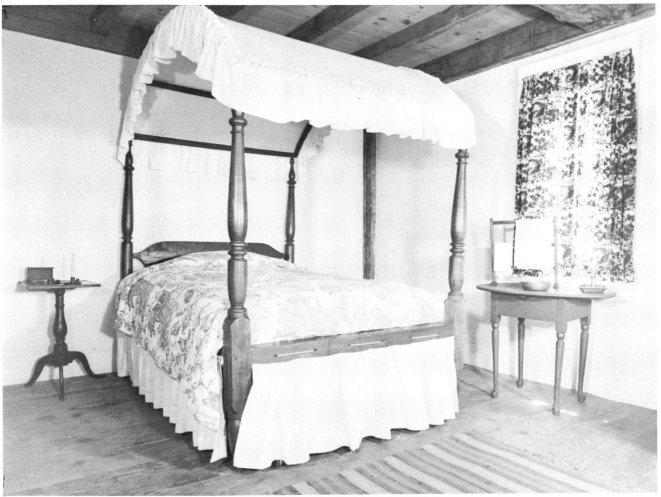

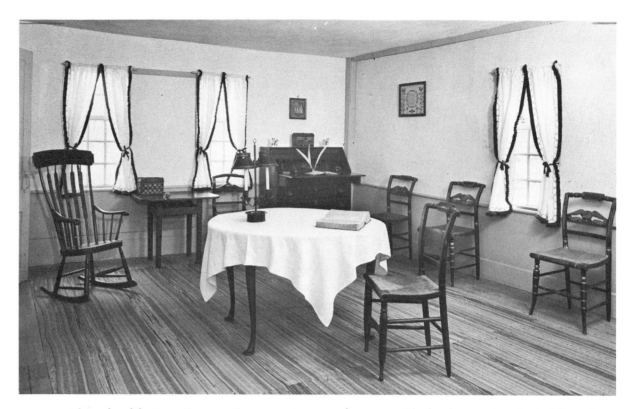

The parlor of the PLINY FREEMAN FARMHOUSE is a room of many uses. The farm's accounts are kept at the mahogany desk, and relaxation is offered by the rocker, contoured for comfort. The drop-leaf Queen Anne center table has the family Bible and a shaded tole candlestand on its diaper-patterned linen cover. The awkwardly proportioned table between the windows, painted red with imitation graining, has on it a sewing basket and pincushion holder. Gold-stenciled eagles ornament the backs of the Hitchcock-type side chairs, and the white linen curtains, copied from those in a contemporary painting, with their dark green fringe and embroidered borders, are tied back with fashionable bows.

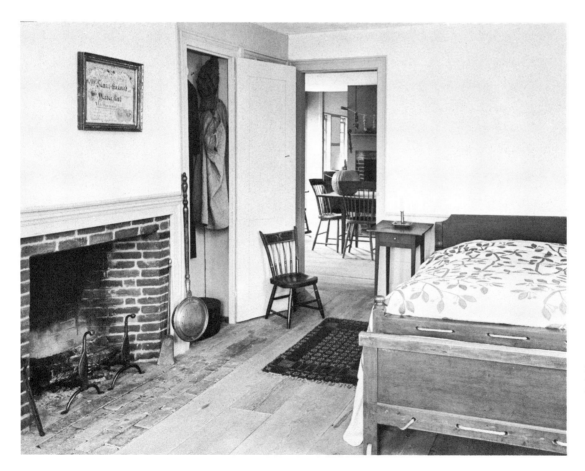

The downstairs chamber of the FREEMAN FARMHOUSE has a simple press bed and trundle bed. The cotton coverlet is appliqué and quilted. Clothing hangs in the open closet, and the hearth is ready for the fire lighted only when special guests or illness warrant such extravagance.

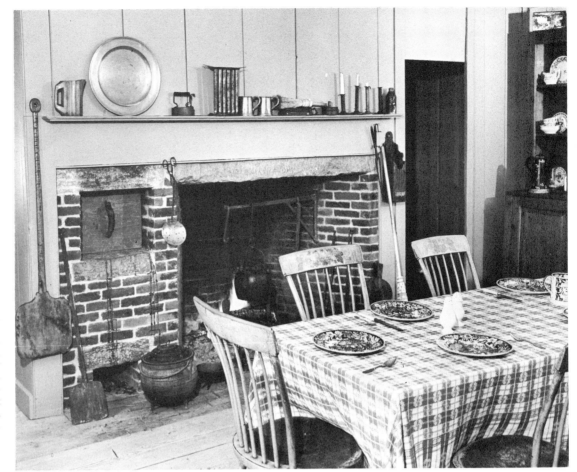

The fireplace of the FREEMAN FARM-HOUSE kitchen has a granite lintel, oven at the side. A kettle hangs from a swinging crane; a wooden peel is at the oven side, pipe box and tongs are at the other end. The long kitchen table, covered with a hand-loomed blue and white linen cloth, is partly set for noonday dinner with Stafford-shire plates, pewter spoons, and cream-ware and redware serving pieces. At the right is a cupboard filled with a treasured Staffordshire china tea set.

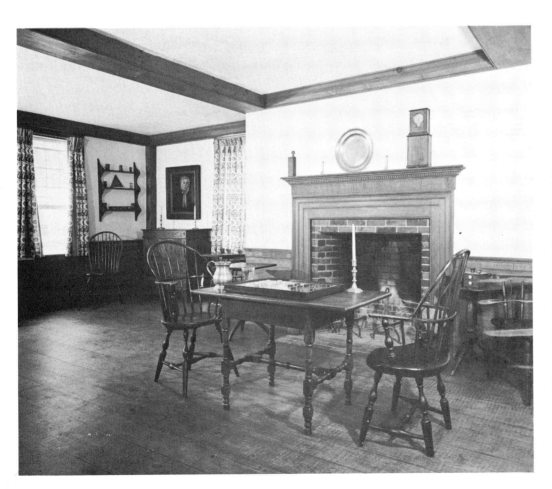

In the gentlemen's game room of the Village TAV-ERN are windsor chairs of several patterns. The pine tavern table has unusual block-and-turned legs and stretcher, and its top has a wide overhang; the cribbage board is of ivory and ebony. There are horn cups on the hanging shelves, and on the high mantel a wooden spill or taper box, and an inter-esting clock made in 1786 by apprentice Levi Hutchins as a farewell gesture and demonstration of skill to his master, Simon Willard of Roxbury, Massachusetts.

121

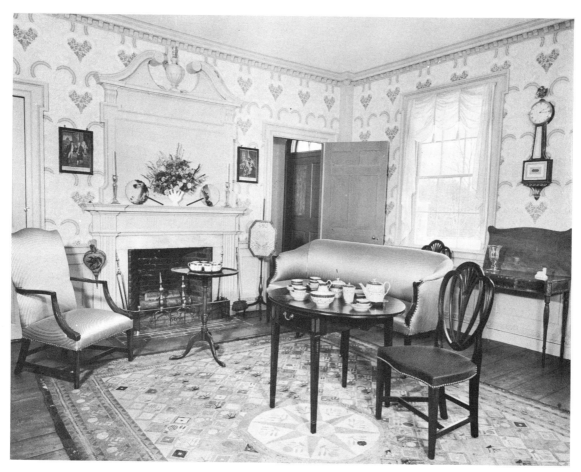

THE SALEM TOWNE HOUSE, built in 1796, has been furnished with every effort to make it look as it would have when lived in by its first owner, General Salem Towne, and his family up to about 1830. The parlor is distinguished for its well-proportioned woodwork, painted a putty color, its "neat" patterned wallpaper, and its fashionable furnishings. Sofa, "Martha Washington" armchair, and six side chairs are in Hepplewhite style, as is the tea table set with late eighteenth-century Worcester porcelain. The tent-stitch carpet is compatible with its surroundings though possibly European.

The Sheraton sideboard in the TOWNE HOUSE dining room is in the newest style, while the mahogany drop-leaf table and set of transitional side chairs are old-fashioned furniture of "best" quality that Salem Towne might have acquired at his marriage in the 1770's. Placed in the center of the table is a creamware cruet set attributed to the Leeds factory. Creamware, cut glass, silver, and Sheffield plate are on the three-tier stand. The painted floor cloth was reproduced following directions in a how-to book of the period.

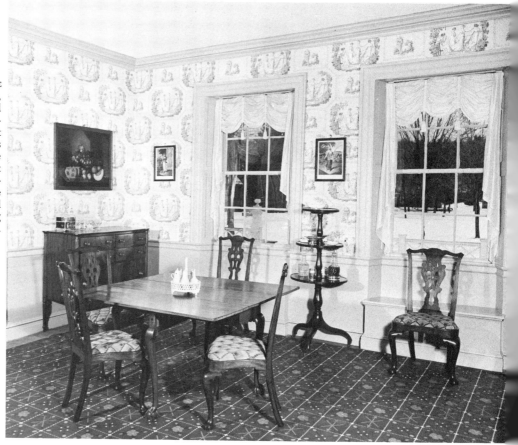

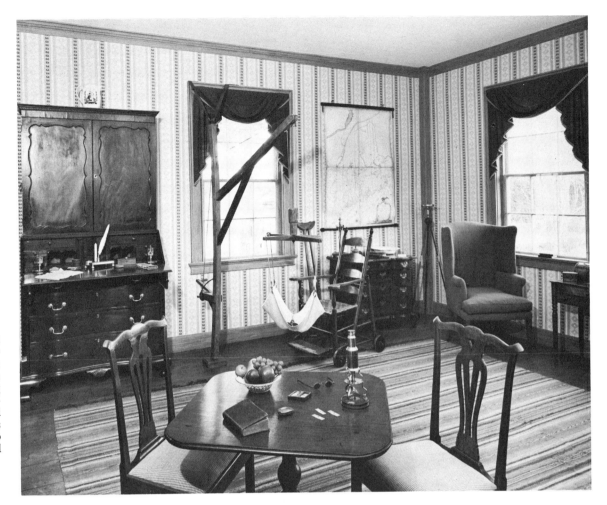

The family sitting room in the TOWNE HOUSE was used also as an office by Salem Towne and his son. Here are a secretary with writing equipment, a microscope with slides, a surveying instrument, a hanging map of the District of Maine. Conveniently placed are a pair of crutches and an invalid's wheel chair that could be drawn up to the adjustable crane designed to aid the sufferer from gout.

The ballroom of the TOWNE HOUSE extends across the full width of the second story and was used as a meeting hall by the Fayette Masonic Lodge, 1798-1806. Original wall painting has been preserved and restored, and an all-seeing eye reproduced on the ceiling. The imposing mahogany armchair carved with Masonic motifs has a Boston history. The other end of the long room can be partitioned off and is furnished as the boys' bedroom.

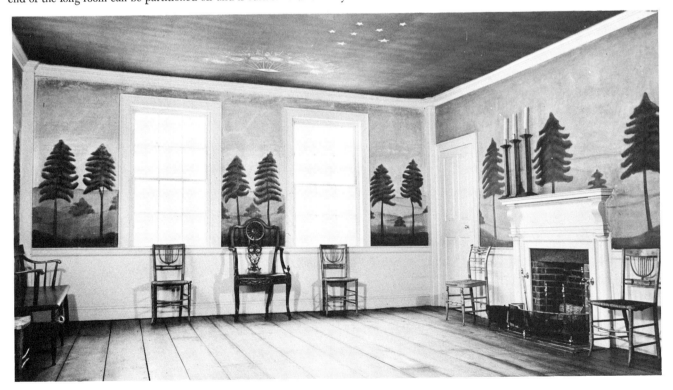

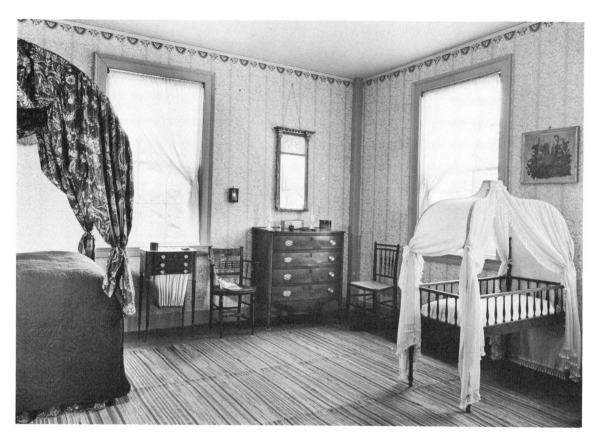

The owners' bedroom in the Salem Towne House is furnished with style and country simplicity. Unbleached muslin is fashionably draped at the windows and on the Sheraton crib. The wallpaper, a lacy white stripe on buff ground, was reproduced from a fragment found under layers of paper on the walls of this room. Rag carpet covers the floor.

The northeast bedroom of the Towne House is arranged for the several daughters of the family, and evidences of the activities of assorted ages may be seen: knitting and tape weaving, playing with dolls, painting and copybook writing. Whitewashed walls and soft gray-green woodwork are the background for a variety of painted furniture. The colorful carpet, woven at the Village, is copied from an early nineteenth-century fragment in the Village collection.

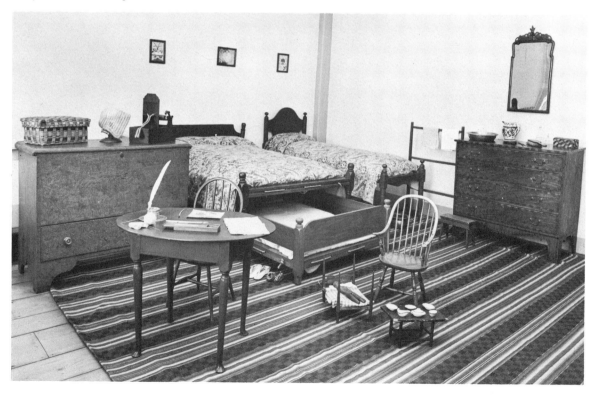

The earliest dated piece of furniture in the Old Sturbridge Village collection is a six-board, notch-sided chest marked 1673. The initials *I W*, two hearts, two diamonds, intersecting lunettes, and crossed lines are impressed into the soft pine with a tool such as a leather stamp.

The furniture

BY MARGARET B. MUNIER

THE VILLAGE FURNITURE COLLECTION, covering the period from the late 1600's to the 1830's, is extensive, varied, and, because of its frequent deviation from formalized styles, of special interest to the collector who delights in creative and individual expression. Some of the pieces were produced by the finest cabinetmakers; others should be considered in terms of their original use and the needs of the first owner. Many early households had "best," "middling," and "common" furniture, and the Village collection reflects these distinctions. A common bench may have been as soundly constructed as the best table in the parlor, but more care was given to the selection of wood, the proportion of the parts, the execution, and the finish, of the parlor piece.

Country furniture was the work of the local cabinetmaker or joiner, the turner, or even the farmer supplying his own needs. That is why so much of it has individuality

Cupboards for storing kitchen and eating utensils were a form of furniture needed in any household. This seventeenth-century one is made of chestnut. Most of the pewter here was made by the Danforth-Boardman group.

Butterfly table, Connecticut, c. 1700, of cherry. Block-and-turned legs, bold curves of the leaf supports, the subtle cant of the base are characteristic of this New England form.

The form and the fan motif of this high chest indicate a date of about 1800. The painted graining, which may have been done then or later, is so well executed that many people have thought the chest really made of mahogany.

Cyma arches and scalloping of the skirt, cabriole legs, and pad feet are all Queen Anne features of a red-painted chest-on-frame made in Massachusetts about 1730-1750. The torus molding of the cornice forms a wide, shallow drawer.

Red-painted pine table (c. 1800) in the Freeman Farmhouse (see *The interiors*). The plainness of this square-topped table is relieved by the grooving or fluting of the tapered legs, the semicircular notchings of the drawer, and the serpentine curves of the apron.

Like the simple chest, the stretcher table persisted in country furniture throughout the eighteenth century and even later, with simplification of the turnings. This octagonal top is an unusual variation: square, round, or oval tops are more common. Originally painted red, the base is maple and the top pine.

and an unconventional character. Fashion played only a small part in its basic design and decorative techniques, and the styles set down in the design books of professional cabinetmakers were modified or but dimly reflected in the form of a chair, the shape of a foot, the carving of an ornament. These were likely to be determined instead by tradition or personal preference. Even when the country craftsman attempted to emulate his more sophisticated contemporaries, his limitations gave his work a flavor of its own.

The woods used had a great deal to do with the design of country furniture. Basic form was influenced by the innate qualities of the material, and many pieces retain the feeling of the boards from which they were cut even when their abrupt angles are refined by beveling, notching, a molded rim, or incised lines. The variety of trees

Hepplewhite mahogany desk in the Freeman Farmhouse parlor. Shaped skirt, inlay, outswept front feet, and over-all proportions give this piece unusual grace. It bears the label of its maker, Ezekiel Brighton of Grafton, Massachusetts, and the date 1816.

Red-painted pine chest-on-frame (1725-1740) in the Freeman Farmhouse (see *The interiors*). The four drawers are set into a low, stocky frame which has the unusual feature of a shallow drawer. The teardrop pulls are replacements.

Black paint on a white base applied with a feather or dry brush in knots and cyma swirls imparts an air of bold exuberance to the simple chest form. This decoration may be considerably later than the piece itself, which exemplifies an eighteenth-century type.

A country craftsman's rather heavy-handed solution of a delicate problem is illustrated by the unusual interior of this desk (early 1700's). It is pine, with molded base and high turned feet.

found throughout the eastern part of the United States was a challenge to the craftsman, and each one was used in such a way as to take advantage of its peculiar qualities. Hickory was selected for the graceful bow of a windsor chair because of its toughness and resiliency. The hardness and flexibility of maple recommended it for the turned legs of a chair, and, as with walnut and cherry, the choicer boards were used for flat surfaces.

Geometric patterns, scratched or carved, embellished much country furniture, with variations of the circle appearing frequently. The heart and other traditional designs were also used, sometimes symbolically but more often just as ornaments. When classical motifs and natural forms became a part of the decorative vocabulary during the second half of the eighteenth century, country furniture responded to fashion by adopting the acanthus leaf, honeysuckle, and bellflower, the cornucopia overflowing with fruit, and the pineapple; but these motifs were more likely to be painted, stenciled, or applied on the surface than carved or built into the form.

In contrast to more formal pieces, country furniture was often painted, especially when the material was a soft wood with little textural graining. Blue, red, brown, dark green, and black were typical colors throughout the period represented at the Village. Occasionally an item constructed of soft wood was painted to simulate the grain of a hard wood such as walnut. A piece of furniture handed down from one generation to another may have been repainted by successive owners; it is often impossible to say just when a coat was applied.

All these types and many others are represented in the furniture collection at Old Sturbridge Village.

Of all American furniture forms the windsor chair is perhaps the most individual and varied. From 1760 on, it was widely used in homes and public institutions. Its makers advertised comb-back, round-top, high-back, low-back, and sack-back chairs useful as garden, parlor, and dining furniture for children and adults, and low chairs for the very young. Left to right: a child's sack- or hoop-back chair, a continuous-arm-and-back windsor made by E. B. Tracy of Connecticut, and a similar child's low chair.

No makeshift but a piece worthy of the "best" room is this walnut Queen Anne side chair, 1740-1750, competently fashioned in the New England tradition. The seat is covered with a reproduced embroidered flame stitch in shades of rose, blue, green, brown, and yellow.

Transitional pieces, combining elements of an old style with a new, are frequent in country furniture. This black-painted pine chair (c. 1750) has the turned legs and stretcher and the Spanish foot of the early 1700's with the pierced splat and back of mid-century mode.

A country cabinetmaker's expression of the shield-back Hepplewhite style. Made of maple, its plainness is relieved by black walnut and fruitwood inlay at the base of the shield. The legs and stretchers are a sturdy continuation of the Chippendale straight-leg style and the seat is rush. Its history indicates a New Hampshire provenance.

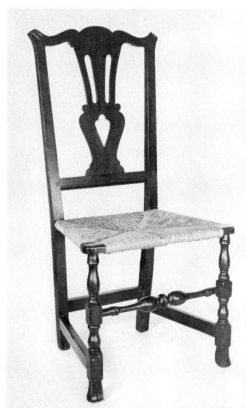

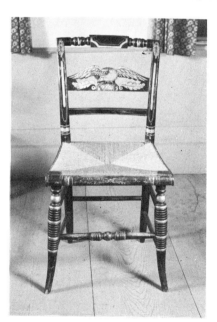

Following the windsor chair in popularity, the fancy chair, derived from Sheraton design, came into full flower by 1825. This one in the Freeman Farmhouse (see *The interiors*) is gilded, and decoratively stenciled on the cross splat with a patriotic eagle atop the world.

THE PARLOR, GOVERNOR'S PALACE, WILLIAMSBURG

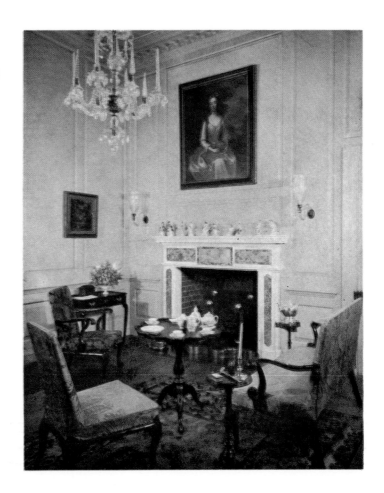

THE SUPPER ROOM,

GOVERNOR'S PALACE, WILLIAMSBURG
(See page 60)

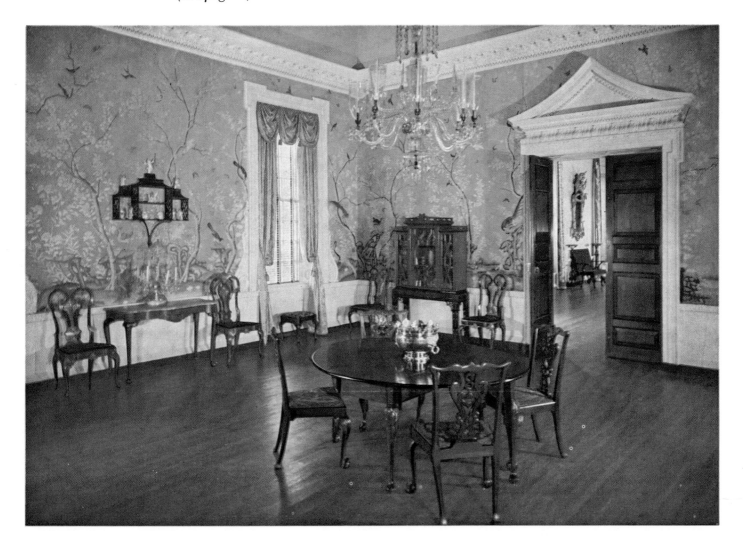

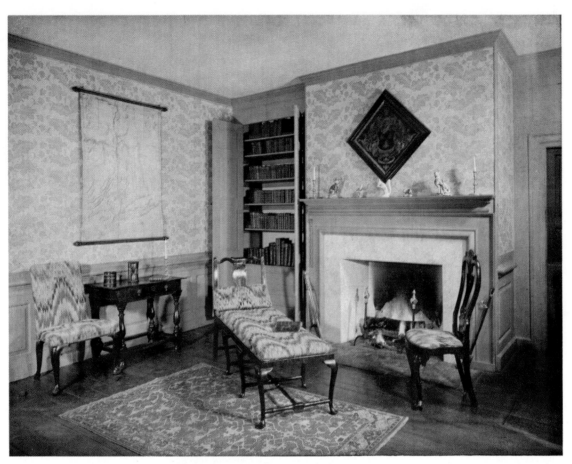

THE LIBRARY, BRUSH-EVERARD HOUSE, WILLIAMSBURG

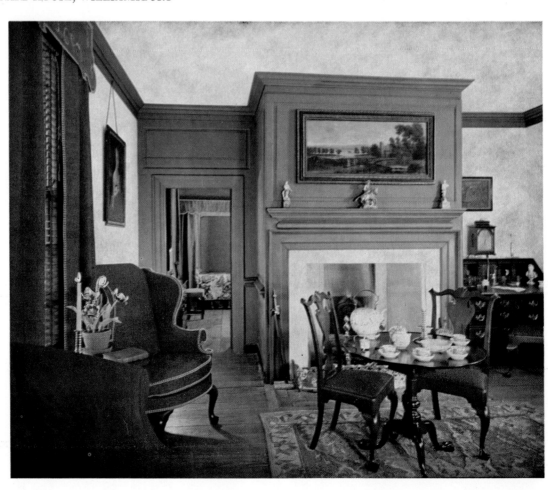

THE PARLOR, BRUSH-EVERARD HOUSE, WILLIAMSBURG

(See page 60)

The collections at
Old Sturbridge Village

OLD STURBRIDGE VILLAGE is a full-scale living exhibit of an early New England rural community of pre-industrial days. In addition to its houses, shops, and other buildings, it has a number of specialized collections that show in detail certain aspects of rural arts and crafts. Some are dispersed through the buildings as appropiate furnishings, others are presented as study collections.

The following pages show samplings drawn from these collections of lighting devices, woodenware, pottery, metalwork, firearms, clocks, textiles, and country art.

The aim of the collections is the same as that of the Village itself—to show the everyday life of the New England farm and village in the first decades of our nation's independence. They are a factual reference library of the skills, activities, pleasures, and ideas of a self-reliant, ingenious, and energetic people.

FRANK O. SPINNEY

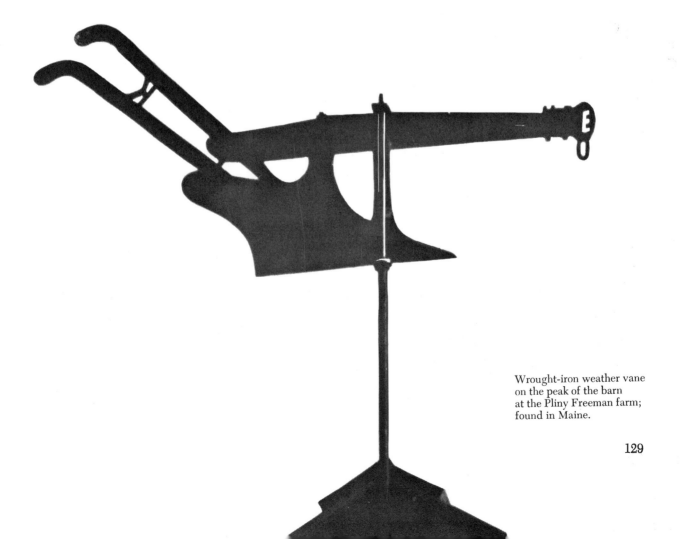

Wrought-iron weather vane
on the peak of the barn
at the Pliny Freeman farm;
found in Maine.

129

BY C. MALCOLM WATKINS

Associate Curator, Division of Ethnology, Smithsonian Institution

The collections: lighting devices

UNTIL 1800 THE LIGHTING OF THE New England small town was little different from what it had been when the Colonies were founded. Candles, now and then an open lamp or a pine splint, rarely a rush soaked in tallow—these constituted the traditional means for combating darkness.

To them were added, around the turn of the century, the first fruits of the era of invention and expansion. Into Nantucket and New Bedford came supplies of whale oil; from Europe, inventions that made its use feasible and convenient. In 1784 Ami Argand, having applied scientific principles to lamp design, had invented the first successful lamp with air drafts and glass chimneys for increased combustion; and in 1787 the simple enclosed lamp, with burners screwed tightly into the top of the reservoir, had been patented by John Miles. By 1800 these improvements on candles were available in New England, where craftsmen made a variety of lighting devices, typically simple and practical.

Chandeliers, toggle arms, adustable reading stands, well-proportioned lamps and candleholders—all these and many more are in the Old Sturbridge Village collection, which is one of the most important of its kind in the world. Beyond showing in detail the progress of artificial illumination in New England, it richly demonstrates European prototypes and comparative developments elsewhere. We can see the greater conservatism of the Pennsylvania German in his lamp forms, while we are soberly discouraged from inflating the New Englander's superiority in matters of ingenuity as we look at the work of his contemporaries. We can trace the course of inventions that were adopted in New England but originated elsewhere, and find lavish illustration of the backgrounds of form and design against which New England lighting devices should be considered. Thus, in presenting the entire sweep of the history of artificial illumination among western European peoples, the collection shows the early lighting of rural New England in proper perspective.

We may turn first to a charming variety of rushlights, those graceful wrought-iron contraptions with pincerlike jaws for grasping fat-soaked rushes. These examples were virtually all purchased in England by A. B. Wells, but it is likely that their counterparts were occasionally used here. One in the Woodside collection was found in the chimney of an eighteenth-century house in Haverhill, Massachusetts, and there are a few indications of their use elsewhere in the Colonies.

It may well be that they served as splintholders, for there are several early allusions to pine splints as lighting sources. Higginson, Wood, and Winthrop all refer to them. According to the last, splints were burned in the "corner" (probably the chimney corner, or fireplace) on a flat stone or iron, except when a stick was taken in the hand to go about the house. Sylvester Judd's *History of Hadley* has much to say about the use of pine splints,

or "candlewood," in the interior Massachusetts towns. The Reverend Nathan Perkins of Hartford, in his account of a tour through Vermont in 1789, wrote complainingly of a lodging in Jericho which "had no comfortable refreshment . . . was almost starved because I could not eat ye coarse fare provided for me . . . no candles pine splinters used in lieu of them . . . bed poor and full of flees." There are numerous holders specifically designed to hold splints, of which the majority are known to be European, but it is clear that in New England splints were used in any manner that was convenient.

At best, splints served only as inexpensive and inferior supplements to the tallow candle, whose evener light was the staple illuminant in New England farmhouses. The history of candlemaking devices is depicted in a fascinating adjunct to the lighting collection at Sturbridge. What is probably the earliest dated candle mold in any collection is a Swiss specimen of walnut, inlaid with a cross and *1578*. It divides in two lateral sections, as did many Continental ones. There are pewter and pottery molds, mostly Pennsylvanian in origin, and a wide diversity of the tin molds which were used in every farmhouse. Most typical of New England are the bundles of "candle sticks" or "broaches"—long whittled rods of wood from which wicks were suspended and dipped in the hot tallow to make candles. "Turnstiles" or dipping machines are also represented, but these are usually associated with commercial manufactories. One such device, characteristically chaste in design, is of New England Shaker origin. Hanging from the ends of its revolving spokes are square panels with holes bored through them for suspending the wicks. It is supported on three slender legs and painted red.

To what extent spermaceti candles found their way to the interior of New England is not known. Probably the owner of the Village's mansion house and others who, like him, bought their furniture in Boston allowed themselves the occasional elegancy of a spermaceti candle. There was sufficient demand by 1761 to justify the existence of the United Company of Spermaceti Candlers in and around Boston. The sign of one of its members, Joseph Palmer, now hangs in the Village, a spouting whale proclaiming the nature of his business.

New England excelled in making handsome devices for holding candles. The turn-of-the-century chandeliers in the Village meeting house are masterpieces of wood and wire. The wood turner and the woodcarver had a hand in the making of the chandeliers, but the tinsmith's contribution was more characteristic. One tin chandelier, illustrated, is utterly simple yet subtle in line and proportion. There are many other tin chandeliers—more than one would expect in a single collection—from New York and Pennsylvania as well as New England.

Adequate light for reading was a constant problem. Much reading must have been done by the light of the fireplace, where certainly the social activities of the

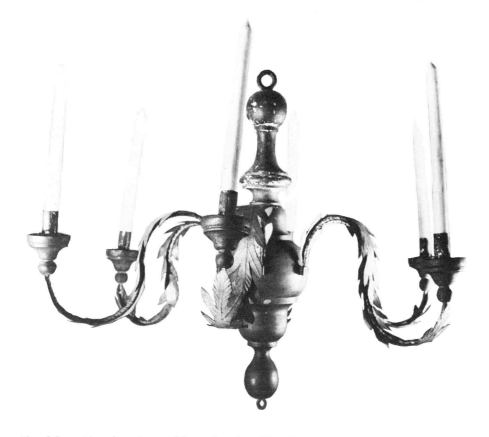

Chandelier with a charming rural flavor (southern New England, early 1800's). Turned wooden shaft and candle cups; wire branches to which delicate tin leaves are soldered.

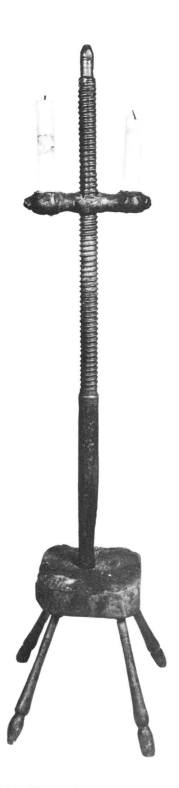

Adjustable wooden candlestand from Connecticut, a characteristic New England example. The short turned arm with candle socket bored near each end moves up and down the threaded shaft, which is secured in a rough octagonal block on four splayed legs. In the Fitch House; a similar stand is shown in the Fenno House east room (see *The interiors*).

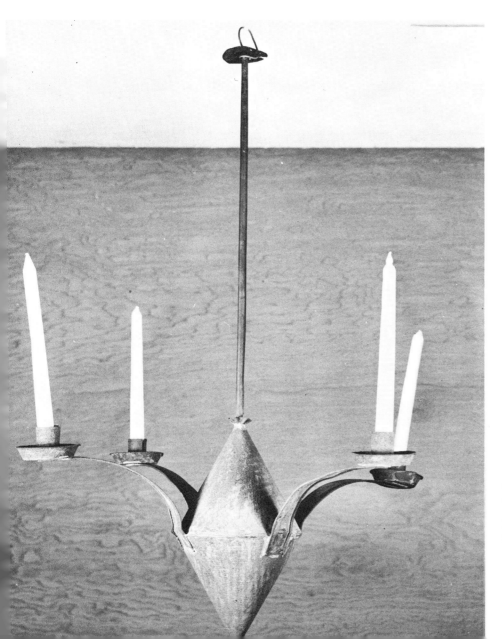

Tin chandelier of ageless simplicity (early 1800's). Probably designed for a tavern ballroom.

131

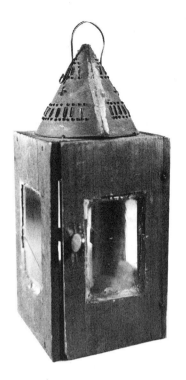

Homemade candle lantern with glass panes set in solid pine sides and conical tin top probably salvaged from a pierced tin lantern. In the Fitch House.

Left to right: Kyal, or "Cape Cod spout lamp," one of a pair; coastal New England, late 1700's or early 1800's. Sheet-iron betty (the wick support is missing). Tin shop lamp, consisting of a whale-oil lamp mounted in a tin pan for a reflector. Early nineteenth-century whale-oil lamp from the Hartford area made by a tinsmith with a flair for the classical. Tin whale-oil lamp (c. 1800) modeled closely after Miles' patented "agitable" lamp of 1787. The last three are developments of Miles' patent.

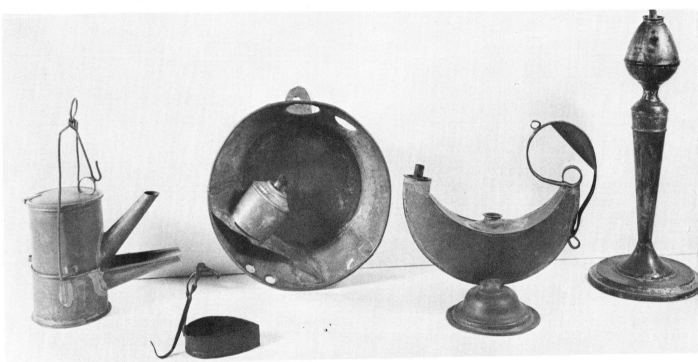

Left to right: Painted tin Argand lamp made in London by the firm of R. Bright, "late Argand & Co.," about 1800; a glass chimney originally fitted on the flange around the tubular burner. Engraved portrait of Ami Argand, lamp inventor. Two tin "portable illuminators," designed by Benjamin Thompson, Count Rumford, a native of Woburn, Massachusetts.

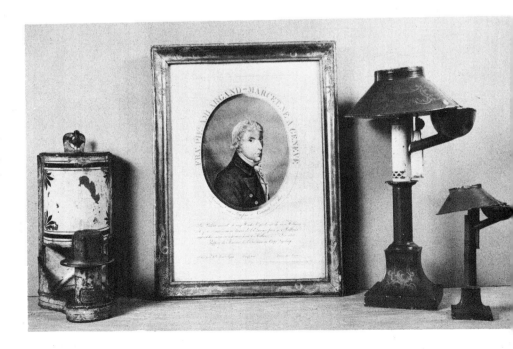

family also were carried on after sundown. Reminiscences of early New England life repeatedly stress the domestic importance of the fire. E. H. Arr, in *New England Bygones* (Philadelphia, 1880), wrote a typical description: "My grandfather's kitchen was a sombre room, ceiled and painted brown; with huge beams, high dressers, and yawning fireplace. It had only two small windows . . . What it lacked by day was light and sunshine. At night, brightened by a roaring backlog, it was full of cheer. Then its beams and ceilings and simple furnishings were enriched by shadows, and the pewter dishes upon its brown dressers shone like silver."

The fire had to be augmented by close light, nevertheless. Iron "hogscraper" candlesticks, ubiquitous in New England farmhouses, were equipped with hooks for hanging on a slat of a ladder-back chair. Adjustable candlestands were fashioned of wood by the village joiner, or simply contrived at home. These were perhaps more frequent in Pennsylvania than New England, but were common to both, and there are many in the collection.

Candleholders for shop work range from simple to complex. Crude little L-shape sconces of wood were used in shoemakers' shops. So was an iron hook-shape device ending in an upright point to impale the candle. An ingenious contraption, also for a cobbler's bench, is the adjustable jointed toggle arm terminating in a hole for a candle or peg lamp.

Pierced tin cylindrical lanterns with conical tops were used in New England from early times to within living memory, and square types with tin frames and glass sides were common. But, as a rule, wooden examples are far rarer in New England than in Pennsylvania. Small portable lanterns were used in New England, as elsewhere; there is a wealth of European lanterns in the collection, some closely resembling New England types. After 1825 or so the whale-oil enclosed lamp made possible the general adoption of improved lanterns with blown-glass globes. The many handsome examples of these include several designed for railroad and marine use.

Before 1800, lamps were little used in New England, particularly inland. Higginson in 1630 mentioned the abundance of fish oil available for lamps, and early probate records bear him out. These were probably iron crusie types and Dutch-style brass spout lamps, of which numerous examples are in the collection. As for the interior towns, Judd states unequivocally that oil was not used. However, grease lamps, or sluts, were known, though only for kitchen or similar use. So-called betty lamps (crusies with wick supports), when they were used in the interior at all, probably burned fat. Betty

lamps in use are shown in the Fitch house and Fenno house kitchens (see *The interiors*).

In the coastal towns a tin cylinder lamp with spout for the wick and drip-catcher underneath was often used. Known as a *kyal*, or "Cape Cod spout lamp," this type was used in shops, or ships, and in loom rooms all along the New England coast.

As late as 1819 John Miles' "agitable" whale-oil lamp, patented in 1787, was still being acclaimed in *Niles' Register*. "Its great security against many of the chances of fire, deservedly places it among the preservations of property; while its neatness recommends it to the patronage of a judicious public." Tinsmiths and pewterers in southern New England used their skill to imitate Miles' patent, braziers in the larger towns made handsome specimens, and by 1820 the glass manufacturers were making great quantities of these lamps. Many types are shown in the collection, from tiny "wine-glass" chamber lamps to elaborate specimens with pressed bases.

After 1830 whale-oil lamps gave way to fluid lamps, designed to burn camphene and other volatile commercial fuels. These are represented, as are the complicated lard lamps that entered with the period of invention.

Meanwhile, scientifically designed lamps based on the Argand principle were introduced in the cities. We know that both Washington and Jefferson owned Argand lamps, and hardware catalogues in the Essex Institute show that they were available to northern contemporaries. There are several rare examples of the Argand lamp, and many variations, such as astral and sinumbra lamps with their ring-shape reservoirs, and the elaborate hydrostatic and Carcel lamps. The Carcel found use in city houses in the early decades of the century, but its occurrence in country villages must have been exceptional. A unique display of Count Rumford's "portable illuminators" shows a rare lamp type which did reach inland.

This is not the place to describe the subsidiary collections of Jewish ceremonial lamps, Catholic processional lanterns, miner's lights, candle snuffers, Renaissance candlesticks, marked Pennsylvania betty lamps, Continental glass lamps, sixteenth-century Swiss soapstone lamps with wick supports, or medieval Spanish candelabra. We leave it to the visitor to survey this rich background as a means of evaluating the history of artificial lighting in New England. In its entirety, the remarkable collection of lighting devices at Old Sturbridge Village is a most significant part of one of the nation's great assemblages of rural art.

Published by permission of the Secretary of the Smithsonian Institution.

Wooden toggle arm (c. 1825), fitted with glass whale-oil peg lamp designed by a shoemaker to give light at his bench.

BY HERBERT C. DARBEE

The collections: treenware

Two pitchers and a funnel,
each carved from
a single piece of maple.

As FOR BUILDING HOUSES AND FURNITURE, so for making household and culinary utensils in rural New England, wood was the material most abundant and nearest to hand. From it the countryman fashioned an extraordinary variety of articles for simplifying his daily tasks, furnishing his table, and equipping his kitchen. The hardwoods of the native forest were conveniently available, and those abnormal excrescences called "burl" were of especial value for various kinds of hollow ware.

The country craftsman's nearest approach to the delicate cutting and smooth finish of the expert woodcarver or the cabinetmaker is to be seen in some of the incised designs on the dozens of butter stamps. Other implements have the plain sturdiness and adequacy to their purpose that make up a considerable part of the appeal of most rural crafts. Proportion and balance, and skill in making use of particular qualities in the wood, lend a note of distinction to the woodenware known as treenware.

Large covered bowl of maple burl,
14 inches in diameter.
The lid has a double rim,
for a close fit both inside and
outside the lip of the bowl.

A maple burl scoop,
with bowl and handle in one piece.
Piggin of hardwood, pine bottom inserted.
A crude pine soap dish,
bound round with a leather thong.

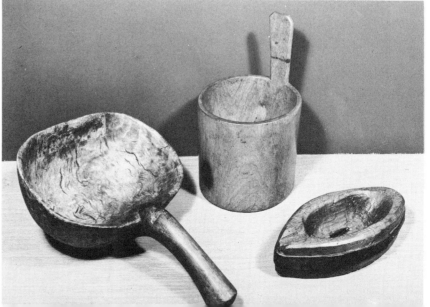

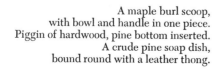

134

Two forms of wooden plate or trencher in birch, the square one with a depression for salt possibly of English origin. Sugar bowl of maple burl, with a nicely turned finial.

Maple whipper for eggs or batter, and a cottage-cheese press of oak cut from a tree trunk or branch, set in a trough hollowed from an oak slab.

Butter stamps, showing the boldly cut patterns often seen in these purely decorative kitchen tools.

Oak ladle of impressive size, cleverly fashioned in one piece from straight-grained wood for the handle and burl for the bowl. Herbs were ground by working the roller back and forth in the crushing tray.

The collections: pottery

BY FRANK O. SPINNEY

The Village potter uses native clay
in his demonstration of the craft.

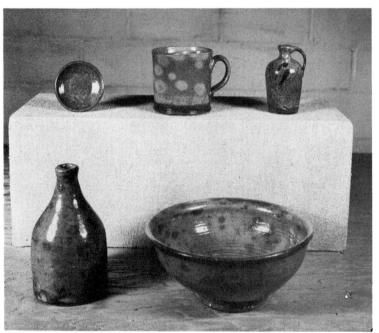

The shaving mug, *top center*, has a smaller cup attached
to the inside wall. It is attributed to Gonic, New Hamp-
shire. The other pieces (all are redware) show a variety
of shapes whose functions are self-evident, so simply is
the ware designed. Makers are unknown.

IN NEW ENGLAND THE MAKING of pottery—stoneware and
redware—stayed close to the craft's earliest traditions of
utility. Any collection of the simple wares of the eight-
eenth and early nineteenth centuries makes this clear,
and it is emphasized when one sees the pieces in their
natural places, on the cupboard shelves, in the buttery,
near the oven, or in any of the other spots in house or
shed where their use is obvious. Only the simplest of
embellishments were added: an abstract design quickly
incised while the piece still whirled on the wheel, a
flourish of slip decoration on plates or platters, a dabbling
of simple glaze combinations with colorful results.

The self-sufficient nature of rural or village life kept
the New England potter hunched over his wheel turning
out milk pans, bean pots, storage jars, footwarmers, jugs,
crocks, bowls, and mugs. Another factor that influenced
his product was New England's glacial clay, serviceable
for bricks and plain earthenware, but not for the making
of more delicate and ornamental things; what New

Top: The two pieces at right, with yellow and brown
glazed decoration, are probably eighteenth-century imports
from England. The redware cup, left, has a light brown
glaze and is slip-lined. Its origin is unknown. *Bottom:* Slip-
decorated redware pans with brown glaze of New England
origin and of eighteenth-century form, turned on the wheel
rather than shaped over a mold. Such wares brighten the
shelves of the Village kitchens (see *The interiors*).

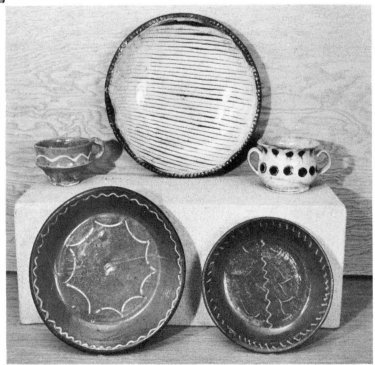

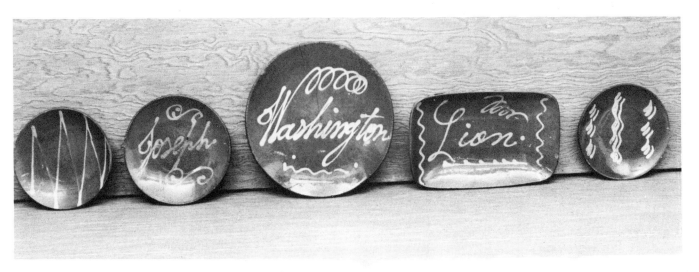

Slip decoration was frequently and attractively used by many New England potters. These forms with reddish brown glaze were shaped over a mold, not turned on the wheel.

Englanders acquired along these lines was imported. All this, of course, is not to say that New England pottery is unique or remarkable in its simplicity and utility. These traits are common to most folkware of any country or any period in this, perhaps the oldest of the crafts.

As one looks at the pottery in its living context, one sees that all the pieces are working articles, for butter-making, cooking, storage, eating, warming, drinking, or other mundane purposes. In the more formal exhibit at the pottery shop, where rarer marked specimens are shown, one feels the same insistence on utility.

Here, too, a potter shows the craft in operation. Using the Village collections as his guide, and working with clay dug from the shores of a nearby pond, once a source for earlier potters of the locality, he re-creates the early forms on the wheel, glazes, and fires them. The almost magical process by which a shapeless lump of clay is raised into a pleasing utensil never fails to excite interest and to provide a better appreciation of the craft.

Stoneware pot with brown glaze, marked BOSTON/1804. Maker unknown.

Redware pot and cover both marked JOHN SAFFORD and STEW POT NO. 3. Olive glaze flecked with red. Safford was working in Monmouth, Maine, in 1855.

Part of the exhibit at the Village pottery. The map of New England is marked with the locations of the several hundred potters known to have worked in the region in the eighteenth and nineteenth centuries.

137

A corner of the blacksmith's house, given over to the principal Village collection of wrought-iron work of every sort.

The collections: metalwork

Wood-handled copper brazier
with wrought-iron legs and support bars,
for keeping food warm.

Brass strainer, 10½ inches in diameter,
with handle of wrought iron and hickory.

BY HERBERT C. DARBEE

THE METAL OBJECTS AT OLD STURBRIDGE are largely the products of the rural blacksmith, the tinker, and the handyman. Metal of any sort was not common in the back-country community, and what could be had was devoted to practical ends where the far more abundant wood could not be made to serve.

This does not mean that the decorative aspect was slighted. The accompanying view of a corner in the wrought-iron exhibit suggests what was done continually in this durable and versatile medium. Tinware also was first of all useful, but rendered decorative through form, pattern, and color.

In these metals and in copper, brass, and pewter, the Village exhibits the variety of hardware and of house and shop equipment characteristic of rural areas early in the last century. There was a good deal of local production, and the traveling peddler was by then an established institution. It was still the day before factory production of identical, if often superior, items; and individuality is blended with utility here too.

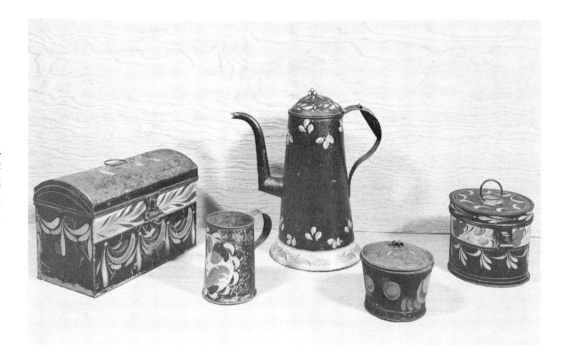

Tinware decorated with flowers, swags, leaves, and fruit in bright greens, reds, and yellows on a background of conventional black, relieved in four of the pieces by a contrasting white band.

The inner faces of a dated and initialed wafer iron.

Pewter by American makers. Deep dish thirteen inches across with touch of Thomas Danforth III (1777-1818), Stepney, Connecticut, and Philadelphia. Plate from the later period of Thomas Badger, Boston, 1786-1815. Pitcher marked *Boardman & Hart, New York,* but made at Hartford, 1827-1831. Porringer with the *Hamlin* and eagle of Samuel Hamlin, 1771-1801, Providence; the second eagle touch, introduced c. 1794.

Pewter teapot of English make (late eighteenth century).

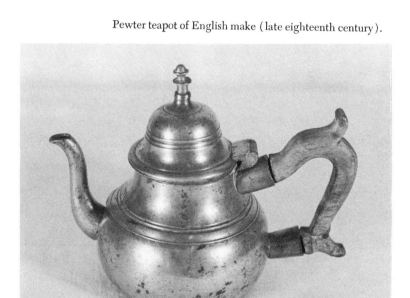

Wrought iron, fashioned into a pair of skewer racks, a wooden-handled food chopper marked *L.F. 1769,* and three forms of trivet.

139

BY CATHERINE FENNELLY

The collections: textiles and costumes

SPINNING, DYEING, and weaving were still important household industries in rural New England at the beginning of the nineteenth century. Home textile-making had received new impetus during enforcement of the non-importation measures of the 1760's and the Revolution, and it continued to grow until after the War of 1812. Several factors account for its continuance: lack of cash in rural areas, which put much imported material out of reach of the farmer's purse; the introduction of carding mills in the 1790's, which enabled the housewife to eliminate one of the most tedious and time-consuming steps in the process; the craze for merino sheep, which gave new impetus to wool-growing; and the Embargo of 1807 and the War of 1812, which largely cut off the American market from European goods. If we are to believe both contemporary observers of the New England scene and those who looked back on it several decades later, there was scarcely a rural household that did not produce most of the textiles used by members of the family. The Reverend Horace Bushnell, in delivering a centennial address in Litchfield, Connecticut, in 1851, termed the era that preceded his the "age of homespun," giving it an apt name that still clings.

The textiles in the Old Sturbridge Village collection are representative of this age in New England: clothing, table and bed linens, blankets, curtains, carpets, and what we might today term pure decoration—a gaily stenciled window shade, painted oilcloths, fantastically embroidered or appliquéd squares, and pockets seemingly made just for fun. On looking at the collection as a whole, one is impressed by the appalling expenditure of time and effort that must have gone into making and sewing fabrics, and by the survival of so much of the product—a surprising amount in view of the proverbial New England frugality that would never allow a piece of material to be discarded until it was worn out. But New Englanders sometimes wore out before their possessions, so that the museum can today acquire the high-waisted woolen suit worn by a small boy the day he was accidentally killed at a house-raising, the exquisitely tucked and embroidered baby's cap, the glazed wool coverlet so carefully handled that it looks as though newly calendered, the appliqué quilt guarded for a hundred and fifty years against the ravages of sun and dust.

Costumes in the Village collection range from linen shirts to silk cloaks. The few women's gowns indicate the endless variations that modified the Empire fashion, and

A corner of the textile demonstration in the Mashapaug House, with wool and flax wheels, cards, and yarn winders. The case at left displays early nineteenth-century homewoven blankets. That at right shows woven coverlets of eighteenth- and early nineteenth-century patterns. One, made in Groton, Connecticut, is dated 1833.

Checks and stripes in blue-, brown-, and red-and-white. The triangular-folded bandanna is cotton. The striped piece is a brown-and-white linsey-woolsey blanket initialed *A.R.* The blanket at lower left is from New Hampshire.

Checked and striped woolen homespuns. All the blankets here are from Massachusetts and New Hampshire. The stripe is a brown, yellow, and cream linsey-woolsey.

Cotton-and-wool coverlet, tan and two shades of green, found in Masachusetts. A center seam suggests that it was woven at home.

Printed cottons, eighteenth and early nineteenth century, mostly English and French. Shown at bottom, a stenciled table cover and a piece of resist printing.

Farmer's smocks or frocks. *Left:* found in Vermont; indigo-and-white striped wool with a brown-and-white checked woolen lining; side seams are open at the bottom to allow freedom of movement. *Right:* found on Cape Cod; heavy white linen, smocked and embroidered at yoke, shoulders, and wrists, with pewter buttons; similar to many nineteenth-century English smocks.

Child's blue woolen suit with high waist and brass buttons. It belonged to a Spencer, Massachusetts, child who died in 1820.

Checked, indigo-dyed fabrics. Apron at left is linen, the other wool. The man's bandanna is also linen. The background is a blue-and-white wool plaid blanket.

142

Detail from a coverlet stenciled boldly in green, yellow, and orange on unbleached cotton. The four sides are bound in pink cotton, with the bottom corners cut out. Signed on the back *Hannah Corbin, Woodstock [Connecticut]*.

Stenciled cotton length, thought to have been a window shade; found in New Hampshire. The urns and vases are yellow, blossoms red and rose, foliage green.

Stenciled cotton table cover, 27¼ inches square. The birds and the border swags are of particular interest. Found in New Hampshire. The colors are rose, yellow, green, brown, and blue.

exemplify the belle's lament: "Plump and rosy was my face, And graceful was my form, Till fashion deem'd it a disgrace To keep my body warm." In this *mode à la grecque* waists were high, bosoms low-cut, skirts narrow, sleeves short. But here, as in all styles, there was a decided time lag in the rural areas, and farm women tended to adapt dress fashions to their way of living. A patchwork-printed cotton dress in the collection has a high, fitted bodice, enormous sleeves foreshadowing the leg-of-mutton of the nineties, and an action-free skirt gathered at the waistline—an 1830 modification of the Empire style. Another gown, a faded pink muslin, has a narrow skirt cut straight from bodice to hem. A white cotton wedding dress has a beautifully embroidered hem, tightly gathered neckline, and long sleeves.

Here, as in every aspect of the textile collection, everyday homespun is today almost non-existent. It was worn until threadbare, then used as patches for mending. Three farmer's smocks, a few waistcoats, jackets, shirts, cloaks, and breeches comprise the limited group of men's clothing. Underclothing would seem to have been reserved to women—petticoats clumsily or beautifully quilted, chemises or shifts, and bodices. Women's indoor caps and outdoor bonnets and calashes are comparatively easy to find. Baby clothes were usually preserved, perhaps for the next baby that never arrived, perhaps for a future grandchild. Dresses for small children, boys as well as girls, are made of printed cotton. The woolens, being more perishable, have largely disappeared.

Linen was more commonly used for sheeting than cotton. Most of the sixty-odd sheets in the collection are seamed down the center, probably an indication that they were woven on narrow home looms. Those without seams are obviously imported or store-purchased, as was the cotton sheeting. Pillow cases are plain white linen. One bolster is a beautiful dark blue-and-white check. Coverlets are woven cotton or linen and wool, plain or patchwork glazed wool with the traditional pumpkin-colored backing, printed cotton, patchwork, stenciled, or candlewick-stitched. Blankets are cream-colored wool with embroidered corners or edge-stitching, checks, stripes, or plaids in several color combinations. Home weaving of blankets in checks, plaids, and stripes goes back to the early eighteenth century. Most of the blankets in the Village collection are from New Hampshire, where the Scotch-Irish tradition of beautiful weaving was strong. Tablecloths and napkins are white linen, most of them woven in a diaper or goose-eye pattern, as are many of the hand towels. Heavier towels and bed ticking are made of coarse linen or tow.

Silk seems to have been worn and used but little in country areas, or perhaps again it was used until worn out. A cotton-lined black cloak belonging to a clergyman's wife, an embroidered waistcoat, an apron, a petticoat, a few bonnets and reticules, a handful of ribbons, a shawl or two, comprise the entire silk collection.

To the uninitiated, textiles may seem at best a tenuous and elusive element in early New England rural life. Yet one has only to examine the roughness of the texture of the farmer's frock, the blend of pattern and color as expressions of a longing for beauty in the stenciled coverlet, or the exquisite, painstaking quilting on a bride's under-skirt to gain new insight into the lives and aspirations of New Englanders of the age of homespun.

BY AMOS G. AVERY

The collections: clocks

Tall, or grandfather, clock (Boston, c. 1760) by Gawen Brown, one of the earliest known New England makers. A contemporary tall clock by Isaac Blaisdell stands in the west parlor of the Fitch House (see *The interiors*).

Tall clock (Roxbury, Massachusetts, c. 1800) made by Simon Willard for Josiah Temple whose name, in addition to Willard's, is on the dial.

Tall clock (Boston, c. 1805) with rocking ship above dial, by Aaron Willard.

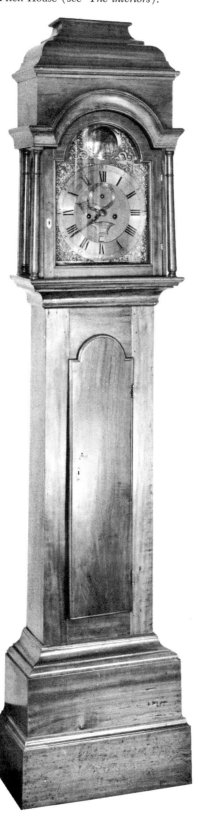

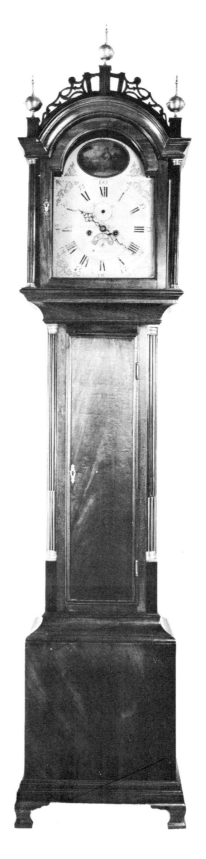

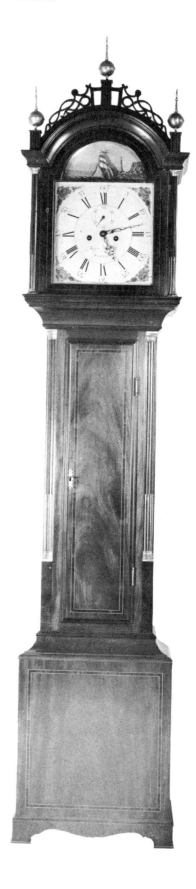

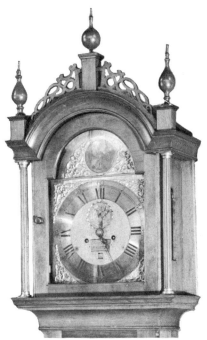

Dial of tall clock (Grafton, Massachusetts, c. 1770) by Benjamin Willard, first clockmaker of the Willard family. As with most early tall clocks, the dial is of finely engraved brass.

Right: Banjo clock (Roxbury, c. 1805) by Simon Willard. An example of the eight-day timepiece for which this maker is best known.

Far right: Girandole (Concord, Massachusetts, c. 1815) by Lemuel Curtis (1790-1857). One of a very few made; sometimes called "the most beautiful American clock."

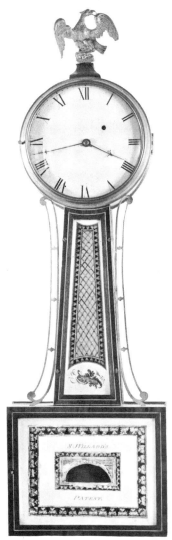

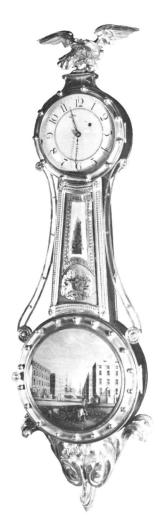

THE HISTORY OF A CENTURY OF CLOCKMAKING in New England is admirably told in the collection of some 175 clocks assembled by J. Cheney Wells. It begins with items made about the middle of the eighteenth century by Gawen Brown (1719-1801) of Boston, Isaac Blaisdell (1738-1791) of Chester, New Hampshire, and Nathaniel Mulliken (d. 1767) of Lexington, Massachusetts; and it closes with the mid-nineteenth-century timekeepers devised by Connecticut Yankees. While the work of few clockmakers in other regions here or abroad is represented, the collection is rich in examples by what may be called the Willard school. These make up the finest group of its kind ever brought together.

Benjamin Willard (1743-1803), born in Grafton, Massachusetts, was the first of the Willard family to take up clockmaking. After serving his apprenticeship with clockmakers in Connecticut, he opened about 1765 a small clock shop at the family farm in Grafton. Here Benjamin's younger brothers, Simon (1753-1848), Ephraim (b. 1775), and Aaron (1757-1844), had their first introduction to the art and craft of clockmaking. This little Grafton shop was thus the birthplace of what was to become an extensive eastern Massachusetts industry.

Simon, the most famous of the four Willard brothers on account of the variety and large number of clocks he produced, worked first at Grafton but by 1780 had established a clock shop in Roxbury. He is especially noted for having invented, in the late 1790's, what he called his patented (1802) timepiece, now known as the banjo clock. Some of his early models in the development of the banjo clock, as well as several fine examples of the typical banjo, are in the collection. Also on exhibit are

outstanding examples of tall (grandfather), lighthouse, gallery, and shelf clocks by Simon Willard.

Aaron, a close second to Simon in importance, also worked in Grafton, then in Roxbury from 1780 into the 1790's when he established himself in Boston. He too is represented in the collection by a variety of clocks.

An extensive colony of skilled artisans and craftsmen, cabinet- and casemakers, dial and glass painters, metalworkers and others surrounded Simon and Aaron in Roxbury and later Aaron at Boston. Each of the brothers had sons or apprentices who were taught in the Willard manner. Clocks by Lemuel Curtis, Elnathan Taber, Simon Willard Jr., Daniel Munroe, Aaron Willard Jr., Abel and Levi Hutchins, all pupils of one or more of the Willard brothers, are included in the collection. Also on display are timepieces by other contemporary makers whose style and workmanship so closely resemble those of the Willards that the influence of these masters is evident.

Clocks of many types—tower, grandfather, shelf, banjo, lyre, shelf lyre, girandole, gallery, lighthouse—were produced by the Willard group, and all were of the finest quality. They surpassed those made during the same period by the Connecticut manufacturers, who were emphasizing quantity rather than quality. This latter group is also represented in the collection, notably by outstanding examples of early experimental models of wooden-movement shelf clocks by Eli Terry (1772-1852) and Seth Thomas (1785-1859)—famous names in Connecticut clock production.

A few Connecticut-made clocks from the beginning (1830-1845) of the period of mass production complete, chronologically, the collection.

Pillar-and-scroll clock (Plymouth, Connecticut, c. 1817) by Eli Terry. An early model of a popular Connecticut shelf clock.

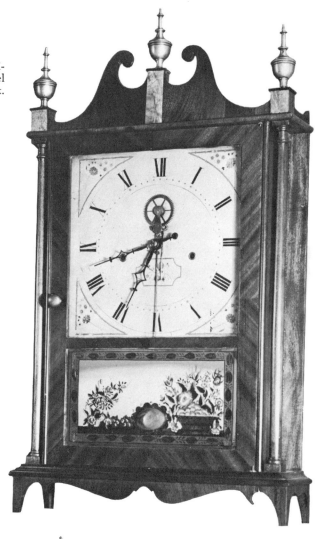

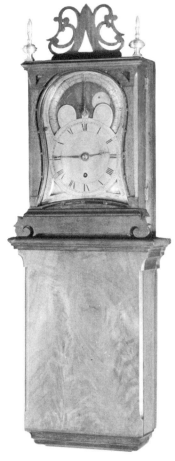

Calendar clock (Grafton, c. 1775) by Simon Willard. Unique example of an early style of wall clock from which the maker developed the banjo.

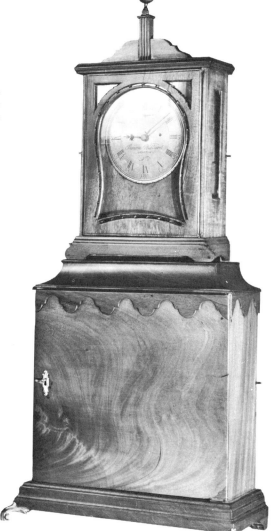

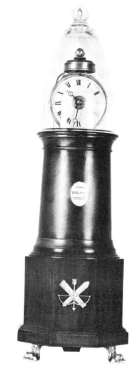

An unusual clock (Roxbury, c. 1825) in the form of a lighthouse, by Simon Willard.

Shelf clock (Grafton, c. 1780) by Simon Willard. A forerunner of the shelf clock later developed by the Willard school of clockmakers.

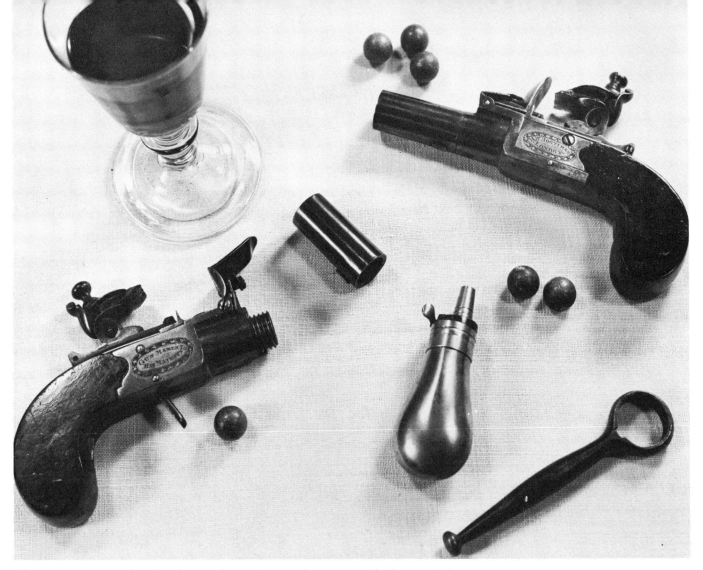

These Mortimer screw-barrel pocket pistols are shown in the process of loading, with their barrel wrench and tiny German silver powder flask. Like most similar arms, they have concealed triggers which automatically spring out when the hammer is cocked. They might well have been carried by an American gentleman of the early nineteenth century.

The collections: firearms

BY HOLMAN J. SWINNEY

Director, Idaho Historical Society

JUST BEFORE 1880, President Timothy Dwight of Yale College sat down to describe his civilization and countryside for those who might come after him. As a beginning, he chose to list the notable and basic features of the social structure of New England. The right to freedom of worship and education came first, and second on his long list he noted, "In both New England, and New York *every man is permitted,* and in some, if not all the States, *is required to possess fire arms."*

Today, when firearms are largely the business of the military, the police, and the relatively small group of hunters, target shooters, and collectors, it is hard to realize how much a part of daily life they were in the early years of the nineteenth century. This was still true of New England, even though occasions for self-defense had long existed only in tall tavern tales of Indian raids and the War for Independence, a generation or two gone by.

But New England was still full of guns. There was scarcely a farmhouse or craftsman's home without a musket behind a door somewhere, and powder and shot are fairly common entries in storekeeper's accounts—though not so common as rum! Furthermore, New England had become the arsenal of the United States. The great manufacturing armory at Springfield, still today the center of rifle production for the Army, had been founded in 1794 on the remains of the repair and storage facilities established there during the Revolution. The system of government musket contracts made with private individuals and financed by advances of government funds had established musket and rifle factories all over New England. On the list of twenty-eight musket contractors under the Act of Congress of July 5, 1798, only eight are not New Englanders, and of the nineteen contractors for 1808-model muskets, eleven had New England shops.

Had these factories produced only the muskets and rifles which armed our soldiers, they would be worth remembering. But they also produced a less tangible but far more important product, for in them was largely developed the technique of manufacture by means of interchangeable parts on which depends our entire system of

147

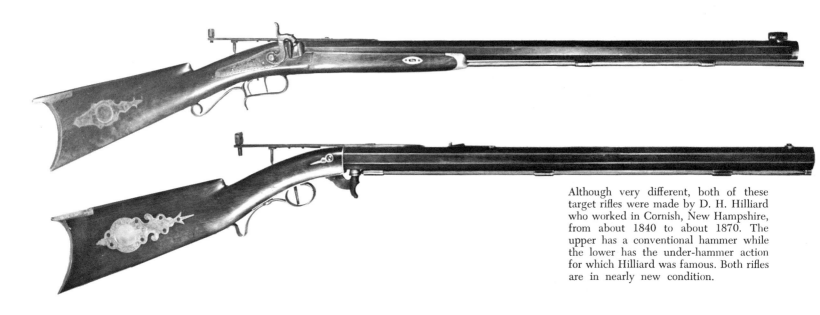

Although very different, both of these target rifles were made by D. H. Hilliard who worked in Cornish, New Hampshire, from about 1840 to about 1870. The upper has a conventional hammer while the lower has the under-hammer action for which Hilliard was famous. Both rifles are in nearly new condition.

A so-called "Kentucky" or Pennsylvania rifle by J. Demuth, probably made c. 1810. A fine example of the long, handsome, highly developed American rifle, originally the specialty of Pennsylvania German gunsmiths. This one is equipped with a fine English lock with roller frizzen and rainproof pan, and has an unusually pleasing patchbox.

A buggy rifle, c. 1860, by J. J. Eastman of Concord, New Hampshire. The case probably did not come with the gun. These miniature target rifles were intended for the enthusiast who did not want to carry the larger and clumsier target rifles along on a trip; thus the name "buggy rifle."

A Hall's patent breechloading "Kentucky" rifle, altered from flintlock to percussion, with detail above showing the breech open. For comparison, a Hall's military rifle, model 1819. John H. Hall of Yarmouth, Maine, patented this system in 1811. Very few of the specimens made privately have survived, and the upper rifle is one of the rarest American shoulder arms.

mass production. This technique was probably devised by Eli Whitney of New Haven, was fostered and developed by government arsenals and private contractors, and was taken over by the machine-tool builders, who themselves sprang in many cases from the firearms industry. As a contribution to American industrial development, it is hard to overestimate the importance of this technique.

As the factories made muskets by the thousands, developing a true industry, the craft tradition was ably carried on by individual gunsmiths. These private gunsmiths—or more properly gunmakers, since they were fully capable of making a complete rifle even if most of them didn't often do it—catered increasingly to the specialist target-shooter. It was already true in 1800 that four-footed game was vanishing in all but the wilder parts of New England, and there are not nearly so many hunting rifles by New England makers remaining today as there are, for instance, by New York Staters. But men were increasingly finding enjoyment in shooting at the mark, and as the century went on, more and more highly developed target rifles were made in New England towns. D. H. Hilliard and J. I. Eastman, examples of whose work are shown, were only two of a long list of gunmakers of the mid-century. Some

of these artisans represent in many ways the pinnacle of the American craft. They could produce rifles superior in accuracy to any in the world and equal in finish to all but the finest English and Continental work.

Through the same years, many foreign guns were imported. The private citizen of means, wanting a fine fowling piece or pistol, generally turned to English or perhaps Belgian work. The flintlock pocket pistols illustrated are plain-finish guns by H. W. Mortimer of London, the maker who held the royal warrant from George III, and might well have been owned by an American gentleman with English connections. Guns of this quality would probably have been ordered through an English factor, or by the customer himself while on a trip to London.

The collection of firearms at Old Sturbridge Village is a general one, but a thread of New England significance runs through it. It displays the work of New England gunmakers and the arms that influenced their work, as well as the guns owned and used by New England soldiers, farmers, hunters, and gentlemen. Few men, when they walk into the gunshop at the Village, fail to feel the thrill which firearms traditionally give Americans.

Water color and needlework on silk. The tree trunks and foliage are embroidered; the rest is meticulously painted to give that effect. Acquired in Brunswick, Maine.

The collections: country art

BY FRANK O. SPINNEY

THE NEW ENGLAND FARMER and villager of the early nineteenth century depended for the most part upon his own muscular energy to extract a living from the land that was his. With primitive equipment, this was an arduous and time-consuming task for himself and his family. Still, like other men, he had aspirations and talents that were not completely satisfied by the mere attainment of a modestly comfortable subsistence. He was active intellectually, spiritually, and in some instances, one might venture to say, aesthetically. Within the fashions and traditions of his time, he sought expression and pleasure in a well-conceived building, a skillfully made chair, and even occasionally in the less functional areas of what can be termed art.

The investigations and collecting activities in the field of such country art during the last two decades have radically revised the long-held concept of the early rural home as drab, austere, and colorless. Now, perhaps, we have gone too far in the other direction and tend to pic-

ture the Yankee farmhouse as sparkling with vivid hues, exciting with painted walls and furniture, its rooms lined like a gallery with portraits, needlework, pictures, memorials, and every sort of homegrown "Art."

There is no doubt, however, that inclination and an encouraging economic margin fostered artistic expression in rural areas. Some good and some horrible to behold, the results ranged from simple embellishment of functional objects to the most conventional forms of portraiture. In the best that emerged from the period, whether the work of craftsmen, schoolgirls, amateurs, or artists, there is an appealing, even striking quality.

At Old Sturbridge Village one finds examples of this country art in the furnishings of the buildings, in the shops of the artisans, and in the collections. The purpose of what is being collected in this sphere—and it has very modest beginnings—is to show representative examples, not the uniquely best, nor certainly the poorest, of what New England created or enjoyed.

Tavern sign, probably from New Hampshire. On the reverse is a painting of a man on horseback.

Water color on paper attributed to Richard Brunton (c. 1760-1832), Connecticut and Massachusetts engraver, silversmith, and artist. One of a pair.

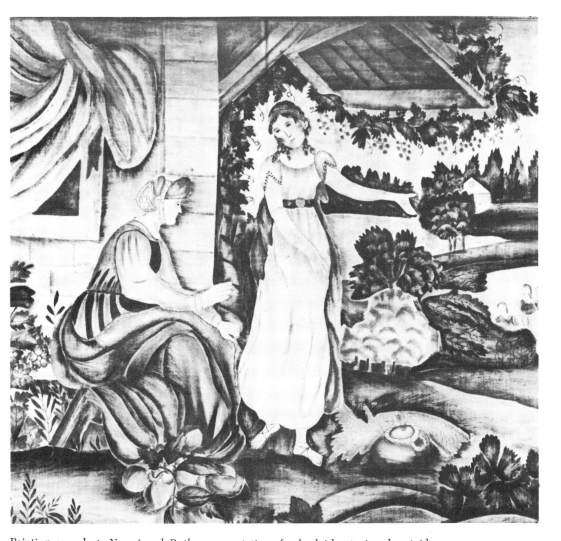

Wooden wrench for tightening cords of a rope bed. 13¾ inches tall. Purchased in New England, although this crude but forceful whittled carving suggests almost anywhere else. However, a stoneware jug modeled in the form of a similar grotesque head (109, *Early New England Potters and Their Wares* by Lura Woodside Watkins, Cambridge, 1950) is known to be of New Hampshire origin.

Painting on velvet, *Naomi and Ruth*, representative of schoolgirl art. An almost identical picture is in the Abby Aldrich Rockefeller Folk Art Collection at Williamsburg.

Dr. Jesse Kittredge Smith (1804-1851), of Mont Vernon, New Hampshire, painted in 1842 by "E. Woolson" (inscribed on back of canvas). Ezra Woolson (1824-1845) is listed as a portrait painter of Fitzwilliam, New Hampshire.

Oil-under-glass portrait of the Reverend Joseph Pope (1746-1826), of Spencer, Massachusetts. Attributed to Benjamin Greenleaf (1786-1864), New England limner.

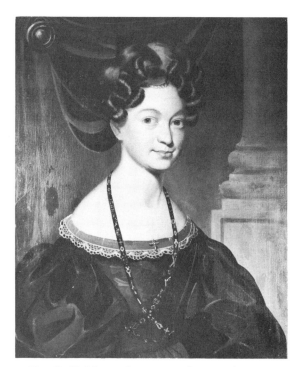

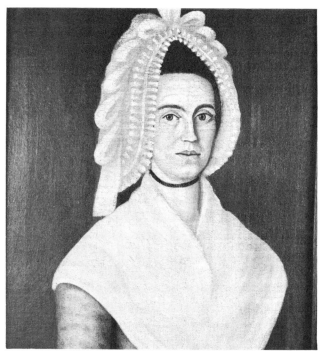

Mrs. D. H. Moor, oil on canvas, by an unknown painter; a lively likeness, executed with competence and a certain dash. Mid-nineteenth century.

Mrs. John Avery (probably Elizabeth Tracy Avery of Norwich, Connecticut), oil on canvas; unknown artist. The stylized costume and strong but wooden features are seen in many portraits. Late 1700's.

Carving of pine . . . *by John H. Bellamy, at 77 Daniel Street [Portsmouth, New Hampshire], January 1859,* according to a note on the back. Known as a cathead, a decoration for the end of the "cat" or projecting timber near a ship's bow, over which the anchor chain was hauled. 14 by 13 inches.

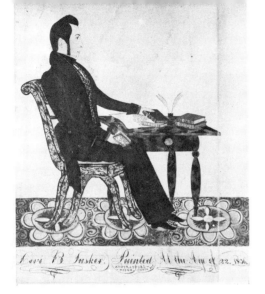

Typical water-color portrait by Joseph H. Davis; inscribed *Levi B. Tasker. Painted at-Strafford-Ridge. March 20th At the age of 22. 1836.* Strafford Ridge is in New Hampshire.

Miniature water-color portrait (4 x 3½ inches) of Nancy Wood Closson. The profile pose of the subject, seated in a curlicue chair with her head in the clouds, is typical of the work of James S. Ellsworth (1802-1873), who painted many miniatures in Connecticut and western Massachusetts.

Overmantel wood panel depicting Moses Marcy (d. 1777) of Sturbridge, Massachusetts. Considered to be pre-Revolutionary and thus one of the earliest of such panels extant.

Genre piece by William Matthew Prior, better known for his conventionalized portraits in oil. At least one replica of this exists, suggesting that Prior made many, as with his Washington portraits on glass. Initialed *W. M. P.* in lower right corner.

Carved pine medallion portrait of Washington, painted to resemble wax; attributed to Samuel McIntire of Salem. This and two similar ones known may be some of the *8 Medallions of Washington, $2.00* listed in McIntire's inventory at his death, 1811. 15½ x 11 inches.

Portrait of James Olmsted (1779-1823) by an unknown artist. Oil on canvas, 29¼ by 25 inches.

Rebecca Tufts Whittemore of West Cambridge, Massachusetts, painted by Ethan Allen Greenwood (1779-1856). The portrait is listed in his diary as having been painted in 1812. Signed and dated *Greenwood pinxt 1811.* Oil on canvas, 25¾ by 19¾ inches.

Frederick Kilner, aged 41. Painted by Wm. F. Ainsworth, Barre, Mass., Aug. 1839 is inscribed on the back of this vigorously executed oil on canvas. William Fisk Ainsworth (1808-1853), hat manufacturer, is hitherto unrecorded as a painter.

Carved wooden eagle, painted and gilded. A spirited interpretation of an ever-popular motif.

Henry Ford's Museum and Greenfield Village

HENRY FORD (1863-1947) was the first great pioneer to combine the collecting of Americana with the preservation of historic American buildings. His collecting activities began before he and Mrs. Ford moved from Detroit to rural Dearborn in 1914.

His first preservation project, the original Ford homestead, was begun in 1919; it was followed by the purchase and restoration of Longfellow's historic Wayside Inn in 1923 and of Botsford Inn near Detroit in 1924. The keen interest in American history which Henry Ford developed as a result of these three preservation projects continued right up to the day of his death.

His great cultural enterprise at Dearborn, the Edison Institute, is a non-profit educational corporation comprising his American history museum, Greenfield Village, and the Greenfield Village Schools. Though visited each year by nearly a million persons — a number approximately equaling the combined total attendance at similar institutions — it has not been adequately known or accurately appraised.

In organizing the Henry Ford Museum and Greenfield Village before their dedication in 1929, Mr. Ford had specific ideas and purposes which made, and still make, extremely good sense. He devised simultaneously both an *indoor* and an *outdoor* museum.

He particularly prized both objects and buildings that had historic associations. Among antiques, for example, he was delighted to acquire a high chest of drawers which belonged to Mary Ball Washington, a card table once owned by John Hancock, a set of furniture from Abraham Lincoln's home in Springfield, Illinois. When it came to buildings, he sought to save those in danger of being destroyed. "I am collecting the history of our people as written into things their hands made and used," Ford said ... "a piece of machinery or anything that is made is like a book, if you can read it."

The Henry Ford Museum is far more than an industrial museum. The three major divisions of its collections — Decorative Arts Galleries, Street of Shops, and Mechanical Arts Hall — cover almost every phase of American history. They were assembled with greatest care and understanding, and masterfully organized. To explore this vast "museum of collections" is to trace the progress and development of America's arts and industries.

In the Decorative Arts Galleries at the front of the museum visitors see chronologically the whole development of American furniture and decorations from the Pilgrim century to the twentieth, period by period and style by style. The Street of Shops — the first such major installation in an American museum, begun in 1931 — shows in twenty-two shops numerous crafts and trades of the late eighteenth and the nineteenth centuries.

In the great Mechanical Arts Hall, covering eight acres of virtually undivided space, exhibits related to agriculture, craft, industrial machinery, steam and electric power, communications, lighting, and transportation trace in broad strokes the progress of America from a frontier agricultural nation to a mighty industrial world power.

Greenfield Village, a peaceful community of yesterday, with its two hundred acres of naturalistic beauty and some one hundred seventeenth-, eighteenth-, and nineteenth-century homes and workshops, was named for the township of Greenfield near Dearborn, where Mrs. Henry Ford was born and reared. It is like no one American village, yet contains the chief elements of most. In fact, its diversity of period, form, and region is the very factor which makes it at once so believable and so attractive. Major categories of the village structures are: the street of early American homes; the buildings around the village green; early nineteenth-century handcraft shops; late nineteenth-century power-operated plants; and homes and shops of famous Americans.

The policy of the Henry Ford Museum and Greenfield Village — based on Mr. Ford's own aims — is to collect, preserve, exhibit, and publish all forms of Americana. In application, this means concentration upon objects made by Americans or, especially in the early periods, used by them. "When we are through," he said, "we shall have reproduced American life as lived; and that, I think, is the best way of preserving at least a part of our history and tradition."

Five basic concepts make Henry Ford's Museum stand out in sharp contrast to other Americana museums founded in the 1920's and later. He planned that it should (1) range in time over all periods of our history, (2) cover many states and regions of our country, (3) represent aspects of both city and country life, and (4) demonstrate accessories and products of every social and economic group. Finally, (5) he had an abiding respect and admiration for the individual American — Revere, McGuffey, Lincoln, Burbank, or Edison — whose product of hand or mind had influenced large numbers of people and who, like himself, had helped to change the face of America.

Clearly, he applied all these criteria in selecting the milestones of American history for exhibit in the Henry Ford Museum and Greenfield Village.

DONALD A. SHELLEY, *Director*

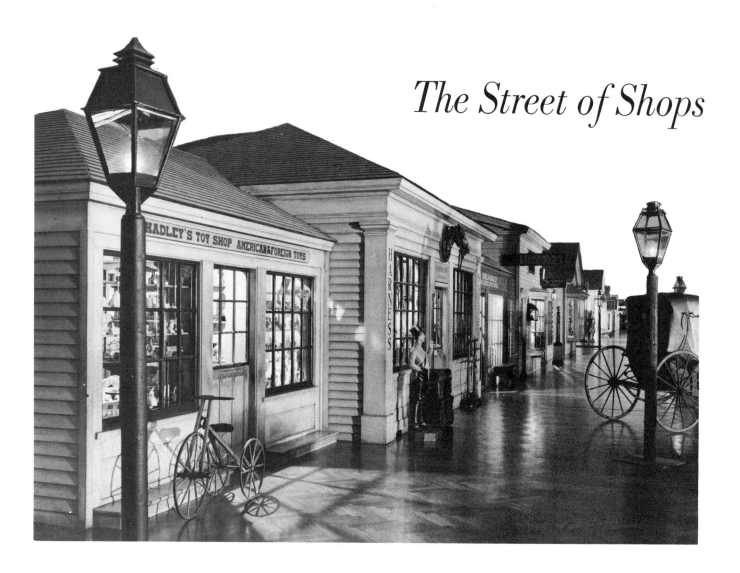

The Street of Shops

THE MOST POPULAR SECTION of the museum is its Street of Shops, largely the conception of Edsel Ford. Here in twenty-two installations visitors can see the crafts and trades of the America of yesterday, with related groups of smaller objects which do not lend themselves so well to exhibition in the open. The illusion created by these displays of the tools and products of the hand craftsman is heightened by working artisans using antique tools to reproduce items of the past; in some instances automatic voice repeaters explain the craft illustrated, or give a brief account of a building. Some shops, such as the Taft black-smith shop, are closely patterned after an original building, and appropriate shop figures, shop signs, and weather vanes, many of them original, are used throughout. In addition to the fifteen shops shown here and elsewhere in this section, as well as in color, the Street—America's first exhibit of this type—has establishments of a wheelwright, a tinsmith, a barber, a cabinetmaker, a carpenter, a dressmaker, and a tintype artist. The sign of the last-named proclaims "We may yet catch the shadow ere the substance fades"—an admirable summing up of the purpose and achievement of the Street.

EAST INDIA SHOP. The East India merchants whose wealth built so many fine houses in Salem, Boston, and Philadelphia during the last century might have furnished their offices with such exotic reminders of far-off places as are seen here. Chinese and China-trade porcelain, scrimshaw, tea canisters, ship and gun models, navigational instruments, beautifully carved chairs from eighteenth-century England drawn up to an elaborate, possibly Irish table, the simple accountant's desk and the all-important iron safe—all speak of the adventure and the profits in an important chapter of American history.

RICHARDSON BOOT AND SHOE SHOP. A. Richardson's shop front and his sign date from the eighteenth century, but the boots and shoes inside are those that might have been sold by a descendant of the second half of the nineteenth century. Men's boots and shoes with soles attached by means of wooden pegs are displayed here, along with delicately hand-stitched fabric and leather footgear for ladies. The cash register is a very early model which records the sale on a paper tape but does not have a cash drawer or a totaling mechanism.

CORNER DRUGSTORE. Some of us can remember drugstores that looked much like this one, but there is excellent precedent for putting it in a museum: George Griffenhagen (*Pharmacy Museums*) tells us that there was a complete apothecary shop in the Dresden Museum as early as the seventeenth century. This almost perfect example of the Victorian drugstore (the interior is from a store in New Brunswick, New Jersey) is more closely related to the apothecary shop than it is to the type which succeeded it and which placed more emphasis on the soda fountain and other activities than on drugs. Many of the patent medicines on the shelves were prepared by Detroit manufacturers.

THE WOODCARVER'S SHOP was designed simply as a display room for the products and tools of the craft. Nineteenth-century woodcarvers were associated with many other trades—they might be ship's carpenters, cabinetmakers, builders, or architects as well—and got what training they had from as many different sources. The shop signs, picture frames, decoys, furniture ornaments, and classic capitals shown here give some idea of the variety of their output. Most of it is anonymous but E. A. McKillop of Balfour, North Carolina, made and signed the folk piece in the corner.

CIGAR-STORE INDIAN carved by Arnold and Peter Ruef, father and son, whose woodcarving shop was located in Tiffin, Ohio, in the 1880's. "Seneca John" belongs in the category of hunting chiefs, according to the classification of these shop signs suggested by Christensen in *Early American Woodcarving*. Costume and pose are conventional, but the carving is far superior to that of most such figures. Height 7 feet 3 inches.

THE ATWOOD VIOLIN SHOP was set up by a violin maker who for years kept Henry Ford's collection in repair, but it was named after a shop kept by Samuel Atwood in Haverhill, Massachusetts, during the early years of this century. This view of a corner gives an idea of the extent of the museum's collection of musical instruments. Outstanding among the exotic specimens hanging on the wall is a seventeenth-century serpent, forerunner of the double bassoon, at the far right; the lute-shape instrument below it is an eighteenth-century hurdy-gurdy. In the right foreground is a 'cello maker's workbench; the 'cello at the left was made about 1720 by Santo Seraphin (1678-1737). Elsewhere in the museum may be seen labeled violins by Stradivarius, Guarnerius, Amati, and Guadagnini.

Three examples from the museum's fine group of music boxes. *From the left:* marked ASTOR COMPANY, 79 CORNHILL, LONDON, c. 1800; by Mermod Frères, St. Croix, Switzerland, 1890 (with castanets, dancing doll, bell ringer, and tambour-playing dolls); Orchestral Regina, New York City, 1903.

HADLEY'S TOY SHOP contains every type of toy to delight a child—or, for that matter, most adults. The range and variety of the collection are indicated by the large doll and the bulldog seen through the open doorway. Made of corn husks folded over the cob and tied to form the head, this simple doll represents what must surely be the earliest native American type; the much later and more sophisticated bulldog is spring actuated.

Of increasing interest to collectors are the penny banks produced in this country in greatest quantity from about 1875. Many of these banks are simply painted cast-iron receptacles for coins, but the most desirable (illustrated in this group from the toy shop) are the realistically decorated ones in which some amusing action rewards the practice of thrift. In the Tammany bank (bottom row, second from left) the politician nods while his arm drops a penny into his pocket. The baseball bank (second row, center) has a pitcher who tosses the coin, a batter who swings and misses, and a catcher who receives and deposits the coin.

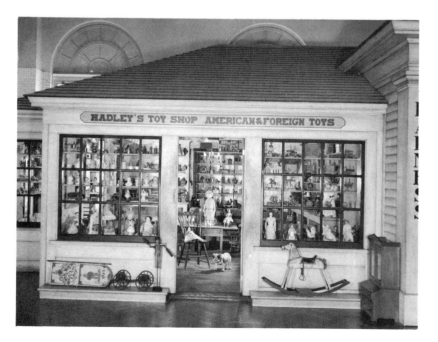

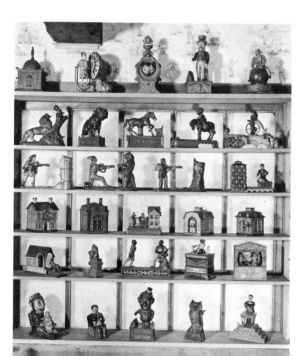

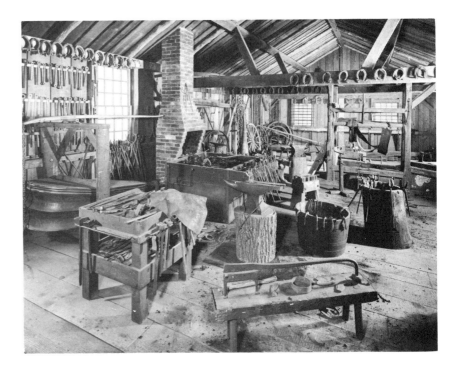

TAFT BLACKSMITH SHOP. The tools and other equipment in this shop came from Millville, near Uxbridge, Massachusetts, where they were used by Caleb Taft about 1830. Longfellow is known to have visited Taft's shop, and it is believed to have furnished the inspiration for his familiar poem on the village blacksmith. The framework at the right rear, under the row of horseshoes on a rafter, is an ox sling. Oxen, who can maintain their balance only on four feet, must be suspended in such a contrivance to be shod.

MORSE LEATHER SHOP. The full set of late nineteenth-century harness maker's tools on view in this combination workshop and display room has been put to actual use in restoring and repairing the museum's collection of horse-drawn vehicles. The large assortment of horse brasses, whips, harness, and brass-studded leather trunks dates from about 1850 to the end of the horse-and-buggy era.

THE JOHN BROWN GUN SHOP is patterned after one kept by John Brown and his son Andrew from 1840 until 1872 at Fremont, New Hampshire; the handsome Victorian Renaissance counter would have been very much à la mode at the end of this period. Like several others in the Street of Shops, the gun shop consists of two sections, one for tools and machinery used in the trade and the other a retail display space. The guns on view include early American military pieces, Pennsylvania rifles, and repeating firearms by Samuel Colt and others. Many gunsmiths also practiced the closely allied trade of locksmithing, as did the proprietors of this shop.

Some beautifully decorated examples from the museum's collection of "Kentucky" rifles. Most guns of this type were actually made in Pennsylvania by smiths of German extraction; the name so generally applied to them is traceable to the vital role these long hunting guns played in the early settlement of the region west of the Cumberland. *Top to bottom:* Percussion rifle, 50 caliber, lock marked GEORGE W. TRYON, PHILADELPHIA (1830-1837); half-stock percussion rifle, 32 caliber, stock engraved *G.S.* (c. 1845-1867); heavy target rifle, octagonal barrel, c. 1810-1825; percussion rifle, 45 caliber, octagonal barrel, lock marked T. LOVELL (c. 1830-1850); flintlock rifle, lock marked EDMUNDS—WARRANTED, stock engraved *Thomas Hess* (c. 1810-1825); percussion rifle, octagonal barrel, c. 1815-1825; flintlock rifle, octagonal barrel, c. 1825; half-stock percussion target rifle, 50 caliber, c. 1870.

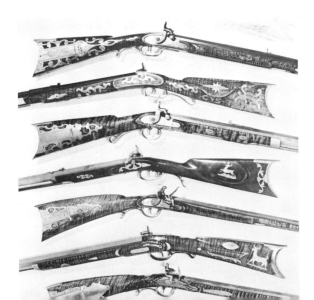

NOYES HORN COMB SHOP. According to *Comb Making in America* (Bernard W. Doyle), the founder of the comb industry in this country was a Noyes—one Enoch, who lived in Newbury, Massachusetts, in the second half of the eighteenth century; other members of the Noyes family were also important contributors to the growth of the industry. Another name that occurs in the early records is that of Follansbee; the tools shown here were acquired from the Walter Follansbee Comb Shop, which still stands in West Newbury. Large manufacturing concerns developed from beginnings in small shops like this one where horn and tortoise-shell combs were made. Horns were boiled in vats, separated into sheets, and pressed between iron plates to form the sheets of translucent material on the shelves at the left. The foot-powered lathe was used for sawing and buffing operations, and a variety of small hand tools for piercing and carving. Tortoise shell (really from a variety of sea turtle) was used for such elaborate back combs as those in the window.

ISABEL BRADLEY MILLINERY SHOP. Most of the hats here belong to the period of the Victorian shop itself, but there are a few earlier models. For instance, the calash (from the French *calèche*, a type of carriage with a hood that can be thrown back) on the right edge of the table was a favorite with ladies of the late eighteenth century; because it could be pulled forward to hide the face it was also called a "bashful bonnet." Such fashionable trifles as hatpins, buttons, fans, and fancy ribbons are also "stocked," and there is a collection of bandboxes: the one at the left of the top shelf is in the Castle Garden pattern.

Also on the Street of Shops, but not illustrated, is a dress shop where more of the museum's costume collection is on view.

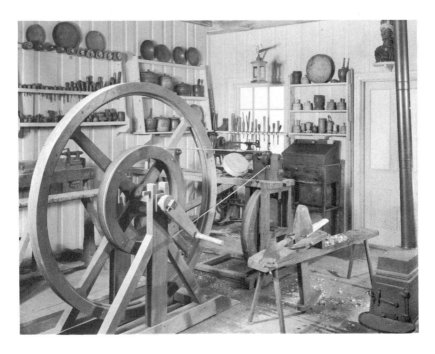

H. CARD'S TURNER'S SHOP. At a time when wood supplied many more articles for daily use than it does today, the turner was a very important member of the community. Several types of hand- and foot-powered lathes, used since ancient times to make the simple "treenware" displayed on the shelves, are exhibited here. The shaving horse in the right foreground was used to hold billets (small sticks of wood) while they were being rough-shaped with a draw knife. Besides a wide variety of wooden utensils for household and farm use, this craftsman also produced bedposts, chair rungs, balusters, and all sorts of other turned articles.

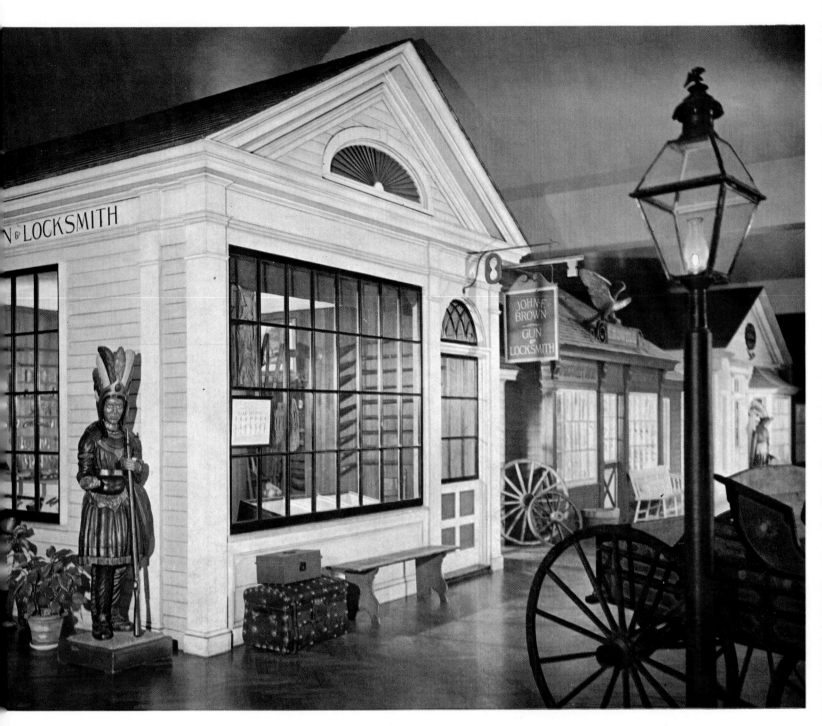

THE STREET OF SHOPS, HENRY FORD MUSEUM

(See page 156)

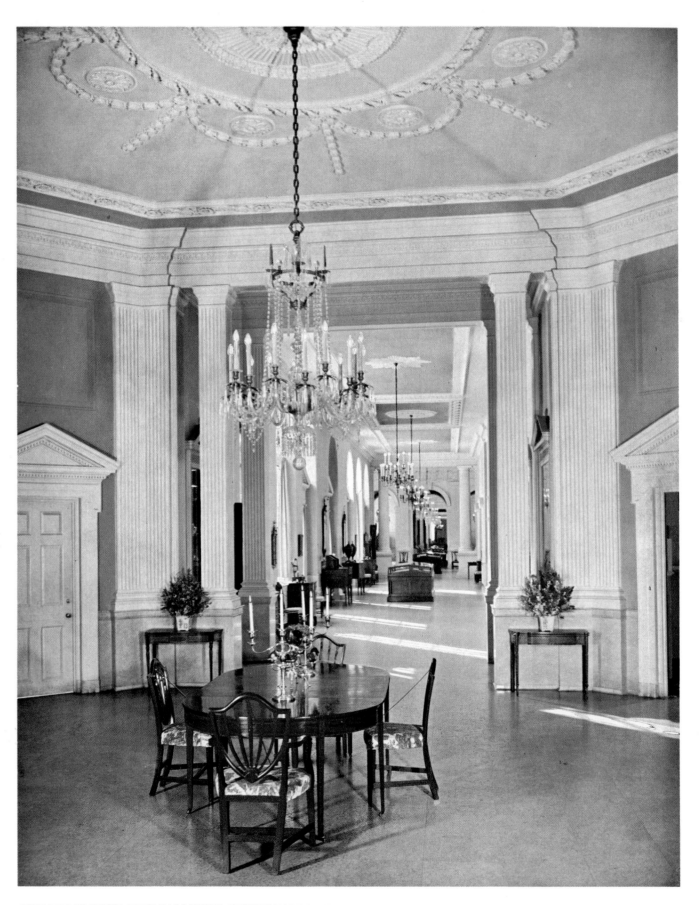

THE DECORATIVE ARTS GALLERIES, HENRY FORD MUSEUM

(See page 155)

The furniture

OF THE FURNITURE COLLECTIONS at the Henry Ford Museum it may be said without exaggeration that here are more examples of fine American cabinetmaking giving equal representation to the successive styles from the seventeenth century through the Victorian period than in any other museum. An emphasis on the whole development is seen in the initial collection formed by Henry Ford in the 1920's and 1930's. His interest in American furniture, already evident by 1914, was increased and sustained by his activities in restoring and preserving historic sites. Many pieces came from well-known early collections, including those of F. W. Fuessenich, Dr. William H. Crim, George S. Palmer, Luke Vincent Lockwood, and Louis Guerineau Myers, or appeared in the two greatest of all American furniture sales, those of the collections of Howard Reifsnyder (1929) and Philip Flayderman (1930). Historic pieces in the collection include examples owned originally by Sir William Pepperell (1696-1759), Mary Ball Washington (George Washington's mother), John Hancock, General Joseph Warren, the Brenton family of Rhode Island, the Schuylers of Albany, and Abraham Lincoln. All these are intrinsically important as examples of fine cabinetmaking besides being historically significant. Noteworthy are inscribed and labeled examples, such as the Hannah Barnard press cupboard, exceptional in its painted decoration of geometric type, rare for early New England; Hadley and Guilford chests with initials of their original owners; labeled works by Edmund Johnson of Salem and Michael Allison of New York. Also important is furniture which can be attributed on stylistic grounds to the Townsend-Goddard cabinetmakers of Newport; William Savery, Thomas Affleck, Benjamin Randolph, and James Gillingham of Philadelphia; Samuel Prince, Gilbert Ash, Duncan Phyfe, and Charles Honoré Lannuier of New York; and, from the Boston-Salem area of Massachusetts, John and Thomas Seymour, Samuel McIntire, and Stephen Badlam.

1. New England banister-back armchair of curly maple painted black; ramshorn arms (ANTIQUES, November 1936, p. 207); c. 1690. The broad top rail is deeply carved with vigorous scrolls (see detail). *At right,* a Flemish-style maple armchair, said to have belonged to Colonel Peter Schuyler, first mayor of Albany and commissioner for Indian affairs of New York. The large gate leg table (Flayderman sale, 1930, No. 465), with single drawer in frame, offers an unusually early example of the use of mahogany in America, c. 1730-1740; it presumably came from the Joseph Reynolds mansion, Bristol, Rhode Island, which was Lafayette's headquarters in September 1778.

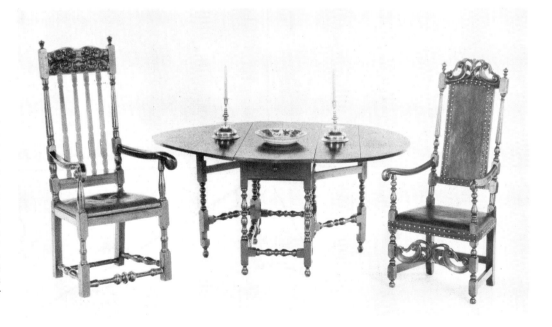

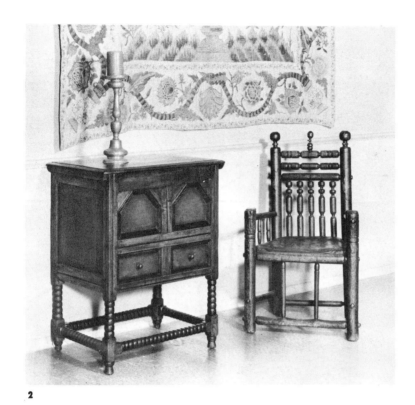

2

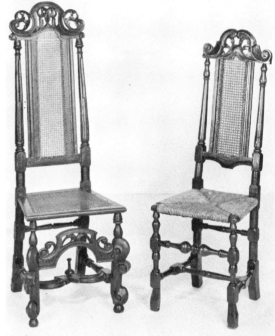

3

4

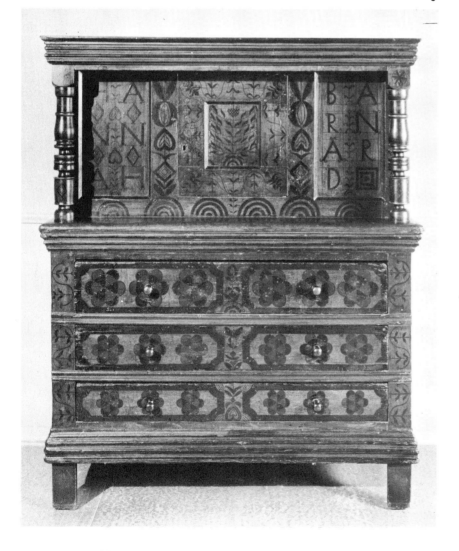

162

5

2. Seventeenth-century pine and maple paneled chest (Lockwood sale, 1954, No. 490); the pine lid opens over a deep well. The form, an early attempt to design a small high chest, disappeared with the arrival of the more practical chest of drawers. The Brewster-type oak armchair has heavy posts indicating an early date, c. 1640-1660. The seat frame is formed of five spindles, a detail to be seen in Nutting's illustration of the chair (*Furniture Treasury*, Vol. II, No. 1816). Formerly in the Fuessenich collection. An Indian palampore, c. 1700, painted and quilted, hangs in the background.

3. New England painted press cupboard of exceptionally early date, from the same region of the Connecticut River Valley as the Hadley chests (ANTIQUES, April 1934, frontispiece; November 1934, p. 167; April 1936, p. 139; Sack, *Fine Points of Furniture*, p. 112; *Art in America*, Spring-Summer 1957, p. 52). Oak and pine. Inscribed with the name of Hannah Barnard, who was born in Hadley, June 8, 1684; married John Marsh 1715; died 1717. Probably made before the end of the seventeenth century. This unusually early and elaborate example of New England painted furniture has a geometric design including hearts and vines, done in polychrome with black. One of a small group with similar decoration of which an example with initials *SW* has belonged since the nineteenth century to the Pocumtuck Valley Memorial Association, Deerfield, Massachusetts. Another example of this type, a chest of drawers which was found in Vermont, was illustrated in ANTIQUES, September 1926, frontispiece.

4. Two Flemish-type caned chairs with scrolled crestings. *Left:* with simplified version of Flemish-scroll front stretcher as well (ANTIQUES, January 1952, p. 16); beech, painted and grained to imitate walnut. This chair, which is probably English, is thought to have belonged to the family of General Henry Dearborn for whom Dearborn, Michigan, was named. The initials *RT* imprinted twice on the left rear leg at the height of the seat are probably those of the maker. C. 1660-1670. The New England chair, *right,* has stiles of beech, cresting of maple, and stretcher of oak and ash (Flayderman sale, No. 461); c. 1690-1710. Owned by Sir William and Lady Pepperell of Kittery, Maine.

5. Massachusetts stretcher table with oak frame, sausage-turned maple stretchers and pine top; 1680-1700 (Lockwood sale, No. 321). The oak and pine desk box (Lockwood sale, No. 489) is remarkable for its half-octagon shape; carved with lunettes enclosing a foliated design seen on seventeenth-century chests. Illustrated in Lockwood, *Colonial Furniture in America*, Vol. I, p. 378, as from Greenfield, Massachusetts.

6. Connecticut "sunflower" or "Hartford" two-drawer chest; quartered oak with pine lid, back, and bottom (ANTIQUES, August 1922, p. 77; Sack, p. 109). Split spindles, bosses, and drawer pulls are of ebonized maple; the moldings framing the panels are painted red; c. 1680. The deep carving is on a punched ground.

7. This Guilford chest (so called because a number have turned up in the vicinity of Guilford, Connecticut) is of oak, painted dark green (ANTIQUES, August 1922, p. 78; September 1935, p. 111), with an emblematic design of crowned Tudor rose and thistle of Scotland which appears also in book ornament of the seventeenth century. Related chests are in the Metropolitan Museum and at Winterthur, and there is one in the Acton Library, Old Saybrook, Con-

6

7

necticut, which has recently been noted in *The Cabinetmakers of America* by Ethel Hall Bjerkoe as having a long history of ownership in Old Saybrook. She also records a seventeenth-century cabinetmaker, carver, and painter, Charles Gillam, working in Old Saybrook (d. 1727), and these two facts may provide a clue to the origin of Guilford chests although no documented example of Gillam's work is known.

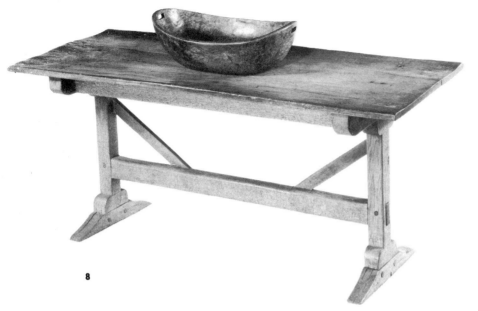

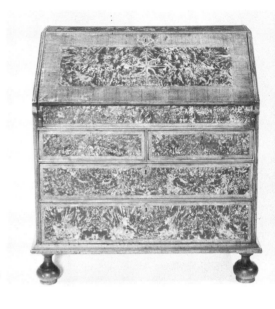

9

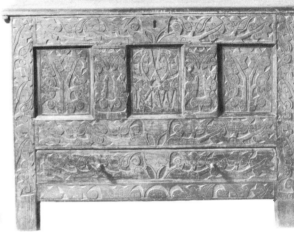

10

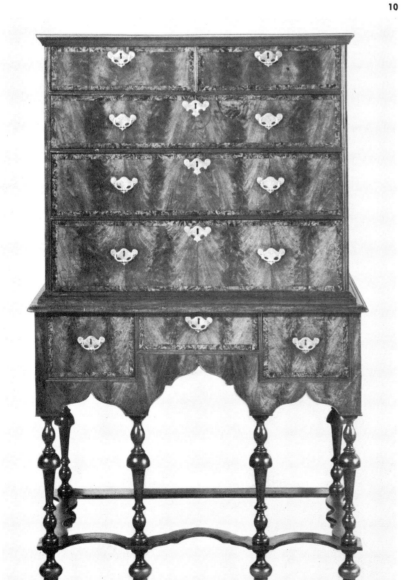

11

8. Massachusetts trestle table of oak with maple top composed of a single board; c. 1650. The well-molded feet are in a remarkable state of preservation.

9. Massachusetts William and Mary desk on ball feet; maple with burl walnut veneer on drawers, which are banded with walnut in herringbone pattern. A movable lid in the writing section gives access to a well, or "secret" compartment, with eight small pine drawers. An exceptionally rich piece, belonging to a small group of burl-veneered furniture which must have been made for families of considerable wealth. 1680-1700.

10. The Mary Ball Washington highboy; walnut with crossbanding of burl walnut; maple sides; fully developed William and Mary type, but before the adoption of heavier moldings on top enclosing a drawer. This highboy, according to family tradition, was acquired by the mother of Margaret Whitley Herndon (wife of Edward Herndon of Laurel Hill, near Fredericksburg) at the sale of part of Mary Ball Washington's estate in Fredericksburg, Virginia, in 1789. It remained in the possession of this Virginia family for almost one hundred and forty years before it was sold, in 1926, by the heirs of Robert Herndon Fife of Oaklawn, near Charlottesville—where it had been since 1846. Exhibited at the Chicago World's Fair in 1893.

11. Hadley chest with initials *MW* for Maria Wheelock; oak with pine lid (No. 91 in Luther's *The Hadley Chest*; ANTIQUES, August 1922, p. 77).

12. New England Queen Anne highboy (ANTIQUES, April 1936, frontispiece) with maple herringbone inlay and burl ash veneer resembling tortoise shell; secondary wood, pine. Formerly on exhibition at the Museum of Fine Arts, Boston, and at the Detroit Institute of Arts, 1930. 1720-1730.

13. Philadelphia Queen Anne side chair, *left,* of superlatively fine type, richly carved with a shell on the spiral-scroll crest; applied shell on the concave apron; leafage rather than cabochon on knee indicates date c. 1740-1750 (Reifsnyder collection, and No. 4 of the set which Mrs. George Bissell lent to the Girl Scouts Exhibition, No. 574). The scroll-foot, dished-top tea table, an exceptional piece, is attributed to Newport although the scroll toe has generally been associated with Philadelphia because of its use on one of the Randolph sample chairs. The scroll, however, is known on a Newport card table at Winterthur (Downs' *American Furniture,* No. 347), and the form of pedestal and turnings of the birdcage are distinctive Newport characteristics. On the table are three pieces from a complete service of English Lowestoft with floral decoration in underglaze blue. The New England wing chair, of walnut with rear legs of maple, has outward-scrolling arms and is upholstered in fine eighteenth-century crewelwork in the tree of life design; c. 1720-1740.

14. Philadelphia Queen Anne walnut daybed with double spoon-shape splats (Reifsnyder sale, No. 672). A somewhat similar daybed is attributed to William Savery in Hornor's *Blue Book* (Plate 53). The design of the splat is close to that of two Philadelphia chairs, No. 28 in Downs and No. 556, Girl Scouts Loan Exhibition. 1730-1740.

12

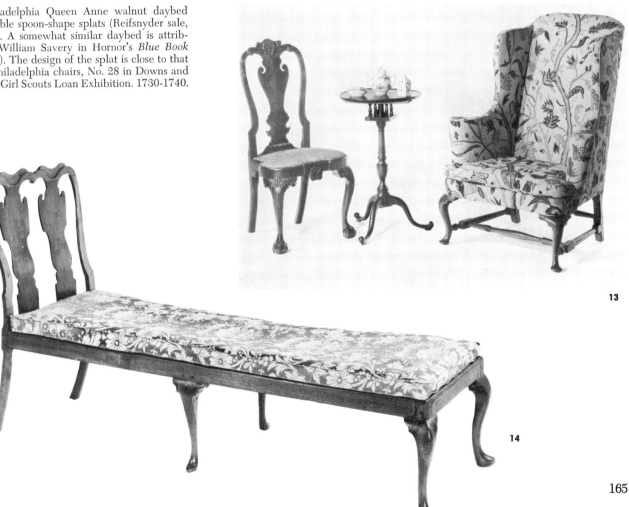

13

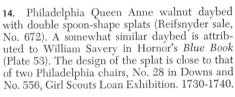

14

165

15

16

17

15. An exceptional Connecticut piece in three separate parts, desk and bookcase on frame; cherry. The Queen Anne pad feet and arched-panel doors indicate an early date. A deeply carved *W* with flourishes on the under side of the bookcase may be a maker's mark; it could also be interpreted as a cipher *JW*, for an owner as yet unidentified, though the location is unusual for such a mark. Particularly interesting is the design of the carved conventionalized leaf panels at the sides of the bookcase, reminiscent of the ornament on late seventeenth-century Connecticut chests. A still more conventionalized leaf pattern or scroll design appears later in Connecticut work, and this unusual piece bridges the gap between the seventeenth century and Chippendale. C. 1730-1750.

16. Very rare Massachusetts mixing table with tile top; c. 1720-1740. Maple, painted black. The top has four five-tile rows of eighteenth-century Dutch blue and white tiles decorated with scenes

from the Old and New Testaments; some of the designs appear more than once. Mixing tables generally had tops of marble, or, still earlier, of slate, and few have survived. A William and Mary example set with tiles is illustrated in Lockwood, *Colonial Furniture*, Vol. II, p. 194. A table similar to the one illustrated, at the Winterthur Museum (Downs, No. 350), is the only other Queen Anne example known.

17. Philadelphia Chippendale dressing table with carved shell on knee, four claw-and-ball feet, inset quarter columns, and finely carved shell and leafage on drawer. The molded edge of the top has incurved corners. The uncarved apron and the shell rather than cabochon on knee suggest an early date. Such a piece marks the beginning of the richest period of Philadelphia furniture, in which mahogany was the usual wood. This is an exception in being of walnut. C. 1750.

166

These four groupings of tables and chairs, one each from Newport, the Connecticut Valley, New York, and Philadelphia, offer interesting regional comparisons. Note the different forms of claw and ball, sculptural in Philadelphia and square in New York. Note also, in general, the flowing lines of Philadelphia; emphasis on square forms in New York (chair structure especially); the characteristic shell of the Townsend cabinetmakers of Newport, placed within a segment of a circle, and Newport's manner of silhouetting the shell on the cresting rail of chairs; the provincialism of Connecticut in retaining the Spanish foot into the mid-eighteenth century—a form developed with vigor and originality on the table illustrated.

18. Newport mahogany dressing table with four pointed slipper feet and early type of shell contained within circular outline. This is strikingly similar to the "mahogany dressing table" mentioned in Job Townsend's bill, 1746, to Samuel Ward, later governor of Rhode Island (ANTIQUES, December 1947, pp. 427, 428; April 1946, p. 230). The museum's dressing table came down in the Brenton family, three of whom were governors of Rhode Island. The Newport Queen Anne walnut side chair with carved shell on the cresting has a label pasted on the bottom: *belonged to Col. Wm. Lithgow in 1756, Llewellyn M. Lithgow's grandfather.* This chair is similar to No. 5, Carpenter's *Arts and Crafts of Newport,* and No. 103 in Downs, and has the same unusual feature of a block on either end of the front stretcher. Brass barber's dish is English, as is the wide-base candlestick which may have been intended for shipboard use; both late seventeenth or early eighteenth century.

19. Connecticut maple dressing table or lowboy with variant of Spanish foot surmounted by heart-shape shield; chamfered, fluted corners; c. 1750 (Sack, *Fine Points of Furniture,* p. 191; ANTIQUES, January 1957, p. 60). New England Spanish-foot maple corner chair showing transition from seventeenth century (as represented by turning of stretchers in William and Mary style) to the eighteenth (seen in the solid, inverted-vase-shape splats); c. 1730.

20. New York mahogany card table of serpentine form favored in New York, with New York's heavy gadrooning; unusual in American work is the carved ruffle carried up from the knee of the cabriole leg over the frieze. C. 1760. The tassel-back side chair is also of New York type, the tassel combined with a ruffle somewhat crudely carved. This chair is dated in an inscription under the seat which also gives the name of the owner: *1757 Philena Barnes.*

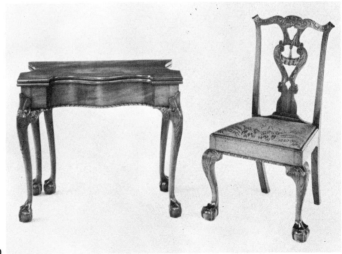

21. Philadelphia Chippendale mahogany card table (ANTIQUES, October 1954, p. 291) with gadrooned serpentine apron, beaded drawer, pierced brackets, cable-molded legs. An almost identical table is in the Karolik collection (No. 62), Museum of Fine Arts, Boston. Both have details known in tables by Thomas Affleck (Hornor, Plates 255, 266, 269). The side chair is of an elaborate type peculiar to Philadelphia. The back is carved like that of the Lambert family chairs (Downs, No. 128), but the seat is plain rather than with carved apron. The Sheffield candlesticks are early, about 1770.

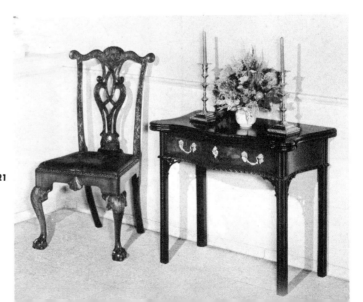

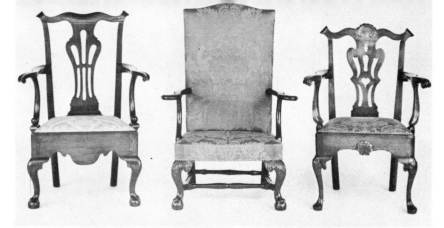

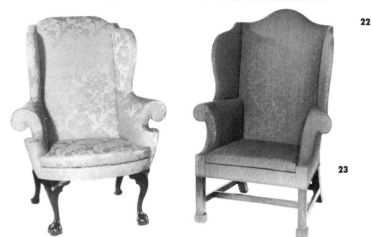

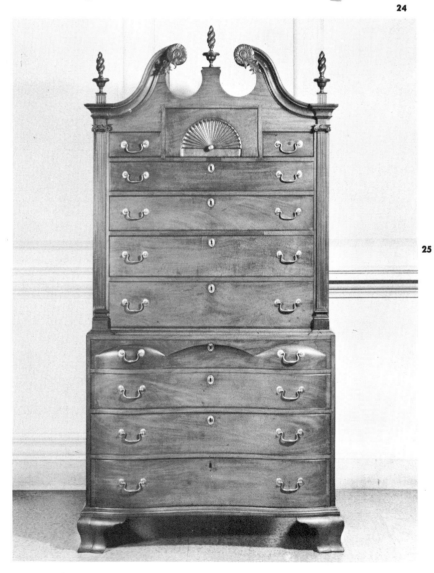

22. Chippendale open-arm chairs. *Left:* a walnut chair dated *1758* on inside of front apron with initials WS (Sack, p. 41). Possibly by William Savery; compare with his labeled armchair (Downs, No. 39). The concave arm supports with a scroll at seat frame are handsomely designed. *Center:* Salem chair with high upholstered back (ANTIQUES, October 1954, p. 293). The shaped arms curve out and are carved with eagles' heads and wings. The low seat is comparable to that of the side chairs of so-called slipper type. This chair is distinguished by handsome carving on the knee of the cabriole and in the execution of the claw-and-ball foot. C. 1750. *Right:* Philadelphia walnut chair attributed to John Elliott, 1760-1780, because of likeness to chairs for Charles Norris (1756) which have similar shell, and also the pronounced scrolls on the knee of the cabriole (see Downs, No. 122, and Hornor, Plates 51 and 309).

23. Philadelphia Chippendale wing chairs. The one on the left came from a direct descendant of the Randolph family and this, with the fine quality in design and craftsmanship, suggests that it may have been the work of Benjamin Randolph; 1760-1770. *Right,* wing chair with Marlborough or straight leg ending in a plinth, a form peculiar to Philadelphia; c. 1775-1785.

24. Exceptionally fine Massachusetts mahogany chest-on-chest which has many points justifying an attribution to Benjamin Frothingham of Charlestown, Massachusetts. The oxbow blocked lower section is the same as that of the labeled desk in the Flayderman sale, now owned by Mrs. Sidney Harwood, shown in ANTIQUES, December 1928, p. 537, and November 1952, p. 395. It has the floral rosettes seen on the labeled chest-on-chest owned by John P. Kinsey (ANTIQUES, November 1952, frontispiece). The leafage dependent from the rosettes is a rich detail found only rarely in American work. It is seen on the Cluett chest-on-chest (Lockwood, Vol. I, Fig. XXVII, and Girl Scouts Catalogue, No. 619), which also has Frothingham details; the shell, for example, is like that on the labeled Kinsey chest-on-chest.

25. Massachusetts Chippendale mahogany bombé or kettlebase chest of drawers, with lower drawers fully conforming to the curved outline of the sides as in the best examples of this form. Others have drawers all of the same width, and the shaping is in the frame, a method of construction which did not require so much skill. The bombé shape appears only in New England work. The claw-and-ball feet show the turned-back talon distinctive of the Boston area. C. 1760. A China-trade porcelain shaving basin with Imari pattern, c. 1740, is flanked by English enameled candlesticks with turquoise panels and floral sprigs on a white ground, c. 1765.

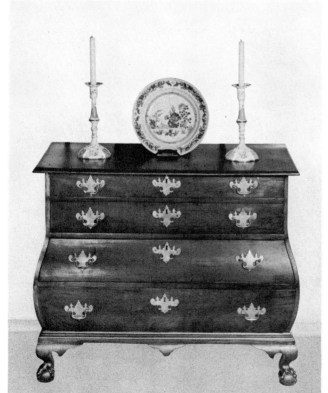

26. *Left:* Newport clock with block-and-shell case by the Townsend-Goddard cabinetmakers. This is an eight-day, weight-driven, hour-strike clock. C. 1785. *Right:* tall clock with works by Christian and Daniel Forrer of Lampeter Township, Lancaster County, Pennsylvania (Flayderman sale, 1930, No. 469: Sack, p. 120), c. 1754-1774. In a walnut case by John Bachman of Lancaster (1746-1829), who came from Switzerland in 1766 and made a number of clock cases for the Forrers, who also came from Switzerland. The style of John Bachman (erroneously called Jacob in earlier accounts, but Jacob was John's grandson and one of five of a furniture-making family) is seen on the hood in the boldly carved leaf scrolls against a punched background.

27. Bracket clocks, unusual in America, may have been something of a specialty with New York makers, for one comparable to this was in the New York furniture exhibition, 1956, at the Museum of the City of New York. The present example, on a contemporary walnut bracket, c. 1775, is signed on the dial *Charles Geddes, New York*. Geddes, who worked in Boston and New York, advertised in 1773 as "clock and watchmaker and finisher from London." The case is veneered in walnut, stands on brass feet and has a brass handle; the dial is brass and there is cast-brass leafage in the spandrels; brass hands. This is an hour-strike, fusee-type movement; a strike-silent dial above. C. 1775.

28. Connecticut block-and-shell slant-top desk, unusual in being of mahogany (cherry is the wood found in other examples of Connecticut Valley block and shell). The front is enclosed in spiral-twisted columns and this feature, with the massive, outer convex shells and inner concave, allies this desk with the chests-on-chest of the Shipman and Bulkeley collections (Connecticut Tercentenary Catalogue, Nos. 220, 223) which have been attributed to the elusive cabinetmaker Aaron Roberts of New Britain, 1758-1831. Because of the exceptionally fine dovetailing comparable to Newport work, the name of John Townsend of Newport, Rhode Island, who was in Connecticut during the Revolution, has recently been suggested for this masterpiece of Connecticut furniture making, but, as Lockwood wrote in the Tercentenary catalogue in 1935, ". . . this subject [Connecticut Valley blockfront] needs further research," and the same may be said today. That this is one of the important examples of the Connecticut blockfront showing strong Newport influence is obvious. C. 1780.

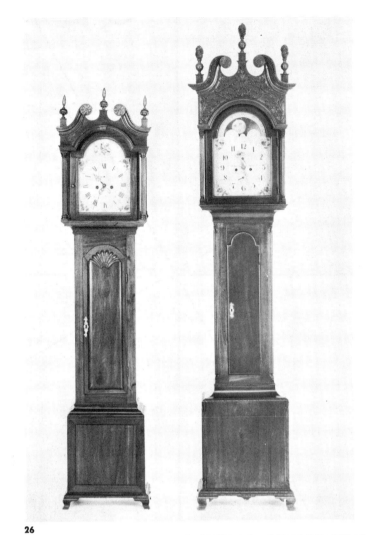

26

27

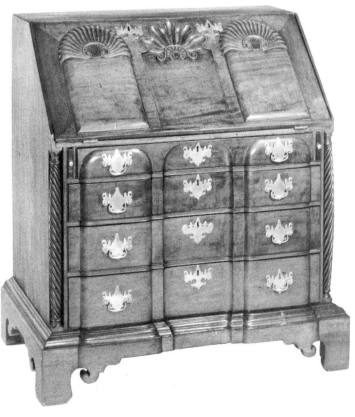

28

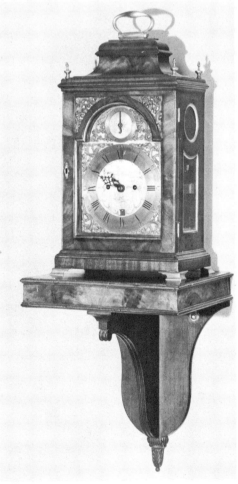

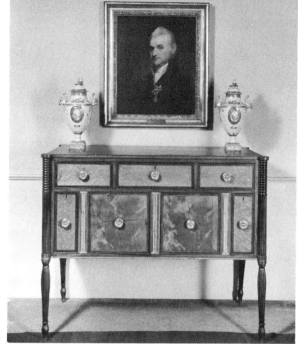

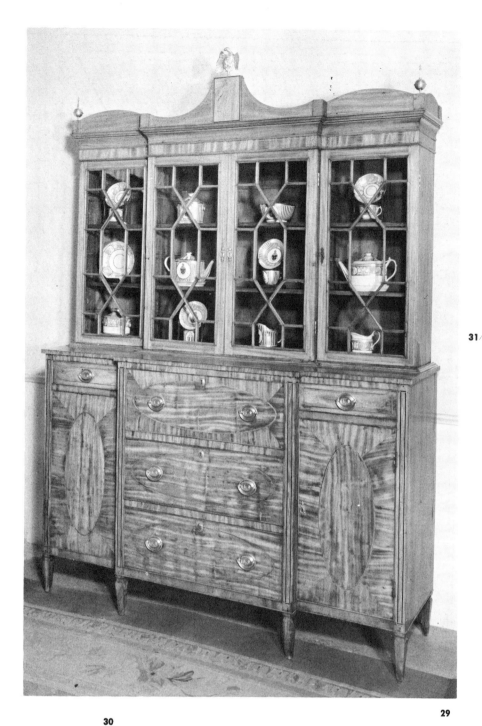

29. "Salem secretary," a breakfront mahogany and satinwood desk and bookcase (illustrated in ANTIQUES for May 1933, p. 170, and August 1935, frontispiece) with paper label of Edmund Johnson of 1 Federal Street, Salem (active 1793-1811), a maker whose work is distinguished by use of finely patterned woods and inlaid oval panels. For a similar labeled breakfront see Lockwood, *Colonial Furniture*, Vol. I, Fig. XLVI. The cabinet contains portions of two Worcester porcelain tea and coffee services, c. 1805.

30. *Left:* Baltimore Hepplewhite mahogany side chair with heart-shape back showing carved sheaf of wheat on three banisters and bellflower inlay. *Center:* New York drapery-back side chair with carved feathers and tassel. *Right:* Massachusetts side chair attributed to Stephen Badlam (1751-1815) of Dorchester Lower Mills, on the basis of a characteristic floral motif seen on signed pieces (ANTIQUES, May 1954, p. 381) and used here on the chair back. All three chairs, 1790-1800.

31. Sheraton mahogany sideboard with bird's-eye maple inlay, attributed to John and Thomas Seymour, as the top edge as well as the bottom show "half-moon" inlay and cupboard doors are flanked by inlaid pilasters, both characteristic of their work. Brass knobs are stamped with a floral design. Boston, c. 1800-1810. The pair of China-trade porcelain urns on marbleized bases have sepia oval medallions showing a fortress in a landscape and floral sprig decoration: c. 1810. Above is Gilbert Stuart's portrait of General Henry Dearborn (1751-1829), in command of the Northern Department during the War of 1812, for whom Dearborn was named.

30

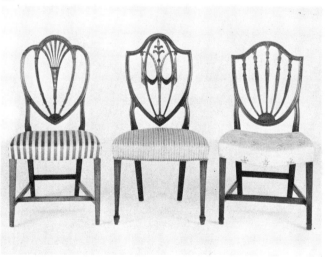

29

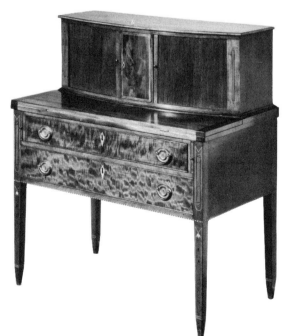

32

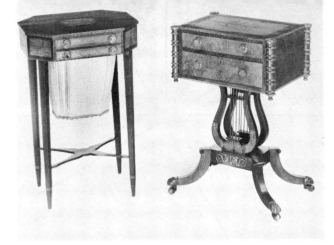

33

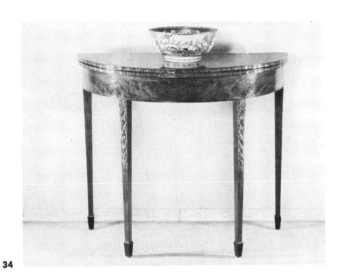

34

32. New England tambour desk with unusual bow-shape front in the tambour section (Sack, *Fine Points of Furniture*, p. 155). A desk of this design is a great rarity. Mahogany with satinwood inlay. 1790-1800.

33. *Left:* Massachusetts mahogany and satinwood sewing table, c. 1800; inscribed under upper drawer *A. Benjamin* (unrecorded as a cabinetmaker). The stretcher is rarely seen on Hepplewhite or Sheraton sewing tables. At *right,* a New York mahogany and maple sewing table with brass mounts in palmette, lyre, and scroll design. Elaborate brass mounts in Empire style like these are found in New York work on labeled pieces by the French-born Charles Honoré Lannuier (d. 1819; ANTIQUES, August 1957, p. 141), to whom this is attributed. C. 1810.

34. Salem mahogany semicircular card table with carving attributed to Samuel McIntire; rosette-carved edge and bowknot, grapes, and leaves on all four legs; may be compared with No. 64, Karolik Collection. 1790-1810. The China-trade porcelain bowl, c. 1770, is decorated with a rare boar-hunting scene rather than the usual fox hunt; the source of the design was an English engraving; the piece was probably made for the English market.

35. New York mahogany card table with stamp of Michael Allison. Two of the legs swivel back when the top is raised. On the back there is the following stamped in a circle: *M. Allison/Cabinet Maker/42-44 Vesey Street . . . [illegible] . . . New York.* The apron is banded in brass, shows a well-carved double swag in the central panel, and has a carved lotus at the front corners; leafage carved on the urn-shape pedestal. Michael Allison was working in New York as early as 1800. Of his labeled pieces, this is most closely related to the style of his neighbor Duncan Phyfe. C. 1800-1810.

36. Mahogany Récamier sofa crisply carved with floral motifs, swags, bows, and tassels on the frame which, with the design of the reeded saber legs ending in brass paw feet, substantiates an attribution to Duncan Phyfe. Although other American makers borrowed the design of the French *Directoire* sofa on which Madame Récamier reclined when her portrait was painted by David, none gave such a functional character to the curve as did Duncan Phyfe, whose rich carving emphasizes rather than obscures the basic form. C. 1810.

35

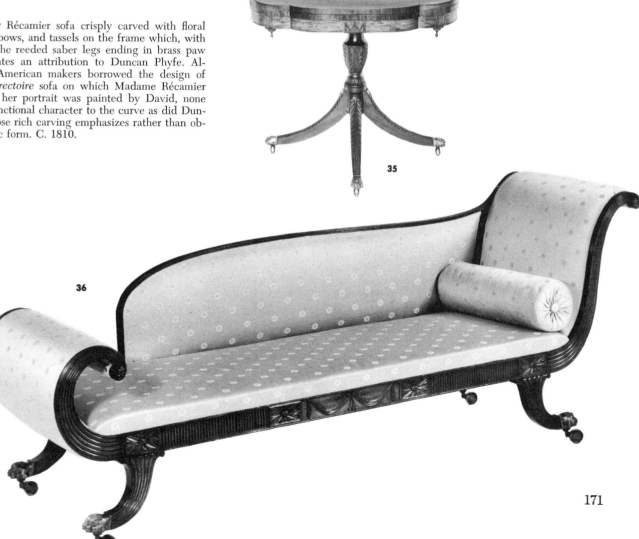

36

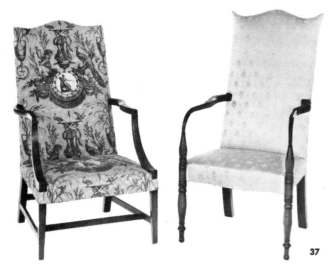

37

37. *Left:* Massachusetts Hepplewhite open-arm chair; mahogany, with tapered, reeded front legs; covered in old mauve and white toile; c. 1790. *Right:* One of a pair of Martha Washington chairs with top and seat of serpentine shape. The reeded arm supports in Sheraton style, which are a continuation of the turned and carved legs, are gracefully formed and finely carved. Sheraton-style "Martha Washingtons" are rare in comparison with those of Hepplewhite design. Massachusetts, c. 1790-1800.

38. *Left:* Pennsylvania clock in inlaid curly maple case; the dial is signed *Jacob Eby/Manheim;* phases of the moon are shown above. Made for Jacob Erisman, in whose family it descended. There is an inlaid oval panel on the front, with an inlaid eagle above the door. Jacob Eby is listed (Brooks Palmer's *American Clocks*) as working 1830-1860, but the finely made case is of earlier date, c. 1800-1810. *Right:* Tall clock, by Leslie & Williams in case probably by Matthew Egerton, Jr., all of New Brunswick, New Jersey; c. 1800. The Monmouth County Historical Association has a Leslie & Williams clock with labeled case by Egerton. The inlay on the door and inlaid bellflower under the inset corner columns suggest the work of Egerton. This is an hour-strike clock which every three hours chimes one of six tunes, whose titles are painted in the arch over the dial: *Bunkerhill* [sic]—*Indian Chief*—*Yanky Dodle* [sic]—*Tink-a-Tink*—*Banks the Deo*—*Danville.*

39. Hepplewhite cherry and mahogany sideboard inlaid with maple, the drawers cross-banded with ash; belonged to the Capron family of Uxbridge, Massachusetts. This elaborately inlaid piece shows the eagle of calligraphic outline and striped shield noted on a number of Connecticut pieces. An unexpected motif in the Federal period is a fleur-de-lis, used on the curving section of the central recess. This terminates the long triangular motif found on many Connecticut and some Rhode Island pieces. The bellflower alternating with black dots and the arched inlaid brackets give unusual sophistication. Similar eagle inlay is seen on a sideboard, No. 411, Flayderman sale; a candlestand, No. 401 of the same sale; and a few other pieces that have occasionally been noted. Origin unknown but consensus favors Connecticut. C. 1790.

40. New York Empire mahogany sideboard with central concave tambour section, animal-paw feet, and stepped board at back with carved pineapple finials; attributed to Duncan Phyfe, c. 1820. (Nancy McClelland's *Duncan Phyfe and the English Regency*, plate 155; Thomas H. Ormsbee's *The Story of American Furniture*, page 251.) An Irish cut-glass compote, late eighteenth century, rests on a separate stand. French gilt-bronze candelabra are in the form of classic figures on rectangular bases with applied laurel leaves and military trophies, c. 1810. The subject of the portrait by Ezra Ames of Albany (1768-1836) has not been identified, but the style of the rose dress suggests 1810-1815 as its date.

41. New England Sheraton-type windsor settee of pine, maple, and hickory; bird-cage top at back and arms; spindles bamboo-turned; painted black. C. 1800-1810. The New England windsor footstool, c. 1750, has oval pine top and maple legs and stretcher painted black. Tin sconces of pressed and punched tin with scalloped tops were made about 1800. The portrait of Washington comes from the Pratt Tavern, Mansfield, Massachusetts, late 1700's.

172

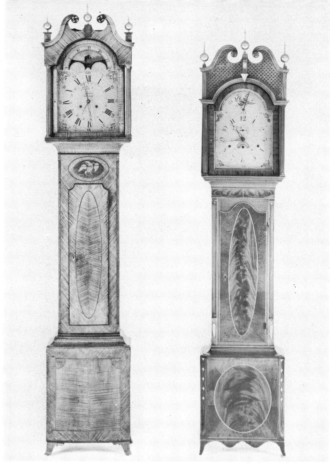

38

42. Pennsylvania painted pine chest of drawers, dark blue-green ground with floral decoration and thumb-print design in red and buff; molded top and chamfered corners; on high, ogee, bracket-like feet; c. 1830. The still life embroidered on satin, embellished with beadwork and an opal, is signed *BHL* and *REL;* in marbleized frame; c. 1850. The early nineteenth-century tin sconces have two candle sockets supported on rolled tin arms against a reflector of fourteen diamond-shape mirrors set in tin.

43. Victorian clocks. *Left:* acorn mantel clock with fusee type of movement, in laminated rosewood case; brass works by Jonathan Clark Brown, Forestville Manufacturing Company, Bristol, Connecticut. Glass tablet shows Brown's residence, a Greek revival house built 1832, which he purchased in 1847. Brown frequently used this view on his clocks. (See ANTIQUES, March 1949, p. 192, an article on acorn clocks by Brooks Palmer.) *Right:* Timby solar clock, Saratoga Springs, New York, 1865. This eight-day solar shelf clock by Lewis E. Whiting, Saratoga Springs, is of a type invented by T. R. Timby, who held four patents, two dated 1863 and two 1865. The globe, by the Boston map maker Gilman Joslin, makes a complete rotation every twenty-four hours.

44. Victorian rosewood couch, from a set of furniture owned by Abraham Lincoln and used in his Springfield home; other pieces in the museum include a table, sofa, two side chairs, and an arm-chair. By John Belter, New York, c. 1850. All the pieces are executed in the laminated construction invented by Belter.

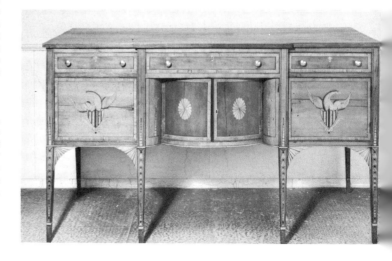

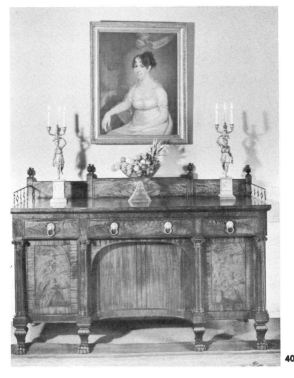

40

41

42

43

44

173

The pottery and porcelain

THE CERAMICS COLLECTIONS at the Henry Ford Museum exemplify virtually all the types of pottery and porcelain made or used in eighteenth- and nineteenth-century America that interest collectors today. The English wares offer a comprehensive sequence from early delft to nineteenth-century luster and ironstone, with a number of rare or unusual items. Famille rose, armorial, marine, and Canton-Nanking types are represented in China-trade porcelain, with some distinguished American-market pieces. The large group of American ceramics has been enriched, over the years, by acquisitions from some of the most notable private collections in this field; outstanding pieces from the McKearin collection of American pottery constitute one such addition recently made to the museum's holdings, and other names recalled on its labels include such well-known pioneer collectors as Jacob Paxson Temple, Rhea Mansfield Knittle, John Ramsay, and George H. Lorimer.

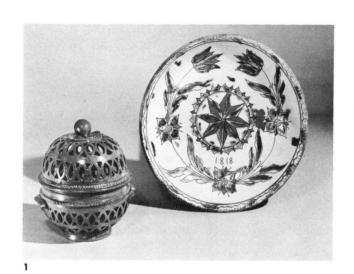

1

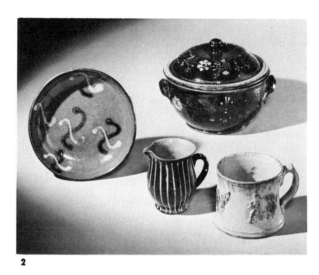

2

3

1. Pennsylvania redware plate, dated 1818, with sgraffito decoration centering on an eight-pointed star and lead glaze splashed with green, by Andrew Headman of Rock Hill Township, Bucks County; from the George H. Lorimer collection. Sugar bowl of glazed redware, mid-nineteenth-century, with an apple and leaves as a finial; height 7½ inches.

2. Pennsylvania redwares. Plate slip-decorated with intersecting green and yellow scrolls and impressed *W/SMITH/WOMELSDORF* by Willoughby Smith (Womelsdorf, Berks County, 1862-1900); diameter 7¼ inches. Large covered bowl attributed to John Nase (Tylersport, Montgomery County, 1829-1850); deep brown glaze and floral decoration in yellow and green slip. Mug, by John Bell (Waynesboro, 1833-1880); relief decoration representing a man with a gun and dog on either side of a spread eagle; brown and green glaze, and impressed mark *J BELL*. Pitcher, c. 1825-1850, in dark brown glaze with lines of white slip and white slip interior.

3. Redware from potteries outside Pennsylvania. New England slip-decorated plate, c. 1825, inscribed *Lafayette;* diameter 13 inches. Covered olive-green and brown sugar bowl with dog finial, attributed to West Virginia. Early nineteenth-century jar from Vermont; strap handles, dark brown glaze, and slip decoration of white splotches. Bottle of the same period, probably from Ohio, with flattened sides, short neck, and circular foot; brilliant, greenish-beige glaze with splotches of red and brown.

4

5

6

7

8

4. Pennsylvania pottery in the form of a lion, attributed to John Bell; c. 1850. Yellow glaze on body and brown on mane, tail tip, and eyes; length 8½ inches.

5. Buff-color pottery pitcher and bowl, lead-glazed on the inside only. The bowl is impressed on one handle with a leaf cluster and *ZOAR* between two stars; on the other handle, with the date *1840* in the same design; diameter 17 inches. Attributed to Solomon Purdy of the Zoar Community founded in 1817 in Tuscarawas County, Ohio; formerly in the Knittle collection. See John Ramsay's article *Zoar and Its Industries* in ANTIQUES for December 1944.

6. Very rare flint-enamel cow. The base is similar to that of the Bennington deer; the rich brown and cream-color glaze is set off by the green foliage known to collectors as cole slaw. The museum has a large collection of Rockingham and flint-enamel wares from Vermont, Maryland, New Jersey, and Ohio.

7. Stoneware jug with stopper, by E. Hall, Newton Township, Muskingum County, Ohio; dated 1858. Elaborately decorated with applied and incised motifs painted blue—clasped hands, a running horse, and a flowering plant growing out of a heart. On one side is impressed *FOUNTAIN OF HEALTH, R. SEAERS;* on the other, three times, *MADE BY E. HALL/OHIO.* Height, 17½ inches. From the McKearin collection.

8. Stoneware from New York State. Churn, gray painted with a long-necked fowl in cobalt blue; the incised mark *M.WOODRUFF/ CORTLAND* stands for Madison Woodruff, who was working in Cortland from 1849 to about 1870; height 19 inches. Goblet, a rare form, gray with blue-painted leaf decoration. Small, heart-shape inkstand, c. 1850, fitted with sander, inkwell, and pen wiper and decorated with rabbits, birds, a fish, an eagle, the American flag, and the initials *E.G.* repeated twice. The jug bears the rare mark *COMMERAWS/STONEWARE/CORLEARS/HOOK/N.YORK.* Marks recorded for this maker are *COMMERAW* or *CORLEARS HOOK,* singly.

9. Stoneware and Rockingham pitchers from New York and New Jersey. Rare tan stoneware toby, marked *AMERICAN/POTTERY CO./JERSEY CITY/N.J.*, 1838-1845. Pitcher, *right*, made at the Salamander Works, Woodbridge, New Jersey, about 1845; decorated with a side-wheel steamship in relief on either side and *KIDD'S TROY HOUSE* in relief on the front; marked on bottom *SALAMANDER WORKS, NEW YORK*. The mark caused confusion until it was realized that the New York "works" was simply the office of the New Jersey pottery. Pitcher, *center*, made by Humiston and Warner at South Amboy before 1850; medium brown glaze. On sides, impressed design of an American eagle, with legends *HUMISTON & WARNER/WARRANTEED SOUTH AMBOY* and *AMERICAN MANUFACTURE/SOUTH AMBOY NEW JERSEY*. From the Temple collection.

10. Transfer-printed earthenwares by American manufacturers. Hexagonal pitcher, attributed to the American Pottery Company of Jersey City, c. 1845; its painted and printed decoration includes crossed American flags under the lip and a view of Castle Garden with the inscription *Landing of Gen. Lafayette/at Castle Garden, New York/16th August 1825;* height 8½ inches. Platter attributed to the Edwin Bennett Pottery Company, Baltimore, late 1800's; transfer-printed in blue with a view of Pickett's charge at Gettysburg and an acorn-and-oak-leaf border enclosing medallions with portraits of the generals Hancock, Longstreet, Lee, and Meade; on the back, the printed inscription, *PICKETTS CHARGE/GETTYSBURG*, with blue eagle and shield.

11. American porcelain. The smallest pitcher has blue and gilt floral decoration and mark *TUCKER & HULME, 1828* in red script. *Center:* one of a pair of presentation pitchers over 10 inches high, made in Greenpoint, New York; molded in a pattern of corn and stalks and with painted decoration in gold, red, blue, and black. Inscribed *CONTINENTAL JOHN MOSHER/AMERICAN PORCELAIN;* and *PRESENTED BY ALDERMAN JAMES STEERS.* *Right:* Parian pitcher made by the United States Pottery, Bennington, Vermont, 1852-1858; raised ribbon mark. The small, four-lobed dish in the form of cabbage leaves on four feet shaped like twigs was made by Knowles, Taylor, and Knowles of East Liverpool, Ohio, 1890-1898. Marked in green on the bottom *K.T.K. CO* in a crowned circle and *LOTUS WARE,* it represents a type made in imitation of the Irish Belleek.

12. Pistol-handled China-trade porcelain urn, one of a pair of monumental size, over 26 inches high. The molded decoration on body, foot, and rim, as well as the finial and handles, is painted in blue and gilt with touches of red and green; English landscapes in sepia fill the medallions on either side and the base is painted in blue and gray to simulate marble. These pieces belonged to the Winthrop family of Boston, descendants of the colonial governor.

The pottery and porcelain: China-trade

13. China-trade porcelain for the American market. Plate, diameter 9⅜ inches, decorated at Canton c. 1785 with blue Fitzhugh border, trumpeting figure of Fame, and the bow-knotted eagle badge of the Order of the Cincinnati in colors. This piece, part of Washington's own Cincinnati service, was inherited by Mrs. Robert E. Lee. Sugar bowl, c. 1800, with orange and gilt swag decoration and an American eagle on either side; the monogram in script on the eagle's shield is *IFC.* Sauce boat, c. 1820, with Fitzhugh border and other decoration in green and an American eagle with a shield carrying the monogram *AF* beneath the lip. Tea caddy, c. 1800, with orange and gilt decoration including an American eagle with spread wings and a red-striped shield on his breast.

14. Delft apothecary's utensils, all attributed to Lambeth. The early eighteenth-century pill slab, 12 inches long, is decorated with the arms of the Worshipful Company of Apothecaries in blue on the white ground; motto and edges of slab are painted a deep purple. The footed drug jar with handle and spout, c. 1720, is decorated in blue; the smaller jar, dated 1723, in polychrome.

15. Staffordshire wares, third quarter of the 1700's. Salt-glaze punch pot, 8½ inches high, enameled pink with polychrome; plate, Astbury-Whieldon type, tortoise-shell glaze and molded border; cauliflower coffeepot, Astbury-Whieldon type. White salt-glaze teapot, molded shell decoration; salt-glaze teapot, white, with country scene in relief and enamel colors; Astbury-Whieldon teapot, molded decoration and bands of colored glaze.

16. Salt-glaze bear hugging a dog, Staffordshire, early eighteenth century; and Staffordshire agateware cat, 1740-1760. The bear's head is removable and serves as a cup. Spots of brown slip give emphasis to ears, eyes, mouth, and collar; a ceramic chain dangles from the muzzle; height 8¾ inches. The cat is veined in brown and white splashed with blue.

17. Part of a complete tea and coffee service for six in red earthenware with a lustrous black glaze. Though this class of pottery often goes by the name of Jackfield, much of it was made by Whieldon and other Staffordshire potters in the mid-1700's. The pieces here are molded with a floral design in relief, and gilded; height of coffeepot, 9 inches.

18. Staffordshire pottery lion, late 1700's; the body in ocher, the mane and other details, brown, on a pale green base with a sponged purple edge; length, 8¼ inches.

19

21

20

22

23

19. Worcester porcelain of the Dr. Wall period, c. 1770. The plate, 7¾ inches in diameter, with scalloped outline, has wide border of "wet blue" with gilding and a pair of exotic birds painted in semi-naturalistic colors. This subject, which was rendered in different styles on many Worcester pieces, also decorates the ribbed cream jug with gilded blue border. The tea caddy with ovoid, ribbed body and flanged top is painted with garlands of flowers in purple, orange, red, and lavender, and bands of ornament in light and dark blue; the finial is shaped like a flower. All these pieces have the crescent mark.

20. Wedgwood jasper plaques. The pair is of unusually large size, each 24¾ inches long. They are decorated in relief with *The Apotheosis of Homer* and *The Apotheosis of Virgil* on a light blue ground, both subjects modeled by Flaxman; impressed mark *WEDGWOOD* on reverse; c. 1785. The small medallion with a portrait of Josiah Wedgwood's partner, Thomas Bentley, modeled by Joachim Smith, in white relief on a medium blue ground, was made in 1774; impressed on the reverse *WEDGWOOD* and *BENTLEY* in script. These portrait medallions are thought of as Wedgwood's most important work in jasper.

21. Part of a gaudy Dutch tea and coffee set painted in carnation pattern in blue, green, yellow, and red; Staffordshire, 1815-1840. The museum's collection of these colorful earthenwares, which are believed to have been made expressly for export to rural areas of this country, includes pieces decorated with the urn, butterfly, single and double rose, grape, dove, lily, zinnia, "war bonnet," and "oyster" motifs.

22. Transfer-printed earthenware platter from the prized American Cities series attributed to James and Ralph Clews c. 1830 (see ANTIQUES, March 1954, p. 238). A view of Detroit, from 1805 to 1847 the capital of Michigan, is printed in dark blue within an unusual double floral border, and *DETROIT*, in blue in a scrolled cartouche, on the back. Length, 20½ inches.

23. Spatterwares from the Tunstall district, Staffordshire. Octagonal sugar bowl, c. 1840, a rare example of spatter decoration in bright yellow; pink tulip with green leaves in the white reserves on either side. The painted fish on the cup and saucer with red spatter border, c. 1825, is also rare. On the barrel-shape, banded pitcher, 1800-1825, sponged decoration in blue surrounds large spots of run-on pigment, gray and brown, like those on the so-called mocha wares made in the same district in the early 1800's; the latter are also well represented in the collection.

178

The glass

AMERICAN GLASS may be seen at the Henry Ford Museum in an extraordinarily large and complete display. In some fifteen hundred specimens all the American glassmaking centers are represented, with a better than usual showing from the Midwest; and all the glassmaking techniques used in this country, from earliest blown types of the eighteenth century to recent art glass of the 1900's. As in other categories, a number of items have come from well-known private collections, such as Howe, Fish, McKearin, Laing, and Klein, and are listed in standard references.

1. Stiegel-type blown glass, eighteenth century. Tumbler of clear glass with engraved tulip decoration, after 1764; height 9 inches. Amethyst pocket or perfume bottle attributed to Stiegel, 1764-1774; pattern-molded in diamond-daisy above vertical flutes. Unusually large diamond-quilted covered bowl in clear, almost silvery, glass, 1760-1800; pattern-molded; flanged, set-in cover has applied swirled knob finial; illustrated in McKearin's *American Glass*, Plate 24, No. 7; *ex coll.* William T. Howe. Engraved tea caddy, possibly American, 1760-1775; blown top with threads cut to fit bottle neck.

2. New Jersey blown glass. Deep bowl in dark amethyst, attributed to Wistarberg, 1740-1760. Aquamarine pitcher with white looping, applied handle and base; early 1800's; height 6⅝ inches. Bulbous sugar bowl in bubbly, deep aquamarine glass, c. 1830; applied lily-pad decoration and galleried rim; domed cover with folded rim and knob finial.

3. Blown glass, nineteenth century. Redford, New York, bluish-aquamarine handled vase, 1835-1850; applied knop stem and wide stepped base. Decanter on tray, South Boston Glass Company, c. 1820; clear bulbous decanter with double-ringed neck, hollow stopper, turned rim; tray and bottle decorated with applied, tooled guilloche bands; height 10¾ inches. Hat whimsey blown in dark olive-amber glass, 1814-1849; attributed to the Willington Glass Company at West Willington, Connecticut. Redford bowl in bluish aquamarine with turned rim and applied lily-pad decoration, 1835-1850.

4. Midwestern blown glass, nineteenth century. Sugar bowl of Pittsburgh type, 1825-1840; heavy glass with faint blue cast. Clear vase looped in amber, Pittsburgh area, mid-1800's; pillar-molded base with dark amber rim; height 9 inches. Salt attributed to Zanesville, Ohio, mid-1800's; green. Aquamarine pan made at Mount Clemens, Michigan, by Hall & Crosier, 1835-1843.

179

5. Blown glass from the Pittsburgh area. Clear sugar bowl and domed cover, c. 1820; engraved leaf and acorn decoration (Innes, *Early Glass of the Pittsburgh Area,* p. 37). One of a pair of sapphire-blue ribbed bar bottles with heavy collar and applied ring, 1835-1850; height 12 inches. Clear paneled compote with amethyst edge on rolled rim; hollow baluster stem; 1825-1840.

6. Midwestern blown sugar bowls with galleried rims. *Top row:* Light cobalt blue, pattern-molded in vertical ribbing; attributed to Bakewell, Page & Bakewell, Pittsburgh, 1825-1835; pear-shape bowl, high applied foot; high domed cover with folded rim, drawn knob finial; height 7½ inches. Clear glass, 1800-1825; pattern-molded panels around base; cover has upturned rim and drawn finial. Amber, attributed to Zanesville, 1815-1820; vertical ribbed bowl with wide shoulder and typically Midwestern double-domed cover. *Bottom row:* Clear glass, 1800-1850, molded in diamond pattern; applied petal base; blue edge on rim and blue acorn finial on high domed cover. Blue bulbous bowl on high flared foot, mid-1800's; domed cover with applied finial and turned rim. Clear glass, 1820-1840; bulbous bowl on knop stem and wide base; bulbous cover, bird finial.

7. Blown-three-mold wisteria sugar bowl, a great rarity. Probably by Frederick Mutzer, a German glassblower who worked in various American glasshouses after 1830. Diamond-and-sunburst pattern of bowl and cover G III-5, McKearin, *American Glass,* where an almost identical bowl by Mutzer (the only other one recorded in this pattern and this color) is illustrated (Plate 125, No. 5). See ANTIQUES, February 1951, p. 133. *Ex coll.* McKearin, Howe, and Laing.

8. Blown-three-mold pitchers, 1815-1835. All of clear glass except the deep blue in right foreground. Three (in foreground) in geometric patterns (McKearin G II-18, G III-8, G III-24); height of smallest, 2¼ inches. *Center:* in horn of plenty pattern. *Right:* in beaded arch pattern (G V-6); possibly made at Sandwich.

9. Sandwich blown-three-mold clear glass. Wine glass (McKearin G II-19); applied knop stem and foot; 1820-1835. Pint decanter in arch-and-fern with snake medallion pattern (G IV-7); lettered *Cherry,* a rare feature; 1830-1840; geometric three-mold stopper not original; height 7½ inches.

10

11

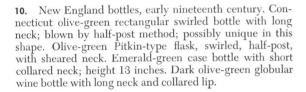

12

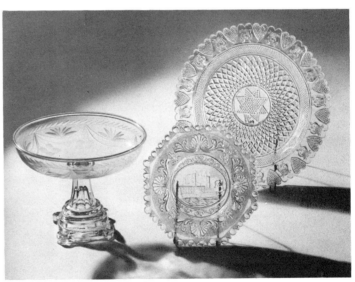

13

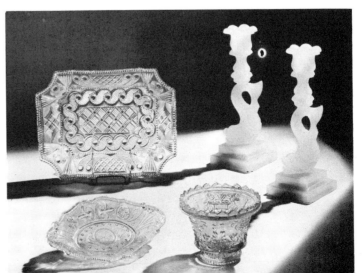

14

10. New England bottles, early nineteenth century. Connecticut olive-green rectangular swirled bottle with long neck; blown by half-post method; possibly unique in this shape. Olive-green Pitkin-type flask, swirled, half-post, with sheared neck. Emerald-green case bottle with short collared neck; height 13 inches. Dark olive-green globular wine bottle with long neck and collared lip.

11. Midwestern bottles. Amber grandfather flask, probably Zanesville, 1825-1850, with broken swirl to the left; height 8⅜ inches. Deep amber half-pint chestnut bottle, Zanesville, 1820-1840; expanded ten-diamond mold; sheared neck. Globular aquamarine broken-swirl bottle with collared lip and applied handle and base; c. 1825. Swirled globular bottle, in unusual citron color; Zanesville, 1820-1840; collared lip; height 8⅜ inches.

12. Flasks. Clear heavy pint flask with sunburst in oval panel on obverse and reverse (McKearin, *American Glass,* No. 286; G VIII-2), Keene Marlboro Street Glass Works; height 8⅛ inches; 1815-1830. Baltimore Glass Works pale citron half-pint *Corn for the World* bottle (McKearin No. 278); height 5⅞ inches; c. 1840. Keene so-called concentric eagle, c. 1850, yellow-green (McKearin No. 198); height 6⅞ inches. Jenny Lind lyre bottle, deep aquamarine (Mc-Kearin, No. 110) probably made in Charlestown, West Virginia, in the 1850's; height 8⅜ inches.

13. Pittsburgh glass. Compote, 1830-1850; bowl with turned rim, engraved swag-and-tassel decoration; octagonal stem; stepped pressed base. Octagonal lacy dish, c. 1835; side-wheeler in center (so-called Fulton pattern); palmette border; bull's-eye and serrated rim (identical with No. 1, Pl. 143, McKearin's *American Glass*). Round dish, c. 1830; diamond star center, within bands of strawberry diamonds and diamond stippling; heart and lyre border; diameter 9⅜ inches.

14. Lacy and pressed glass of the Boston and Sandwich Glass Company, 1835-1860. Clear, rectangular peacock-eye dish with flared sides and scalloped edge; length 10 inches. Pair of "clam-broth" dolphin candlesticks with hexagonal petal sockets and square stepped bases. Oval dish with fine scalloped edge; butterfly medallion in center; one of three sizes in the collection; length 8¼ inches. Heavy pale green sugar bowl, flower-basket and acanthus-leaf decoration; serrated rim; base not centered; cover missing; exhibited, Corning Museum of Glass, 1954, No. 221 in catalogue; formerly in the McKearin collection. Two whole galleries of the museum are devoted to a study collection of lacy and other pressed glass. In Greenfield Village is a reproduction of part of the Sandwich factory.

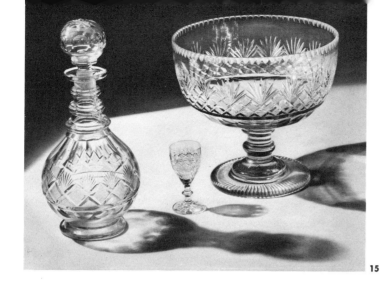

15

16

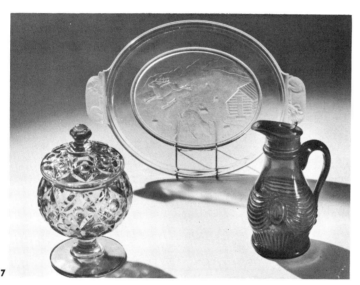

17

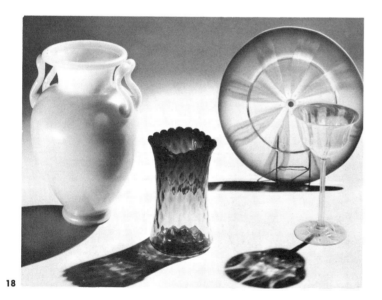

18

19

15. Pittsburgh blown and cut glass, c. 1825. Decanter, with tooled triple-ringed neck and applied base, is cut with panels and strawberry-diamond and fan design; hollow ball stopper with applied neck, star-cut and paneled; height 11 inches. Wine glass, probably Bakewell, Page & Bakewell; cut in strawberry-diamond and fan pattern; one from a large set of matched water goblets, champagnes, and wines. Compote, probably Bakewell, Page & Bakewell; bowl paneled below strawberry-diamond and fan cutting; base ray-cut.

16. Pattern glass. *Left:* coin compote; 1892; frosted American coins on stem, bowl, cover, and finial; height 10¼ inches. Spoon holder, tulip pattern, c. 1860.

17. Pressed glass. A unique electric-blue sugar bowl and cover in four-petal pattern, c. 1850 (McKearin, *American Glass*, Pl. 213, No. 5). Clear and frosted platter in Westward-ho pattern, Gillinder and Sons, Philadelphia; 1876; length 13 inches. Sapphire-blue syrup jug, Lincoln drape pattern, Boston and Sandwich Glass Company, c. 1865; tin lid.

18. Art glass. Opalescent opaque-white urn-shape vase with paper label marked: *Steuben, made in Corning, New York, U.S.A.;* c. 1910; height 10½ inches. Amberina vase, probably New England Glass Company, c. 1890; pattern-molded in diamond design; tooled from round base to square top with scalloped rim. Tiffany Favrile glass plate and wine glass; blown in colors shading from clear opalescent to turquoise green; 1890's.

19. Paperweights. New England Glass Company pear, 1860-1875; orange and yellow, applied to flat clear glass base; François Pierre from Baccarat introduced the fruits for which this factory is famous. Penholder, attributed to Ravenna, Ohio, c. 1900; characteristic tall center bubble; red starflower above multicolored ground; height 5 inches. Midwestern weight, c. 1900; four long teardrops rise from yellow and lavender ground and are connected by opaque white arches. Boston and Sandwich Glass Company pink poinsettia, the favorite floral motif of this factory, late 1800's on *latticinio* ground; bedewed. Millville clear-glass weight with blue cushion on which a horse-drawn steam fire engine appears in white with touches of red, yellow, and blue (the design was cast in a steel die); c. 1875. Clear-glass weight with black-eyed green frog on a mottled white "stone," c. 1900.

The glass: English and Irish

20. Irish (?) bowl with oval tray, c. 1800; diamond-cut design; rim with cut floral engraved panels. Irish candlestick, of blown and cut clear glass with octagonal baluster stem and wide flared base; V-cut decoration on scalloped, flared socket rim; height 10 inches. Irish jelly glass, one of a pair, c. 1820; clear, blown polygonal with scalloped rim and base; entire exterior surface cut; height 4½ inches.

21. English clear open-work basket with loop handles; one of a pair; mid 1700's. Clear glass goblet, c. 1830, engraved with view of the early locomotive *Rocket*, built by Robert Stephenson in Darlington, England, 1829 (the museum has a full-scale operating reconstruction of this locomotive built from the original drawings); height 9¼ inches. Bristol sapphire finger bowl, with gilt rim, one of a pair, c. 1800; signed in gilt by Isaac Jacobs of Bristol, glassmaker to George III. Deep cobalt-blue decanter and stopper with gilt and white enamel decoration, c. 1800.

22. English or Irish glass sconce, one of pair, c. 1780. Brilliantly cut with faceted shaft, canopies, and candle cups, notched arms, spires, sunbursts, faceted festoons and drops. A fine example of a type made from the 1750's to 1780's; the classic urn finial suggests a date toward the end of that period. Height 25 inches.

23. Irish covered urn, c. 1815-1820; an unusual example combining many techniques in an experimental period. Pattern-molded paneled bowl on pressed square base; galleried rim hung with faceted drops; blown cover with applied finial; spray and diamond cutting. Height 7 inches.

20

21

22

23

183

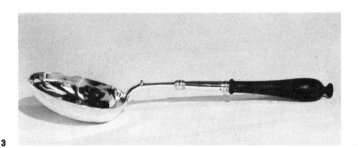

The silver

AMERICAN SILVER at the Henry Ford Museum shows an evenly balanced emphasis on Boston, New York, and Philadelphia work, including a remarkable group of tankards and mugs, and offers as well significant pieces from Albany and Rhode Island. Such regional types as Boston's gourd-shape caudle cup, New York's paneled punch bowl, and Philadelphia's elongated pear-shape coffeepot are handsomely exemplified. There are pine-tree shillings by the earliest American silversmiths known by surviving work, Hull and Sanderson of Boston; and Paul Revere is represented by nine pieces of his silver. The English silver includes work by the great London goldsmiths Lamerie, Courtauld, and Storr, as well as one of the finest sets of apostle spoons in America. An interest in silver was one which Henry Ford shared with his son: a group of thirty outstanding pieces was presented to the museum by Edsel Ford in 1936. Exhibited with these shining objects is a set of early silversmith's tools of the sort that fashioned them.

1. Boston caudle cup by Jeremiah Dummer (1645-1718). Engraved *MH* for Mary Hollingsworth, who married Philip English in 1675. She was accused during the Salem, Massachusetts, witchcraft trials. Height 3¼ inches.

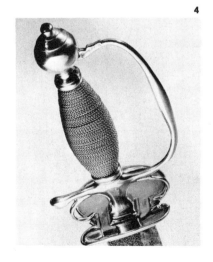

2. Boston presentation pieces by Benjamin Burt (1729-1805). Tankard with midband characteristic of region; presented in 1749 to Timothy Hilliard, a Harvard tutor, by his pupils, according to a Latin inscription; rococo cartouche encloses a globe at center top; height 8¼ inches. Cup, one of a pair, inscribed *The Property/of the Third Church of Christ/in Lynn/1774.*

3. Boston ladle of rare size, by William Burt (1726-1751). Engraved *IRM;* somewhat similar to No. 18 in the exhibition at the Museum of Fine Arts, Boston, 1956; length 16 inches.

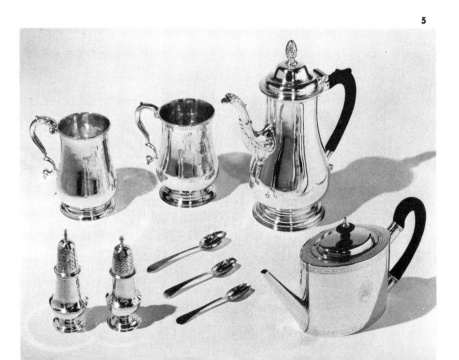

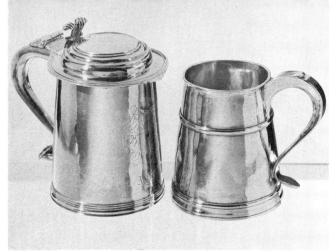

6

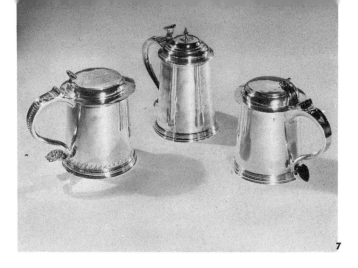

7

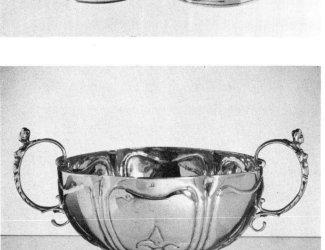

8

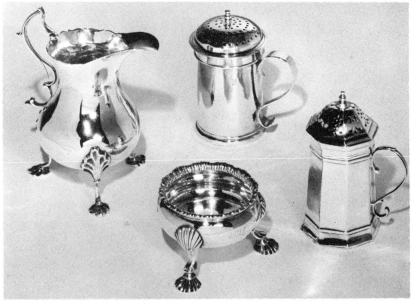

10

9

6. Boston drinking vessels. Tankard by John Noyes (1674-1749), engraved with armorial escutcheon in acanthus-leaf mantling of early eighteenth century; engraved initials of original owners *P/RE*; height 5⅝ inches. Mug by Andrew Tyler (1692-1741). Sharply tapering body; engraved on handle *F/IR*.

7. Three important tankards. *Left:* by Peter van Dyck (New York, 1684-1751); once owned as a family heirloom by John Pintard, founder of the New-York Historical Society; Pintard arms engraved by J. D. Stout, 1815, when Pintard presented it to his grandson (ANTIQUES, December 1956, frontispiece); exhibited, Museum of Fine Arts, Boston, 1956; height 7⅝ inches. *Center:* by Samuel Casey (South Kingstown, Rhode Island, c. 1724-1770), with unidentified arms; mark s. CASEY in rectangle; height 8¾ inches. *Right:* by Johannis Nys (Philadelphia, 1671-1734); scroll thumbpiece and heart-shaped handle tip; mark *IN* in heart twice on body and three times on lid; engraved on handle in shaded block letters *A/TM*; height 5 9/16 inches.

8-9. New York paneled drinking bowl with caryatid handles (first recorded by John Marshall Phillips in ANTIQUES, July 1943, p. 21), by Jesse Kip (1660-1722, working 1682-1710). Engraved *VD/IM* for Jacob and Maria van Dorn; engraved on rim *1699*. This is the earliest unchanged American racing trophy, won in a one-mile race on King's Highway in Middletown, New Jersey, by a colt owned by the Van Dorns. Exhibited, Museum of Fine Arts, Boston, 1956. Diameter handle to handle, 8½ inches.

10. Creamer by John Burt Lyng (New York, Freeman 1761); height 4⅝ inches. Straight-sided dredger by Samuel Vernon (Newport, 1683-1737). One of set of four New York salts; unidentified makers' mark *E & I* in Roman capitals in rectangle; c. 1760. Octagonal dredger by Jacob Hurd (Boston, 1702/3-1758); mark, *HURD* in italic capital and lower-case in long oval.

4. Sword hilt by William Cowell, Jr. (Boston, 1713-1761). Ball pommel and turned tip; silver wire wound on wooden grip; swelled knuckle guard; bulb-tip ferrule; molded edge on shell guard; length of hilt, 6 inches. Exhibited at the Corcoran Gallery of Art, 1954-1955, and at the Museum of Fine Arts, Boston, 1956.

5. Pre- and post-Revolutionary work of Paul Revere (Boston, 1735-1818). The pyriform shapes of coffeepot, two cans, and two casters are in the rococo style which persisted until about 1785 in America, but since Revere produced no silver during the Revolution these may have been made before 1775. The oval, straight-sided teapot with bright-cut engraved wreath enclosing *JAW* belongs to the classical period, c. 1790. Two spoons (a pair, *below*) have the single drop joint at bowl and down-turned handle that began to be made about 1770, while the other teaspoon, with bright-cut engraving, dates c. 1790-1800. Height of coffeepot, 10¾ inches.

185

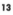

11

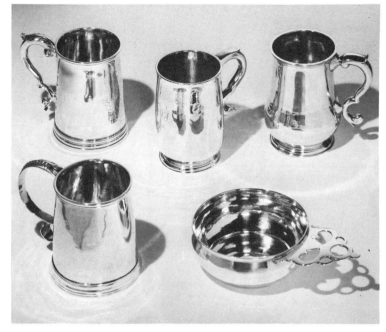

12

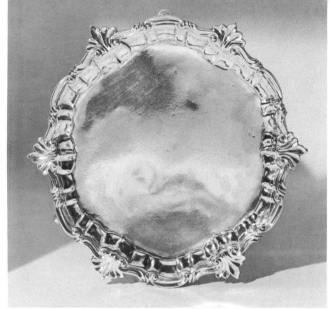

13

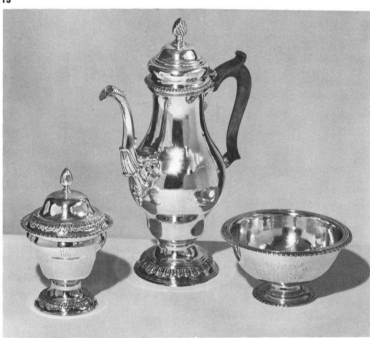

14

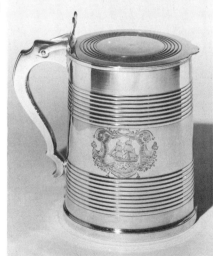

11. Except for the Albany mug (lower left) by Jacob Gerritse Lansing (1681-1767), these pieces were made in the city of New York. The Lansing mug was illustrated as No. 18 in ANTIQUES for October 1954, p. 284; height 4⅛ inches. *Upper left:* mug (one of a pair) by John Burger (w. 1786-1807); inscription in bright-cut wreath, *The/ gift of/Francis & Ellener/Van Dyke/2d Baptist Church/New York;* 1790. *Center:* "Schuyler" can by Peter van Dyck, engraved on top of handle *S/IS; ex coll.* Mrs. J. Amory Haskell. *Top right:* can by Adrian Bancker (1703-1772), engraved *L/P.C* on bottom. The porringer, engraved *M/I°A* on the bottom, is by Richard van Dyck (1717-1770).

12. New York salver by Myer Myers (1723-1795). The only known piece bearing Myers' own mark (script in shaped rectangle) and also *H & M,* for Halstead & Myers. Exhibited, Brooklyn Museum, 1954; Museum of Fine Arts, Boston, 1956. Diameter 7 inches.

13. Philadelphia work. Coffeepot by Joseph Anthony, Jr. (1762-1814); elongated pear-shape with double-dome top, in typical Philadelphia rococo style; height to top of flame finial, 13 inches. *Left:* footed, pear-shape sugar bowl and cover by William Hollingshead (w. 1754-1785). *Right:* footed bowl with gadrooning on rim and foot, by Joseph Richardson, Sr. (1711-1784).

14. Philadelphia flat-top tankard by Joseph Lownes (c. 1754-1820). Engraved ship and inscription: *Presented by the/underwriters of/London/to Capt. John Cassin/Brig Lavinia of/Philadelphia;* c. 1790; height 7¾ inches.

15. Philadelphia tea silver. Caddy with bright-cut borders of vermiculate scrolls, by Joseph Lownes; height 6 inches. Sugar bowl from a three-piece tea set by Joseph Richardson, Jr. (1752-1831); in classical urn shape on square base; engraved *JMH* in bright-cut foliated script. Drum-shape teapot by Joseph Anthony, Jr.

15

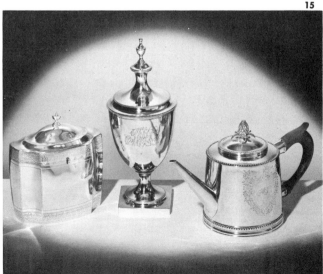

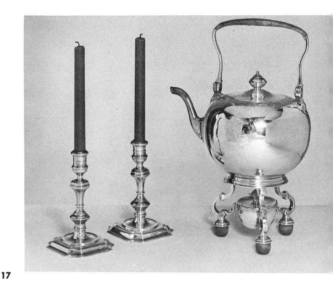

17

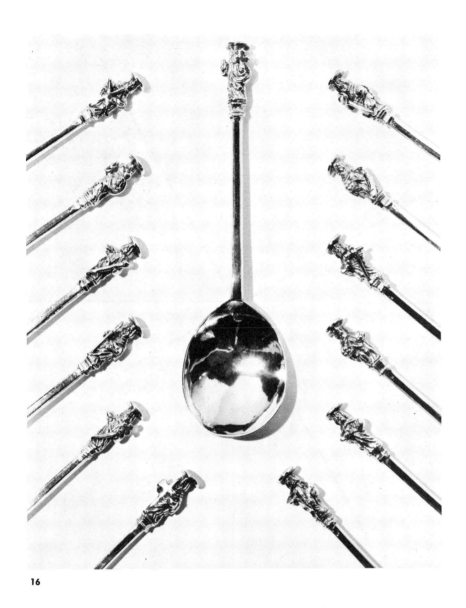

16

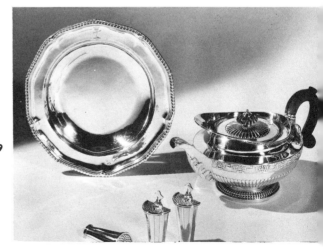

18

19

16. Complete set of James I apostle spoons, by the maker IS, London, 1617-1618. An apostle spoon was customarily given as a christening present; English examples date between the late 1400's and the late 1600's; complete sets of thirteen (the Master and twelve apostles) were seldom made, and a set by the same maker in the same year is extremely rare. Only five such sets were recorded in 1929 (Rupert's *Apostle Spoons*) when this, known as the Sulhamstead set, was partially illustrated (Pl. XVIII). The gilded figures of the apostles show emblems according to the German system, and in the nimbus of each is a low-relief figure of a dove as symbol of the descent of the Holy Ghost.

17. George I silver by Paul de Lamerie (London, 1688-1751), in the restrained style of his early work. Teakettle on stand with spirit lamp, 1723-1724; height 14¾ inches. Pair of candlesticks, 1716-1717.

18. George II cruet stand by John Delmester, London, 1766-1767. Of the type known as a "Warwick" cruet, a term probably of nineteenth-century origin. Engraved crest on cartouche and on each piece. Height 8¾ inches.

19. Soup plate, teapot, and three pepper pots by Paul Storr, London. Earliest is the soup plate, with date letter for 1814-1815, one of a set of twelve with matching set of twelve service plates. The teapot, illustrating the elaborate ornamentation found in Storr's work, was made in 1818-1819. The pepper pots are part of a rare set of twelve which may well be unique: four marked on top *W* for white; four, *B* for black; and the rest, *C* for cayenne. 1832-1833; height 3⅜ inches.

The other metals

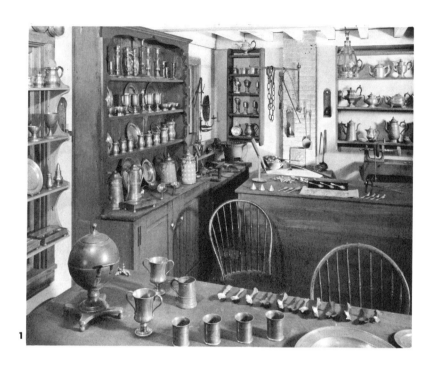

1. One of several shops where craftsmen work in the early tradition of their trades is the pewterer's shop. On display are English, Continental, and American pewter from the museum's collection, along with the molds and tools of the pewterer's craft. Casting, hammering, and spinning are the traditional methods of working the metal. Here the craftsman may be seen using molds for casting, stakes for hammering, a lathe for spinning.

2. Nineteenth-century molds for casting plates, spoons, and buttons. The plate mold is bronze and iron and produces an eight-inch plate with *JS, 1826*, and tic-tac-toe design incised on the bottom; length 23½ inches. The spoon mold of bronze casts a trifid-handled rat-tail eight-inch spoon. Buttons formed in the wooden-handled brass button mold are graduated from ⅞ to 9/16 inches.

3. Early nineteenth-century individual communion set consisting of cup and tray, both unmarked; height of the cup, 2⅛ inches; (Ledlie I. Laughlin, *Pewter in America*, Plate XXXI). The larger cup engraved *E.M.* is a mid-eighteenth-century church piece, unmarked, with handle missing; height 4¼ inches. It is similar to two cups shown in Laughlin, Plate XXXV. See also the set of four related cups shown in ANTIQUES, September 1956, p. 258.

4. The basic shape of the porringer bowl does not vary much but the design of the handle often indicates period, region, and individual maker. The crown-handled example has the mark, TD & SB in rectangle, of Thomas and Sherman Boardman of Hartford, w. 1810-1830; applied handle with bracket; diameter 5¼ inches. The solid shaped handle marked SM on the handle bracket is the work of Samuel Melville of Newport, w. 1793-1800. Even simpler is the solid, almost square, handle cast in one with the porringer basin; the piece is unmarked but attributed to Elisha Kirk of York, Pennsylvania, w. 1780-1790 (similar to Laughlin, Plate XIII). The flowered handle in center, marked CALDER . . . VID . . . with eagle, is by

William Calder, Providence, w. 1817-1856. The porringer at right, marked FB in wreath, is by Frederick Bassett, New York, w. 1761-1800 (Carl Jacobs, *Guide to American Pewter*, No. 27).

5. Two teapots in the classic tradition, very similar in form to silver of the period. *Above:* oval with fluted panels, hinged lid, carved wooden finial, and ebonized wood handle; decorated with bright-cut engraving and unmarked, 1790-1800; height 6⅛ inches. *Below:* marked E. BROWN & CO. in rectangle (unrecorded), c. 1810-1815; the decoration is bright-cut engraving with cipher *AH* in an oval medallion; hinged lid, wood finial, and ebonized wood handle.

6. Church pewter of the nineteenth century. *Top:* pieces by Boardman & Co., Hartford, Connecticut. Spout tankard with hinged domed top and triple-tiered finial, 1825-1827; New York eagle mark (Carl Jacobs, *Guide to American Pewter*, No. 39), height 9¼ inches. The plate and dome-top flagon also have the New York eagle mark. The beakers (from a group of nine) are attributed to Boardman and Company, 1825-1850. *Center:* the wide-rimmed bowl, which is unmarked, is attributed to Israel Trask, Beverly, Massachusetts. The flagon is by William Calder, Providence; marked CALDER in rectangle; 1825-1850. Chalices by Israel Trask of Beverly are marked I TRASK in rectangle and are formed from sheet pewter on knop stems and bell bases, c. 1805-1815. *Bottom:* an unmarked pair of chalices probably made in New England, 1800-1850. The Britannia flagon is marked H. YALE & CO. WALLINGFORD, 1824-1831. Also by H. Yale and Company are the chalices bearing the same mark, 1824-1831.

7. New York pewter. The flat-top tankard with three-part crenate lip and fish-tail handle is marked FB in a circle with fleur-de-lis, for Frederick Bassett. The very large unmarked beaker is attributed to John Bassett, w. 1720-1761; height 6 11/16 inches. The slant-sided quart-size pot or mug is also by Frederick Bassett.

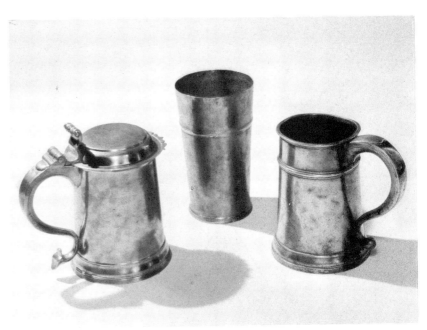

7

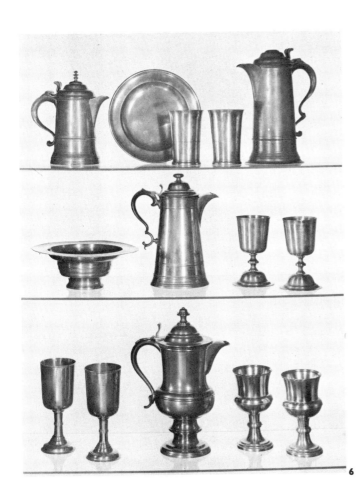

6

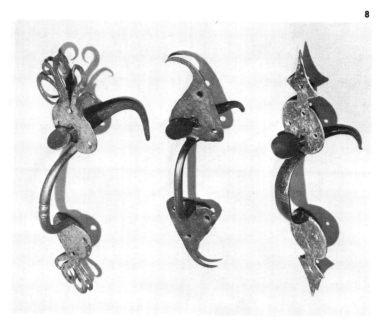

8

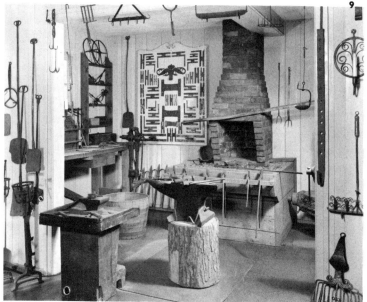

9

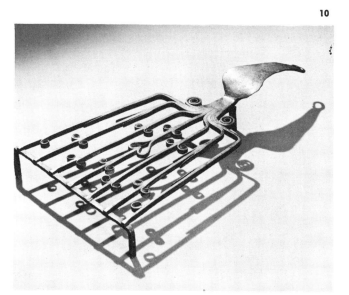

10

11

12

13

14

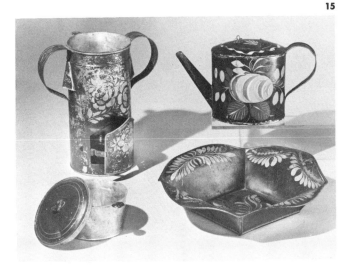

15

16

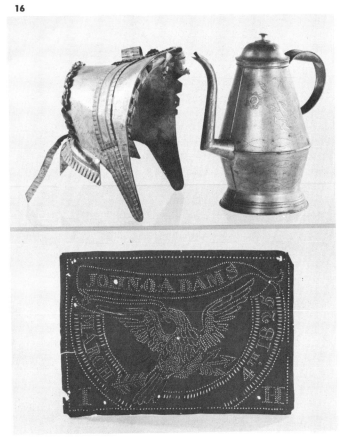

8. Wrought-iron latches, Suffolk type. Pennsylvania, eighteenth-century foliated cusps with hand-grasp modeled in the middle; from Connecticut, the eighteenth-century tulip cusps with plain hand-grasp, height 13¾ inches; Massachusetts, eighteenth-century, ball-and-spear cusps with strap hand-grasp.

9. The Rowell wrought iron shop has two rooms—a small workroom equipped in mid-nineteenth-century fashion with a forge, bellows, anvil, and related tools, as well as a panel of sample hinges; and adjoining shop used to display a large collection of wrought-iron hardware and household implements of English and American manufacture dating from the seventeenth to the late nineteenth century.

10. Pennsylvania German wrought-iron grille, late eighteenth century. Except for the support at the front, the ornamented platform and broad handle are formed from a single iron bar. The heart motif so popular in the folk art of the region is handsomely used in this simple piece. Length 24¾ inches.

11. Wrought-iron equipment for the hearth. *Left:* swivel toaster made up of a pivoted platform with heart design on a long-handled tripod support, Pennsylvania, c. 1800. *Center:* andiron (one of a pair) with shaft terminating in a snake's head, New England, c. 1800; height 16 inches. *Right:* late eighteenth-century andiron (one of a pair) with shaft terminating in an ornamental ring. There is also an extensive collection of eighteenth- and nineteenth-century brass andirons in the museum.

12, 13. Weathervanes. The rooster, of wrought iron, was made about 1800. The automobile, of copper, was made about 1900, probably for use on a garage, and was found in central New York. In contrast is the running horse made of sheet iron about 1850; eye and mane are indicated by punch work.

14. The tin peddler's wagon (seen in the museum against a background of early locomotives) was a familiar sight through the country during the nineteenth century. These traveling salesmen became quite numerous after the Revolution, selling wares made in New England. In the nineteenth century elaborate systems of storehouses were set up in rural areas to furnish the peddlers with stock for six or eight months. Eventually dry goods, hardware, and assorted merchandise were added to the tin peddler's wares. This wagon, built c. 1860 by Hannah Brothers, Sharon, Pennsylvania, tinware manufacturers, is typical with its red paint striped in yellow, green, and black. Hinged panels on each side open to display goods, and the adjustable rack on the rear was used for farm goods taken in trade.

15. Decorated tinware. Food warmer (with double boiler in foreground), also used as a nursery lamp. It is stenciled in red and yellow on green and has a whale-oil lamp painted blue. Marked inside the cover *A present to Eldress Easter and Sister Lucy, Sept. 13th, 1837.* Height 9½ inches. The apple tray at right is Pennsylvania German, japanned brown with tulip-and-leaf design painted in red, white, yellow, and green. Also Pennsylvania German is the straight-sided oval teapot, black with free-hand-painted design in red, green, and yellow.

16. Tin was used for decoration as well as for household utensils. Such whimsies as this sheet-tin copy of a lady's hat ornamented with ribbons and bows were probably never intended to be worn; this one was made as a tenth wedding anniversary gift, c. 1875; height 10 inches. The punched tin coffeepot decorated with flowers in a vase and chain design is marked *EUBELE* on the handle. It is of Pennsylvania origin, c. 1830-1850. Of pierced tin is the pie safe panel with its patriotic design commemorating the inauguration of John Q. Adams in 1825; marked IH.

Lighting

In its collection of lighting devices the Henry Ford Museum takes, deservedly, special pride. Illustrating the whole history of lighting, it is one of the most comprehensive in the country, comparable only to those at the Smithsonian Institution and at Old Sturbridge Village. Its section on the electric light alone is the largest and most complete in the world. This special emphasis is due to Henry Ford's long and close friendship with Thomas A. Edison, for whom he named his whole cultural enterprise:

the Edison Institute comprises the Henry Ford Museum, Greenfield Village, and the Greenfield Village Schools. An outstanding feature of the Village is the complex of buildings in which Edison's laboratory and workshops from Menlo Park are preserved.

Illustrated at the top of this page is Edison's first practical incandescent lamp, 1879, from the museum's collection. Other lighting devices are shown with *Furniture; English and Irish glass; English silver;* and *Other metals.*

CANDLEMAKER'S SHOP. Here candles of beeswax and bayberry are made by the old hand methods. Molds of many sizes, in tin, pewter, and pottery, are at hand and, in the foreground, a wax-pouring device with multiple orifices for filling a whole row of molds at once. Note the rare circular molds suspended from the ceiling. The dipping rack in the background works on the principle of a balance: as the dipped candles grow heavier, iron weights can be added to the balance pans in compensation.

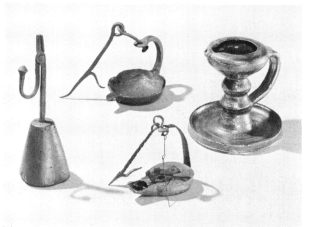

Lights of simple basic types used in America from earliest colonial days until the mid-1800's. *Left to right:* Rush or splint holder of wrought iron set in conical wood base; height 8¼ inches. Crusie, or so-called open betty lamp, with hanger, of wrought iron. True betty lamp with wick channel and closed reservoir, of wrought iron; pivoted lid with bird finial; wire wick pick. Grease lamp of glazed redware, with wick channel, probably Pennsylvania.

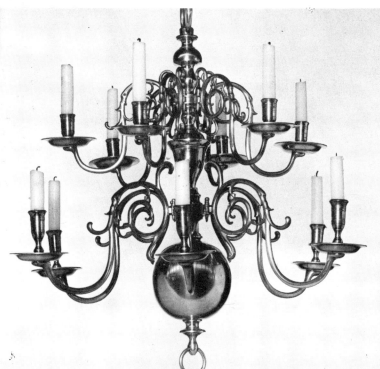

English brass chandelier, early 1700's, perhaps the most impressive of a large group of chandeliers, candelabra, and girandoles. The well-modeled baluster stem with urn and ball supports two tiers of six candle arms each, the arms finely scrolled and terminating in narrow candle cups with drip pans. Diameter 27 inches.

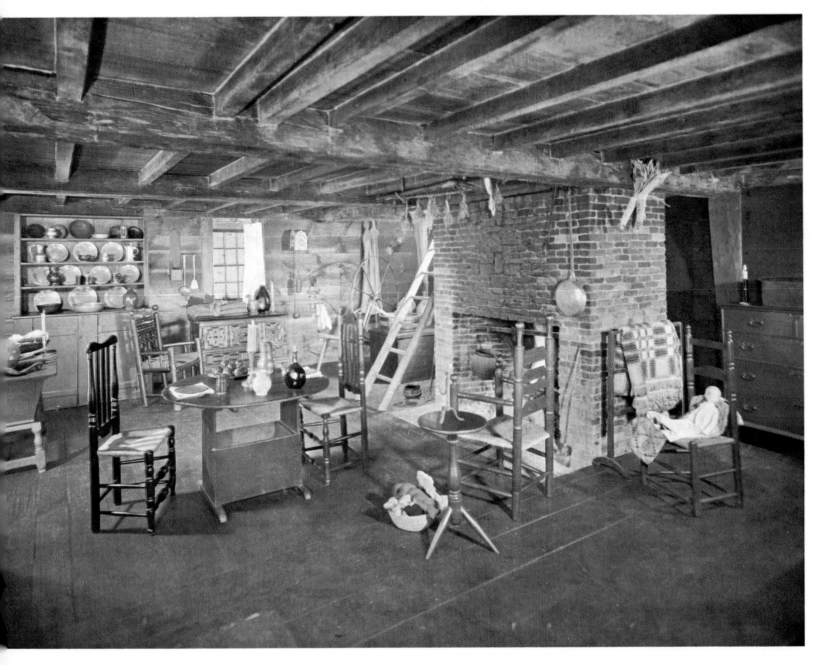

THE PLYMPTON HOUSE, GREENFIELD VILLAGE

(See page 198)

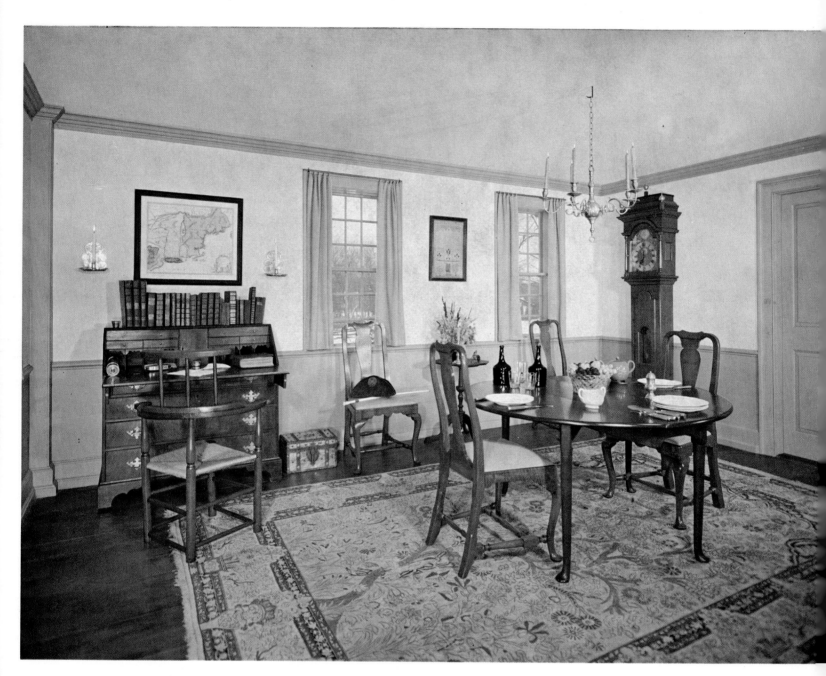

THE DINING ROOM, SECRETARY HOUSE, GREENFIELD VILLAGE

(See page 200)

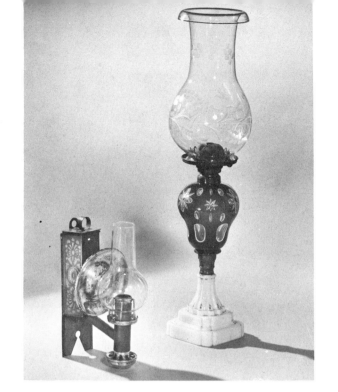

American whale-oil and kerosene lamps. Hanging wall lamp of Argand type with circular burner and blown-glass chimney, c. 1835-1840; painted and stenciled tin with brass fittings and silvered reflector. Glass kerosene lamp attributed to Sandwich, c. 1870-1880; blue and white overlay font on gilded opaque-white base; engraved blown-glass shade with rolled rim; brass fittings; height 24¼ inches.

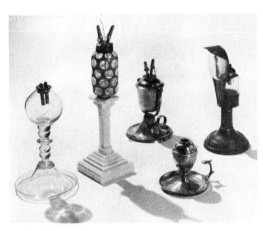

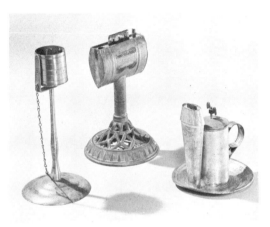

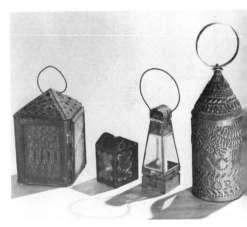

American whale-oil and camphene lamps, c. 1830-1860. Clear blown glass with solid baluster stem and saucer base, made by the Boston and Sandwich Glass Company; reservoir fitted with tin double burner for whale oil. Glass peg lamp, rose and white overlay gilded, with brass camphene burners and pewter extinguishers; fitted in an opaque-white glass columnar candlestick; over-all height 12½ inches. Pewter swinging lamp for hanging, carrying, or setting on a table, the font suspended by copper pins; brass camphene burners with pewter caps. Cast brass lamp with saucer base and finger grip, for use with oil or camphene burner. Painted tin lamp on cast-iron base, with blown-glass reservoir and double whale-oil burner; glass bull's-eye to intensify light.

Dated and marked lamps for grease or lard. Grease lamp, with swinging brass font on iron stand; stamped on font supports *1855* and *P.D.*, for Peter Derr, Berks County, Pennsylvania; height 10 inches. Lard lamp of tin on cast-iron base, gilded; stamped *SN. & H.C. Ufford,/117 Court St./Boston/Kinnears Patent/Feb. 4, 1851.* Grease lamp of tin with iron plunger for forcing fuel from reservoir into font; stamped on plunger *I. Smith, Pat'd Aug. 8, 1854.* The collection also includes special-purpose lights, lighters, lamp fillers, snuffers, and extinguishers.

American tin lanterns. Triangular, with candle socket, pressed-glass panes; 1830-1840. Japanned folding pocket lantern; mica panes; compartments for candles and matches in hinged back; marked *Minor's Patent, Jan. 24th, 1865.* Lantern with removable tin kerosene lamp, c. 1860-1875; beveled glass panels. Cylindrical lantern with candle socket, c. 1830; the words *Jackson Forever* in the piercing confirm the nineteenth-century date; height 17¼ inches.

Chandelier for gas, American, c. 1880. Brass ceiling fixture, three scroll arms wound with tendrils; grape-leaf motif in pierced cast ball of stem, repeated in cocks; each light equipped with mantle and cylindrical glass shade. Diameter 30 inches.

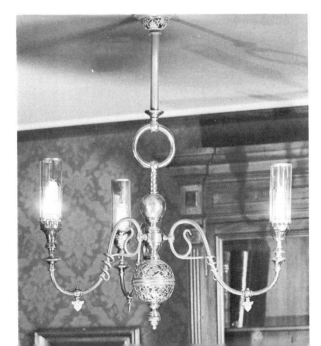

193

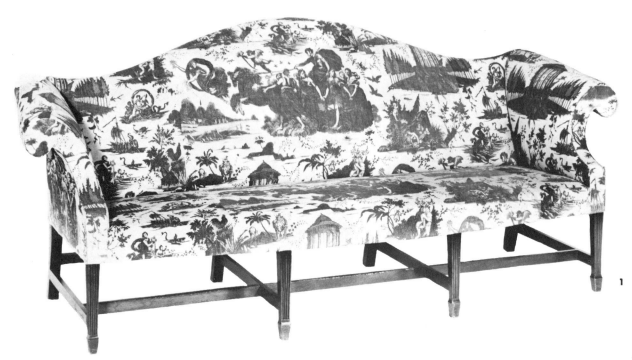

The textiles

194

1. Late eighteenth-century French printed cotton on a New York mahogany sofa of transitional Chippendale-Hepplewhite style. The pattern of the fabric, printed in red, is based on Guido Reni's fresco *Aurora* in the Rospigliosi Palace in Rome. Other textiles may be seen with *Furniture*.

2. Detail from a pair of resist-dyed linen bed curtains, with original tape bindings, probably American, c. 1750. The design is printed in two shades of blue. The source of this class of textile has been much discussed recently.

3. Chintz, probably made in France in the late 1700's for the English and American markets; block-printed on cotton with India motifs in light blue, pink, wine, brown, and tan. This handsome print has been copied as part of the Henry Ford Museum's reproduction program, and is now on the market in the colors of the original and in others as well.

4. Embroidered bedcover of handwoven wool with blue wool fringe, New York State, 1778. The squared pattern of conventionalized motifs, embroidered in blue crewels, calls to mind the Delft tiles used in houses of New Amsterdam. The initials and date S(?)MD./AL. 78 are worked in the center. This textile was reproduced (in detail) on the cover of ANTIQUES for June 1953, and on the end papers of *The Index of American Design*.

5. Hooked rug, New England, early nineteenth century. Eagle on shield and background of mountain peaks, within border of scrolls and oak leaves. Red, white, blue, brown, and black. Length, 60½ inches.

6. This striking Pennsylvania quilt, c. 1850, with bright-colored printed cottons appliquéd on a white cotton ground, is one of a great variety of bedspreads in the museum. The collection also boasts one of the few surviving printed cottons by John Hewson (ANTIQUES, August 1953, page 121), first calico printer in Philadelphia, 1774; formerly in the Peto collection.

7. Jacquard-woven two-panel wool and cotton coverlet in red, white, and blue; Ohio, 1857. The unusual double border of trains on two sides makes this a favorite in a museum known for its great transportation exhibits. Large floral medallions fill the center; in the corners is woven *LOUDONVI/LLE. ASHL./COUNTY./OHIO. 1857/WOVE./BY. PETER/GRIMM.* Length, 7 feet 9 inches. One of a sizable collection of similarly woven coverlets featuring such motifs as Independence Hall, eagles, American presidents, and Masonic emblems.

8. A selection of American homespuns of the early 1800's. *Left:* linen and cotton handkerchiefs in blue, red, brown, and orange checks; *center:* woolen blanket, one of a pair, woven with large blue plaid on white; *right:* woolen blanket in blue and orange plaid.

5

6

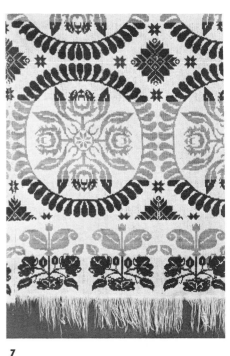

7

8

195

The paintings

THESE PICTURES are selected from the Henry Ford Museum's varied collection of American paintings, which range in date from the early eighteenth century to the late nineteenth, and in character from primitives to academic portraits. Among the latter are the Gilbert Stuart and the Ezra Ames shown with Federal pieces in the section devoted to furniture. American folk art forms a considerable group in the museum; besides pictures here, we show examples of pottery in the *Pottery and porcelain: American* section; weathervanes and ironwork in *Other metals;* woodcarving in *The Street of Shops.*

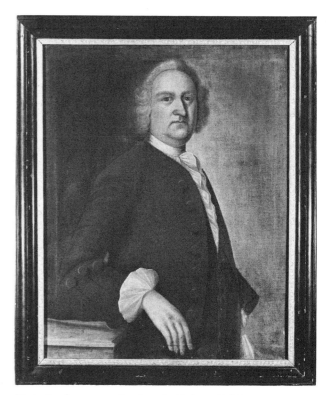

Portrait of a man. By Joseph Badger (1708-1765), the chief painter of portraits in Boston after John Smibert retired; also a house painter and glazier. His were the most realistic portraits of leading Bostonians before the arrival of Copley about 1755. Oil on canvas, 36 by 28½ inches; original black frame.

Fractur drawing by the versatile Henrich Otto of Lancaster County, Pennsylvania, who also decorated chests and printed fracturs from his own woodblocks, in the latter 1700's. Parrots were a favorite motif of his; to the green and red birds here he added golden lions rampant, borrowed from heraldry. Water color, 9 by 13½ inches.

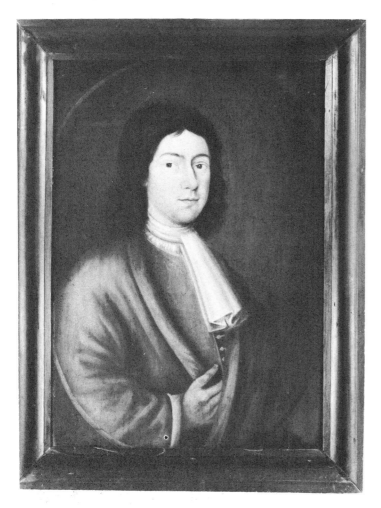

Portrait of David Marinus, c. 1700; by Gerret Duyckinck (1660-c. 1710), one of a family of limners, glaziers, and glass stainers working in New York in the late 1600's and early 1700's. Marinus was minister of the Dutch Reform Church in Aquackanock (now Passaic), New Jersey. Oil on panel, 37¼ by 28¾ inches.

196

Landscape in charcoal on marble-dust paper, an effective if ghostly technique used especially by nineteenth-century schoolgirls. Inscribed on backboard, *Picture, Alexander Hamilton's Grave/July 25, 1852/Miss Mary E. Richardson/Stafford/Genasee County/New York*; 15¼ by 21 inches.

A striking portrait of a lady with a rose, by an unidentified Pennsylvania artist, c. 1840. The pale face with its almost sculptural quality contrasts with somber tones of dress and background. Oil on canvas, 35½ by 31½ inches including the original painted and grained frame.

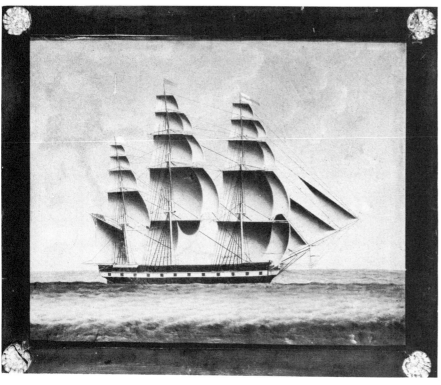

American clipper ship in full sail, probably by a New England painter, c. 1840. Oil on canvas, 23½ by 28¾ over all; original pine frame painted black with gilded gesso shells in corners.

The painter of this purposeful child with a cat supports the claim to untrammeled honesty so often made for American nineteenth-century primitives. Oil on composition board, 23¼ by 14⅞ inches.

Red Mill near Yellow Springs, Ohio, by unidentified artist, Ohio, c. 1850. Vivid in color, this painting came from a part of Ohio of special interest to Henry Ford because several such mills once operated there. Oil on panel, 15 by 27 inches including pine molding.

Greenfield Village

GREENFIELD VILLAGE, the outdoor extension of the Henry Ford Museum, consists of nearly one hundred buildings from all parts of the American past. Not a restoration or reconstruction of any particular community, it is a collection of significant *original* buildings moved with utmost care and understanding from their former sites where many of them faced destruction or decay. Here they are placed in a sympathetic setting where they blend harmoniously to form a microcosm of the American past, made more vivid by such convincing details as flowering gardens, working craftsmen, blowing whistles, horse-drawn vehicles, and free-roaming domestic animals.

The street of homes, ranging from an English cottage of a type known by the earliest American settlers to a late Victorian residence that might have been occupied by our own parents, presents an instructive picture of the evolution of domestic architecture and decoration. The green is surrounded by the Court House, Chapel, Town Hall, Inn, School, Post Office, and General Store, and near these are establishments which supported the economy of American towns. In addition to the shops of the blacksmith, cooper, potter, miller, and shoemaker, Greenfield Village presents such unusual installations as a silk mill (complete with mulberry grove), and a carding mill, a glassblowing plant, a hooked-rug pattern shop, and a tintype studio. In all of these, workmen may be seen demonstrating the techniques of their nearly-forgotten trades.

The self-sufficiency of an earlier day, and its dependence on hand labor, are emphasized in an adjoining industrial section comprising mills, foundries, and factories of the nineteenth century where the steam engine has supplanted hand and horse power. Among these establishments are sawmills (both up-and-down and circular types), machine shops, a cider mill, a sugar mill, an electric generating plant, and even an early automobile factory. The advent of the twentieth century is represented by the actual workshops and homes of Edison and Wright and Ford where the electric light, the airplane, and the automobile were born.

The following pages give an impression of the scope of Henry Ford's Greenfield Village, which offers a vivid and nostalgic picture of America's full, rich past.

Shown in color is the interior of the one-room PLYMPTON HOUSE, from Sudbury, Massachusetts, which was built in 1638 on the property of Thomas Plympton, a founder of the Puritan settlement of Sudbury Plantation. Henry Ford's restoration of this house was prompted by his interest in the Wayside Inn, which stood near it. Its seventeenth- and early eighteenth-century furnishings include Brewster, Carver, and banister-back chairs, a fine paneled chest (1680-1700) from Plymouth, slipware and stoneware, and a wag-on-the-wall clock.

The ivy-covered COTSWOLD COTTAGE was built in the sheep-herding district of southwestern England, the Cotswolds, early in the seventeenth century, and illustrates architecture and living conditions familiar to many early colonists in America. The two-family limestone house has leaded casement windows, limestone roof, lead eaves trough and downspouts, and dovecot in one gable. Equipped with seventeenth-century English furnishings, it offers an interesting comparison with the nearby Plympton House. A limestone wall encloses the house with its English flower and vegetable gardens, barn, dovecot, and forge.

Originally located on the Patuxent River in southern Maryland, the SUSQUEHANNA HOUSE was begun shortly after 1650 and with its long narrow construction and doors affording cross ventilation is typical of the architecture of the tidewater region. It was the home of Christopher Rousbie, collector of customs for Charles II, who was stabbed to death in 1684 because of a dispute over tax funds of Lord Baltimore's. Behind the building are a tobacco field, a semiformal garden of boxwood, myrtle, and fruit trees, and outbuildings. The house was a gift of Samuel Davis Young of Grand Rapids, Michigan, in 1942 in memory of his wife, Lolita Carpenter Young, a descendant of the original owner.

This room of the SUSQUEHANNA HOUSE is furnished primarily with English oak of the Jacobean period. The date 1626 is carved in the top rail of the wainscot chair at right. The center table is covered with a cloth in the manner of the time, and on it are early brass candlesticks, wine bottle and glasses, and a box of filigree work. The portrait (c. 1720) is attributed to J. Cooper. The house also contains some American pieces, and an important collection of seventeenth-century English beadwork and raised-work embroidery.

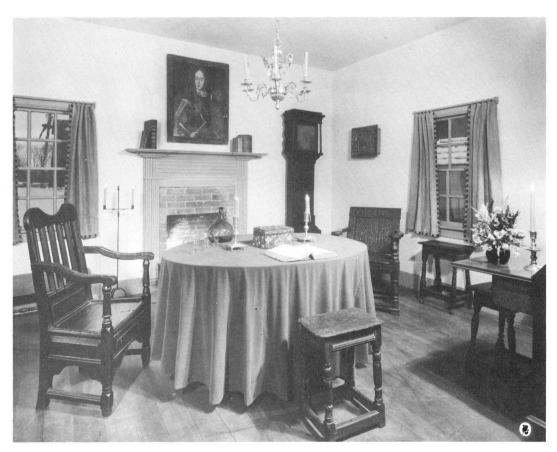

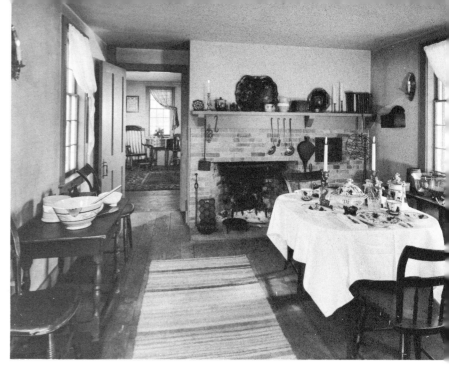

LUTHER BURBANK HOUSE. The house where Luther Burbank was born in 1849 was moved to Greenfield Village from Lancaster, Massachusetts. This kitchen-dining room is furnished with painted furniture of the first half of the 1800's. The table is set with a gaudy ironstone service and cobalt Sandwich candlesticks, cup plates, and salts. The parlor, glimpsed through the open door, has painted furniture and numerous examples of folk art, including a signed painting by the Boston artist William Matthew Prior (1806-1873).

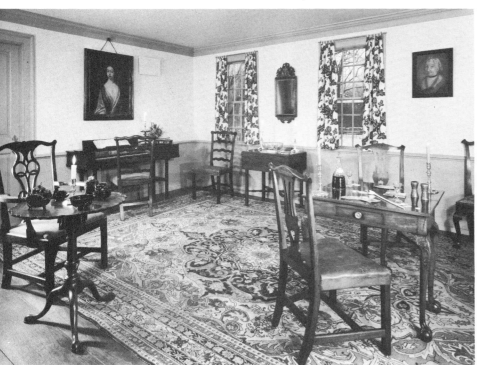

The five-bay, central-chimney, Georgian SECRETARY HOUSE from Exeter, New Hampshire, built about 1750 by John Giddings, takes its name from the fact that it was once occupied by the first secretary of state of New Hampshire, Joseph Pearson, who married John Giddings' daughter, Mehitable. An inventory of the house made at Pearson's death in 1823 aided in the furnishing of the interior. In the gray-blue living or family room, shown here, a portrait of "Miss Huysche" of Charleston, South Carolina, attributed to Charles Bridges (working 1735-1740), hangs above a square piano (1781) made by Thomas Saxby of York, England. The New England gaming table is noteworthy. Curtains are of blue resist. The dining room of this house is shown in color.

SARAH JORDAN'S BOARDING HOUSE, from Menlo Park, New Jersey, was the home of Thomas A. Edison's workmen while he was experimenting with electricity, and it was the first private building in the world to be lighted by Edison's incandescent light (1879). The exposed wiring and the converted kerosene hanging lamp can be seen in the dining room here. The table is set with English "tea leaf" ironstone and pressed glass in Liberty Bell pattern. The absence of curtains is explained by the fact that the surviving Edison employees interviewed by Henry Ford remembered the house as having had only white window shades.

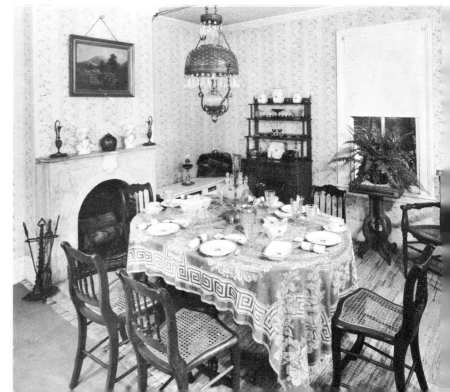

MCGUFFEY HOMESTEAD. William Holmes McGuffey, author of the *Eclectic* readers and spellers, was born in 1800 in this log cabin from Washington County, Pennsylvania. It is built of squared timbers, notched at the corners and mortared between, and has one room, with a loft above reached by the outdoor steps beside the stone chimney. Henry Ford had McGuffey's readers reprinted for use in the Greenfield Village Schools which he founded and in which his educational philosophy of "learning by doing" is still practiced.

In the LOGAN COUNTY COURT HOUSE, from Postville (now Lincoln), Illinois, young Abraham Lincoln practiced law from 1840 to 1847 when he was a circuit rider in frontier Illinois. In addition to the restored courtroom, the building contains a notable collection of Lincoln memorabilia including some china used in the White House and the blood-stained chair from Ford's Theatre in Washington, as well as a program of that fatal evening's entertainment.

WATERFORD GENERAL STORE and, in the background, CLINTON INN. The store, built in Waterford, Michigan, in 1854, also served as village post office. It is completely stocked with everything from food staples to drugs and dry goods; much of the old merchandise on the shelves came from a nineteenth-century general store at Minaville, New York. The inn, built at Clinton, Michigan, in 1831-1832, was the first overnight stop on the Detroit-Chicago stagecoach run—a trip that took at least eight days.

FORD HOMESTEAD. The birthplace of Henry Ford (July 30, 1863) was restored and equipped by Ford in 1919 with many of the original furnishings exactly as he remembered them from his childhood. The parlor, which was used only on special occasions, had Victorian furniture upholstered in horsehair and was dominated by a J. Estey and Company cottage organ made at Brattleboro, Vermont. The buildings on this page are remarkable in that in each case the original occupants participated in the restoration and most of the contents are original.

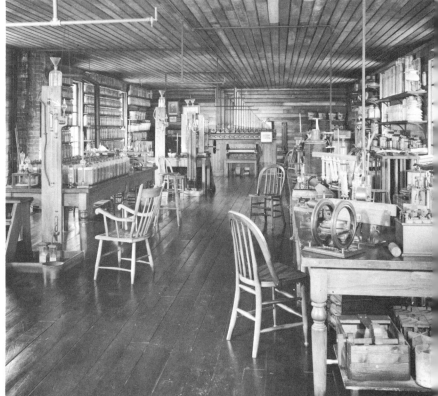

MENLO PARK LABORATORY. Thomas A. Edison's laboratory from Menlo Park, New Jersey, built in 1876, was moved to Greenfield Village in 1928, along with all outlying buildings including the machine shop, office, and lamp factory. Used by Edison during his most productive period (1876-1886), these buildings constitute the world's first industrial research center. From this upstairs laboratory came the electric light, phonograph, radio tube, typewriter, mimeograph, telephone transmitter, and many other important inventions. On October 21, 1929, fiftieth anniversary of the electric light and dedication day of Greenfield Village and the Henry Ford Museum, Edison re-enacted here the invention of his incandescent lamp.

WRIGHT HOME AND CYCLE SHOP. From 1870 to 1912 this frame house from Dayton, Ohio, was the home of the brothers Wilbur and Orville Wright. In 1902-1903 they constructed the first successful airplane in the adjacent Cycle Shop, where they had begun to make and sell bicycles in 1896.

202

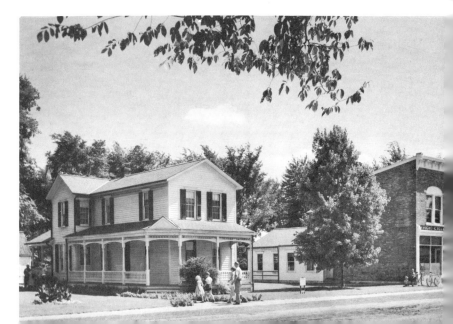

The New York State Historical Association at Cooperstown

COOPERSTOWN IS A HIGHLAND VILLAGE curving around the foot of the same Lake Otsego where James Fenimore Cooper fished as a boy and let his fancy rove as a man. The hills that rise high around lake and village give a sense of peace protected from today's pressures, and past the village flow, quietly and tree-shaded, as the outlet of the lake, the beginnings of the Susquehanna River. There are scores of buildings from the first fifty years of village history which ended in 1836; there are scores of families whose ancestors bought their land from William Cooper, the novelist's father.

To this environment Stephen C. Clark invited the New York State Historical Association in 1939. Through his vision and leadership and with the counsel of a distinguished board of trustees it has grown from a relatively small society with a limited program to a major force in the rising interest which Americans are taking in their own history.

While Fenimore House and the Farmers' Museum are the best-known aspects of the Association's program, they are most clearly understood when seen in relation to the whole. Despite its name, the New York State Historical Association is neither supported, directed, nor controlled by the State of New York. It is a membership organization with a very active junior program in the schools of the state; with an increasingly important research library; with two magazines, *New York History* for scholars and *The Yorker* for young people; with an annual workshop for local historians; and with a two-week educational program each summer, Seminars on American Culture, which draws three to four hundred adults from every part of the United States and Canada.

The common thread that runs through these projects and the museums is an emphasis on social history, especially on the folk life of our people as it was lived in the years after the Revolution and before the Civil War.

Fenimore House and Farmers' Museum together are teaching museums which are, in turn, part of a historical society which views itself as an educational institution. We are seeking to understand and to teach, in a great variety of ways, the story of working men and women, their handskills, crafts, arts, architecture, laughter, politics. Other museums and historical societies have recorded superbly how the cultural leaders of our past lived; we speak of followers and forefathers of leaders. Stress is on upstate New York, but there are areas (folk art, for example) where we go beyond the state's boundaries, and there are others which are more limited (Village Crossroads, for example).

Farmers' Museum began as a collection of farm tools and implements, but by 1945 when it moved into the great stone dairy barn of the late Edward Severin Clark (the Main Building), it had already broadened its base. Now the Main Building concentrates on three themes of frontier life: the house a family lived in and the way it was constructed, the land that supported the family, and the crafts and handskills that made life possible. We aim to show the tool in use by the craftsman, for in no other way can its function be made so clear, and whenever possible we encourage the visitor to use the tools himself. We long ago tore up the last "Please do not touch" sign.

Beyond the Main Building lies the Village Crossroads, the kind of hamlet that marked the beginnings of many of our thriving towns and cities in the section of New York lying west of the Hudson Valley. The buildings—thirteen of them—were carefully selected as architecturally characteristic and moved to the Crossroads. Furnishings, decorations, and activities inside and outside the buildings represent, as faithfully as our research can determine them, the details of life as lived by working people in our part of York State before 1840.

In Fenimore House, built as a private residence in 1931, are displayed our collections of American painting and American folk art. The genre paintings by academic artists deal with the same subject matter as the Farmers' Museum. Quite apart from their artistic excellence, these are firsthand reports by painters who knew rural life a century to a century and a half ago. And the landscape paintings, from the same period and of upstate New York, provide the setting. As one would expect in the village he made famous, a room is devoted to James Fenimore Cooper, one of the great reporters of upstate life.

Fenimore House also contains our library which, of necessity, is the nerve center for everything we accomplish. Strong in New York State local history, it grows yearly stronger in diaries, journals, and daybooks of craftsmen, farmers, small businessmen. Here too is a major archive of New York's folklore, and here have been deposited the library and patterns of the Esther Stevens Brazer Guild of the Historical Society of Early American Decoration, Inc.

The Cooperstown complex is more than museums, more than a historical society, more than a junior and adult education program. It is a project for which there is no adequate label. I am not sure it needs one as long as it continues to stir the American imagination and create a surer understanding of our roots.

LOUIS C. JONES, *Director*

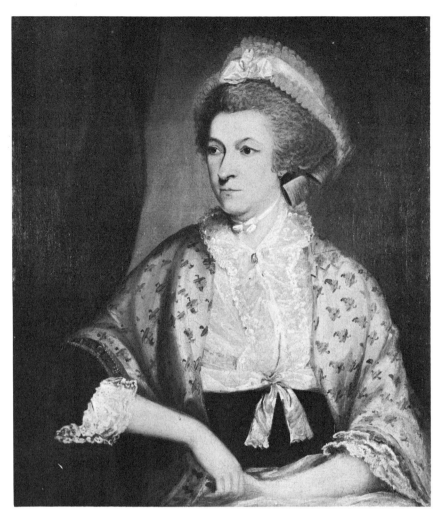

Abigail Adams, by Ralph Earl (1751-1801); oil on canvas, 30½ by 26⅜ inches; signed *R. Earl, pinx.* Characteristic of Earl's work in England; painted presumably in 1785, soon after the Adamses arrived in London where Adams was the United States' first ambassador to the Court of St. James. Earl returned to America the same year. Also at Fenimore House is Earl's portrait of Major General von Steuben, 1786.

Joseph Brant (Thayendanegea) (1742-1807), by Gilbert Stuart (1755-1828); oil on canvas, 30 by 25 inches. Brant was the distinguished leader of the Mohawks in the warfare of the New York frontier—the area surrounding present-day Cooperstown—in their days of victory and years of defeat and displacement. In their behalf he twice visited London, where he was portrayed by Romney in 1776 and twice by Stuart in 1786. He was also painted by Charles Willson Peale in 1797 and by Ezra Ames in Albany in 1806; the Ames portrait, which was copied by Catlin, is also at Fenimore House. This Stuart is shown as it hangs above a New York State fireplace of c. 1800 in Fenimore House, with Brant's sash (*ceinture fléchée*) above it.

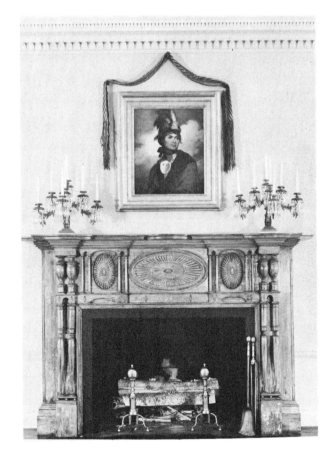

The paintings

THE DISTINGUISHED COLLECTION of American paintings at Fenimore House presents a stimulating variety of techniques and types. Portraiture, landscape, genre, and still life from the late 1700's to the early 1900's are represented. In all these categories New York State subjects and artists are, appropriately, emphasized, as in portraits of and by New Yorkers, local scenes by upstate painters, and illustrations for the writings of Cooper. But these have been selected as works of art, not purely for their regional or historical interest, and they are shown with paintings as remote from New York as a Civil War battle scene and a Wisconsin landscape.

The American folk art collection for which Fenimore House is renowned began in 1949 with a few pieces already in the museum and thirteen woodcarvings and paintings from the collection of Mrs. Elie Nadelman. The next year Stephen C. Clark bought the remarkably varied

Little Girl with Red Shoes, by John Brewster, Jr., 1807. Signed and dated. Oil on canvas, 34⅞ by 24⅞ inches. The artist, according to Groce and Wallace, was born a deaf-mute at Hampton, Connecticut, in 1766 and was still living in 1846. About 1830 he was painting portraits and miniatures in Portland, Maine, but in the early 1800's he was working in Boston and Salem, and he has also been traced in Connecticut. This portrait shows a grave little girl in white, with brown hair and blue eyes, holding one of her red shoes by its black ribbon and standing, one foot bare, on a floor stenciled in dark brown and black.

collection assembled by Jean and Howard Lipman. Since then each year has seen a few more pieces added until 1958 when Mr. Clark again made a major addition with one hundred fifty paintings from the collection of the late Mr. and Mrs. William J. Gunn.

This collection was virtually unknown before its purchase: no research had been done on the pictures, no photographs taken, and, so far as could be determined, not one item had been published before the presentation of the *Little Girl with Red Shoes* in Antiques for February 1959. Yet it is a major collection of American non-academic painting. About half the pictures are portraits, many of children; the rest comprise landscape, genre, still life, historical and symbolical subjects, memorials, and calligraphic art. Their dates cover the century from the 1780's to the 1880's, with the majority between 1810 and 1840. While many are anonymous, four are attributable through

signature or style to John Brewster, Jr., three to T. Chambers, two to Joseph Whiting Stock, four to Ruth Bascom, six to Prior and Hamlin, and one to Jeremiah Paul.

Many of the Association's other paintings are well known through publication and through exhibition outside of Cooperstown. Several, for example, were included in the showing of American paintings at the Brussels World's Fair in 1958, and others have been seen in museums all over this country. Not a few have appeared in Antiques, and a number of those from the Lipman collection are recorded in the books by Jean Lipman. Illustrated here are some of these old favorites and some less familiar, which together represent the scope and quality of the collection. Numerically the greatest part of the collection is the folk art, but no attempt is made here to separate folk art from fine art: within major categories, the pictures are shown in chronological sequence.

Catherine Ann Russell Nelson (Mrs. Samuel Nelson), by
Samuel F. B. Morse (1791-1872); oil on canvas, 31½ by
26 inches. One of a pair (with her husband) at Fenimore
House, both with red wallpaper background, painted prob-
ably in 1826 when Morse spent a summer at Cooperstown
(see ANTIQUES, January 1949, p. 63). Samuel Nelson, a
judge of the United States Supreme Court 1845-1873, was
one of the great figures of Cooperstown from the 1820's on;
he had a summer home on the site of Fenimore House, and
his summer law office is now at the Farmers' Museum (see
The Village Crossroads). Also owned by the association
are Morse portraits of Moss Kent and Elkanah Watson.

Laura Hall (Mrs. Ambrose Kasson, 1787-1869), by J. Brown;
oil on canvas, 72 by 36 inches; signed and dated 1808. Only
two other portraits by this forceful artist are known. They
are of Laura's parents, Calvin and Mercy Barnes Hall; all
three were painted in Cheshire, Massachusetts. Hall was
later a glassmaker in what is now North Utica, New York.
Laura and her husband also settled in the area.

Mrs. Fenton, by an unknown artist; water color, 13¾ by 11¾ inches; c. 1840. One of five portraits in original wide beveled frames, the others of a man, two boys, and a girl. Tradition says the subjects were members of the Fenton family of the Hudson Valley, and *Miss Prudy Fenton* is inscribed on the back of the girl's portrait. The name *McCoy* (presumably that of the artist) is written on the back of the frames of father and sons. Attached to the mother's sleeve is a lock of real hair.

Eliza Smith. Oil on canvas, 36½ by 27 inches; 1832(?). According to an ancient paper pasted to the canvas, Eliza, born 1827, was painted at the age of five by the "Pastor of Broad Street Christian Church, Providence, R.I.," and later spent forty years as a schoolteacher in "Johnson, R.I." Here she floats above the landscape on a magic carpet.

Presenting baby, by an unknown artist; oil on canvas, 20 by 14 inches; mid-1800's. Folk art representations of babies do not always show them at their best. This example, however, succeeds admirably in conveying a more or less universal parental attitude: nothing must be permitted to draw the viewer's attention from the charms of the latest addition to the family.

Leatherstocking meets the law, by John Quidor (1801-1881); oil on canvas, 27¼ by 34¼ inches; signed, back and front, *J. Quidor N. York/May 27, 1832.* One of several paintings at Cooperstown illustrating scenes from James Fenimore Cooper's works; first owned by the novelist's daughter, this depicts a scene from *The Pioneers* which was set across Otsego Lake from the place where Fenimore House now stands. John I. H. Baur (1942) called it Quidor's "most broadly humorous composition."

Smith and Dimon Shipyard, East River, New York City, by James Fulton Pringle (1788-1847); oil on canvas, 32 by 50¾ inches; signed and dated 1833. Full of technological detail, this pictorial record was painted by an Englishman the year after he came to America. From this shipyard later came *Rainbow* (1845), the first extreme clipper; and *Sea Witch* (1846), said to have broken more speed records than any other American sailing vessel.

Steamer Niagara . . ., by James Bard (1815-1897); oil on canvas, 39½ by 61 inches; signed and dated 1852. Inscribed in lower left, *Steamer Niagara Passing Fort Washington Point 1845/Built by Messrs. Wm. & Thos. Collyer of New York 1845.* This painting, a characteristic example of Bard's meticulous work, belonged to Albert De Groot whose name appears on it, and was given to the Association by his grandson's widow.

Politicians in a Country Bar, by James G. Clonney (1812-1867); oil on canvas, 17⅛ by 21⅛ inches; signed and dated 1844. Clonney painted in Cooperstown in the 1850's. This picture was used as a document in the Association's research on equipment for the Bump Tavern. Also in the collection is Clonney's water-color sketch (3 by 4 inches) of this subject.

Eel Spearing at Setauket, 1845, by William Sidney Mount; signed and dated. Oil on canvas, 29 by 36⅝ inches. Of the collection of forty-odd genre paintings in Fenimore House, this is probably the best known and the most popular.

Cider Making in the Country, by George Henry Durrie (1820-1863); oil on canvas, 35⅝ by 54 inches; signed and dated 1863. Another pictorial document, this one of farm life; at the same time a very pleasing work by a well-known New England landscapist. Made popular by Currier & Ives through their lithograph *Autumn in New England— Cider Making* (published 1866).

209

Farm scene near Gotham, Wisconsin, by Paul A. Seifert (1840-1920); water color, 22 by 31 inches; c. 1880. Hitherto unpublished, this portrait of a Wisconsin farm has Seifert's recognizable characteristics of neatness, clarity, and a sense of space in a layered composition—the orderly works of man against a still-untamed background. One of three paintings in the collection by this artist, who came from Germany in 1867.

Whaling scene, by an unknown artist, C.W.B.; oil on sailcloth, 24⅛ by 37⅛ inches; initialed and dated 1892. Whaling has been depicted by all sorts of artists, academic and otherwise, and by many printmakers, but few have given a greater sense of its danger and drama than this unidentified primitive.

Col. Glover's fishermen leaving Marblehead for Cambridge, 1775, by J. Orne Johnson Frost (1852-1929); oil (house paints) on pressed board; 23½ by 49½ inches; 1920's. Striking design, movement, and color characterize the work of this recently discovered primitive of Marblehead who took up painting at seventy after a life as fisherman and restaurant keeper. His subjects were historical events and local scenes; *Peaches Point, Marblehead* is also in the collection.

Marimaid, by Mary Ann Willson; water color on paper, 13 by 15½ inches; 1810-1825. The bold, imaginative, brightly colored creation of a frontier artist who lived in a log house in Greene County, New York, with a farmer-companion, Miss Brundage. About twenty examples of her work are known. The bow and arrow are as unexpected as the patchwork tail.

Memorial by Eunice Pinney (1770-1849); water color and pin pricking, 18½ by 15¾ inches; c. 1815. There are four pictures in the collection by this early Connecticut water-colorist admired for her vigorous design and robust colors. *Two Women* was first published on the cover of ANTIQUES, May 1932. The others are a Masonic mourning piece, and one memorializing the artist herself. This one, though apparently portraying an actual family in a specific village, bears no name.

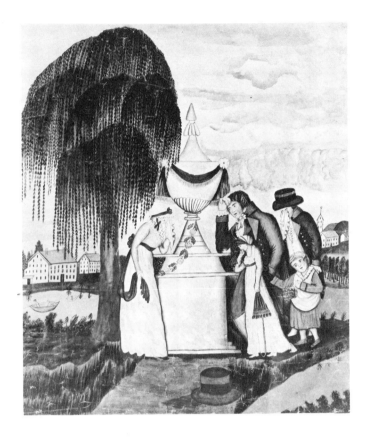

Tropical bird and fruit, by an unknown artist; water color, 24½ by 18¾ inches; c. 1830. A graceful composition of unusual elements, in the shaded technique associated with still-life paintings on velvet.

Peaceable Kingdom, by Dr. William Hallowell (1801-1890); "Drawn . . . with a pen," India ink on paper, 15¾ by 19¾ inches; signed and dated 1865. Far more elaborate than most calligraphic pictures, this tight, convoluted composition is reminiscent of Edward Hicks' paintings of the *Peaceable Kingdom*. Two excellent examples of the latter are also in the collection. Hallowell was a physician and dentist of Norristown, Pennsylvania, and, like Hicks, a prominent Quaker.

211

The sculpture

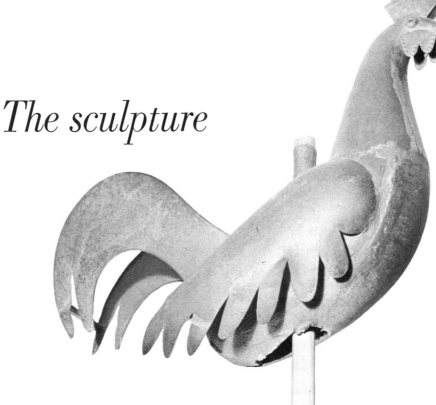

Cock weathervane of sheet iron; height 13½ inches. Though source and date are unknown, this piece is reminiscent of early weathervanes in New Netherlands and also of some in French Canada.

Female figure of carved wood, originally gessoed and gilded; height 46 inches. A provocative piece, raising questions as to date, source, purpose, and significance. Though the carving lacks "the American look," the wood has been identified as an American pine. Possibly once part of a group, and presumably an allegorical subject; probably, considering its perishable surface, intended as an interior decoration. *On long-term loan from the Smith College Art Gallery.*

THE FOLK ART collection in Fenimore House is outstanding for its sculpture as well as its paintings. It includes figureheads, weathervanes, shop signs, ship and architectural decorations, toys, and portrait busts and figures— mostly in wood, but also in metals and ceramics. The artist-craftsmen who produced them are largely unidentified, and much of their work is difficult to date with any exactitude. Also at Fenimore House is a collection of life masks of notable Americans by John Henry Isaac Browere.

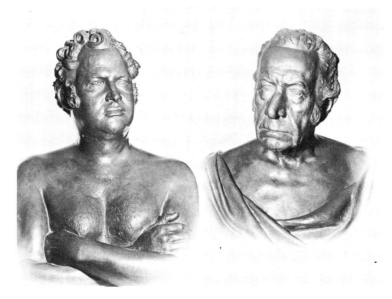

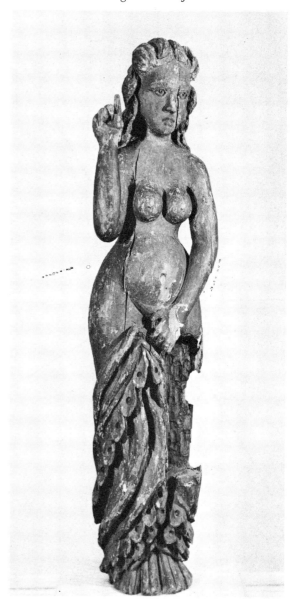

Life masks of General Alexander Macomb (1782-1841) and Gilbert Stuart (1755-1828) by John Henry Isaac Browere (1790-1834). By a secret formula the New York sculptor modeled remarkably realistic life masks of many leading Americans between 1817 and 1833. These two were done in 1825. Eighteen of his plaster casts are now preserved at Cooperstown (only three or four others survive, in other museums); the bronzes displayed in Fenimore House were cast from them in 1940.

Cigar-store figure of carved wood, polychromed; the skirt consists of thirteen separate pieces; head and arms were also separately carved; skin is painted brown, dress green, fringe gold; early 1800's. This strong, uncluttered figure is more boldly modeled than the later, stereotyped cigar-store Indians. Traditionally it was carved by a Negro slave in Freehold, New Jersey.

Liberty cap, of carved wood with traces of original polychromy; height 9½ inches; probably early 1800's. The liberty cap has been a part of our patriotic iconography since the late 1700's, akin to the *bonnet phrygien* of Revolutionary France and to the *pileus* of ancient Rome (a felt cap worn by manumitted slaves). This one is bordered by a row of stars; a hole in the base suggests it may have been carried on a pole in political parades.

Dancing Negro; woodcarving, originally polychromed; possibly a tavern sign; height 3 feet 11 inches; probably 1825-1850. Time and weather have left only hints of the colors, and the feet too are worn away, but the bare grain of the wood accentuates the movement and immense vitality of the figure. One of the great pieces of early American sculpture.

Sea-serpent weathervane of wood; length 53 inches; probably early nineteenth century. An unusual motif, most effectively designed.

Head of a Boy, by Alexander Ames; carved and painted wood; height 18 inches; signature and date incised in base; 1847. Believed to be a portrait of Millard Dewey of Angola, near Buffalo, New York. A three-dimensional counterpart of the best primitive portraits of its day, showing in this different medium the same kind of stylized modeling, neat detail, and strong characterization. Other Ames sculptures may be seen in museums at Buffalo, New York; Fitchburg, Massachusetts; and Williamsburg, Virginia.

Ship's figurehead of carved and painted wood; height 37 inches; 1830's. Classic features crowned by an elaborate coiffure, cleanly carved.

Man Sitting on a Stump, by Anthony W. Baecher (1824-1889). Terra cotta, painted; unmarked; height 19 inches; 1870's or '80's. According to Rice and Stoudt, *The Shenandoah Pottery,* Baecher was the most skilled of the Shenandoah potters. A native of Bavaria, he settled at Winchester, Virginia, before the Civil War, and practiced his craft there and also, until about 1880, in Frederick County, Maryland. He made earthenware in many useful and ornamental forms, including animal and human figures. This unglazed figure, acquired by Rice from Baecher's son, is obviously a portrait—or caricature. (Illustrated, *op. cit.,* p. 84, and catalogued as No. 1656, p. 252.)

Mare and foal weathervane of wood, the mare in flat outline, the foal slightly modeled; painted red and black; length 31 inches; c. 1850. Found in Rhode Island. The self-conscious humor evident here is a quality rare in American folk art.

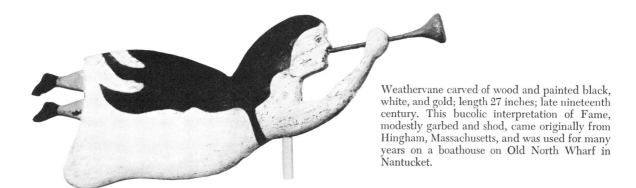

Weathervane carved of wood and painted black, white, and gold; length 27 inches; late nineteenth century. This bucolic interpretation of Fame, modestly garbed and shod, came originally from Hingham, Massachusetts, and was used for many years on a boathouse on Old North Wharf in Nantucket.

Majestic bull of carved wood used in making copper weathervanes; length 45 inches; mid-nineteenth century. From such a wood carving, plaster molds were made, and metal molds from the plaster; then sheet copper was beaten into form on the metal. The work was done in sections and soldered together to produce a hollow copper weathervane, which was then covered with gold leaf.

Carved wood peacock, the body painted green, the tail multicolored; height 10 inches. Instead of having his tail at right angles to his body like any self-respecting peacock, this comical bird has a flat appendage parallel to his body; presumably this was a vane to catch the wind, though in view of its small size the figure may simply have been a toy.

Flying eagle, wood carving composed of five separate pieces, gessoed and gilded; height 28 inches. Found in New York State; probably designed as an architectural adornment.

215

The painted decoration

BY NINA FLETCHER LITTLE

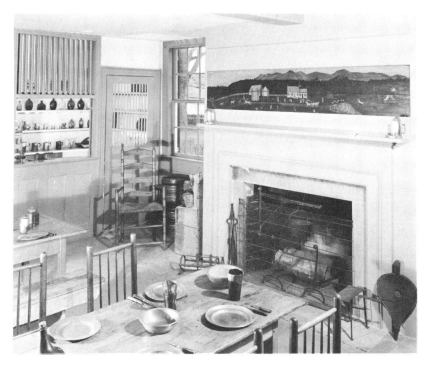

Barroom of the Bump Tavern with overmantel painting from the Van Bergen house (built 1729), Leeds, Greene County, New York. When this house was demolished in 1862 the board was removed to a new house erected on the same site, where it remained until acquired by the New York State Historical Association in 1954. Here it is installed in such a way that it can be removed for exhibition.

DURING THE LAST DECADE there has been increasing interest in early decorative painting, and the collection of the New York State Historical Association now contains documented examples in all the major categories. This material has been installed in the Farmers' Museum buildings with the intention of showing it in its original context.

Ten years ago the public was unaware of the number of landscape panels and stenciled walls still in existence in New York State. But as interest increased through information made available during the Seminars in American Culture, reports began to come in concerning decorated walls, floors, woodwork, and furniture in many parts of the state. Correspondents were urged to photograph and describe their finds and to deposit the data at the Association's headquarters where they are kept on file for the use of all interested scholars.

Decorative landscapes painted on sections of room paneling became popular in the seaboard states during the mid-1700's. They began to go out of fashion by 1800 because post-Revolutionary architectural styles did not emphasize the overmantel. Of the few eighteenth-century examples found in New York State, a particularly fine one is in the Bump Tavern barroom. This originally formed part of the woodwork in the home of Martin van Bergen, a stone farmhouse built in 1729 in the present town of Leeds.

A second architectural painting executed on a wood panel was found, framed by short pilasters, below the bar

Center section of the Leeds overmantel (mid-eighteenth century), showing Van Bergen's stone farmhouse and its outbuildings with the Catskill Mountains in the background. The owner and his wife stand before the house, watching a loaded wagon pass, while other members of the family, Negro servants, and farm animals enliven the scene. In the foreground an Indian with gun is meekly followed by his squaw with papoose. Apart from its liveliness and charm, this painting is the finest pictorial record yet discovered of early eighteenth-century farm life in the Hudson River Valley. Length of entire panel, 7½ feet.

216

Architectural painting from Potter Hollow Tavern, Albany County, mid-1800's; signed *W. W. Cornwell pin . . .* The artist emphasizes the coming of steam to the Hudson Valley with sidewheelers plying the placid river and a wood-burning locomotive drawing a train of small passenger cars. *Fenimore House.*

in the old Potter Hollow Tavern in Potter Hollow, a well-known landmark destroyed by fire in March 1957. This scene, painted about a hundred years later than the Van Bergen panel, illustrates with naïve charm the coming of steamboat and railroad to the Hudson River area. An unusual feature is the signature of the otherwise unidentified artist, *W. W. Cornwell pin. . . .*

A comparison of the various stenciled plaster walls which are gradually emerging in central and upper New York indicates that itinerant decorators traveled westward in the wake of the pioneers during the first half of the nineteenth century. New England houses of this period exhibit many patterns similar (and some identical) to those now being discovered west of the Hudson River.

In the Bump Tavern, which originally stood in Ashland, Greene County, several rooms of stenciling were found under later wallpaper. The motifs are attributed on stylistic evidence to the itinerant artist "Stimp," a shadowy personality whose distinctive designs are identified with a group of houses in western Connecticut. Similar patterns in the Perry house in Dover Plains suggest that he may have crossed the New York border near that point, and, proceeding northwesterly, eventually arrived in Ashland. There he was probably lodged by the landlord in return for decorating the upper hall, chamber, and ballroom of the Bump Tavern.

The floor stenciling of the Lippitt parlor is typical of farmhouse floors in central New York between 1790 and

Stenciled walls in upper hall of the Bump Tavern (c. 1830), painted in dark green, red, and black on a white background. Discovered after the building was moved from Ashland to Cooperstown, the original stenciling had to be, for the most part, removed when the room was replastered; but the center section, customarily concealed behind a removable panel of wallboard, may be seen here as found. Border, frieze, and several wall patterns closely resemble designs attributed to an itinerant called "Stimp" in Janet Waring's *Early American Stencils on Walls and Furniture.*

Stenciled floor in the parlor of the Lippitt Farmhouse. Black motifs painted on a gray ground, copied from a design in a house in West Edmeston, twenty miles west of Cooperstown. Such decoration was typical of many floors of the first quarter of the 1800's. The chest is grain-painted in black on a yellow-tan background. The larger box is of pine embellished with a wreath of red, black, yellow, and white flowers on a dark blue-green background. Bride's boxes were repositories for feminine treasures and were frequently decorated by their owners. This example is cream-white, with panels outlined in green and red enclosing colorful birds, butterflies, and grapes, with the initials *M.A.B.*

217

1820. This small repeat pattern was taken from one in West Edmeston. That in the gentlemen's reading room of the Bump Tavern was copied from a floor in nearby Willowbrook, a house built in 1816 and now known as the Cooper Inn. This design (shown in the illustration opposite, lower right) is more formal than most painted examples and appears to simulate a woven ingrain carpet of the 1830-1840 period.

A group of decorated walls painted freehand, also in the collection, will soon be installed in the lower hall of the Bump Tavern. They were originally in the Carroll house, an early nineteenth-century turnpike tavern in East Springfield, about twelve miles north of Cooperstown, and the decoration was found under layers of later paper. The

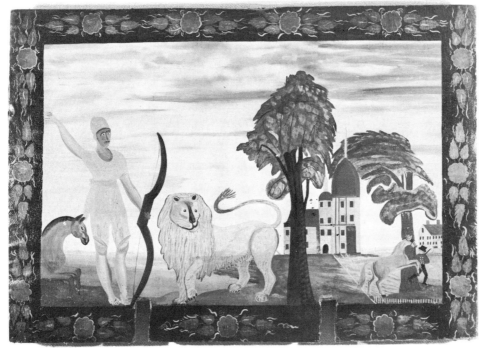

Section of plaster wall from the Carroll house, East Springfield, New York. Painted freehand with a bold technique in strong dark colors; a type of decoration popular from 1825 to 1840. Two walls from the house are signed *William Price 1831.*

Romantic Scene with Lion. Fireboard, oil on canvas mounted on a wood frame. An interesting combination of the techniques of the ornamental painter in which a stenciled border frames a freehand landscape. So-called Oriental scenery was of great popular interest during the 1830's. *Fenimore House.*

Bear and Beeves. Fireboard painted on wood; height 33 inches. The humorous title derives from a note in Hedrick's *History of Agriculture in the State of New York* mentioning Timothy Bigelow's trip to Niagara Falls in 1805, during the course of which he heard that the settlers hung fresh meat in the trees to keep in hot weather. If the large red objects hanging from the branches are intended to represent meat, the bear is apparently climbing the wrong tree. Paintings believed to be by the same unknown artist have been found in houses in Grafton and Lisbon, New Hampshire. *Fenimore House.*

A country washstand found in Water-
loo, New York. Painted gray and deco-
rated freehand in silver. The striping
is effectively painted in shades of gray
and black. *Bump Tavern.*

Three painted side chairs. *Left,* a Hudson Valley chair painted black with swan
splat and decoration of gold leaf with burnt umber and red detail. *Center,* a
Rhode Island arrow-back chair with unusual top rail decorated with a tiger
in a landscape, painted black with yellow and red striping. *Right,* a Penn-
sylvania chair painted gray with striping in green and brown. *Fenimore House.*

plaster of almost every interior wall was painted with
scenery and semitropical landscapes which included naval
battles, military figures, a parade of ladies and gentlemen,
and Indians lurking behind trees. The signature of the
artist, *William Price 1831,* appears twice, in the east upper
chamber and in a closet. These walls have been divided
between the Winterthur Museum and the New York State
Historical Association.

Painting fireboards was also an important part of the
repertoire of the traveling artist. Made of either wood or
canvas, they were used to close fireplaces when these were
not in use. Several interesting examples are in the collec-
tion, representing the romantic taste and the primitive
techniques of the first half of the nineteenth century.

Decorated window shades, painted on thin cambric to
render them "transparent," added gaiety and color to the
nineteenth-century home. A pair exhibiting picturesque
scenes is installed in the reading room of the Bump Tavern.
Some such shades were manufactured and sold commer-
cially, while others were made at home after directions in
contemporary art-instruction books.

The Tavern and the Lippitt Farmhouse contain some
interesting decorated furniture illustrating the types used
in country homes during the first half of the nineteenth
century. Pine chests were skillfully grained by local arti-
sans to simulate more costly woods. Others enriched their
surroundings with colorful, informal patterns applied by
brush, cork, or feather. Many pieces were ladies' work,
stenciled with patterns laid on bright backgrounds, or
painted freehand with graceful vines and flowers. Sets of
chairs, factory-decorated during the second quarter of the
century, were an important item in the home. Several
regional examples in Fenimore House exhibit stenciled
and freehand decoration typical of their locality and
period.

A corner of the gentlemen's reading room, Bump Tavern. The
fireboard is from Jefferson, New York. Slots allow the andirons to
rest outside on the hearth. The stenciled floor has a yellow ocher
ground with red and green designs (a sample of the original from
which it was copied is kept in the room for comparison). The
painted window shade was used in the Knapp house, Morris,
New York. Such shades were manufactured from 1830 to 1860.

The country furniture

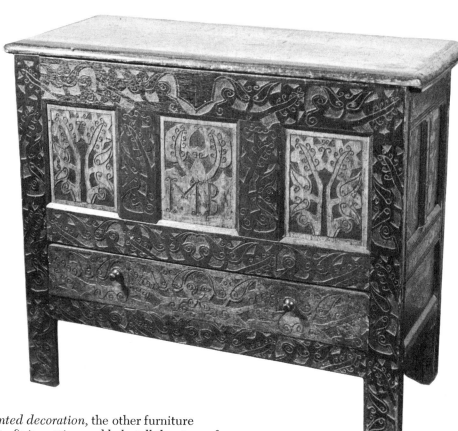

LIKE THE PIECES SHOWN in *The painted decoration,* the other furniture
at Cooperstown has been selected to fit its setting and help tell the story of
pioneer life in upstate New York. It shows how rural craftsmanship and
taste often reflected the major style trends—at some distance in time and space—
yet sometimes departed from them completely. This is not a collection of
the finest and rarest cabinetwork of the period: it is what was
commonly used in villages and farmhouses of the region up to the mid-1800's.
Many items are significant from the collector's point of view;
seen in place together, all are convincingly evocative.

Hadley chest, initialed *MB;*
c. 1713. Handsome and use-
ful heirlooms like this were
brought from New England
by early settlers in New
York. This one was made for
Martha Bridgman, who mar-
ried Hezekiah Root in 1713
(Luther, *The Hadley Chest,*
p. 73). *Lippitt Farmhouse.*

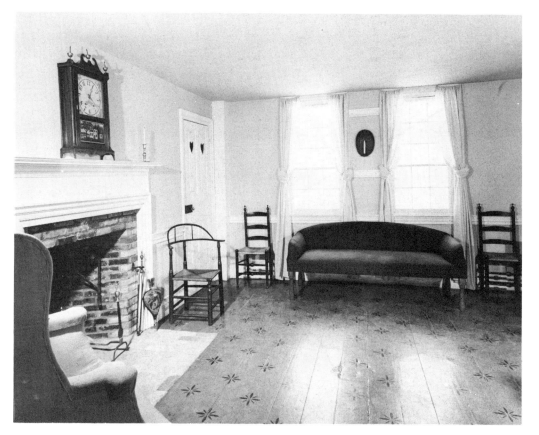

In the Lippitt parlor is a
plain but unusual settee with
pine frame on turned legs,
upholstered in quilted linsey-
woolsey. The ever-useful lad-
der-back chairs flanking it
have strong turnings. The cor-
ner chair has an unconven-
tional bow-back and thin arm
rail, apparently adapted from
windsor design. A Seth
Thomas clock in Terry pillar-
and-scroll case lends a dressy
note.

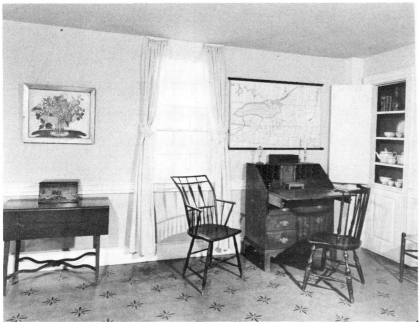

A cherry drop-leaf table in a simplified version of Hepplewhite design is given distinction by its serpentine cross stretcher. The pine box on it is decorated with a painted scene, and the bamboo-turned, arrow-back windsor, with striping. The walnut desk is country Chippendale, made possibly as late as the 1800's. The windsor before it is of a New England type carried over to New York. *Lippitt parlor.*

The Lippitt kitchen is used for more than cooking. A pine writing box, painted green, which can be locked to preserve family papers, is kept conveniently on a long, strong, sawbuck table. Splint-seated chairs include a comfortable rocker and a sturdy ladder-back for the rag doll. Pewter, glass, and English earthenware are displayed on the red-painted pine dresser, an early Hudson Valley piece, which is also handy for holding a dough tray, basket, candles, and herbs.

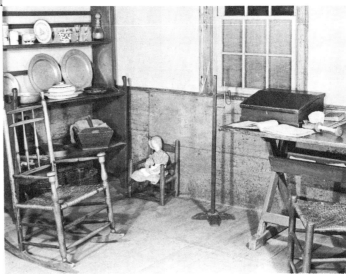

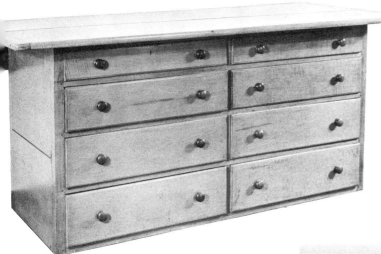

No picture of New York life would be complete without reference to the Shakers, whose earliest communities were in the eastern part of the state, at Watervliet and Lebanon. Their fine, clean craftsmanship is represented at Cooperstown by this tailoress's table. *Fenimore House.*

In the ladies' parlor of the Bump Tavern a stocky hutch table with drawer and widely overhanging octagonal top shows the wear of many generations; the other furniture is somewhat later. The serpentine-top side table and the small slant-top desk, both of pine, have the straight tapered legs that became popular in the 1780's and lingered long in rural regions. The chairs are nineteenth-century country versions of earlier types.

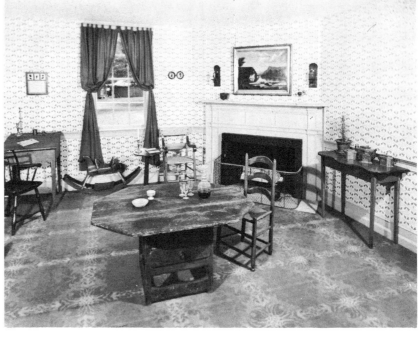

221

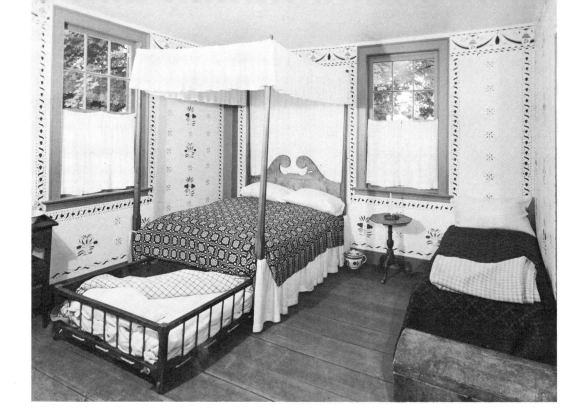

The textiles

BY VIRGINIA D. PARSLOW, *Assistant curator, Farmers' Museum*

THE FARMERS' MUSEUM is concerned not only with showing its visitors the finished products of the pioneer, but with giving them an understanding of how, and from what raw materials, the necessities of life were obtained on the frontier. Important among these were clothing for the family, furnishing fabrics for the household, and textiles and cordage for farming operations.

A small field of flax is planted each year near the Lippitt Farmhouse, where it may be seen by the visitor as it grows and blossoms and is pulled, rippled, retted, and dried. Demonstrations on the second floor of the Farmers' Museum show the processing of the flax to obtain the fiber. The operations involved, in which the original tools of the pioneer are used, include beetling and breaking to crush the inner stem, scutching or swingling to remove this broken shive, and heckling or hetcheling to separate the long fibers.

The heckled flax fiber is spread out in a thin web so that when it is wound on the distaff it resembles a huge cocoon. As fibers are drawn down from this holder and smoothed with dampened fingers, the revolving spindle of the flax wheel twists them into finished linen yarn and winds this onto the spool.

From the filled spool the yarn is wound onto the cross arms of the reel, which measures it into knots and skeins (the amount of yarn spun must be measured to determine the number of yards of cloth which can be woven from it). These skeins are washed and then wound on paper quills or bobbins made from elderberry stalks, placed in the shuttle, and finally woven into patterned linen cloth on the barn-frame loom.

The process of heckling the flax fibers leaves a by-product called tow—short and tangled fibers of various grades depending on the size of heckle used. The finer and cleaner grades were spun and woven into coarse fabrics for work clothing, towels, bedticks, and sacks. The coarsest was spun into heavy yarn on a special tow wheel and laid into rope (a process occasionally demonstrated at the museum). The story of flax is thus told visually from seed to finished textile.

Flax was not the only textile fiber used by the pioneer, so sheep are to be seen in the pasture or in the fold at the farmstead. These are sheared each spring and the fleece is taken to the demonstration area, where it is picked free from burrs and tangles, carded into rolls on hand cards, and spun into woolen yarn.

Skeins of woolen yarn are sometimes dyed in a large copper kettle hung over an open fire at the farmhouse. The yarn is first simmered in a bath of alum dissolved in rain-water and then in a decoction of the dyestuff, in order to impart as permanent a color as possible. As in pioneer days, goldenrod blossoms, alder bark, and sumac berries are collected from the fields for producing the commonest colors. A bed of madder growing behind the farmhouse supplies a red dyestuff. Materials which the pioneer might purchase often included the dried root of madder and the ever-popular indigo; more rarely cochineal, which produced the desirable but expensive scarlet red, was bought.

Cotton was not a farm product in the northern sections of this country, but after 1800 it was readily purchasable in the form of yarn. Bed coverlets were woven of cotton and woolen yarns, and cotton was often combined with homespun linen for table linens and toweling. Cotton also replaced linen for the warp of the common material known as linsey-woolsey.

A few original textiles are used in the demonstration area as examples of various techniques, patterns, and

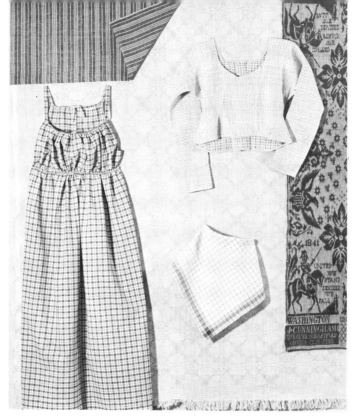

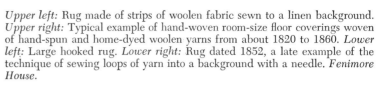

Household and clothing fabrics. *Upper left:* Striped linsey-woolsey, once part of a petticoat. *Lower left:* Woman's blue plaid apron in empire style. *Upper right:* Young woman's blouse of hand-woven linen in blue, gold, and natural, in an eighteenth-century style. *Lower right:* blue and white linen handkerchief. *Background:* Diaper-pattern linen tablecloth, and damask table cover of cotton and blue woolen woven by James Cunningham of New Hartford, New York, in 1841.

Quilts and bedspreads. *Clockwise from upper left:* Quilt typical of the red, green, and white appliqué style of about 1840. Bedspread of hand-woven cotton embroidered with the cotton yarn known as candlewicking; this one is dated 1825. Pieced and appliqué quilt with embroidered detail. Quilt made up of a star-form pieced center of printed cotton with corners of appliqué woodblock chintz and quilted border. Quilted bedcover of a copperplate-printed cotton exported from England in quantity during the last quarter of the eighteenth century. *Fenimore House.*

Parlor bedroom in Lippitt Farmhouse. Original textiles shown include striped woolen carpet, summer-and-winter coverlet and rose-wheel embroidered blanket on the chest, checked linen bed hangings, and bedspread of hand-woven cotton and wool with woolen embroidery.

Swingling and spinning flax. Swingling board and knife are used here to remove bits of broken stem from the flax fibers. Linen yarn is being spun on the flax wheel from the fibers arranged on the distaff. *Farmers' Museum.*

material uses, and many more are found in their appropriate places in the buildings of the Village Crossroads and farmstead. At both the Bump Tavern and the Lippitt Farmhouse the beds are made up with hand-woven sheets, pillowcases, blankets, coverlets, and bedcovers. Carpets, table linens, towels, and bed and window hangings show the wide variety of color and pattern in textiles which was available in the pioneer community.

The folk art collection, housed at Fenimore House, also includes some textiles: here the decorative rugs and the bedquilts are to be found. The rugs are in the yarn-sewn, shirred-patch, and hooked techniques. Most of the quilts displayed are of the more decorative appliqué type, but there are also pieced ones in the collection.

Hours of research insure that each tool, process, and pattern is as authentic as possible. The weaves and patterns of the original fabrics in the textile collections of the museums are constantly being studied and analyzed. These patterns are used in the fabrics woven for demonstration.

Library source material such as weavers' account books (ANTIQUES, April 1956, p. 346), old printed weaving pattern books, and newspaper advertisements help the staff to decide which types of textiles belong in the several buildings of the museum. Information from manuscripts and printed sources has also been used to determine the processes and materials used to produce the beautiful colors found in the old pieces.

Spinning wool. Woolen yarn being spun on the great wheel from rolls produced with the hand cards. *Farmers' Museum.*

Barn-frame loom. Warp-striped woolen carpeting being woven on an eighteenth-century loom from yarns colored with natural dyes. *Farmers' Museum.*

Pioneer farm tools. With these simple farm tools and whatever else a pioneer family could heap in its two-wheeled oxcart, the forests of upstate New York were cleared, the land was farmed, and homes were established. With few exceptions tools were made of wood, reinforced occasionally with a bit of iron. Most of the implements shown here are readily recognizable. The triangular spiked frame at the left was used for harrowing; the four-bladed grain cradle in the center of the wall is an improvement on the single-bladed scythe; and the shallow splint utensil below it is a winnowing basket.

The crafts

Clearing the land, growing food or hunting for it, building homes and making them comfortable— these were the primary concerns of the pioneer. For them he needed skills and tools. In the Main Building of the Farmers' Museum his tools are on display, and many of his skills as well.

Tools for house construction. To appreciate the strength of the pre-Civil War building, it is necessary to know something of the method of cutting and joining its framework. Shown here are the steps from cutting and dressing the timber to mortising and pegging the frame. Tools are for the most part from the William B. Sprague collection.

Log house construction. An exhibit which shows at a glance the method by which the corners were joined in log house construction in central New York.

Brick, plaster, and slate. With these humble materials and a handful of tools unchanged since Roman times, craftsmen built the sturdy homes of the eighteenth and nineteenth centuries. Despite increased mechanization in the building trades the handskills of the bricklayer, the mason, and the slater are still in demand.

Woodworking. Tools of cabinetmaker and turner, kept sharpened and honed, are used to turn out benches, spoons, and other useful articles for demonstration and sale. These are from the Sprague collection. Another carpentry bench has a sign which says: "These tools and this wood are here for your use. Try your hand."

Guns and decoys. Wild-fowling, the gentleman's sport of today, was from the earliest days of the Colonies an important source of food for the pioneer's or farmer's family; by mid-nineteenth century the shooting of waterfowl for food had become a commercial operation so extensive that several species were completely wiped out before the Federal government prohibited the sale of game in 1918. Decoys, ranging from crudely chopped-out ducks or geese to sophisticated versions of shore birds of identifiable species, helped lure the fowl within range of the gunner. (See *Wild Fowl Decoys* by Joel Barber, ANTIQUES, April 1935, p. 145.) The gun on the back wall is a 7½-foot Hudson Valley fowling piece from the first quarter of the eighteenth century. With a barrel 6 feet long and ¾ of an inch in diameter, it wrought havoc on the birds of its day. Stock and workmanship are Dutch, but the barrel bears English proofmarks of 1702.

Heating devices. Stoves like these made the uninsulated homes of mid-eighteenth-century upstate New York livable in the gray winter months. *From left:* Box stove made by the Shakers, possibly as early as 1780; they continued to produce the type through the first half of the nineteenth century. Franklin stove (for a discussion of the type see ANTIQUES, July 1922, p. 27) by James Wilson of Poughkeepsie, New York, first manufacturer to patent it by that name; here a sheet-tin dome greatly increases the stove's efficiency. Wilson often used this design, surrounding the eagle with thirteen, seventeen, or twenty stars; collar, knobs, and gallery are of brass. Franklin stove, late eighteenth century; cf. Peirce, *Fire on the Hearth*, Pl. 10. Two-column stove, a type popular in Pennsylvania and New York in the 1840's; the two "funnels" give off an amount of heat surprising from a firebox this size. *Foreground:* Heated soapstones added much to our ancestors' comfort, as did the footwarmers they took with them when they went abroad; the cylindrical form of this one is unusual.

Basketry. Working in splint and straw to make baskets, beehives, ox muzzles, and straw hats was a common rural occupation which supplemented the incomes of many rural families. The materials were cheap, the tools few, and the work could be done by children, invalids, and old people. Basketry still survives as a practical craft in many areas.

Printing. The printer uses a Washington hand press, built by one Taylor in 1846, which was in operation for more than fifty years producing the Andes, New York, *Recorder;* it can print two full-size newspaper pages at one pull of the lever. He also prints handbills in reproduction or adaptation of nineteenth-century examples in the Museum's collection. The exterior of the 1829 Printing Office is shown in *The Village Crossroads.*

Broom making. The broom maker works at his noisy, whirring apparatus enveloped in the smell of freshly cut broom straw. The machinery he uses was made by Shakers at the Watervliet (Niskayuna) community in New York State.

Eel spearing. Examples of functional beauty in wrought ironwork are the cressets which supported burning pine knots and birch bark for use in night fishing, and the multipronged spears for catching eels. The picture showing eel spearing is reproduced from the W. S. Mount original in Fenimore House, which is shown in detail with *The paintings.*

The Village Crossroads

In the early days of settlement each farm was a community in itself, but as farms multiplied and travel between them increased centers of trade and service grew up at the country crossroads. The self-sufficient farmer who built his own house and barn and clothed and fed his family with the raw material he raised still had to call upon the specialized skills of the village doctor, lawyer, and blacksmith. He had to provide schooling for his children, and exchange his goods at the village store for the things he could not make or raise. Communities like the Village Crossroads at the Farmers' Museum gradually grew up to fill his needs. Here thirteen buildings, each selected for its architectural interest and suitability, have been brought together from a hundred-mile area to form a typical upstate community of the period 1786-1840.

The store and, beyond it, the school. The store was built in Toddsville, New York, about 1820 for the workers of a local mill and neighboring farmers. It was brought to Cooperstown in 1944 and refitted with thick wooden shelves and counters filled with samples of what must have been its original stock: locally grown apples, grain, cheese, imported tea and coffee, spices, cotton, wooden buttons, notions, boots, and whale oil. In the rear of the building are two rooms, one for storage and one equipped as a post office.

Established near Morris, New York, before 1828, the stone and frame school building at the Crossroads was named after its founder and first teacher, Thomas Filer, a farm boy from Connecticut who came to work in the Butternuts Valley. The schoolroom looks much as it did when he taught there—pine desks, slates, blackboard, and wood-burning box stove in the center. The tuition fee was half a cord of wood per scholar, and prize students were privileged to carry wood and stoke the fire. Because most of the pupils were needed on the farm at harvest time the winter term began late in October and lasted about sixteen weeks; the summer term ran from April to mid-July. Such schools often had as many as fifty students ranging in age from five to twenty.

228

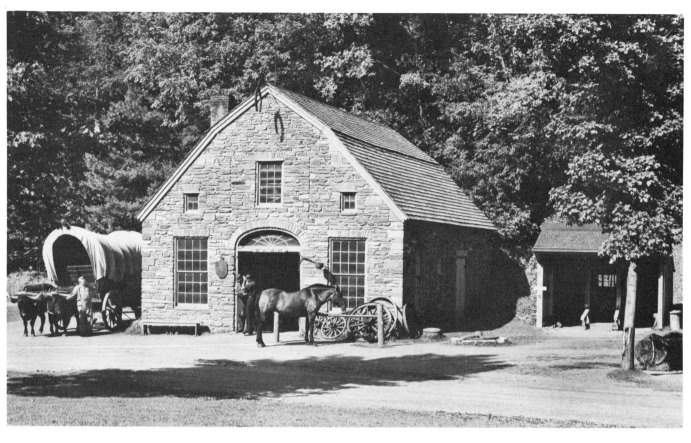

The New Berlin smithy was built in 1827 and remained in continuous use until 1934. Re-erected at the Village Crossroads in 1947, the smithy is again alive with its two glowing forges, wheelwright's tools, grooving hammers, and ox sling or trevis used in shoeing oxen. The wheelwright's stone can be seen to the right of the shop: an iron tire was placed on the stone and heated by a round fire of hemlock bark; then water thrown on the hot metal shrank the iron to proper size and made it secure. The village blacksmith made much more than horseshoes and wagon wheels; the entire community relied on his skill and ingenuity for plows, files, saws, kitchen utensils, hinges, candleholders—every necessity made of iron.

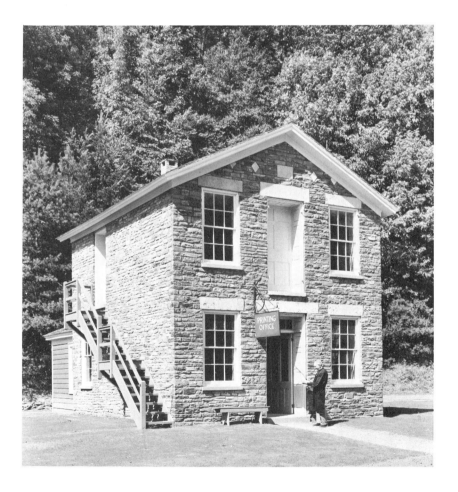

Newspapers were established soon after the community itself, and the farmers depended on the country editor for their news of the outside world—news that might be many months old. The Crossroads printing office was built in Middlefield, New York, in 1829. Rebuilt in Cooperstown, 10 miles from its original site, it is today the working shop of a country printer-editor who produces a newspaper besides printing handbills, stationery, and business forms. The shop is equipped with a Washington hand press of 1846 and with all the tools, from type stick to imposing stone, needed to print the country weekly in one ten-hour day of furious activity on the part of the printer and his helpers.

The village doctor frequently had his office in his house but sometimes he used a separate building, like the small frame Greek Revival structure from Westford, New York, built in 1829. With the help of the New York State Medical Society, this two-room office has been equipped with old textbooks, surgical instruments, vials, wooden splints, and home-made medicines of the early nineteenth-century country doctor. Like Elhanen Jackson, first to use this office, most country doctors were also apothecaries, dentists, and farmers on the side.

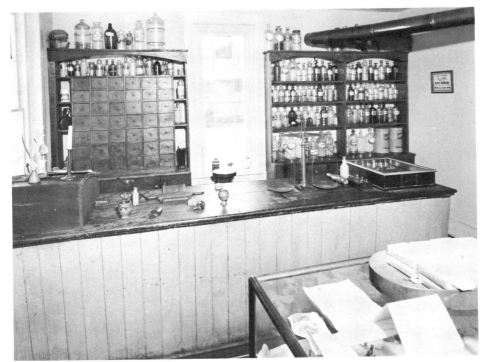

Not every community was fortunate enough to have a druggist shop, but the one at the Crossroads, from nearby Hartwick, shows what did exist. This building, originally a doctor's office, was erected in 1832. The exhibits of medicines, perfumes, paints, and soaps are based on advertisements in Cooperstown papers (1800 to 1820) of items sold in the Druggist Shop of Deacon George Pomeroy, brother-in-law of James Fenimore Cooper. Scales, mortar and pestle, wooden medicine chest, leeches, and glass apothecary jars were all standard equipment in shops of the period. Herbs for the doctor and druggist are grown in the garden between the shop and the doctor's office.

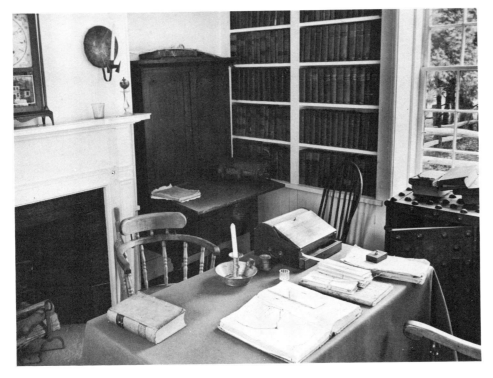

The Crossroads lawyer's office is appropriately a classic structure built near this site in 1829 by Samuel Nelson, Cooperstown lawyer and later justice of the United States Supreme Court. (Portraits of Nelson and his wife are in Fenimore House: see *The paintings*.) The outer office holds the clerk's desk, a small table, rocking chair, and box stove. The inner office has a fireplace with mantel clock, an iron safe, and a country-made secretary-bookcase in late Sheraton style. Furnished by the New York State Bar Association, the office has a rare law library of over a thousand volumes all published before 1850.

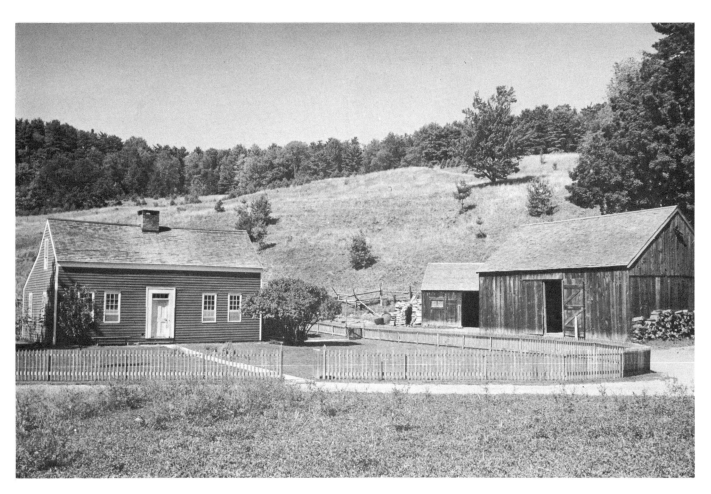

The Lippitt homestead at the end of the village road is the gift of a family whose forebears bought land in nearby Hinman Hollow from Judge William Cooper and built the farmhouse on it. House, barns, and land are maintained as a working farm: domestic chores in the busy kitchen, pigs and chickens in the yard, farm tools in the barn, wood piled against the shed. The house is furnished as it would have been in 1820; simple country pieces were chosen, similar to those in contemporary local inventories and wills and the daybook of a New York State cabinetmaker (see *The country furniture* and *The painted decoration*). The house is a salt box, a plan brought to New York from New England by the early settlers. The homestead warmly recreates the average farm in the average rural community of the region.

The Bump Tavern, built about 1800 in Windham, New York, was operated as an inn for more than eighty years. Restored as a typical upstate turnpike tavern of 1820-1830, it bears the name of a nineteenth-century owner who raised the roof of the original building and added the porches and wing at the rear. Gentlemen's reading room, ladies' parlor, taproom, and bedrooms are all furnished with simple pieces of the early nineteenth century (see *The country furniture*). The stenciling in the ballroom and the overmantel painting in the taproom are of special interest (see *The painted decoration*). A wagon shed near the tavern houses the large historical, religious, and topical paintings by George J. Mastin (1814-1910) which the artist displayed as a traveling exhibit.

Fenimore House. Built as a private residence in 1931; since 1945 the headquarters of the New York State Historical Association. Here too are housed the library and the collections of painting and sculpture.

The Farmers' Museum, Main Building. Built as a dairy barn in 1918. The sign at the door reads: "The Farmers' Museum and Village Crossroads show how the plain people of yesterday, in doing their daily work, built a great nation where only a great forest had stood."

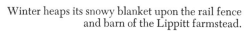

Winter heaps its snowy blanket upon the rail fence and barn of the Lippitt farmstead.

Old Deerfield,

Massachusetts

THREE QUESTIONS are frequently asked about Deerfield:

What makes Deerfield different?

How did we become interested in it?

How is the preservation work being financed? These questions deserve answers.

Charm, architecture, history, education, courage—these are what make Deerfield different.

In 1782, the Reverend William Bentley of Salem wrote of Deerfield: "The street is one measured mile, running north and south—about sixty houses on the street are in better style than in any of the towns I saw." Today there are fifty-four houses along that street; twenty-six of them are among those Bentley saw and thirteen others are of the first quarter of the nineteenth century. There are seventy-eight exhibition rooms. It is not, however, a museum village, dead at night, nor is it a ghost town. True, here one finds no neon lights, no garish store windows, no cinema—but one may walk beneath the venerable elms at evening and see lights appear in hundreds of ancient windows.

Deerfield was a frontier of freedom as England and France struggled for possession of this continent. Resurgent after the Indian raids and captivities of its early days, it fought for freedom again in the Revolution, declaring for independence by a town vote on June 25, 1776, over a week before the declaration at Philadelphia.

In peacetime Deerfield has always fostered freedom of thought through education. Today it has three private schools: Bement, Eaglebrook, and Deerfield Academy. Each instills in its pupils an appreciation of the past and thus inspires young people of today to be leaders of tomorrow. The motto of the Academy is "Be worthy of your heritage."

The things that make Deerfield the special place it is would be sufficient to excite one's interest, but we had additional reasons. For almost a quarter of a century we have cherished our close relationship with Frank Boyden, the Academy's renowned headmaster, and his wife, Helen Childs Boyden, herself an extraordinary teacher. Our common interest in preserving the village has strengthened this friendship and one project has led to another. For instance, the Deerfield Inn was thoroughly inade-

quate, so its purchase and renovation was our first effort. Then, as the Academy housing problems became acute, we realized that preserving some of the eighteenth-century houses could accomplish two things: maintain the buildings for museum purposes and provide better living conditions for Deerfield's fine faculty.

Many Deerfield residents take pride in maintaining their old homes in order to preserve the spirit of the early days. The Old Indian House Association carries on activities in its replica of David Hoyt's home which was the center of the 1704 attack. The Pocumtuck Valley Memorial Association, the local historical society organized in 1870, maintains a museum with invaluable collections relating to life in eighteenth-century Deerfield; it also owns the Frary House, a tavern in Revolutionary War days. And we have given of our time, enthusiasm, and resources to carry forward the project.

To insure the continuation of our efforts, the Heritage Foundation was established in 1952. The purposes of the Foundation are "to promote the cause of education in and appreciation of the rich heritage of the early Colonies . . . to stimulate and promote in any manner an interest in and a desire to preserve the principles of our early settlers and the standards which have made this country great . . . to receive gifts of money or tangible personal property, the income or principal of which may be used for any of the purposes of the Foundation."

The work proceeds slowly because of inadequate funds, although the Foundation has received over the last few years some greatly appreciated gifts for endowment, general expense, scholarship, building, and other purposes. The Heritage Foundation already owns several of the old houses, a good deal of furniture, and other decorative art items. In addition it started in 1956 an eight-week summer course for unmarried college undergraduates, to encourage the younger generation to enter the museum and American studies fields.

Thus, through the united efforts of several groups and individuals as well as the generosity of many friends of Deerfield, the work goes forward.

HELEN AND HENRY N. FLYNT, *Heritage Foundation*

In Parson Ashley's study, an important piece is the Connecticut Valley sunflower chest which belonged originally to Israel Williams of Hatfield and was acquired among the heirlooms of the Billings family of Deerfield. It is in company with a late seventeenth-century Brewster chair and black-painted banister-back chair, probably Massachusetts, while the cherry desk-on-frame of simple type may have been made in the Connecticut Valley. On top of the sunflower chest are a Bristol delft posset pot, c. 1700, and a pair of unmarked pewter flagons which are probably of Connecticut Valley origin. *Ashley House.*

The furniture

THE DEVELOPMENT OF NEW ENGLAND furniture from the seventeenth century through Hepplewhite and Sheraton is closely related to geography. The Atlantic coast schools are found around the great harbors, at Boston, Salem, and Newport, while the inland school grew up in the fertile valley crossing Massachusetts and Connecticut, in which a string of prosperous communities provided the history of American cabinetmaking with such names as Hatfield, Hadley, Windsor, Hartford, Glastonbury, New Britain, and Middletown. Deerfield is part of that region, and the houses at Deerfield, supplemented by Memorial Hall, present what is undoubtedly the finest assemblage of Connecticut Valley furniture in existence—naturally in company with examples from Boston, Salem, Newburyport, Newport, and the eastern part of New England, as they would have been originally. These are all considered here, in separate sections on the Connecticut Valley and its outstanding types, and on other parts of New England, early and later.

Furniture with a long record of local ownership has been secured for Deerfield whenever possible; such are the Connecticut sunflower chest and the richly inlaid secretary from the Billings family, at the Ashley and Sheldon-Hawks Houses, and Dr. William Stoddard Williams' furniture at the Dwight-Barnard House. The butterfly table in the sewing room of the Sheldon-Hawks

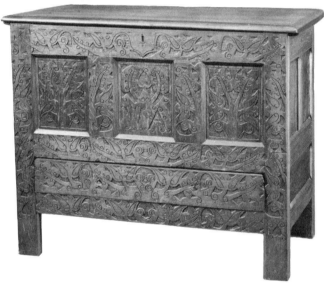

Hadley chest with initials *WA* (Luther, *The Hadley Chest*, No. 9). Originally it was assumed that the initials stood for William Arms, husband of Joanna Hawks, who founded the Arms family in this country about 1676. Luther suggests that it was more probably made for the founder's son William. In either case, it is the only known instance of a Hadley chest bearing the initials of a male alone. It descended in the Arms family until presented to the Pocumtuck Valley Memorial Association. Oak with pine top; staple hinges; painted red. *Memorial Hall.*

House is a Deerfield piece and the maple drop-leaf table in the Ashley House kitchen belonged to the Williams family. The three side chairs attributed to Eliphalet Chapin in the parlor of the Sheldon-Hawks House were originally in the Dwight House in Springfield before it was moved to Deerfield.

Connecticut Valley furniture

AMONG CHARACTERISTIC FORMS of Connecticut Valley furniture are the sunflower chest of the Hartford area, whose carved floral disk, more like an aster than a sunflower, is

The carved shell and fluted urn finials on this Connecticut blockfront cherry clockcase are close to Newport work, suggesting comparison with a blockfront chest of drawers from the collection of Reginald A. Lewis which Joseph Downs called "perhaps the nearest of any known block-front and shell-carved piece to the type made in Newport" (ANTIQUES, December 1947, page 429). *Ashley House.*

Connecticut Valley cherry desk and bookcase. According to an initialed notation on the back, made by Israel Guild in the 1790's for Ann Stoddard of Hatfield who married John Williams of Conway, a descendant of Parson John Williams of Deerfield. This shows how late Queen Anne details such as the pad foot were retained in New England. Although the inset quarter columns are stop-fluted above and spiral-twisted in the lower section, close examination shows that the piece was so constructed. *Dwight-Barnard House.*

revived at a later period in the ever-present Connecticut sunburst; the Hadley chest, made in Hadley and also in an area north and south of that town; the modest imitation of a Philadelphia style in a simplified pierced cartouche finial and lattice pediment on Chapin high chests; and the sturdy Connecticut variant of Newport's block-and-shell, traceable to the presence of John Townsend of Newport at Middletown and Norwich in 1768 and 1777. Other Connecticut Valley traits include the square, ribbed foot; chamfered corners; wide overhang; the outlining of fans with incised lines or punched motifs; the lap joint of Chapin doors; the notched pediments said to be typical of Aaron Roberts.

Cherry chest of drawers, on frame; pine interior. This was given by David Hoyt, 1722-1814, of Deerfield, to his daughter Mary, wife of Dr. William Stoddard Williams. This is among the Williams family pieces (including portraits by Jennys) which are now in the room furnished as Dr. Williams' office. *Dwight-Barnard House.*

This small chest of drawers with widely overhanging, scalloped top, chamfered corners, and claw-and-ball feet is a New England piece, perhaps Connecticut Valley; c. 1750. *Allen House.*

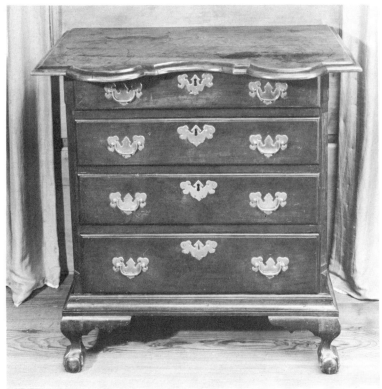

Folding-top cherry table, among the Williams family pieces, which has gadrooning similar to that on the Amzi Chapin table (see facing page); probably Connecticut Valley. *Dwight-Barnard House.*

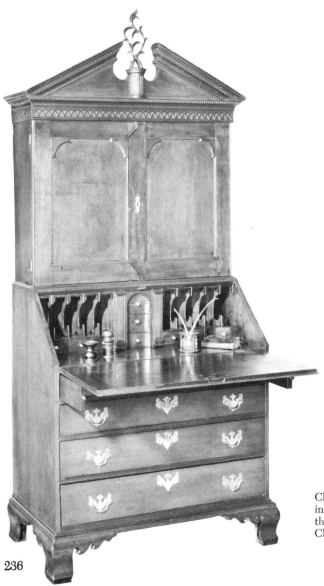

Connecticut Valley: Chapin type

SINCE "ELIPHELET CHAPIN" BY EMILY M. DAVIS was published (ANTIQUES, April 1939, page 172) there has been little if any evidence to establish a distinction between the work of Eliphalet (Eliphelet) Chapin (1741-1807) and that of his second cousin Aaron (1753-1838). Eliphalet probably developed the style which both used while working together from 1774 to 1783, and each continued alone. While chairs in the Garvan collection formerly owned by Dr. Irving W. Lyon, which are known to have documentary association with Eliphalet (ANTIQUES, January 1937, page 11), have afforded a basis for attribution of chairs at least, case pieces can be assigned to the Chapins only because so many of similar type have come down in old families living in South Windsor and East Windsor Hill. This is Chapin territory and there is no known cabinetmaker in the vicinity who has a better claim to association with these delicately designed highboys and secretaries, generally surmounted by what Downs calls a sea-horse cartouche, and often having a lattice pediment (see facing page).

A sojourn in Philadelphia for Eliphalet before estab-

Cherry secretary. The fret-carved frieze is rare in Connecticut work, but the pierced finial and the lap joint of the cupboard doors are marked Chapin characteristics. *Allen House.*

236

lishing himself in East Windsor in 1771 is mentioned by Downs in *American Furniture,* and certainly many Philadelphia characteristics are observable in Chapin work—among them the mortise-and-tenon construction in the seat rail of the chair illustrated; the inset quarter columns on the Governor Strong secretary; and the use of a pierced finial on the other Deerfield secretary shown, which is a simplified form of the cartouche of Philadelphia.

A signed, folding-top table in the Ashley House introduces another member of the family, Amzi Chapin, who may be identified at this time as the youngest brother of Aaron. According to information given to us by the Connecticut Historical Society, he was born in Springfield, March 2, 1768; married in Westmoreland, Pennsylvania, October 10, 1800, to Hannah Power; and died in Northfield, Ohio, February 19, 1835. Apparently he learned his trade in the family but it would also seem that he may have continued as a cabinetmaker after moving to the west, as the Deerfield table turned up in Chicago. Doubtless more of his work will come to light.

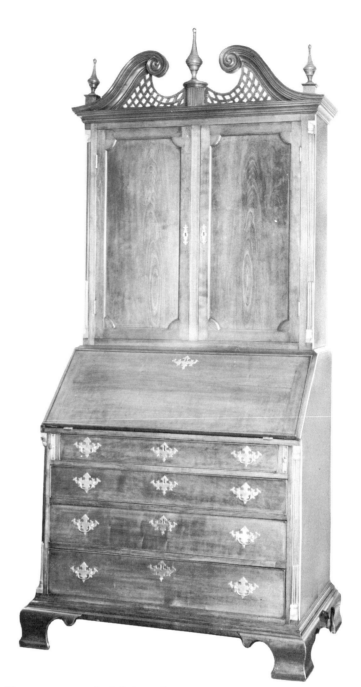

Cherry secretary which belonged to Governor Caleb Strong of Massachusetts (Flayderman sale, 1930, No. 502). The inset quarter columns have brass capitals and bases and stopped fluting which give unusual elegance to the piece. The spiral terminals of the scrolled pediment and fluted plinth under the central finial are Chapin characteristics. The home of Governor Strong was in Northampton, Massachusetts, about thirty miles up the Connecticut River from East Windsor, Connecticut. *The Manse.*

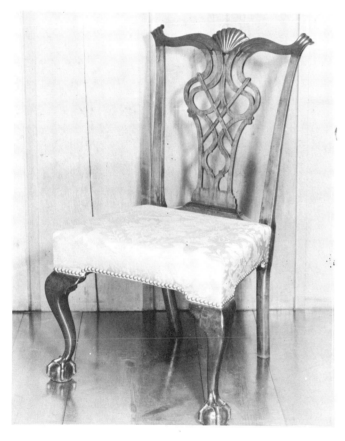

One of three Chippendale chairs of a set attributed to Eliphalet Chapin because of the claw-and-ball foot, which is like that on the documented chairs in the Garvan collection. *Allen House.*

Cherry half-round table with folding top and gadrooning on frieze; die stamp AMZI CHAPIN on top of swinging leg. *Ashley House.*

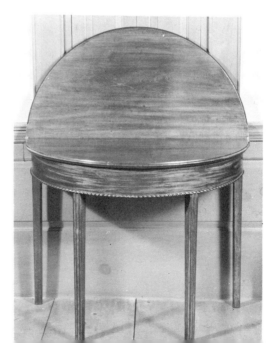

237

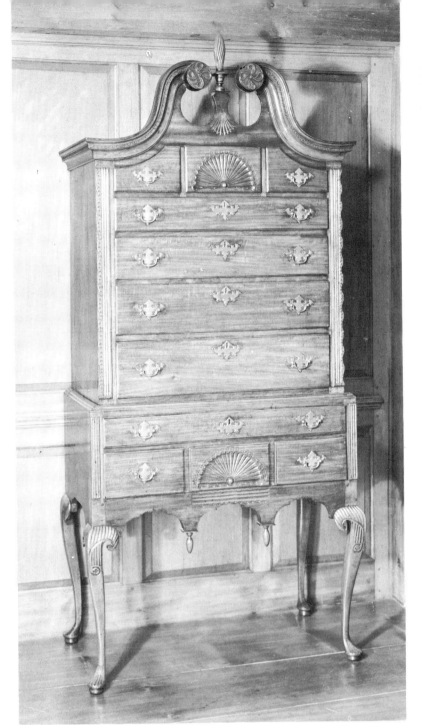

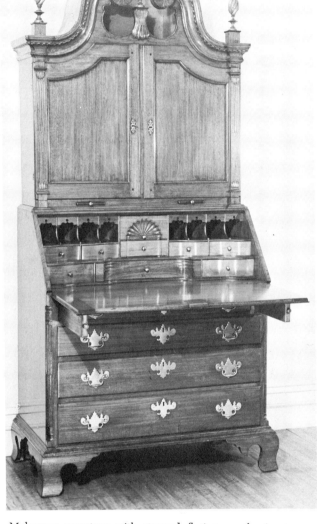

Mahogany and cherry high chest of graceful and elaborate type. The fluting on the raised pad feet is in harmony with the intaglio carving on the knee. The unusual wavy edge of the pilasters reflects the outlining of the fans. *Ashley House.*

Mahogany secretary with stopped fluting on the inset quarter columns of the base and on the pilasters of the cabinet section, the latter having a segment of a shell as a capital. The beading on the edge of the notched opening of the pediment was apparently favored by Roberts. *Allen House.*

Connecticut Valley: Aaron Roberts type

"AARON ROBERTS, IN NEW BRITAIN, has long been recognized as an able cabinetmaker of double chests and other case pieces in cherry; several with rope-twist columns at the corners may be from his hand. He lived from 1758 to 1830." This quotation from Downs' *American Furniture* (page xvi) provides as much information as is available about one of the most interesting Connecticut cabinetmakers. Some of the characteristics of his work are said to be: an applied elongated shell in the center of a pediment; dentils formed of applied blocks; a quatrefoil on a scrolled top; two small notches in the opening of a pediment; an applied bead on this opening; an unusual design of geometric, intaglio lines on the knee of a cabriole; an incised wavy edge outlining a fan. A further study of the work of Roberts is awaited with interest, but up to the present documentation is lacking.

238

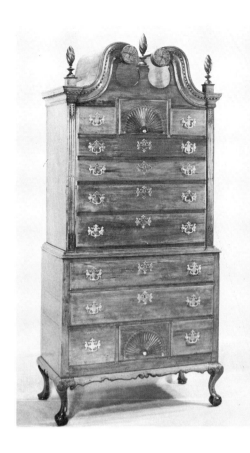

Left. Cherry chest-on-chest with details in treatment of pediment and carved fans comparable to Nos. 90, 145, and 235 in *Three Centuries of Connecticut Furniture* catalogue of the Connecticut Tercentenary Exhibition (1935). Among Roberts-type details are the applied dentil blocks and the notch in the pediment opening. *Allen House.*

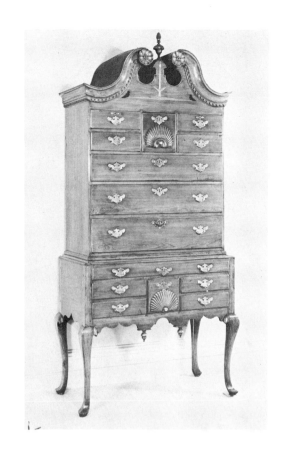

Right. Cherry high chest with unusual inlay of birds and conventionalized tree in pediment. The beading of the opening is held by small brass nails. The turned-up corners of the pediment are characteristic of Connecticut and the dentil is "Roberts type" but the raised pad foot, convex applied shell, and rosette on the pediment are details which, with the exceptional inlay, make attribution difficult. *Allen House.*

Connecticut Valley: Daniel Clay

ACCORDING TO A STUDY OF DANIEL CLAY made by Julia D. Sophronia Snow (ANTIQUES, April 1934, page 138), this Connecticut Valley cabinetmaker established himself in Greenfield, Massachusetts, in 1794; his arrival is recorded in the Greenfield *Gazette*, February 20, 1794. The date November 4, 1794, appears on the label illustrated, which is on the clock in the parlor of the Dwight-Barnard house. Miss Snow illustrated another label of the same date found on a cherry chest of drawers.

Clay was born in Middletown, Connecticut, in 1770 and may have been trained there, or in a neighboring town, so that when he arrived in Greenfield he was ready to open his own shop. From his advertisements offering to pur-

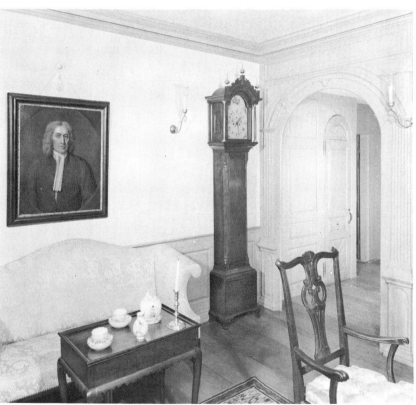

The long-case clock by David Wood of Newburyport is in a cherry case which bears the label of Daniel Clay of Greenfield, Massachusetts. A Queen Anne dished-top tea table with scalloped skirt, made locally for the Dr. Thomas Williams family, is set with China-trade porcelain. The Chippendale sofa is probably a Rhode Island piece, c. 1760. The portrait of John Barnard by Peter Pelham is discussed in *Portraits*. See also color view of this room. *Dwight-Barnard House.*

Daniel Clay label, on the clock in the Dwight-Barnard House parlor.

CABINET WORK.

DANIEL CLAY, AT HIS SHOP IN GREENFIELD,

MAKES all kinds of Cabinet and Shop Joinery Work, and constantly keeps an assortment on hand, which he will sell on reasonable terms, for Cash, all kinds of Country Produce & Lumber, or approved Credit. Every favour will be duly acknowledged, by their humble servant,

DANIEL CLAY.

November 4, 1794.

239

chase "white oak, ash, white maple, and bass plank for chair bottoms" it would seem windsors were a specialty of Clay's.

Some unusual and elaborate case pieces combining Chippendale and Hepplewhite characteristics have become associated with Clay because of the family history of the secretary in the Sheldon-Hawks House, which has been continuously in Deerfield, originally owned by the Ephraim Williams family and then, through inheritance, by the Billings family. It has always been known as the work of Daniel Clay, but other than this tradition there is no basis for making a definite attribution to him of the elaborately inlaid and carved pieces which have become associated with his name. The labeled pieces do not show ornamentation of this kind.

As to the source of such an elaborate architectural style in this part of the Connecticut Valley, it may be worth considering that Asher Benjamin's first edition of *The Country Builder's Assistant* was published in Greenfield in 1796. On Plate 7 is a design for a Corinthian capital which could have served for the somewhat primitive carving of the mahogany capital on the cherry pilaster of this re-

markable secretary. The arrangement of acanthus leaves resembles Benjamin's interpretation, with the curled-over tips of the fronds in vertical rows instead of alternating in the usual manner, as they do in Chippendale's *Director* or in Sheraton's *Drawing Book*.

With these elements from the Chippendale style, the maker has used an elaborate geometric inlay of ebony, holly, and box. While inlay is typical of the Hepplewhite period, and its use was doubtless inspired by the new fashion, this is exaggerated in scale, giving it a character distinctly its own. The construction of the canted pilasters is unusual: though they form an integral part of the door fronts and swing open with them, as on cabinet fronts of other New England case pieces of architectural type, the pilasters are not flush with the central section.

The chest-on-chest illustrated here has the same Gothic fret in the frieze as the secretary, and in addition a well-executed egg-and-dart molding over a delicate dentil and a minute beading. The Gothic fret is unusual in Connecticut Valley work, but another example is seen in the Deerfield collections: a cherry secretary illustrated in the section *Chapin type*.

Cherry carved and inlaid chest-on-chest attributed to Clay. *Sheldon-Hawks House.*

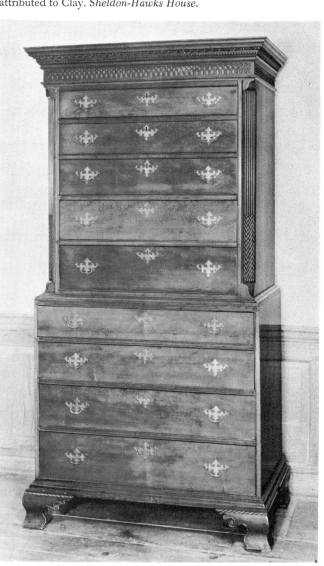

Connecticut Valley secretary of cherry, carved and inlaid; attributed to Daniel Clay, c. 1800. *Sheldon-Hawks House.*

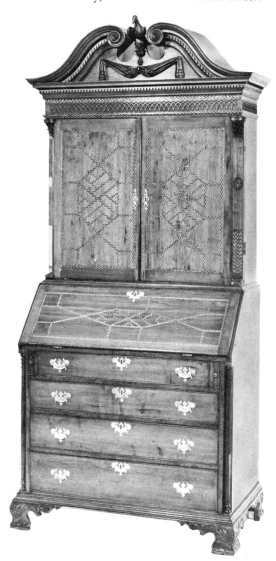

ALTHOUGH THERE IS, APPROPRIATELY ENOUGH, a concentration of Connecticut Valley furniture at Deerfield, there are many examples of other New England work, particularly from the region of Boston, Salem, and Ipswich, with a group of especial interest from Newport. One may study at Deerfield examples of carved and painted furniture of early New England, and the development of Queen Anne types with some handsome Queen Anne lowboys. An outstanding example of Massachusetts Chippendale is a secretary in the Ashley House which was probably made by Benjamin Frothingham.

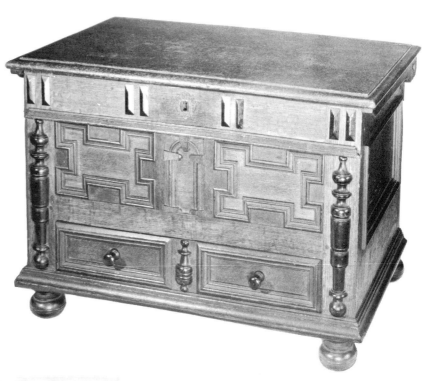

Small oak chest with geometric panels; applied spindles painted black; cleat hinges; oak till. A fine example, 1680-1690, from the Revere family; in the sale of Miss Laura Revere Little's collection, September, 1947. *Hall Tavern.*

Paneled and painted one-drawer chest with initials *S N.* Oak with pine panels and top, paneled ends. The ball feet are attached to the extended stiles, as on a chest in the Wadsworth Atheneum (Nutting, *Furniture Treasury,* No. 53). 1690-1700. *Allen House.*

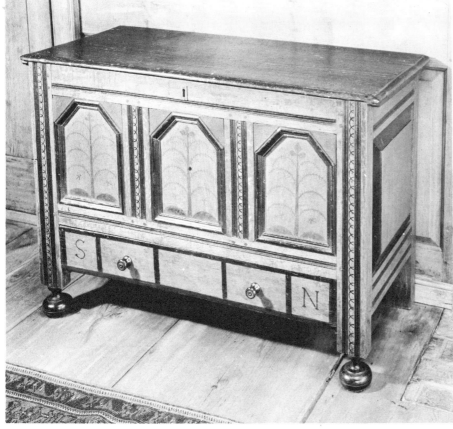

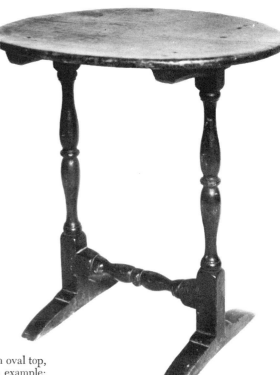

Small trestle-foot table or stand with oval top, painted black, an exceedingly rare example; late seventeenth century. *Ashley House.*

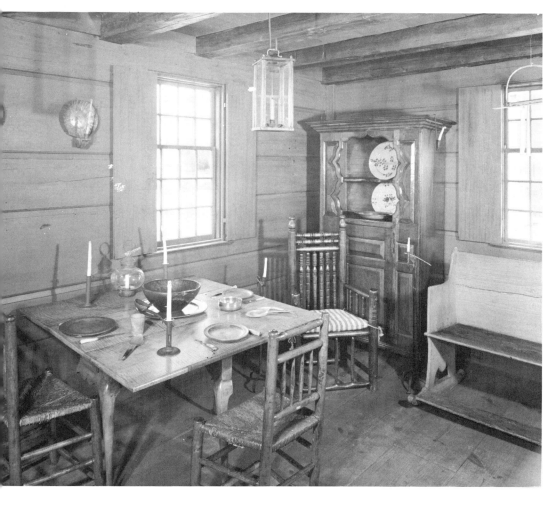

The maple drop-leaf table in this kitchen belonged originally to the Williams family of Deerfield. Beside it are two small Carver side chairs of the second half of the 1600's. The turned armchair of Brewster type, c. 1650-1670, from Rhode Island, is painted brown and black; dowels which run through the front posts show as small knobs. The paneled pine cupboard, with a suggestion of French-Canadian influence in its shaped opening, is illustrated in Nutting's *Furniture Treasury*, No. 495. The settle on original rockers has a wide concave footrest. *Ashley House.*

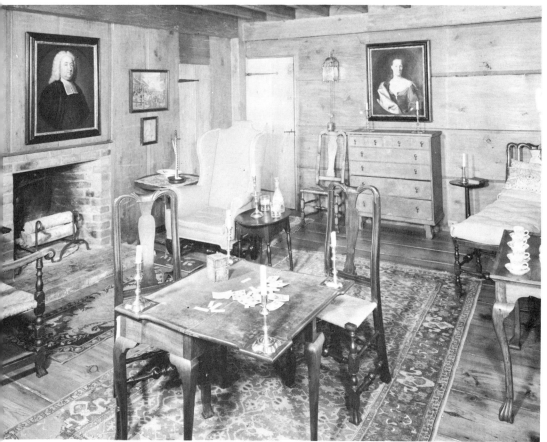

Among a number of pieces of Spanish-foot furniture, a fine example is the cherry dished-top tea table at the right. A pair of Queen Anne side chairs and an early eighteenth-century daybed offer simplified versions, and there is a crude but interesting interpretation of the Spanish foot on the red-painted pine chest of drawers at the end of the room. It is also found in very simplified style on the black-painted wing chair, c. 1720-1730. A well-designed foot is seen on a turned armchair, left of fireplace. The Queen Anne card table has its original blue velvet top. Copley's portrait of the Reverend Arthur Browne is illustrated in detail in *Portraits. Allen House.*

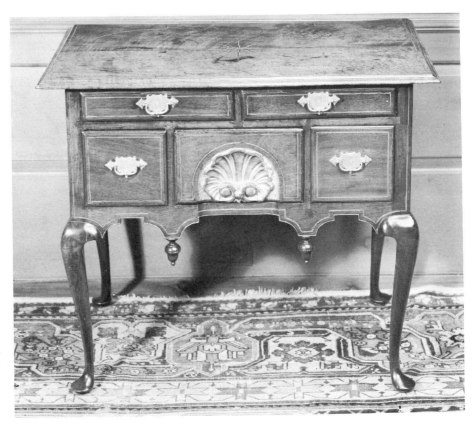

An example of the richest type of Queen Anne furniture in New England is this inlaid, carved, and gilt mahogany lowboy with variegated star inlay on top and sides; secondary wood, pine; 1725-1740. *Ashley House.*

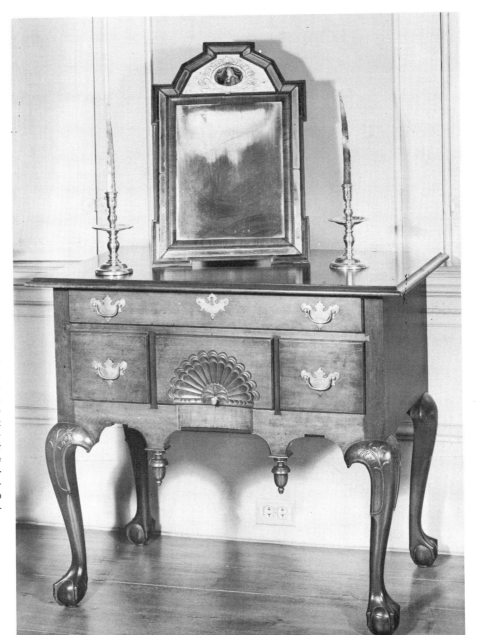

An exceptional example of Connecticut work is this cherry lowboy or dressing table, with triple-rayed shell which is apparently unique; the vine carving on the knee is also unprecedented. The four well-carved claw-and-ball feet are of the muscular type associated with Philadelphia work. This feature, with the florid character of the whole treatment, has suggested Benjamin Burnham, Connecticut, as a possible maker. His signed desk of 1769 in the Metropolitan Museum, recording a Philadelphia apprenticeship, has similar feet and in general an ornate, robust style akin to that of this lowboy. The courting mirror, with stepped cresting enclosing a portrait, is used as a dressing glass between two early eighteenth-century English brass candlesticks. *Ashley House.*

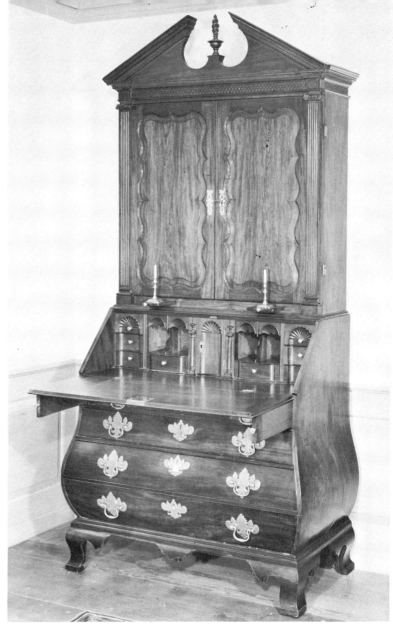

Bombé case pieces with richly carved upper sections were a specialty of exceptionally accomplished Boston makers. This secretary-bookcase is attributed, on the basis of the sum total of minor details, to Benjamin Frothingham (ANTIQUES, November 1952, p. 392 and June 1953, p. 502). Originally owned by the Ames family of Boston. *Dwight-Barnard House.*

The Marsh-Longfellow-Dana mahogany and gilt secretary attributed to Benjamin Frothingham (ANTIQUES, June 1953, p. 505). Owned about 1775 by the Reverend John Marsh of Wethersfield, chaplain in Washington's army, it was later in the possession of Henry Wadsworth Longfellow, whose daughter married Richard Henry Dana, author of *Two Years before the Mast. Ashley House.*

Dished-top mahogany tea table with extended rat-claw foot and spirally reeded half-urn in the pedestal. Probably Newport, c. 1770-1780. *Allen House.*

Massachusetts mahogany side chair with interlaced splat based on a design of Manwaring; the cabriole shows a well-carved acanthus and the typical Massachusetts claw and ball. *Ashley House.*

Rare Rhode Island Queen Anne "slipper" chair, of the type which Downs says is "both a back stool and a slipper chair and is related to the small stuffed armchairs designated as ladies' chairs" (*American Furniture,* No. 98). Three were in the Newport exhibition in 1953 and two are at Winterthur. This example has the type of back which indicates a probable mid-century date. *Allen House.*

Mahogany pole screen with claw foot and reeded urn; probably Newport. The American needlework panel showing the Fishing Lady is illustrated in detail in *Textiles. Allen House.*

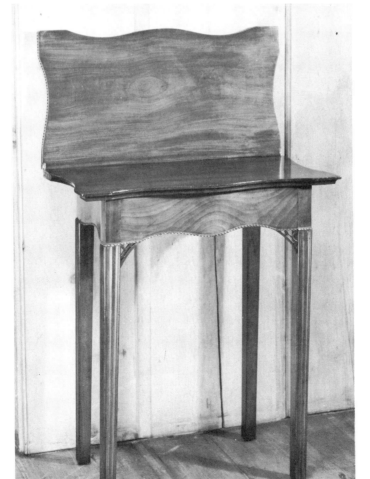

Very small folding-top mahogany table (24 inches wide) with shaped front and sides, fret brackets, beading on apron, molded legs, and fluted edge of the upper section (which can be seen at the side) identifying it with the Townsend-Goddard cabinetmakers (cf. Carpenter's *Arts and Crafts of Newport,* No. 67); c. 1780. *Allen House.*

This Seymour sideboard combines inlay with carving and reeding, effecting a union of Hepplewhite and Sheraton detail (ANTIQUES, October 1937, p. 177). The inlay of light and dark wood on the tambour doors is like the treatment on the labeled secretary in the collection of Mrs. Andrew Varick Stout (ANTIQUES, October 1937, p. 176). The fluted pilaster above the reeded leg appears earlier in Seymour work than the use of engaged columns. Finely patterned crotch mahogany veneer is to be noted, as is the contrast of vertical and lateral pattern in the cabinet and drawer fronts. Ivory inlaid keyholes were favored by the cabinet-making Seymours. Made about 1800. *Asa Stebbins House.*

Salem two-drawer small sideboard, mahogany, with pine interior; the lower drawer partly reeded. The engaged reeded columns are crowned with a carved waterleaf on a punched ground formed with the six-pointed star favored by Salem carvers and generally attributed to McIntire. C. 1800. *Asa Stebbins House.*

New England: Hepplewhite and Sheraton

IN 1799 ASA STEBBINS, prosperous owner of the gristmill in Deerfield, was able to make extensive additions and improvements to the house which he inherited from his father, Joseph. The original house, built about 1750, forms the ell of the first two-story brick house built in Deerfield. The interior had painted wall decorations, which have been restored, and the house was known as the most luxurious in the village.

The Federal period witnessed the production of fine New England furniture in the shops of Boston, Salem, and Newburyport; Newport, while declining as a mercantile center, still had excellent cabinetmakers. Outstanding pieces of New England Federal furniture have been acquired for Deerfield, particularly for the Stebbins and Dwight-Barnard Houses.

Rare Newport mahogany mixing table with inset marble top, c. 1790. Originally owned by a Newport family. Newport characteristics are seen in the four rows of inlay simulating fluting at the top of the tapering legs, and in the segmented pendants on the legs. Compare Carpenter's *Arts and Crafts of Newport*, Nos. 68 and 69. *Asa Stebbins House.*

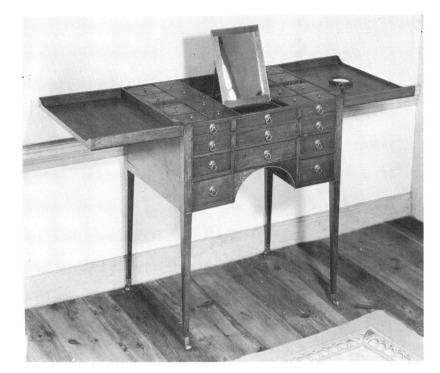

Cherry dressing table, possibly of Connecticut origin, of the type called a "Beau Brummell" and extremely rare in American work. This modern name is an anachronism, for Beau Brummell was born in 1788 and designs similar to this were in Hepplewhite's *Guide* of that · year (as *Ladies Dressing Tables*). C. 1800. *Dwight-Barnard House.*

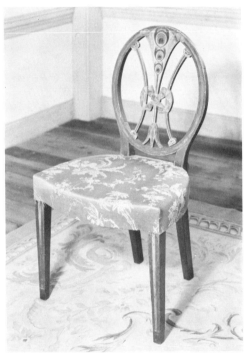

One of six Salem painted oval-back side chairs, probably decorated by Robert Cowan; peacock and bow-knot pattern in the splats; brown ground with design chiefly in greens and yellows; green stripe on legs. These offer a simplified version of the Derby painted oval-back chairs made in Philadelphia for the Salem mansion. Robert Cowan, 1762-1846, born in Scotland, was in Salem before 1782 and is known to have done ornamental painting in 1791 for Elias Hasket Derby (Derby family papers, Essex Institute, and *American Decorative Wall Painting*, by Nina Fletcher Little). C. 1800. *Dwight-Barnard House.*

Long-case clock signed D. WOOD/NEWBURYPORT. Mahogany inlaid case, inset quarter columns with brass mounts. David Wood, 1766-c.1850, a well-known clockmaker of Newburyport, advertised in 1792 his shop ". . . in Market Square, near Rev. Andrews' Meeting House." C. 1800. *Asa Stebbins House.*

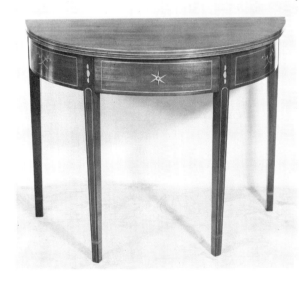

One of a pair of half-round inlaid mahogany card tables which may be Newport work, suggested by a similarity in style and proportions to the John Townsend labeled card table (Carpenter, *Arts and Crafts of Newport*, No. 68) and the labeled Stephen and Thomas Goddard table in the Metropolitan Museum (ANTIQUES, June 1950, p. 448). *Asa Stebbins House.*

247

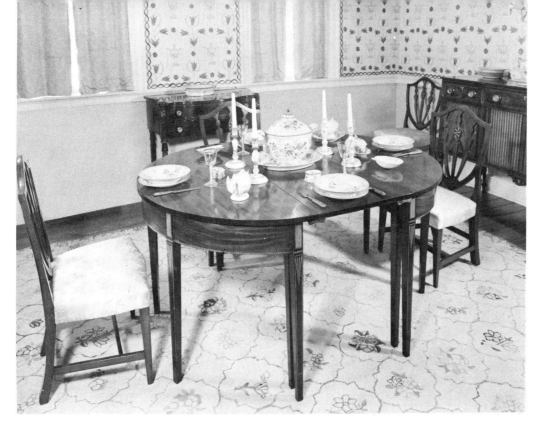

In the stenciled dining room, late eighteenth-century China-trade porcelain with *famille rose* decoration is arrayed on the dining table, serving table, and sideboard. These latter pieces are illustrated in detail in *Furniture, New England*. The Connecticut mahogany dining table is inlaid with satinwood and another wood stained dark green. *Asa Stebbins House.*

The ceramics

THE LATEST ADDITION to the collection of ceramics at Deerfield is a historic tea set in China-trade porcelain, decorated with the eagle insignia of the Society of the Cincinnati and the monogram *DT*. Cincinnati porcelain is rare at best; comparatively little was made, between 1784 and 1800, for the original members of what has been called "America's noblest clan," and less has survived. This set was made for David Townsend of Boston, a surgeon with the Massachusetts troops during the Revolution and a charter member of the Cincinnati. Preserved with the porcelain by his descendants were Townsend's certificate of membership in the society, dated at Philadelphia, May 5, 1784, and a letter to him dated at "Canton in China, 20 Dec. 1790," which reads:

Accept, my dear friend, as a mark of my esteem and affection, a tea set of porcelain, ornamented with the Cincinnati and your cypher. I hope shortly after its arrival to be with you, and in company with your amiable partner, see whether a little good tea improves or loses any part of its flavor in passing from one hemisphere to the other. Interim—believe me always/ Yours/ S. Shaw.

This list is appended to the letter: "2 teapots & stands, Sugar bowl & do, Milk ewer, Bowl & dish, 6 breakfast cups & saucers, 12 afternoon do." Over thirty of those forty-five pieces survive and, with the documents, have been acquired for Deerfield.

The writer of the letter was Major Samuel Shaw (1754-1794) who went to Canton in 1784 as supercargo on the *Empress of China,* the first American ship to sail to the Orient; who made three later trips and became the first American consul at Canton; and who was a charter member of the Cincinnati and ordered the emblematic porcelain for Washington, Knox, and others. The story of Major Shaw and the Cincinnati porcelain is recounted at length

China-trade porcelain from tea service decorated in blue and gold with Cincinnati eagle insignia and initials *DT*, sent from China in 1790. *Sheldon-Hawks House.*

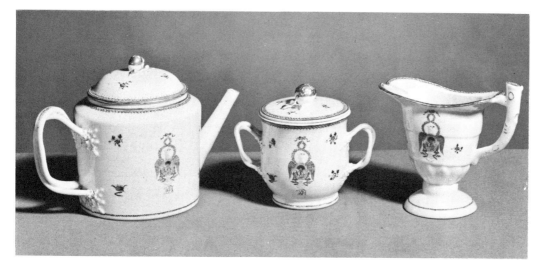

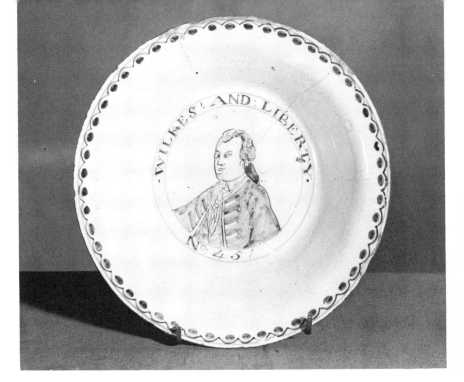

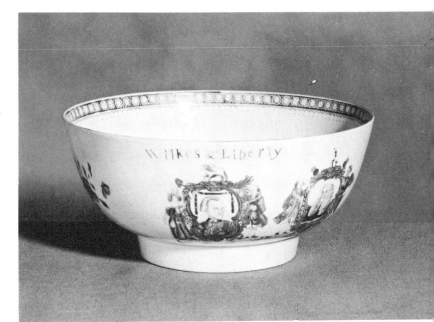

Bowl and dish commemorating Wilkes and Liberty; c. 1770. *Below,* China-trade porcelain, with caricature coats of arms in polychrome on both sides, one showing Wilkes in red coat, inscribed *Always ready in a Good Cause;* the other, a judge in wig and black gown, inscribed *Justice without Pitie. Left,* English delft with blue decoration, portrait of Wilkes and patriotic inscription. *Allen House.*

Spherical teapot with relief decoration on spout and handle, from a China-trade porcelain tea set with *famille rose* painting of a high order; the ship flies the British flag. *Allen House.*

by W. Stephen Thomas in ANTIQUES for May 1935, and there all the surviving Townsend china and Shaw's letter are illustrated.

Even aside from this important acquisition, the Deerfield collection is rich in China-trade porcelain. The dining room of the Asa Stebbins house, shown here, is colorful with *famille rose* pieces, not all from the same set but of the same type and period. A cupboard in the Dwight-Barnard parlor is filled with items in the Judgment of Paris pattern (see *Interiors*). And in virtually every room are individual pieces whose decoration represents the various categories of special interest to collectors—floral, sporting, marine, armorial, genre, commemorative.

Of the last type an important example is the *Wilkes & Liberty* punch bowl illustrated. John Wilkes was a conspicuous figure in English politics in the 1760's and 1770's. He was in and out of Parliament, in and out of jail; at one time an exile, at another Lord Mayor of London; a formidable agitator, an honest reformer. He was a symbol of liberty to the artisans and lower classes in England, and to the American colonists, whose cause he also championed. *No. 45* became a patriotic byword, referring to his inflammatory forty-fifth issue of *The North Briton* published in 1763, for which he was first imprisoned. Wilkes' name and slogans and squint-eyed portrait appeared on all sorts of popular mementoes in England and America. *No. 45* is on Paul Revere's silver *Sons of Liberty* bowl, now in the Museum of Fine Arts, Boston. The pseudo-armorial design of the Deerfield porcelain bowl, composed of motifs charged with political allegory, was probably copied from a contemporary cartoon; the same design appears on a China-trade bowl in the Winterthur Museum. Another Wilkes commemorative item at Deerfield is a deep dish of English delft.

That China-trade porcelain, English delft, and also creamware were used at Deerfield in the eighteenth century is indicated by fragments of such wares that have been uncovered there along with telling bits of metal, glass, and other materials. Shards found during excavation for the Dwight-Barnard House, which was moved from Springfield to its present site, are on exhibit. There are also significant items of Dutch Delft, and of other English ceramics of the period.

Lambeth delft. Plate with blue decoration showing Dutch influence in the crowned cartouche, which encloses the initials *M/IR* and the date *1704*—the date of the Deerfield Massacre. The wine bottles, two for white wine and one for sack *(sec* or dry sherry), are dated *1650;* according to F. H. Garner (*English Delftware*), this may indicate the year when the bottles were filled. *Ashley House.*

Lambeth delft dish with wide rim and cavetto center, decorated in blue with portrait of Charles II and date 1666—the date of the great fire of London. Formerly in the Wilfred Buckley collection. *Allen House.*

Series of octagonal Merry Man plates, Lambeth delft, decorated in blue. The boldly painted arabesques (variants of the crowned cartouche on the 1704 plate above) enclose the well-known inscriptions: *1 what is a merry man/ 2 let him doe what he cane/ 3 to entertaine his guests/ 4 with wine and merry iests/ 5 but if his wife doth frowne/ 6 all merriment goes downe.* Dated Merry Man plates are known from 1684 to 1742; octagonal examples are early and rare. *Asa Stebbins House.*

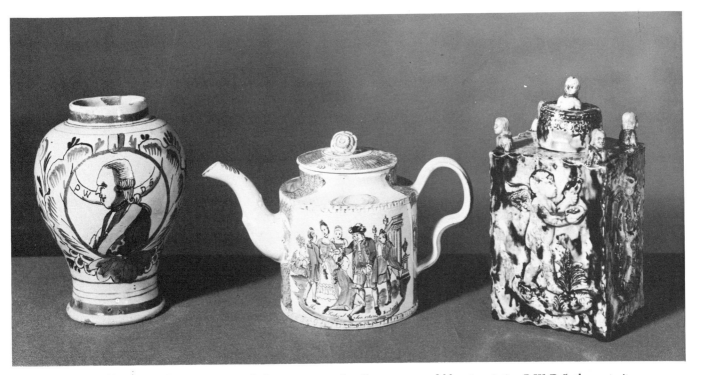

Dutch Delft tea caddy in vase shape, c. 1766, with decoration in red, yellow, green, and blue, inscription *P W D 5;* the portrait is doubtless that of Prince William V of Orange, whose reign began in 1766. English creamware teapot, late eighteenth century, with figures painted in bright red, green, and black, borders rose and green; scene, *The Prodigal Son returns Reclaim'd;* reverse, *The Prodigal Son Toasted on his Return.* Rare Whieldon tea caddy, c. 1760, with mottled glaze in greens and browns; raised figures of cupids on sides, molded busts on top and cover. *Sheldon-Hawks House.*

Delft punch bowl celebrating the birth of William V of Orange. Decoration in blue, green, red, and yellow shows child in cradle with *W* above, cherub, oranges, and inscription *1749/ Vivat / D: GVB.* The cradle, representing a contemporary form apparently in wicker, resembles early eighteenth-century examples modeled in slipware. Reverse, landscape with youth bearing flag, inscription *1749/ Vivat/ Oranje.* Center of bowl, ship painting. *Allen House.*

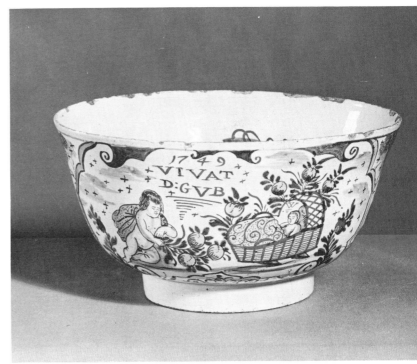

Fragments of creamware and China-trade porcelain excavated in Deerfield indicate the kinds of wares used there in the late eighteenth century. *Dwight-Barnard House.*

251

English salt glaze (c. 1760-1780). Plates, tureen, and platter with molded relief decoration in diaper and basketwork; the large tureen has lion-mask feet. Pierced and molded oval dish. Choice sauceboat with relief and polychrome decoration, a tea-drinking scene. *Asa Stebbins House.*

English creamware with black transfer-printed decoration. Covered punch bowl, diameter 12½ inches, marked WEDGWOOD; rural scenes on cover, conversation groups on exterior, ship picture with inscription *John Janston* in interior. Plate, diameter 12⅛ inches, unmarked, decorated with the same ship transfer and inscription. These and many other ceramics were given by John B. Morris. *Hall Tavern.*

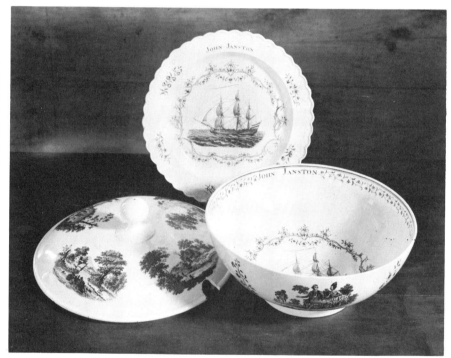

Creamware bowl with pierced cover and dish (English, late 1700's); flower finial, twisted-stem handles; traces of gilding on finial, handles, and rims. One of two choice matched examples. *Asa Stebbins House.*

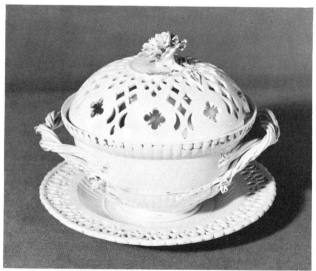

Whieldon plates with tortoise-shell glaze (c. 1760). *Left,* with molded rim in diaper-and-shell pattern; compare with the molded salt glaze above. *Right,* octagonal, with gadroon rim. *Asa Stebbins House.*

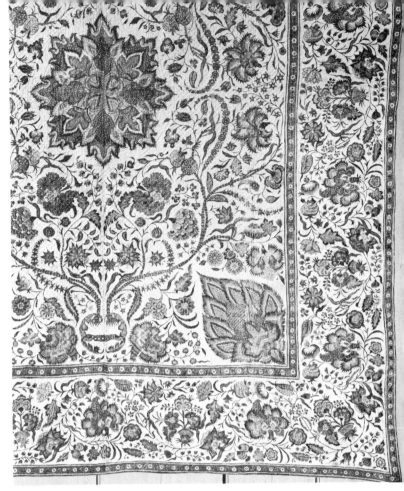

Eighteenth-century Indian cotton, printed and painted in red and blue with black outlines, and quilted. *Sheldon–Hawks House.*

Seventeenth-century English crewelwork bed hangings and cover in blue, green, rose-red, and shades of brown. *Ashley House.*

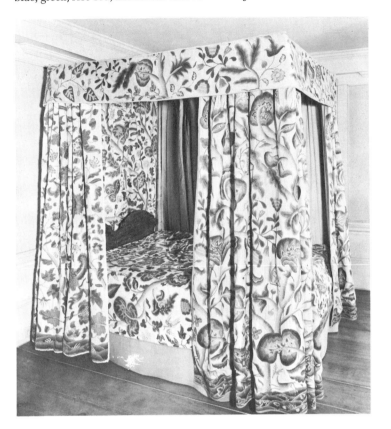

The textiles

TEXTILES MAKE UP AN IMPORTANT category of antiques at Deerfield. The examples to be seen in the various houses typify imported and American-made materials that might have served for use or decoration in homes of the period; many have the added interest of contemporary needle-work.

From the middle of the 1600's, embroidered bed hangings like the set used in the Ashley house were popular in England and, presumably, in America, though here such fine bed furniture must always have been the exception rather than the rule. The name, crewelwork, given to this type of embroidery is derived from the loosely-twisted worsted yarns, called crewels, with which the design was worked on a ground of linen or twilled cotton or other stuff. The yarns were evidently supplied in different grades, from fine to coarse; if spun and dyed at home, as they apparently were in America, they were bound to vary in weight and texture and consequently to give different effects when made up. What is often spoken of as crewel stitch—its other names are stem stitch and outline stitch—is actually only one of many stitches employed in this work. Like the easily recognized chain stitch, it was sometimes used in parallel rows to make up the whole design; on other pieces it outlines leaves and flowers and other motifs that are then filled in with a variety of stitches, such as Oriental and long-and-short stitch.

One invariable characteristic of crewelwork is that the ground material is never entirely obscured by the embroi-dery, though this latter may cover more or less of the space—in American examples, usually less. But what immediately identifies crewelwork for most of us is its design, the unmistakable echo of the Indian chintzes, with their traditional tree of life and floral patterns, that were brought into Europe by the trading companies from the seventeenth century on. An article by K. B. Brett in ANTIQUES for December 1953 describes these hand-painted and resist-dyed Indian cottons, of which the Deerfield collection includes a fine eighteenth-century example, and traces their influence on European needlework and printed fabrics.

In the course of the 1700's, the large branching-tree patterns lost popularity with the needleworkers and freely rendered floral designs are more typical of late eighteenth-century work. One American crewelwork spread at Deerfield with a scattered design of floral motifs may have been made as early as 1750. An old inscription says that it was made in that year by Esther Strong, wife of the first minister of North Coventry, Connecticut; and that the needlewoman's mother, a daughter of the Reverend Mr. Williams, was "taken captive by the Indians at Deerfield."

Crewelwork was revived in Deerfield in the 1890's and early 1900's, and examples are preserved in Memorial Hall. This late embroidery is easily distinguishable from the early: its scattered floral designs are worked on linen in shades of blue only.

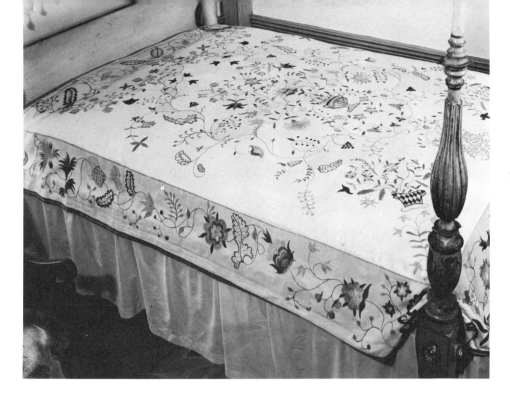

Crewelwork bedcover in shades of blue, green, yellow, rose, and brown, with the embroidered legend *Betsy Clark her work 1767* along one edge (next to the headboard). Shown on a painted and gilded Sheraton bed which is one of the Williams family pieces (see *Interiors*). The bedcover was given by Gertrude Cochrane Smith. *Dwight-Barnard House.*

Rare early New England woven and embroidered rug (3 feet, 4 inches, by 6 feet, 6 inches) with floral motifs in red, blue, and white on a green ground. *Ashley House.*

Wool-on-wool coverlet from the Connecticut Valley. The design is carried out in shades of tan with blue and green on a dark brown embroidered ground. *Ashley House.*

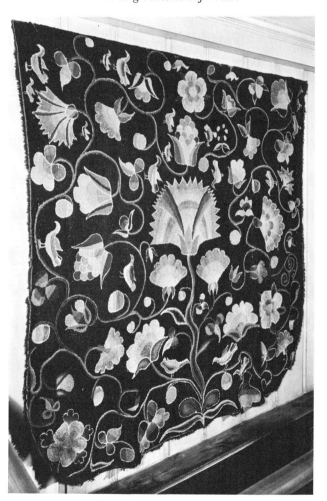

Closely related to crewelwork by the spirit of its design, the wool-on-wool embroidered coverlet that hangs above the stairway of the Ashley House is perhaps the most arresting example of American needlework at Deerfield. Over the years since July 1924, ANTIQUES has illustrated most of the early wool-on-wool coverlets that have come to light (see especially ANTIQUES for November 1927, page 386; and for December 1932, page 229). Most of these are dated (the earliest, 1748; the latest, 1826) and practically all have been thought to come from the Connecticut River Valley.

Another exceptional piece is the woven and embroidered rug, probably of New England origin, in the south bedroom of the Ashley House; it has a weft made of folded strips of cloth covered with green woolen yarn. While rag rugs are thought to have been woven in the eighteenth century and even before that time, no surviving early examples can be pointed out. The Deerfield example, which may date from the late 1700's, was probably saved because of its embroidery in woolen yarn.

Besides embellishing upholstery and floor coverings, needlework made pictures to be framed and hung on the wall. The embroidered picture first became popular in England in the reign of Charles I (1625-1649), taking its subject most often from the Old Testament, classical mythology, or pastoral poetry, and repeating over and

New England Queen Anne wing chair covered with eighteenth-century English needlework in silk thread. The design, carried out in chain stitch, seems to reflect Oriental influence; the predominating colors are blue, rose-red, and pale yellow-green. *Allen House.*

over in different compositions the same mysterious little animals, flowers, birds, castles, and human figures, copied perhaps from contemporary pattern books. In one type, known today as stumpwork though "raised work" was probably the contemporary name for it, parts of the design were padded to make them stand out. There is no evidence that this elaborate technique was ever practiced in America, but another popular type of embroidered picture, worked on canvas in tent stitch or petit point, is represented at Deerfield by the charming little piece from Newburyport signed by Mary Upelbe. Another specimen of needlework we may class with embroidered pictures is the hatchment that hangs in the Ashley House parlor. A hatchment was a heraldic symbol of mourning, displayed on the outside of the house of a person who had recently died; it consisted of the arms of the deceased painted on a lozenge-shape panel against a black background. Hatchments were not infrequently copied in needlework as a memorial. The example illustrated was made by Anne Grant, who married in 1775 the Reverend John Marsh, original owner of the Frothingham secretary now in the Ashley House parlor (see *Furniture, New England*).

As the eighteenth century advanced, printed textiles and those with woven designs were increasingly favored over needlework for most decorative purposes, but amateur embroideresses evidently kept busy on such projects as seats for chairs and settees and panels for card-table tops and fire screens. Most of this work was carried out in the durable and effective tent stitch on canvas; cross-stitch and flame stitch, also known as Hungarian stitch, were alternatives. It is interesting to be able to compare, at Deerfield, an American needlework panel for a pole

English needlework picture of the early eighteenth century representing Orpheus with his lute surrounded by animals, birds, and insects. The various motifs are executed in stumpwork on white satin, their many colors now faded; in the original frame. *Ashley House.*

American needlework picture in petit point depicting a man and woman in costumes of red, blue, and gray. Worked at the bottom is *1767/ Mary Upelbe;* this piece came from Newburyport, Massachusetts. *Allen House.*

255

Hatchment with the Grant arms embroidered in tan, red, blue, and green silk, and silver and gold thread. *Ashley House.*

Chair seat embroidered in flame stitch, in shades of blue, red, and green, by Anne White of Haverhill, who married Dr. Saltonstall in 1780. An old inscription, still on the chair, says that this panel was one of a set begun by Anne White at the age of fourteen; the chair came from the old Saltonstall house at Haverhill. *Ashley House.*

Detail of a quilted coverlet of blue and white resist-dyed cotton. *Dwight-Barnard House.*

screen with an English example of very similar design. The motif developed on both is the so-called Fishing Lady (see ANTIQUES for August 1923, page 70; September 1929, page 180; July 1941, page 28; and June 1944, page 301).

As early as 1758 Benjamin Franklin wrote from France about buying cottons "printed curiously from copper plates," and in 1761 an advertiser in the *Boston Gazette* offered "Cotton Copper Plate Furniture for beds." The printed fabric used on the bed and at the windows of the north bedroom in the Allen House is an English copperplate print, of special interest because it bears the manufacturer's name and the date 1761.

Considerable attention has been directed lately to a group of textiles printed by the resist method, generally in shades of indigo blue. Though there is no doubt that such textiles were used in eighteenth-century America for upholstery and other purposes, students disagree as to whether any of them were printed in this country. An example illustrated here from the Deerfield collection represents the type now considered most likely to be of American production.

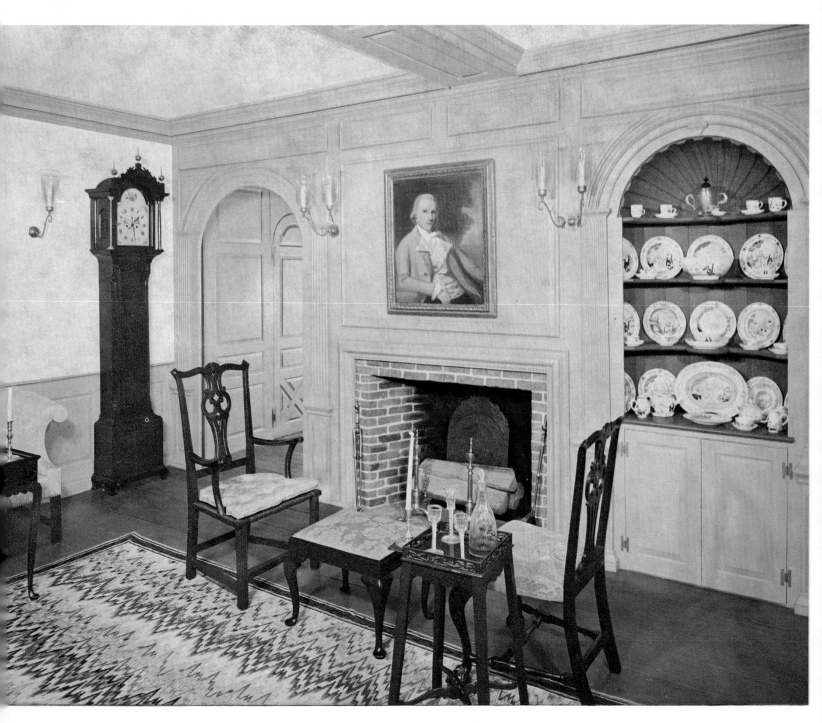

THE PARLOR, DWIGHT-BARNARD HOUSE, DEERFIELD

(See page 275)

THE ASHLEY HOUSE, DEERFIELD

(See page 234)

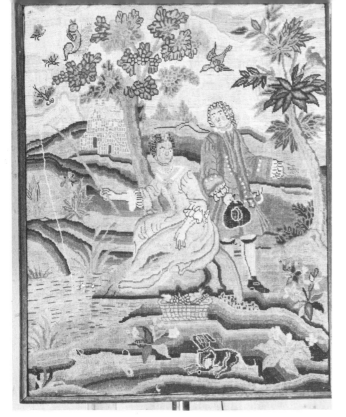

Needlework panel in the Fishing Lady design on a New-
port tripod pole screen. The woman's dress is gray and
the man's costume red; the background is in green, browns,
and blues. *Allen House.*

Needlework panel on an eighteenth-century English pole
screen, the design representing a more sophisticated ver-
sion of the Fishing Lady pattern that was popular in New
England. The woman is in red, the man in blue and gray,
the background in shades of blue, brown, and red. The
work on this panel is much finer than that in the American
example illustrated. *Allen House.*

Detail of cotton fabric copperplate-printed in light blue
in rococo design with classical ruins. The manufacturer's
name, R. JONES, and the date 1761 appear at the base of
the wall, directly below the pointed spindle whorl that
dangles from the girl's hand. *Allen House.*

257

Lighting

Wall sconce of China-trade porcelain in the form of an extended hand holding a brass urn-shape candle socket; one of a pair—though both are left hands (c. 1780). The floral decoration of the plaque is chiefly in iron red and rose. *Asa Stebbins House.*

LIGHTING DEVICES AT DEERFIELD range in character from simple wrought-iron rushlight holders to elegant crystal chandeliers. Perhaps the most entertaining, and one of the rarest, is the porcelain fist holding a brass candlestick, shown here. There are wall sconces of more conventional form in glass, and in carved wood, and chandeliers in brass, pewter, glass, and tin. Most of these handsome devices for multiple illumination are of the second half of the eighteenth century, while many of the single candlesticks are earlier. An important key to dating, for example, is the shape of the socket: wide rims or flanges rarely appear before about 1760.

The iron rushlight and candle holders, crusies and betty lamps, and tin lanterns represent humbler types but with examples that are unusual and often distinguished. While these types were made in America, it is frequently difficult to judge the origin and date of a specific item, for basically similar forms were made the world over for hundreds of years. Throughout the eighteenth century candles remained something of a luxury, and great skill and ingenuity went into devising worthy means of supporting them and intensifying their light—though many homes knew no better illumination than the flicker of a burning rush or rag soaked in grease.

The English glass and ormolu sconce dating from the late 1700's is one of a pair; below it a brass toggle-arm candleholder of the same period is attached to the fireplace molding. The cupboard shelves are filled with a Liverpool transfer-decorated tea service (c. 1810) and an earlier service in Dr. Wall Worcester porcelain; a pierced creamware dish stands on the oval Hepplewhite serving table. The print on the chimney breast is a French mezzotint of "Jean Hancock" after a subject "peint par Jean Wilckinson à Boston," after Hancock had become president of the Continental Congress. *Asa Stebbins House.*

Wall sconce carved of wood in classical motifs, covered with gesso and gilded; carved wood eagle painted black; brass urn-shape sockets and festooned chains (probably English, c. 1800). One of a pair (there is also a matching pair of reproductions). *Asa Stebbins House.*

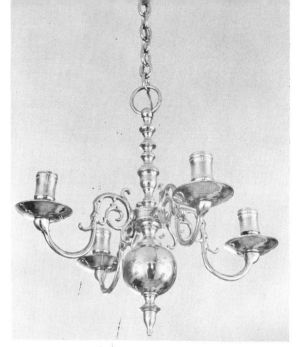

English brass chandelier, one of a pair of unusually small size (width, 13½ inches). The deep, unflanged sockets, baluster stem, and scrolled arms indicate a date in the mid-1700's. *Asa Stebbins House.*

Pewter chandelier with four scrolled branches attached to the midband of a ball hanging from a baluster stem (probably English, mid-eighteenth century). A very similar pewter chandelier hangs in the Raleigh Tavern in Colonial Williamsburg. *Allen House.*

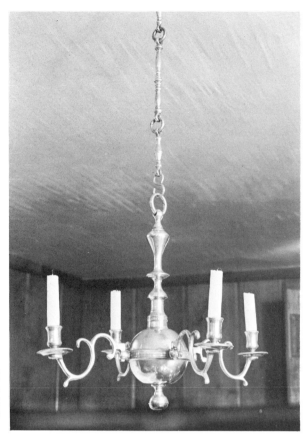

In the north parlor of the Asa Stebbins house the varied lighting devices include a fine small English glass chandelier with notched branches, tall spires, faceted stem, and delicate canopy, of about 1770-1785. On the mahogany and satinwood card table, ascribed to John Seymour, is a pair of late eighteenth-century candelabra of ormolu, black lacquer, and glass, probably French, while a pair of Bristol blue glass candlesticks of the early 1800's stands on the tambour desk. This fine Sheraton mahogany piece with satinwood inlay is also credited to Seymour. The mahogany is veneered on chestnut, and pine is used for drawer sides and bottoms. The portrait above is of a Dr. Dudley by Samuel L. Waldo (1783-1861). The armchair, formerly in the Lockwood collection, is by Joseph Short of Newburyport, who advertised that he made Martha Washington chairs. The very fine punch bowl on the card table and the mug on the desk are of China-trade porcelain, both decorated with hunting scenes from engravings by Thomas Burford after drawings by the English artist James Seymour; four of these engravings hang in the same room. The walls of the room are blue green, the woodwork white, the draperies cherry red, the Aubusson rug beige, rose, and green. The Stebbins house was the most richly furnished in Federal Deerfield.

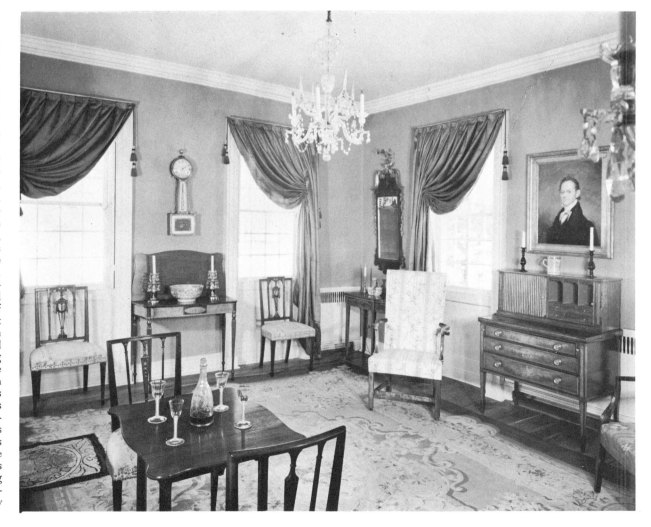

Eighteenth-century English brass. Queen Anne taperstick (early 1700's). Pair of hexagonal-baluster candlesticks with matching snuffer holder (early 1700's). Candlestick with lobed base and adjustable slide in hollow stem for raising candle as it burns (mid-1700's). Unusual adjustable candlestick composed of wire frame, with deep bowl-shape base (probably late 1700's). Tinder lighter constructed like a flint-lock pistol and mounted with candle socket (mid-1700's); the name *Richards* engraved on the lock plate may refer to one of the several recorded English makers of flintlock pistols in the eighteenth century. *Asa Stebbins House.*

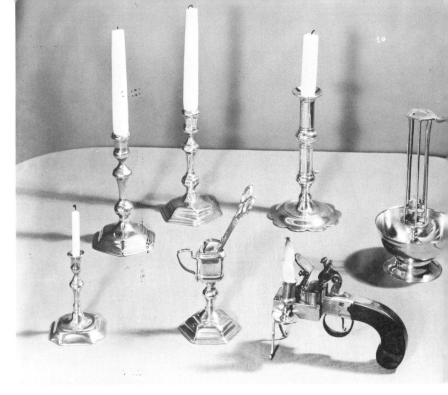

Eighteenth-century earthenware and glass. English delft candlestick with a floral design predominantly yellow and blue, with some green, and outlining in aubergine, on a greenish ground (c. 1740). Whieldon tortoise-shell chamberstick in greens and browns, molded decoration in relief, piercing in the saucer, with mask at base of handle (c. 1750). English glass candlesticks, one with angular, swirled stem and faceted, domed base (c. 1725), the other with unrimmed socket, air-twist stem, and terraced base (c. 1760). *Allen House and Sheldon-Hawks House.*

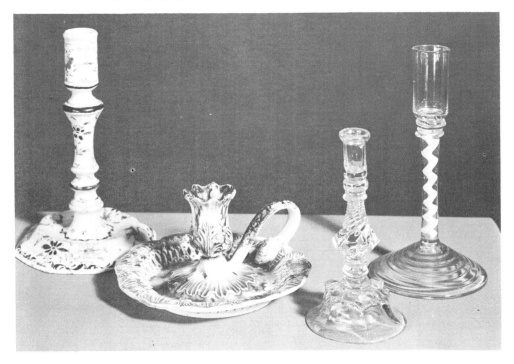

English taperstick of agate in rose-gray coloring, with octagonal baluster stem and base, and silver mounts; one of a pair (c. 1730). *Asa Stebbins House.*

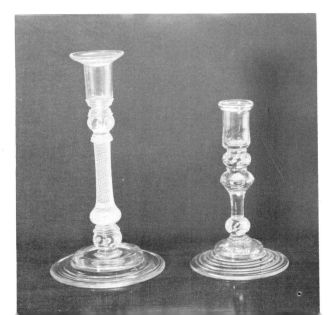

English glass candlesticks. *Left,* with flanged socket, *latticinio* stem, beaded knops, and domed foot (c. 1765). *Right,* with narrow socket, baluster stem, beaded knops, domed and terraced base (c. 1730). Compare with the brass forms above. *Asa Stebbins House.*

260

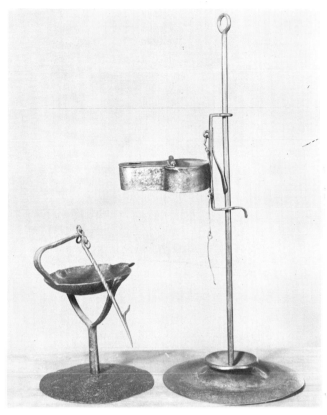

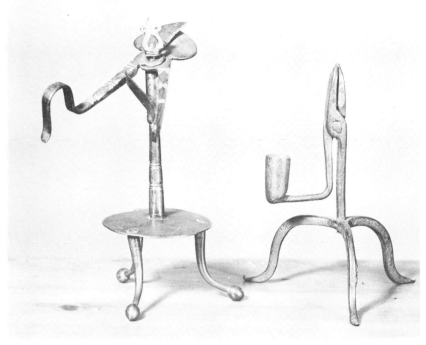

Early wrought iron. *Left,* taper holder with grooved rod and ornamental notching on handle (late seventeenth century); the taper was coiled around the rod upwards from the flat table above the three ball feet, and held in the clip at the top. *Right,* rushlight or splint holder with candle socket attached to the counterpoise, mounted on three scroll legs (early 1700's); a basic form produced with variations for centuries. *Hall Tavern.*

Primitive lamps of wrought iron. *Left,* single crusie, a simple saucer lamp with grooved lip to support the wick. Walter Hough has called the crusie the Roman lamp translated into the Iron Age. This example has not only the usual hooked spike for hanging the lamp, but also an attached stand. *Right,* betty lamp on adjustable standard, with attached wick pick. The betty is an improved crusie with a separately fashioned wick channel instead of the groove in the lip. This one also has a cover over the fuel reservoir. *Hall Tavern.*

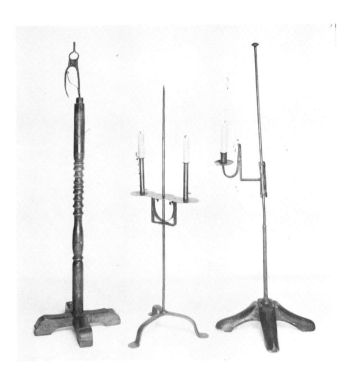

Painted tin lantern with six glazed sides and tiered, pierced top; two candles. A four-sided lantern of this type, now in the Concord Antiquarian Society, is believed to have hung in Christ Church steeple as a signal to Paul Revere in 1775; two similar examples were hung on the Boston Liberty Tree in 1766. *Hall Tavern.*

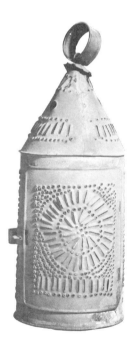

Wrought-iron rushlight or splint holder on wood standard whose turnings suggest a late seventeenth-century date. Wrought-iron stand with adjustable attachment for two candles; the unusually deep sockets have slides for raising the candles (early 1700's). Wrought-iron stand on wooden base, with adjustable holder for one candle and rushlight (early 1700's). *Hall Tavern.*

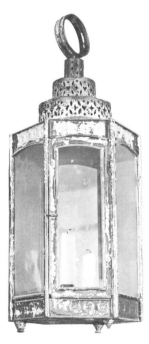

Pierced tin lantern with conical top. Such products of the local tinsmith required no glass and were fairly windproof, but let out little light; the decorative piercing seems to have been primarily for ventilation. Though commonly called "Paul Revere lanterns," they have no known association with the patriot. Perhaps made in the late 1700's, they continued well after 1800. *Hall Tavern.*

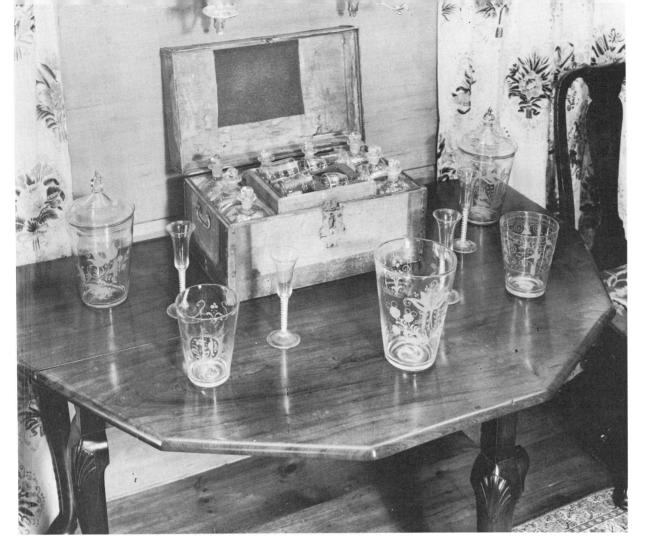

On a rare twelve-sided Queen Anne drop-leaf mahogany table with shell-carved knees, examples of eighteenth-century blown glass represent types of great interest to collectors. The large tumblers or flips (c. 1770), two with covers, have the shallow copper-wheel engraving in spreading floral and bird designs associated with Stiegel's work in the Continental tradition. The four matching English wines with bell-shape bowls on unknopped, opaque-twist stems are of the third quarter of the 1700's. The painted, iron-bound traveling chest, its complement of glassware remarkably preserved, has space for two gilded tumblers, three wines, eight large and six small decanters. *Allen House.*

The glass

THE CRAFT OF THE GLASSMAKER is represented at Deerfield in chandeliers, candlesticks, and lanterns, as shown in *Lighting;* vials and other apothecary's gear, shown in the doctor's office of the Dwight-Barnard House; and in drinking vessels, decanters, and tablewares in all the houses. The few examples selected for illustration here emphasize English and American work of the eighteenth and nineteenth centuries.

Besides utilitarian pieces, chiefly drinking vessels, a decorative plaque is included which exemplifies the technique of encasing porcelaneous cameos, called sulphides, in glass. This process, originated in Bohemia, was practiced in France from about 1815; it was introduced into England and patented there before 1819 by Apsley Pellatt, who called it cameo incrustation. Such cameos, embedded in paper weights, bottles, and other forms as well as plaques, continued popular until about 1870. Examples with busts of Washington and Lafayette, in oval plaques whose deep sunburst cutting and sawtooth edges resemble those of the Franklin medallion at Deerfield, are illustrated in Jokelson's *Antique French Paperweights.*

Cameo incrustation of Franklin (probably French, c. 1815-1825). Diameter 3⅞ inches. *Asa Stebbins House.*

262

English opaque-white mugs (c. 1770) with enamel decoration in iron red and pink, blue, yellow, and green; figure and landscape subjects in rococo medallions, surrounded by floral motifs. The loose, bold manner of painting suggests a possible Newcastle origin. *Ashley House.*

American blown-three-mold clear flips in geometric pattern (McKearin, GII-18), with a band of diamond diapering between bands of vertical ribbing (c. 1825-1835). Height of tallest, 6 inches. *Asa Stebbins House.*

Aquamarine dish, a rare product of the short-lived Franklin Glass Factory Company which made window glass and hollow ware at Warwick, Massachusetts, 1812-1816. Diameter, 11⅛ inches. *Memorial Hall.*

The church silver

THE BRICK CHURCH ON THE NORTH SIDE of the common at Deerfield has fourteen early pieces of American silver, chiefly by Boston makers, which are recorded in Jones' *Old Silver of the American Churches.* These include five tankards, three cups, a caudle cup, four beakers, and a basin. The church was founded in 1686, and the present building, erected in 1824, is the Fifth Meeting House.

Seven examples from the silver at the Brick Church are illustrated here, including the work of Dixwell, Pollard, Hurd, Samuel and John Edwards, and Paul Revere. The latest is a tankard (1802) by Joseph Loring, which was apparently patterned on the Revere tankard of 1763, except that Loring did not use the cherub mask on the handle. The Loring tankard was the gift of Elijah Arms, whose portrait by William Jennys is illustrated among Deerfield *Portraits.*

The donor of the Revere tankard, and earlier of a beaker by John Edwards, was Samuel Barnard. Revere's bill for the tankard is still in existence; once owned by Deerfield's distinguished historian, George Sheldon, it is now in Greenfield, owned by one of his descendants. The bill shows a charge of £10 12s 8d for 30 oz 8 dwts of silver, with £3 for the making, and 3s 4d for engraving the inscription: *The Gift/ of Samuel Barnard Esqʳ/ to the Church of Christ/ in Deerfield/ 1763.* Samuel Barnard (1684-1762), one of the survivors of

the Massacre of 1704, removed in later life to Salem where he became a wealthy merchant. He left funds for church silver to parishes in Salem, Greenfield, and Deerfield, but only the Deerfield silver has survived.

A brother-in-law of Barnard, Thomas Wells, who was military leader of a scouting party to the border of Canada in 1725, left the Hurd tankard dated *1750* on which this gift "to the Church of Christ in Dear-Field" is recorded in an inscription encircled with palm branches and festoons. A cousin, Ebenezer Wells (1691-1758), of a family long prominent in Deerfield, gave a tankard by Samuel Edwards which differs from the Boston type in not having a midband.

John Dixwell's two-handled cup inscribed *Deerfield Chh* is one of the early pieces in the group, since this maker, the son of the regicide, died in 1725. He was the first in America to make this style of cup, with strap handles, which seems not to have a prototype in English silver. The name of the donor is not recorded.

The caudle cup representing a rare Boston maker, William Pollard (1690-1746), has the additional interest of having been presented by Deerfield's first school teacher, Hannah Beaman, who returned from captivity in Canada to become an active member of the community. The cup is undated but was probably made in 1739 when she left a bequest to schools in Deerfield.

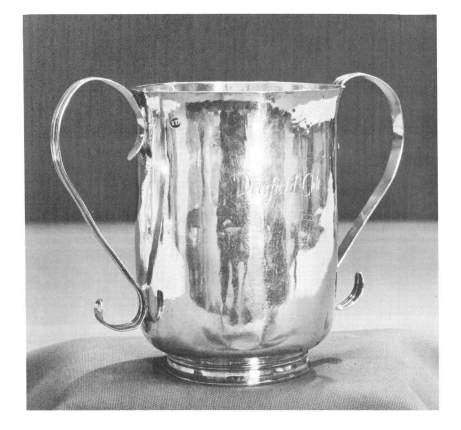

Two-handled cup by John Dixwell, New Haven and Boston, 1680-1725. Donor unknown.

Beaker by John Edwards, Boston, 1671-1746; the gift of Samuel Barnard as a young man in 1723, before his removal to Salem; the Revere tankard illustrated opposite was his bequest.

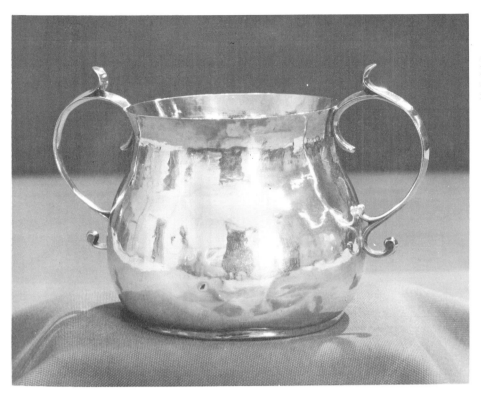

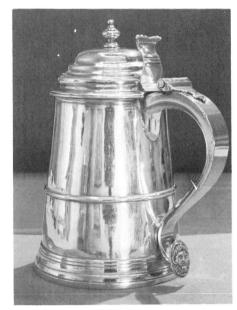

Caudle cup by William Pollard, Boston, 1690-1746. Inscribed *H Beamon,* for Hannah Beaman.

Tankard, dated 1750, by Jacob Hurd, Boston, 1702-1758. Presented by Thomas Wells, born c. 1678.

Tankard by Paul Revere, dated in the inscription 1763. Given by Samuel Barnard, 1684-1762.

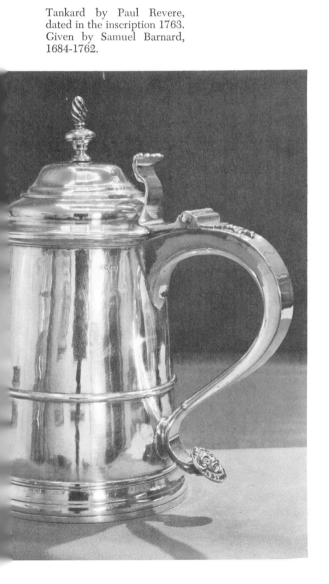

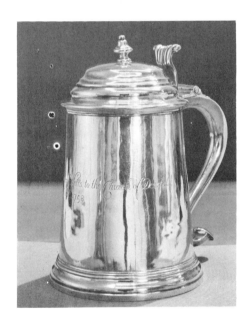

Tankard, dated 1758, by Samuel Edwards, Boston, 1705-1762; bequest of Ebenezer Wells, 1691-1758. *Right.*

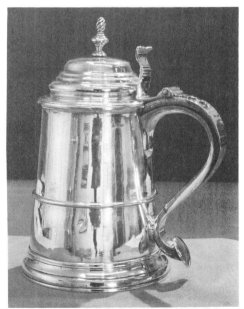

Tankard by Joseph Loring, Boston, 1743-1815. Presented by Elijah Arms, 1802.

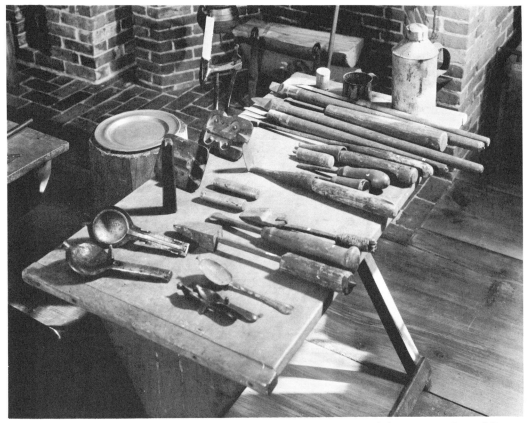

Tools of the pewterer Samuel Pierce, 1767-1840, of Greenfield, with spoon molds and spoons. A pewter plate rests on a wooden chuck used to shape the piece in spinning. Note the insulating corncob handle on one of the soldering irons. The face of Pierce's iron die, which stands upright in foreground, is shown in detail at the right. *Hall Tavern.*

The pewter

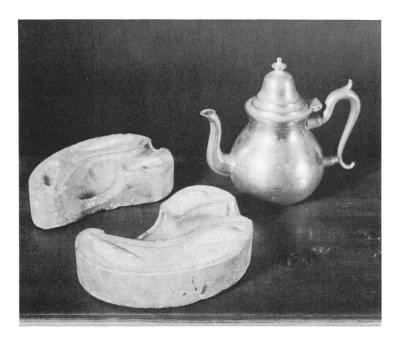

Teapot by Samuel Pierce, with the plaster mold in which he fashioned the spout. *Hall Tavern.*

Plate, beaker, and coffeepot by Samuel Pierce. The beaker carries his rare initial mark. Diameter of plate, 11¼ inches. *Hall Tavern.*

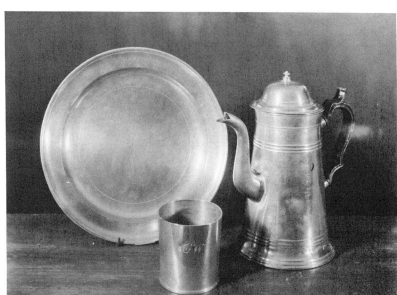

THE PEWTER AT DEERFIELD, in itself an important collection, is given special significance by the display of lathe tools, hand tools, and molds used by an early Connecticut Valley pewterer. Burnishers, forceps, soldering irons, knurl, files, turning hooks, chasing tools—all are there, along with the chuck on which the pewterer fashioned his plates, and the iron die with which he stamped his mark on his wares. The craftsman who used these tools was Samuel Pierce (1767-1840), who worked for forty years a stone's throw from Deerfield in Greenfield, Massachusetts. Born in Middletown, Connecticut, Pierce probably learned his trade from Joseph Danforth, a member of the leading family of Connecticut pewterers, and his own work was of the highest standard. He used three marks: a large eagle with his name; later, a smaller eagle with his name (illustrated here); and a rare punch with his initals over X.

The fascinating story of the discovery of Pierce's tools in an old chest in the Pierce family carriage house was first told in ANTIQUES (February 1927) by Julia D. Sophronia Snow of Greenfield, who identified Samuel as a local craftsman. Pierce pewter is further discussed by Ledlie I. Laughlin *(Pewter in America)*, who presented the tool chest and its interesting contents, and by Marion and Oliver Deming in ANTIQUES for July 1957. The tools may now be seen in a graphic display in the Hall Tavern, with pieces by Pierce and other American pewterers.

Tableware, lighting devices, and other objects of American and English pewter may also be seen in the other Deerfield buildings, and examples are illustrated elsewhere in these pages. Some of the greatest rarities are in Memorial Hall, a part of the collection of Solon L. Newton (1841-1901) of Greenfield. This early-formed collection, which comprises also ceramics, brass, ironwork, and some furniture, was left on Mr. Newton's death to the Pocumtuck Valley Memorial Association.

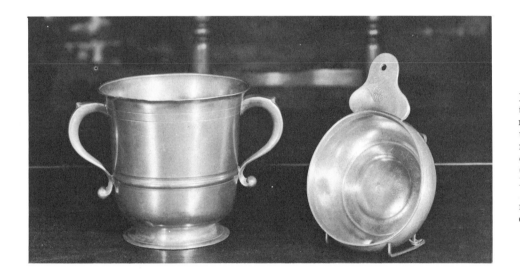

Pewter in the Solon L. Newton collection. Large two-handled cup, probably made here though the form is very unusual in American pewter; indistinct maker's mark, a standing bird, unrecorded; height 6⅛ inches, top diameter 6⅜ inches, extreme width 9½ inches. Porringer by David Melville, c. 1756-1793, of Newport, a rare form by this maker; mark on solid handle; diameter of bowl, 5¼ inches. *Memorial Hall.*

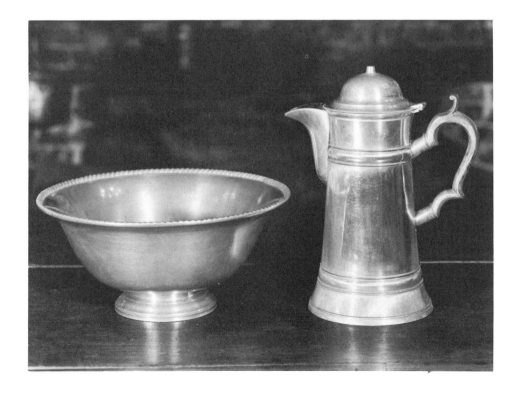

Communion pewter from the Unitarian Church of Charlemont, Massachusetts. Baptismal bowl with gadrooned edge, on foot; unmarked but attributed to Oliver Trask, 1792-1847, of Beverly, Massachusetts. Flagon with covered spout, beading on lid, broad convex bands on body—all unusual features in New England pewter; pewter handle; mark, O. TRASK. Oliver Trask and his older brother, Israel, produced some of the best work of the brittania period. *Memorial Hall.*

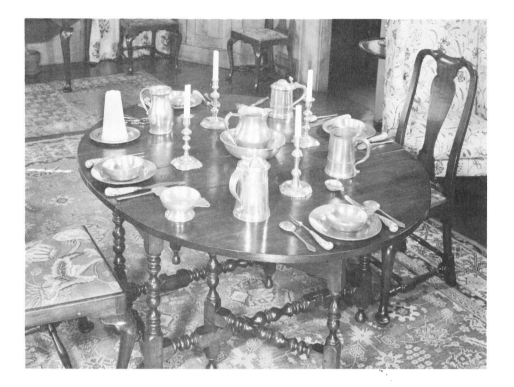

English and American pewter sets the table with basins and wide-rimmed plates, tankards, measure, and mug, candlesticks, pitcher, footed bowl, miniature porringer, and spoons. The knives and forks have Whieldon pistol handles. The large cone of sugar is in the customary form known to our ancestors. New England Queen Anne chairs with crewelwork seats are drawn up to the New England walnut gateleg table. *Allen House.*

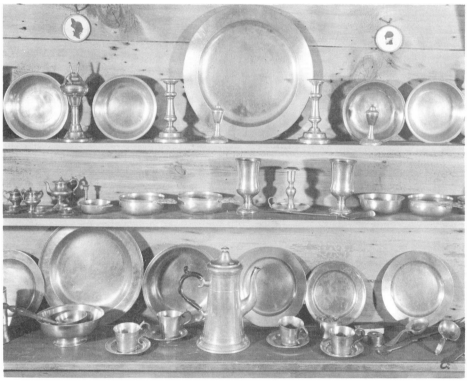

Pewter of the eighteenth and early nineteenth centuries, much of it American, including bowls and silhouette frames by Samuel Pierce. *Hall Tavern.*

Set of four pewter two-handled communion cups in the Solon L. Newton collection. Bands of gadrooning on body and foot, beading on handles. Marked RB with rose and crown; maker unidentified. The form is rare in American work, and this set is unique; Laughlin says, "No finer examples of the craftsmanship of the American pewterer have survived." He illustrates a cup closely similar, but without handles (*Pewter in America*, Pl. XXXV, 231). Extreme width 7⅛ inches. *Memorial Hall.*

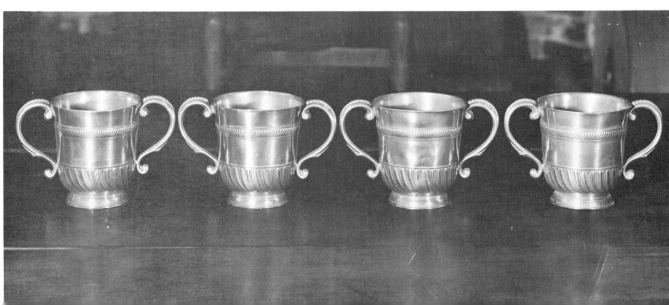

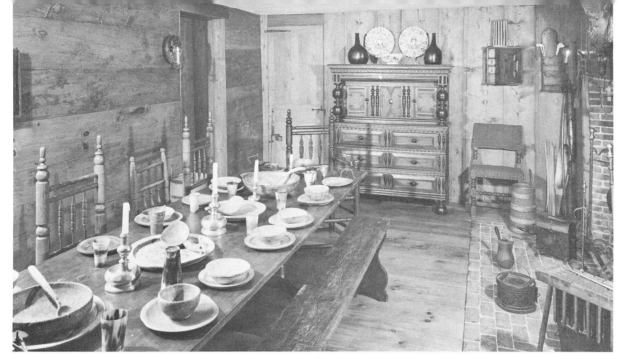

Treenware is seen in an appropriate setting on the long trestle table—dishes and plates, some with the broad rim typical of the 1600's and carried over into later eras; bowls, ladles, spoons, and forks of wood; beakers and ladles of horn. The candlesticks are seventeenth-century English pewter. The seventeenth-century oak press cupboard is an important piece, originally owned by the Saltonstall family of Massachusetts. It has the serrated moldings found on Plymouth pieces (see Nutting's *Furniture Treasury*, Nos. 455, 462). The double melon-bulb supports, painted black like the other turnings, are unusual. The doors have geometric paneling and the three drawers below are paneled to appear six. The Saltonstall coat of arms is painted inside the upper part of the piece. Hanging above the Cromwellian chair is an oak spice box (c. 1680-1700) originally owned by the Revere family of Boston. *Hall Tavern.*

The treenware

In a scrolled pewter spoon rack (English, early 1700's) hang spoons of wood and horn, and a wooden fork whose simplified trifid end suggests the late 1600's, though its four tines probably indicate a later date. *Hall Tavern.*

Small pine wall box, probably for salt (New England, 1690-1710). Decorated with a chisel in geometrical motifs in the manner known as Frisian carving; painted red. *Hall Tavern.*

TREENWARE, THOUGH ONE of the more minor of the minor arts, offers as much variety as any. The many small objects "made of tree" in America are part of an ancient tradition brought from Europe, where for centuries wood had been whittled and chiseled and turned to fashion all sorts of domestic utensils. While Continental examples are sometimes quite elaborate, most of those found here are simple, and their appeal lies as much in functional form and sympathetic material as in ornamentation.

There are excellent examples of Deerfield treenware used for eating and drinking in the days before pewter and earthenware were generally available. They were made of local woods—often hard to identify—by turners, who sometimes showed considerable ingenuity in converting a burl or root into a bowl, a crotch or branch into a ladle. Included in the same classification are utensils of horn, which were fashioned by the same craftsmen for similar purposes. Joiners too produced small objects of wood which may be considered more as treen than as furniture, like the carved box shown here.

Treenware continued to be made and used into the nineteenth century. Since it perpetuated early forms, it is difficult to date with assurance, but comparatively little that was made before 1700 has survived.

John Barnard, deacon of Cotton Mather's church in Boston. By Peter Pelham; dated 1727. Oil on canvas, 30 x 25 inches. *Dwight-Barnard House.*

The American portraits

Portrait of John Barnard, attributed to Peter Pelham

THE STERN, PURITANICAL LIKENESS of John Barnard recently acquired by Old Deerfield has not been seen by the public since 1871, when it was in the annual exhibition of the Boston Athenaeum and was referred to by August Thorndike Perkins as painted by Peter Pelham. Thus it is an important new discovery to students of colonial painting, and its history and technical claims to authenticity are considered here in some detail.

Purchased last year from descendants of John Barnard, the portrait was brought to the Boston Museum of Fine Arts for examination. The sitter is identified on the back of the canvas by this inscription: *John Barnard. Deacon of Cotton Mather's Church. father's Great Great Grandfather.* [owner] *M.D. R.T. Jackson.* An old label on the back, probably placed there at the time of the Boston Athenaeum exhibition of 1871 since its text agrees with the entry in the Athenaeum catalogue, reads: "Deacon Barnard of Cotton Mather's Church (1727) supposed to be by Peter Pelham. Owner: Dr. J.B.S. Jackson." When A. T. Perkins published his monograph *John Singleton Copley* in 1873 he stated in the preface: "A portrait of Deacon Barnard of Mather's Church dated 1728 [sic] was exhibited in Boston last year, and may be ascribed confidently to Pelham. It is owned by Dr. J. B. S. Jackson of Boston."

The portrait is inscribed on the front above the sitter's head *Æta: Suæ 74 / 1727,* and technical examination of this inscription shows it to be a genuine part of the original paint film, not a later addition. The stretcher of the painting is of American basswood, and the frame, which appears to be the original, is made of American pine. These facts all support the claim that the portrait was painted in America in the year 1727.

John Barnard, Boston merchant, was born in 1653 and would have been seventy-four years old in 1727, which agrees with the inscription quoted above. He died in 1732, leaving a more famous son, John Barnard, who was for many years Congregational minister in Marblehead, and whose autobiography has been published by the Massachusetts Historical Society *Collections.*

The portrait is modeled in the technique employed by English painters of the early eighteenth century, influenced by the Kneller tradition. If it was painted in Boston in 1727, then the logical painter to attribute it to is Peter Pelham, the only English-trained painter known to have resided in Boston in that year. Pelham, born in England in 1697, was trained as a mezzotint engraver there. Emigrating to Boston in 1727, he shortly thereafter painted a portrait of Cotton Mather now owned by the American Antiquarian Society, which also owns his portrait of Mather Byles. These two portraits and that of John Barnard show the same system of modeling, though the two at the Antiquarian Society are not in as good a state of preservation as the portrait of Barnard. No other documented oil portraits by Pelham have come to light, and he is known today chiefly for his fourteen fine portraits in mezzotint of leading New England dignitaries, executed between his arrival in Boston in 1727 and his death there in 1751. The discovery therefore of this vigorous portrait, with its strong claim as to the identity of sitter and painter, is important. —BARBARA N. PARKER

Other portraits

THE EARLY STYLE OF COPLEY is represented at Deerfield by the portraits of the Reverend Arthur Browne and his wife of Portsmouth, New Hampshire, which, according to the record in Parker and Wheeler's *John Singleton Copley,* were painted about 1756. The clergyman's portrait is done very much in the manner of Copley's stepfather, Peter Pelham; the figure is placed in an oval and has none of the later decorative accessories.

The portrait of a gentleman of the Werden-Wilcocks (or Willcocks) family of New York represents a rare New York painter, John Mare (1739-c. 1795), who was a brother-in-law of William Williams and may have had instruction from him. Mare painted in Albany in 1759-1760, but by 1761 had returned to New York, where he painted portraits of members of the Keteltas, Beekman, Livingston, and other prominent New York families.

Ralph Earl's portrait of Dr. Joseph Trumbull, which has come to light only in recent years, is of outstanding importance. It was painted in London toward the close of the artist's English period (1778-1785), and has much in common with his later work in Connecticut. A letter regarding a sitting for the portrait is in the possession of Mr. Flynt. It was written by Earl from Windsor to Dr. Trumbull in London on Thursday, September 23, 1784, saying, "On Sunday you must appear with me early in the morning to proceed to business and to dine with me if you possibly can." Dr. Trumbull was born at Suffield, Connecticut, settled in Petersham, Massachusetts, and moved to Worcester about 1803. He traveled much in Europe and was frequently in London. The portrait is mentioned in his will as "my half-length portrait painted in London in 1784."

The Reverend Arthur Browne, 1699-1773, rector of Queen's Chapel (now St. John's Church), Portsmouth, New Hampshire. By Copley, painted c. 1756. *Allen House.*

Dr. Joseph Trumbull, 1756-1824. By Ralph Earl, painted in London in 1784. *Dwight-Barnard House.*

A gentleman of the Werden-Wilcocks (Willcocks) family, New York, c. 1765. Attributed to John Mare (1739-c. 1795). *Allen House.*

271

Dr. William Stoddard Williams, 1762-1829. By William Jennys, 1801. This and the companion portrait lent by Elizabeth Fuller. *Dwight-Barnard House.*

Sally Buell. By Ralph Earl, signed and dated 1796. This is one of Earl's Litchfield, Connecticut, portraits and is accompanied by a companion portrait of Sally's sister Mary. *Sheldon-Hawks House.*

There are four portraits by William Jennys at Deerfield. Those of Dr. William Stoddard Williams and his wife aided in clarifying the Jennys problem, which was solved in the exhibition of the work of Richard and William Jennys held by the Connecticut Historical Society, Hartford, November 1955-January 1956 (ANTIQUES, February 1956, page 153). The long-standing confusion over J. William and William has been resolved and only William remains, as it is now evident that a calligraphic flourish on the letter W on a receipt signed by William brought temporarily into the record a J. William. His existence seemed at first to be substantiated by an inscription on the portrait of Colonel Constant Storrs, and by an entry in the daybook of Dr. William Stoddard Williams under date of September 8, 1801: *Pd Wm Jennys $24 for paintg. my wife's & my Portrait $2 for Frames.* The letters Pd were mistaken for a J crowned with an eighteenth-century flourish.

William Jennys, whose relationship, if any, to Richard has never been established, is shown by Dr. Williams' record to have been in Deerfield in 1801. There is enough resemblance between the work of Richard and William to make it seem probable that William was the former's

son, working first in the region of New Milford, Connecticut, where Richard was active between 1794 and 1798. The Deerfield portraits of Dr. Williams and his wife, and of Colonel Elijah Arms and his wife, are in a style different from that of Williams' early work and show a developing power in suggesting the modeling of the faces and the skillful use of highlights, so that there was some justification for thinking there were three artists named Jennys.

The portraits of William Montague and his wife, Persis Russell, by Erastus Salisbury Field, came to the Pocumtuck Valley Memorial Association from Sunderland, where Field died at the age of ninety-five in 1900. The costumes would place these in his early period, 1830-1835. His method of painting lace, accented with black dots, is seen in the cap worn by Mrs. Montague. Field, who was born in Leverett, Massachusetts, apparently had some instruction before he left for New York and three months in the studio of S. F. B. Morse in 1824. After his marriage in 1831 he painted in Hartford, Connecticut, then returned to Massachusetts, where he painted in Palmer and Monson, later returned to his native Leverett, and settled in Sunderland in 1859.

Persis Russell (Mrs. William Montague). By Erastus Salisbury Field, 1805-1900. *Memorial Hall.*

William Montague. Presented by Lucinda Montague Gunn of Sunderland to the Pocumtuck Valley Memorial Association. By Field. *Memorial Hall.*

Captain Elijah Arms, 1727-1802, of Deerfield and Mill River. By William Jennys, probably 1801. *Memorial Hall.*

Naomi Lyman (Mrs. Elijah Arms), 1737-1818. By William Jennys, probably 1801. *Memorial Hall.*

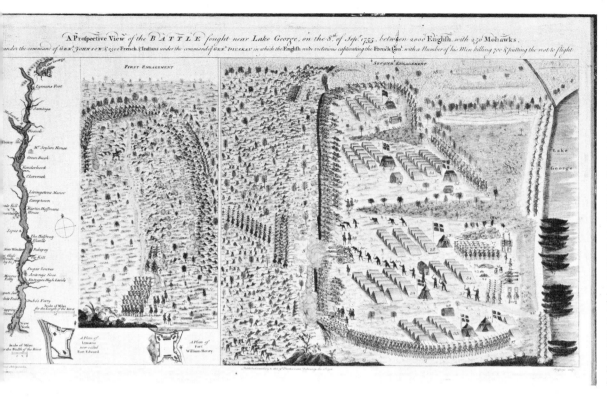

The Blodget plan of the Battle of Lake George. "A Prospective View *of the* BATTLE *fought near Lake George, on the 8th of Sepr. 1755, between 2000* English *with 250 Mohawks, under the command of Genl. Johnson: & 2500* French & Indians *under the command of Genl. Dieskau in which the* English *were victorious captivating* [sic]*the* French *Genl. with a Number of his Men killing 700 & putting the rest to flight.*" This was drawn by an eye-witness, Samuel Blodget of Boston, a sutler with the English forces; it was engraved by Thomas Johnston and published December 22, 1755, in Boston, the first historical print drawn and engraved in America. Only a few impressions of the American issue are known, and the English versions, printed in 1756 by Thomas Jefferys, London, of which this is one, are very scarce. The Hudson River is shown across the top of the design in the American version. This view is the first portrayal of the Indian method of fighting from ambush. *Ashley House.*

The prints

The Carwitham view of Boston, entitled *A South East View of the Great Town of Boston . . . I. Carwitham sculp. Printed for Carington Bowles, London.* This view which shows the city of Smibert's day, 1731-1736, is probably the second state, according to Stokes' *American Historical Prints,* as Carington Bowles did not succeed Thomas Bowles until 1764. The design is largely based on the Burgis view of Boston, 1722, and shows the Long Wharf, the Town House built 1711, ten Boston churches, and, in the distance, the beacon on what became Beacon Hill. *Asa Stebbins House.*

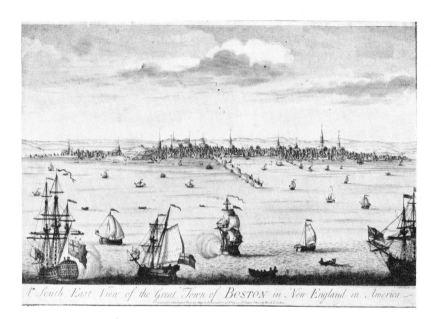

Revolutionary cartoons. Eighteenth-century shadow-boxes with elaborate shellwork have preserved the freshness of the original coloring of two important Revolutionary cartoons published in England, 1774-1775, which show sympathy with the cause of the colonists. They have been discussed by R. T. H. Halsey in *The Boston Port Bill,* in which he attributed the designs to Philip Dawe. At the left is *The Bostonians Paying the Excise Man,* a mezzotint published by Sayer & Bennett, London, October 1774, based on an actual incident in which an unfortunate tax collector was tarred and feathered and forced to drink a toast in tea to the eleven members of the royal family. At right is *The Bostonians in Distress.* Great sympathy was shown to Boston, suffering under the cruel regulations of the Port Bill, and supplies of food and money were sent from neighboring towns. In the print, a cage represents the blockade of Boston, and a boatload of food the supplies sent to the city. Also at Deerfield, in the Allen House, is Paul Revere's engraving of 1770, *The Boston Massacre,* the most famous American historical print. This is fully discussed by Clarence S. Brigham in *Paul Revere's Engravings* (1955), from which an excerpt appeared in ANTIQUES for July 1955. *Hall Tavern.*

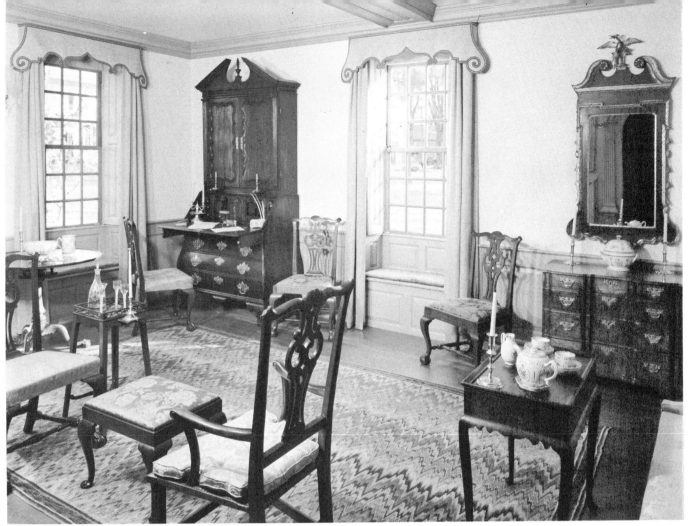

The parlor of the Dwight-Barnard House has its original window seats with paneled sides and folding shutters; doors and floor are also original. The paneling is painted greenish-gray, the original color. The exceptionally fine Massachusetts bombé desk and bookcase, c. 1770, is shown in detail in *The furniture: New England*. The chest of drawers, c. 1760, has flat blocking typical of Massachusetts. An American origin can be claimed for the mahogany and gilt architectural mirror crowned with a phoenix. Stools were seldom made in America; here is a New England Queen Anne example. Of special interest is a group of Massachusetts chairs showing variations of a pierced, scrolled splat based on Manwaring, often called Salem chairs because many were owned in Salem families. The one at the desk came from Salem, but the birch armchair in the foreground is from Plymouth and is the earliest of the group, c. 1750-1760. More sophisticated is the finely carved chair at left of the window. Probably English are the little stand with pierced gallery and the fine needlework carpet in flame stitch. See color view of this room. *Dwight-Barnard House.* *(Facing page 256)*

Interiors

THE DWIGHT-BARNARD HOUSE, a fine Connecticut Valley dwelling, was moved to Deerfield from Springfield, Massachusetts, and opened in 1954. Built in 1725, it was purchased in 1743 by Timothy Dwight (1715-1768), whose grandfather, Timothy Dwight of Dedham, had helped to plan the town of Deerfield and owned property there. The land on which the house now stands was purchased in 1768 by Joseph Barnard, and his son Ebenezer practiced medicine on the site from 1772 to 1790. Among the furnishings of the Dwight-Barnard House are heirlooms from two other Deerfield physicians related by marriage to the Dwights: Dr. Thomas Williams (1718-1775) and his son, Dr. William Stoddard Williams (1762-1829). The heirlooms are gifts and loans from their descendants, Elizabeth Fuller and Catherine Arms, in memory of their mother, Mary Williams Fuller.

The Sheldon-Hawks House was restored in 1956.

Among the more than thirty houses original to the mile-long village street, it marks the first wave of prosperity that came to Deerfield when the captives returned from Canada following the French and Indian Massacre of 1704. Like others of this period (c. 1725), it has the salt-box sweep at the back, unpainted clapboards, narrow windows with inside shutters, and entrance door between fluted pilasters but with pitch rather than scroll pediment. The house was built about 1734 by John Sheldon and stands on land owned by the Sheldon family from 1708 until the death of Susan Hawks, last of the line, in 1946 —the longest single family holding in Hampshire County. George Sheldon wrote his history of Deerfield while living in this house. Present furnishings include many original Sheldon possessions and a quantity of fine eighteenth-century needlework and textiles, American and European, including a variety of costumes.

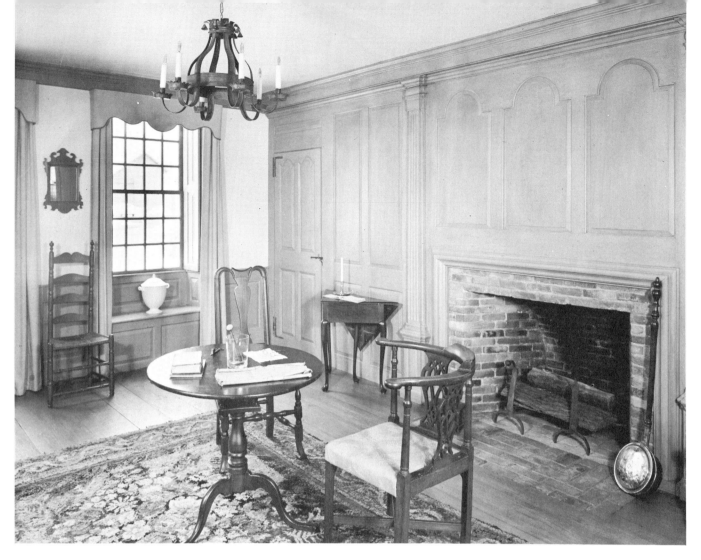

In the doctor's office, with furniture from the Williams family, are a birdcage table, corner chair, two Queen Anne Spanish-foot chairs, ladder-back chair, and handkerchief table, as well as a large early floral hooked rug made in Deerfield. The warming pan by the fire was used by Dr. Williams. The leech jar which stands in the window seat is Wedgwood. On the table is Dr. Williams' daybook. The portraits of himself and his wife hang in this room (see *Portraits*). The window paneling and seats, doors, and floors are original and the fireplace wall has been restored on the basis of evidence supplied by some of the existing panels (the original color was found to be a strong blue with azure cast); and the plaster walls above the dado are white. *Dwight-Barnard House.*

The cabinet in the doctor's office (not part of the original construction) has been arranged to show Delft drug jars, along with glassware, scales, mortar, bleeding bowl, and other equipment which belonged to Dr. William Stoddard Williams and his father, Dr. Thomas Williams. The folding-top table with gadrooned skirting on the frieze, also owned by Dr. Williams, is illustrated in *Connecticut Valley Furniture. Dwight-Barnard House.*

In the north parlor of the Sheldon-Hawks House is the massive carved and inlaid cherry secretary traditionally ascribed to Daniel Clay of nearby Greenfield—the key piece for attribution to Clay of elaborate work of this kind (see *The furniture: Connecticut Valley*). The three side chairs in the center are attributed to Eliphalet Chapin of Hartford because of their close similarity to a chair in the Garvan collection (ANTIQUES, April 1939, p. 172). The Newport dished-top tea table has the swirl carving on the pillar vase which identifies Townsend-Goddard work (compare Carpenter's *Arts and Crafts of Newport*, Nos. 78, 79). Two chairs here are outstanding Newport pieces: the Queen Anne at left which has the Newport shell with dependent husk on the knee, and shell on the cresting; and the Chippendale chair with interlaced splat (ANTIQUES, July 1955, p. 45) which has characteristic stopped fluting on the front legs. The red and gold chandelier of wood with iron arms and tin sockets is rare, early, and attractive. The carpet is an eighteenth-century Ushak, a type frequently used in colonial America. *Sheldon-Hawks House.*

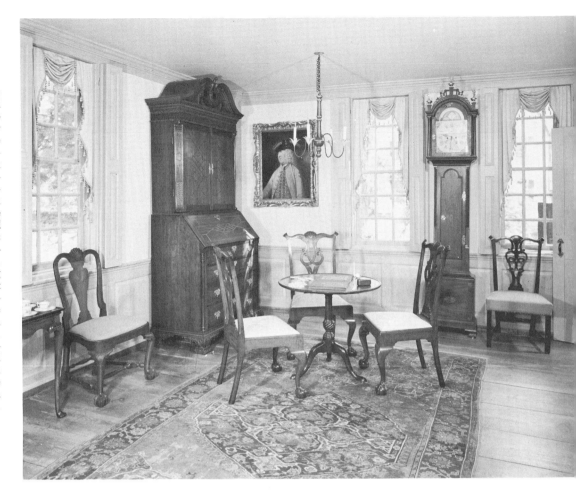

The north bedroom has original fielded paneling of the period 1700-1735, with a bolection molding around the fireplace. It is of pine, free of knots, and unpainted. The pencil-post bed has draperies and valance of English flame stitch, and at the head an unusual embroidered panel with baroque motifs in a closely wrought design, probably Continental work of the eighteenth century. By the fireplace is a New England Queen Anne easy chair covered in leather, and beside it an unusual small stand with trefoil top. The blanket chest beside the bed was made 1680-1700, and decorated slightly later in the Boston area with a painted design of branching motifs in red and green. To the left of the fireplace a Queen Anne mirror with applied gilt decoration hangs over a New England Queen Anne lowboy. The portrait of John Steven Greenleaf by John Wollaston over the fireplace shows the dress of about 1740, appropriate in a room where most of the furnishings are of the first half of the eighteenth century. *Sheldon-Hawks House.*

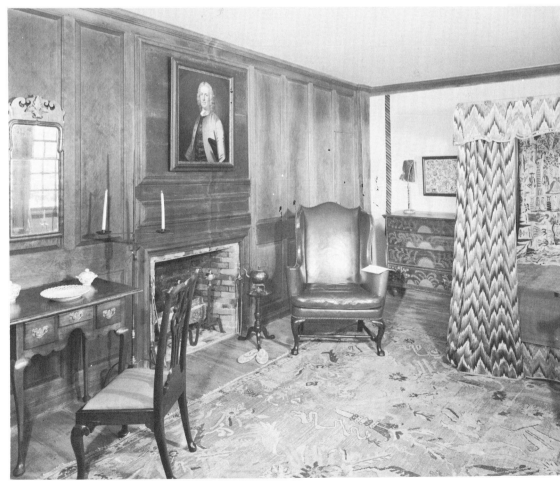

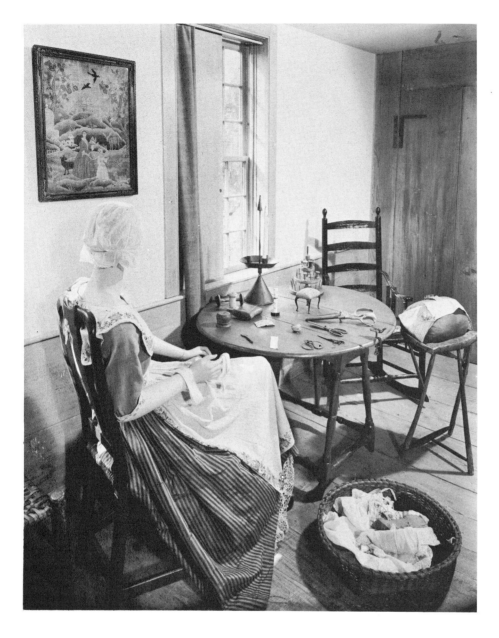

Sewing room arranged with the early tools of the needleworker; beside the maple butterfly table, a Deerfield piece, is an early lacemaking stand with tripod base, whittled legs, and T-shape stretcher. It has a semicircular top with braces holding the cushion for pins and hand shuttles. On the table is a pair of large, brass-handled tailor's scissors marked *T. Wilkinson & Son Makers Sheffield;* a miniature Queen Anne upholstered stool which serves as a needle cushion; a Bilston enamel needlecase; four-tiered wooden spool holder, painted red; tin candle holder; wooden spools; darning shoe and metal sewing bird, the last attached to the edge of the table at right. The basket represents a Deerfield industry. On the wall is an English needlework picture of the Queen Anne period. *Sheldon-Hawks House.*

The Frary House, one of the oldest structures in Franklin County, was one of the first buildings to be restored in Deerfield. The north part of the house is thought to have been built about 1685 by Samson Frary. The building became an inn when purchased and enlarged by Selah Barnard in 1763 and has since gone through many changes. In 1890, the old structure was saved from ruin by Miss C. Alice Baker who bequeathed it to the Pocumtuck Valley Memorial Association. The family room of the innkeeper is now furnished with New England country pieces, chiefly painted pine, of the early and mid-eighteenth century.

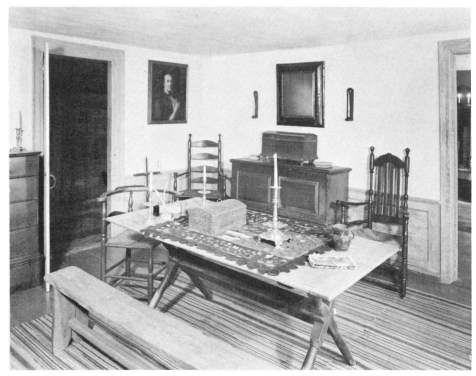

The Shelburne Museum at Shelburne, Vermont

THE SHELBURNE MUSEUM has been called a collection of collections. It is not a restoration. It is not a village. It is a grouping of houses and objects preserved because of their beauty or their historic value.

It was my husband who taught me to be aware of the beauty and historic interest that a building can possess, but I inherited my taste for collecting from my parents, Mr. and Mrs. Henry O. Havemeyer, whose collection of European art is now in the Metropolitan Museum of Art.

My collecting started at an early age. I recall my mother's saying of the folk sculpture, "How can you, who have been brought up with Rembrandts and Manets, collect and live with such worthless American carvings?" But I loved my folk art—also my furniture, toys, china and quilts, and all the rest of it—just as much as she did her fine examples of European art.

Many times since the start of the Museum I have been asked how it came into being. There were three principal factors: my husband's interest in old buildings, my enthusiasm for collecting, and the love we both have always had for Vermont. My husband's parents, Dr. and Mrs. William Seward Webb, moved to Shelburne from Burlington in 1888, and this is where members of our generation and some of the next have settled.

In 1947 a family gathering was called to determine what should be done with the fine carriages Dr. and Mrs. Webb had left. It was decided that my husband and I should take them and try to find some land in the village on which to erect a barn where they could be cared for and exhibited so that the public might enjoy them. This sounds like a simple project, but it involved almost endless complications and it gave us our first experience with the problems of locating, building, reconstructing, restoring, and creating harmonious interior settings—problems that had to be solved afresh for each addition to the Museum.

Now that was the spark that lit the fire: with the carriages as the first collection, we proceeded to obtain some eight acres of land on Route 7 south of Shelburne village, a couple of miles east of Lake Champlain. In time we have acquired for the Museum grounds over twenty acres, one parcel at a time.

That first building, the Horseshoe barn, was constructed of hand-hewn timbers from ten old Vermont barns and two gristmills. Besides the many carriages in the original group, it now houses countless other carriages and sleighs. Big as it is, it cannot hold the entire collection of more than three hundred items, and a large annex and shed have had to be added.

The twenty-eight buildings which today comprise the Museum are simple, for they represent for the most part early Vermont. Only three have come from out of the state, and they are from nearby New Hampshire, Massachusetts, and New York. The earliest is a salt-box house, found in North Hadley, Massachusetts, when I was looking for early floor boards. It was such a gem we purchased it and re-erected it here. Now it is called the Prentis house because it was mostly furnished by Katharine Prentis Murphy, and to me it stands not only for life in New England but also for friendship and loyalty, for two people working together to achieve something worth while.

There are no fewer than twenty-seven collections in the Museum. Even the lilacs around the old houses are a collection, one which my husband and I began on our Long Island place when we were first married.

Of these many collections in the Museum, all but six were made by me during the last fifty years. The doll collection, my first interest, was begun when I was fifteen. The folk art collection was started just before we were married, and then came the quilts and coverlets. Now there are almost three hundred items listed in each of these categories. Maybe they are my favorites; it is hard for me to tell. It has always been my belief that if one is a true collector one finds and buys piece by piece. However, since the Museum was created I have bought several collections, as well as adding to those we had originally.

Our gifts have been wonderful. We have received not only collections but individual items. To all the donors we are deeply grateful.

The structures at the Museum and their collections are diverse not only in period but in character, a basic concept that departs rather radically from that followed by other outdoor museums. We are proud possessors of a lighthouse, which was moved from a reef in mid-Lake Champlain. The great thousand-ton sidewheeler S. S. *Ticonderoga*, which was transported two miles overland to its final resting ground, has become part of our scheme. Although many thought the boat would dwarf the other buildings it fits in architecturally as if it had always been there. The 168-foot double-lane Covered Bridge with a side passage for pedestrians, moved from Cambridge, Vermont, over thirty miles away, is one of our most important preservations. All three, the lighthouse, the boat, and the covered bridge, are unique.

We have been called pioneers in the museum field, which is a fine tribute and gives us confidence. We have never thought of ourselves as pioneers. We have collected the things that seem to us, at least, to have beauty, and we have placed them in buildings that seem to us to have integrity and charm. We have all worked conscientiously and hard in an effort to preserve many worthwhile objects from our fine American heritage and we are most grateful for the recognition the Shelburne Museum has received.

ELECTRA H. WEBB, *Founder*

The buildings

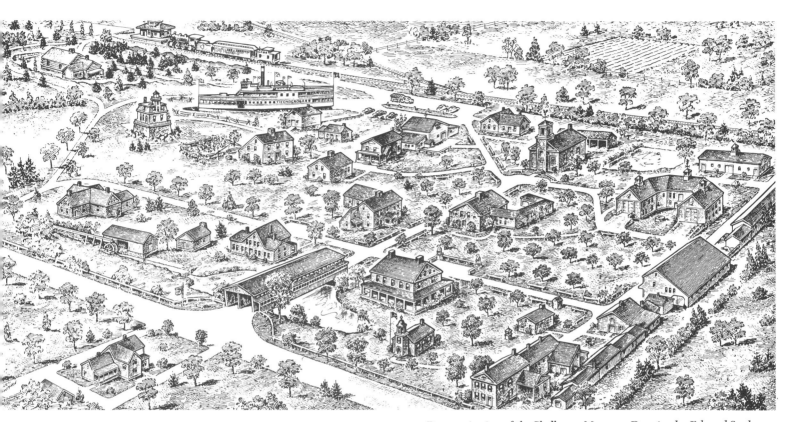

Panoramic view of the Shelburne Museum. *Drawing by Edward Sanborn.*

MOST OF THE ELEMENTS of the "architecture collection" of the Shelburne Museum were moved to the site from other parts of Vermont and are representative of late eighteenth- and nineteenth-century buildings in the region. Besides the dwellings, meetinghouse, schoolhouse, inn, country store, and smithy that one might see in many a Vermont village, there are an up-and-down sawmill, a great covered bridge, a log camp, and a horse-stand shed from the Shaker community at Canterbury, New Hampshire. A tiny jail all of slate contrasts with a huge red barn in the shape of a horseshoe, which houses the superb collection of vehicles. Most spectacular of all is what may be classed as marine architecture—the S. S. *Ticonderoga.* More than twenty buildings have been opened to the public and more are being added. A number are furnished as they might have been originally; the others are used for exhibiting the specialized collections.

The great covered bridge through which one enters the museum from Route 7 is the only one with two lanes and a footpath surviving within Vermont. Built about 1845 over the Lamoille River at Cambridge, it is 165 feet long, a splendid example of the arch truss patented by Theodore Burr in the early 1800's.

280

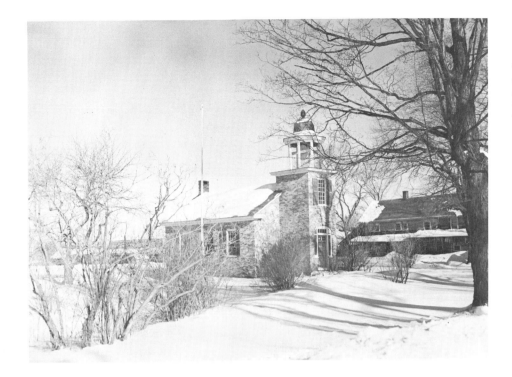

The little schoolhouse, only 38 by 22 feet in size, was built in Vergennes, a few miles south of Shelburne, in 1830. Of local pink brick, it has a projecting vestibule entered by an arched doorway and surmounted by an octagonal belfry with acorn finial. The one-room interior, still bearing the scars of generations of schoolchildren, is refitted with old desks and blackboards, stove and books. Long disused and dilapidated, this was the first building moved to the Shelburne Museum in 1946.

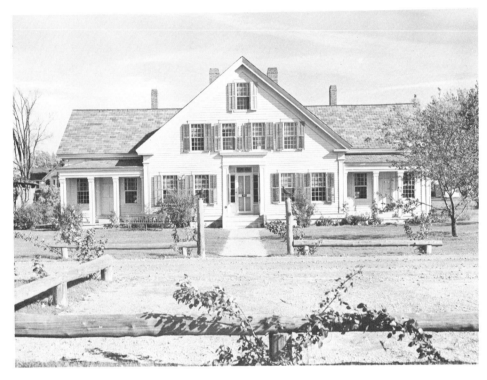

Dorset House. Built about 1850 as a two-family dwelling in the marble-quarrying part of Vermont. Marble was used as a veneer on the foundation, and also for porch floors and front walk. The high gable on the front is seen on many Vermont houses of the time, though not all are so pleasingly balanced with two wings. Exhibited in the Dorset House are the decoy collection and rarities from the elephant folio of Audubon's *Birds of America*.

From 1783 the stagecoach inn at Charlotte, Vermont, built and operated by Captain Hezekiah Barnes, offered shelter to travelers between Montreal and New York. After his death it passed through many ownerships with attendant alterations, and in 1949 was reconstructed at Shelburne in its original form, with wide central hallway, ten fireplaces, and second-floor ballroom. It has the simplicity of the frontier which Vermont was in the late 1700's, but its ample proportions suggest comfort, and it contains some of the widest boards and longest timbers still to be seen anywhere. The collection of folk sculpture is displayed here.

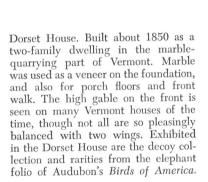

The Colchester Reef Lighthouse wa
built two miles off shore in Lake Cham
plain in 1871, and for sixty-two yea
warned ships and men of dangerou
shoals. Designed by Albert R. Dow o
Burlington, Vermont, it is a two-stor
clapboard house 25 feet square, perche
on rocks, with a fashionable mansar
roof and, above, the light tower with
plate-glass windows. The light itse
was an oil lamp whose beam was i
tensified by magnifying lenses and ha
a visibility of 11 miles over a 36(
degree circle. When bad weather c
down its range, a fog bell struck ever
twenty seconds. In 1933 the light wa
replaced by an automatic blinker, an
the last lighthouse keepers came ashor
In time the building was acquired f
the museum and, in the face of gre
difficulties, was moved ashore and r
erected on the grounds in 1952. Throug
the courtesy of the United States Coa
Guard, the lenses, fog bell, keepe
dory and other appurtenances are aga
in place. The historic lighthouse no
serves as an exhibition building f
prints and paintings relating to Ame
ican marine history.

*Macdonough's Victory on Lake Cham-
plain . . . Septr. 11, 1814.* Engraving
after the painting by H. Reinagle, pub-
lished by Benjamin Tanner, Philadel-
phia, 1816. 19 by 25 inches over all.
In the American Naval Gallery in the
Colchester Reef Lighthouse, which in-
cludes prints of battles in all American
conflicts up to the Civil War.

*A Shoal of Sperm Whale. Off the Island
of Hawaii* . . . Aquatint by J. Hill, after
a painting by Thomas Birch from a
sketch by Cornelius B. Hulsart; pub-
lished by Hulsart, New York, 1838.
16½ by 24¼ inches. The episode pic-
tured took place in 1833 and Hulsart
was on one of the ships. This and *Cap-
turing a Sperm Whale* are the rarest
pair of American aquatints; they are
among the numerous dramatic prints
in the Whaling Gallery in the Col-
chester Lighthouse.

*The Ship, "Angelique"./5th Ship of the
"Australian Packet Line"* . . . Lithograph
by J. Cameron, published by Charles
Currier, New York. Large folio. A recent
discovery, unrecorded by Peters. The
marine pictures in the Colchester Light-
house include many Curriers and other
prints, and a group of ship paintings by
James and John Bard.

Pride of the museum is the S. S. *Ticonderoga,* the finest surviving example of its type. Launched at Shelburne Harbor in 1906, this great vessel, with a length of 220 feet, beam of 57½ feet, and displacement of 892 tons, was active on Lake Champlain for nearly half a century. Then in 1953 she had to be retired, for such steamboating had become obsolete and trained personnel was lacking. The Shelburne Museum determined to preserve this noble example of marine architecture, the last of the line of Vermont-built sidewheelers on Lake Champlain which had begun with the *Vermont* in 1808. The moving of the *Ti* from the lake overland nearly two miles to the museum grounds was as exciting as the ship's whole previous history, a dramatic and impressive achievement of modern engineering. Now at her last mooring near the Colchester Lighthouse, the *Ticonderoga* may be seen from stem to stern, in some ways even better than when she was afloat. Her vertical steam engine and walking beam, paddle wheels and boilers, fore-castle, smokestack, and lifeboats are as complete as her richly finished decks, compartments, and staterooms. The interior woodwork of butternut and cherry is paneled and carved. A huge mirror at the head of the stairs to the saloon reflects the gold stenciling on the ceilings. At the forward end of the stateroom hall are an elegant plush-covered circular seat originally used on the S. S. *Vermont II* (1871-1903), and the wheel from the U. S. Navy battleship *Vermont.*

283

The interiors

FIVE OF THE OLD HOUSES thus far opened are completely furnished as they might have been originally—the four shown here and a tiny slate-roofed stone cottage of 1840, such as sheltered many an early Vermont family. In each case not only have pieces suitable in style and period been used, but an imaginary family has been created to live in the house, and all the furnishings have been selected to meet their specific needs and tastes.

The Dutton House

In both architecture and furnishings the Dutton House demonstrates the time lag in styles always seen in remote regions. It was built in 1782 in Cavendish, Vermont, by Salmon Dutton who brought with him from Massachusetts memories of the early salt-box construction, with narrow entrance hall from which the stairs rise steeply in front of the large central chimney, a room on either side, and the kitchen behind. A long ell at the rear adds interior space as well as architectural interest.

The furniture, like the house itself, recalls early traditions. In the parlor the butterfly table with its unusually handsome interior, the screw-arm candlestand, and the turned slat-back chair are of the very early 1700's. The daybed retains a seventeenth-century character in its turned legs and stretchers though the back shows Queen Anne influence. Eighteenth-century portraits hang on the wall, and a striped woven carpet gives life to the floor.

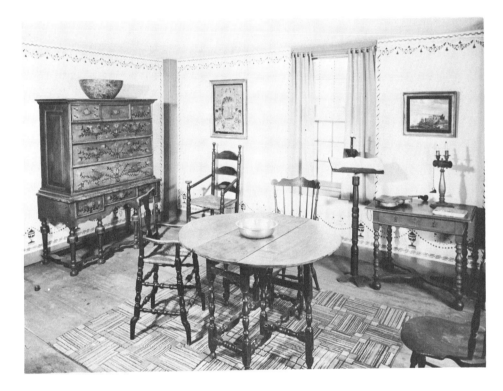

Stenciling discovered on the walls under layers of wallpaper was reproduced where the original could not be saved. Outstanding here is the William and Mary highboy whose painted decoration is signed *RLG 1738*. A fascinating play of pattern is seen in the varied leg turnings of highboy, gateleg table, high chair, cross-stretcher table, and music stand—all dating close to 1700.

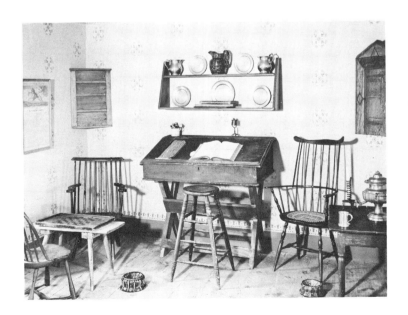

The ground floor of the ell is furnished as a harvest room, a comfortable eating and gathering place. Windsor chairs are drawn close to the checkerboard; Bennington pottery and pewter brighten the hanging shelves and cupboards. The high lift-top desk is an unusual eighteenth-century New England piece, mounted on a sawbuck trestle and used with a high stool.

285

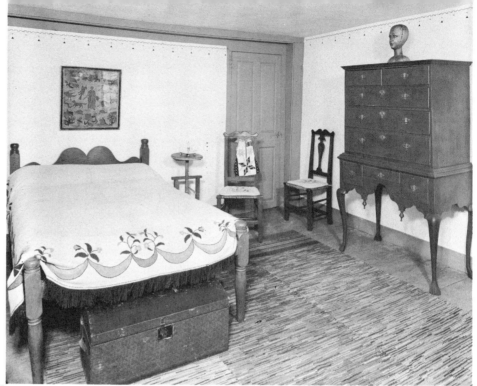

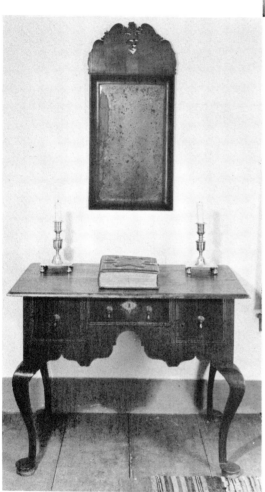

The northeast bedroom has a stenciled frieze whose swag motif is repeated in the embroidered coverlet on the low-post painted bed. The cabriole legs of the Queen Anne painted maple highboy (Rhode Island, 1710-1730) end in a simplified and most unusual version of the Spanish foot. The carved head on top of the highboy is to hang a bonnet on.

A great rarity in the bedroom is a Queen Anne painted lowboy or dressing table from Connecticut (1700-1720) whose cabriole legs continue the sprightly curves of the scrolled skirt and end in unusually large, deep, pad feet. The walnut-veneered looking-glass above it, of the William and Mary period, has a high cresting broken by a pierced heart motif, and its original beveled glass.

A painted pine bed with posts turned in the classic taste is hung in contemporary fringed dimity, matching the window curtains. The painted decoration of the ball-foot chest, in red and white on a black ground, is like that of a similar chest in a bedroom of the Sheldon-Hawks House at Deerfield. Another furniture rarity is the Spanish-foot stretcher table.

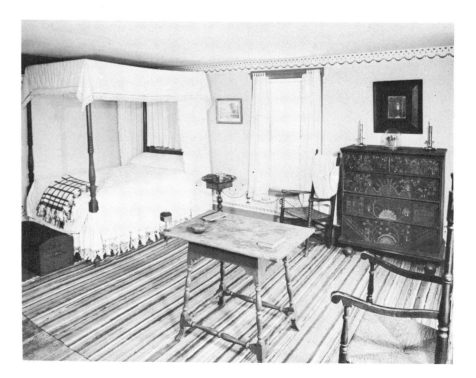

The Prentis House is the earliest of the architectural units on the museum grounds. Of traditional salt-box type, it was built about 1733 in Hadley, Massachusetts, and, remarkably, was never altered. When moved to the museum, it retained all its original woodwork and also its unusual chimney which at the second-floor level encloses the seven flues in an enormous brick cone. The furnishing was done by Mrs. Katherine Prentis Murphy, and presents notable examples of the furniture and decorations made and used in New England when the house was new.

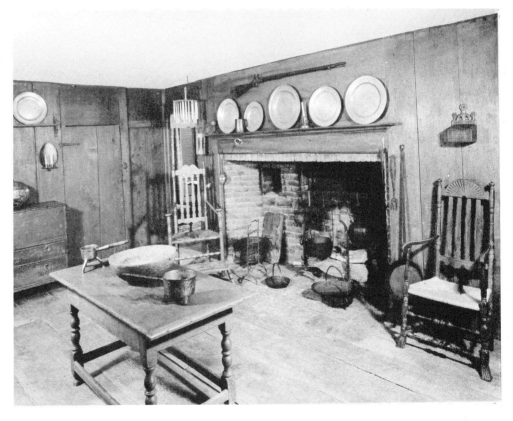

The kitchen in the lean-to has a big brick fireplace and sheathed walls, with small borning room adjacent on one side and buttery on the other. The fireplace with its long crane has an appropriate complement of iron pots, skillets, racks, and skewers; huge burl bowls, pewter chargers, and a three-legged pot of bell metal dated 1678 are near at hand. The banister-back armchair at the left of the fireplace, with high arms and front posts ending in large turned "mushrooms," was found in Connecticut; the Spanish-foot one at the right, with sunburst crest, came from New Hampshire.

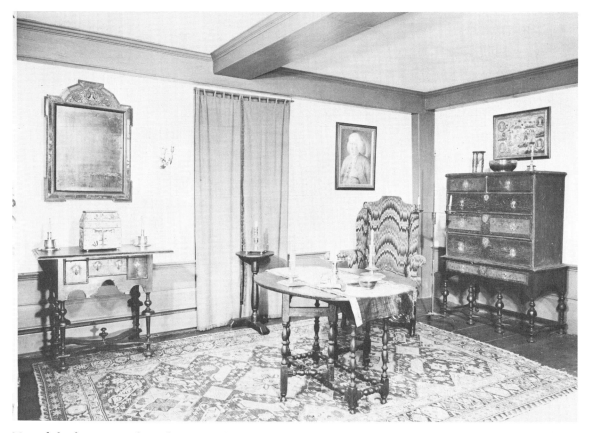

Most of the furniture in the parlor was made in New England in the very early 1700's if not before—the large gate leg table with antique velvet cover. William and Mary maple lowboy painted black, turned candlestand, and William and Mary painted chest-on-frame. Of interest are the examples of seventeenth-century English needlework: the stunning flame-stitch upholstery on the wing chair of similar date and source, the framed picture over the high chest, the raised work covering the casket on the lowboy. Fine brass candlesticks of the seventeenth century include the columnar pair on the table; also rare is the American iron and brass candlestand in the corner. Dr. Samuel Johnson portrayed in pastel gazes down on this colorful scene.

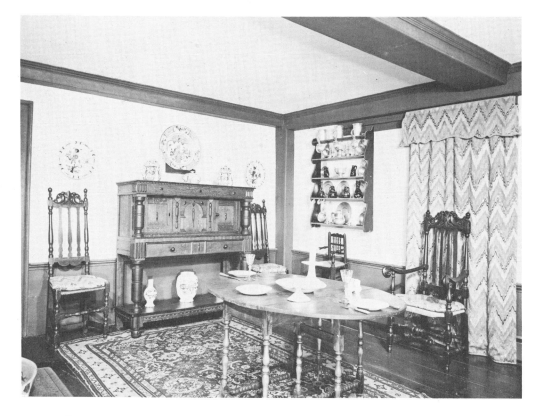

In the dining room, a collection of early English delft is arrayed on the seventeenth-century Massachusetts court cupboard and on the finely turned gate leg table from New Hampshire. Rarities are the seventeenth-century Lambeth candlestick, standing salt, fuddling cups, and dated plates, and the pair of covered posset pots. Of great interest too is the collection of early English and American pewter displayed on hanging shelves. The banister-back chairs are attributed to John Gaines of New Hampshire; the armchair once belonged to the silversmith Jeremiah Dummer. The silk flame stitch of which chair cushions and curtains are made is the earliest thing in the room.

THE PARLOR, STENCIL HOUSE, SHELBURNE MUSEUM

(See page 293)

THE DINING ROOM, STENCIL HOUSE, SHELBURNE MUSEUM

(See page 294)

The east chamber is furnished as far as possible with items of the seventeenth century. Against the fireplace wall stands a seventeenth-century oak chest, and in the corner a rare turned stand holds a pewter bowl and pitcher. The banister-back armchair has unusual turnings and crest, and stretchers under the arms.

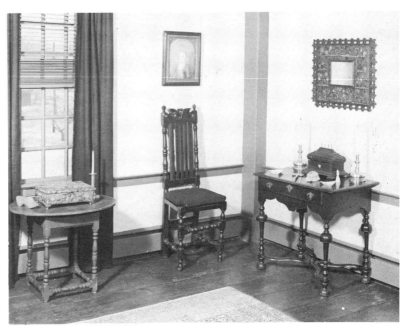

In the east chamber a small looking glass in wide beadwork border and carved frame hangs above a New England William and Mary dressing table which offers interesting comparison with the one in the parlor. The matching early English pewter candlesticks here are noteworthy. The table and chair have particularly good turnings.

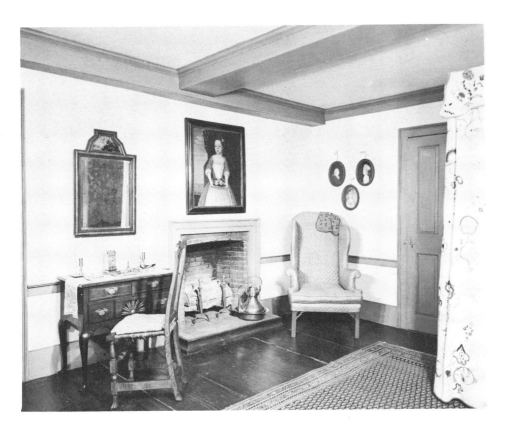

The west chamber is dominated by crewel-embroidered bed hangings worked in New England in the mid-1700's. Used with them is a rosy quilted bedspread of the silk and wool fabric known as say, and the wing chair is covered in quilted pink silk. A New England Spanish-foot chair in maple is drawn up to the graceful Queen Anne walnut dressing table which has cross-banded drawers and striking fan inlay. The walnut-framed looking glass, of the early 1700's, has a painted scene in the crest. An eighteenth-century portrait of a girl in red echoes the colors of the crewelwork, and three small oval pastels above the wing chair, which are attributed to Sharples, are appropriately hung by red ribbons.

289

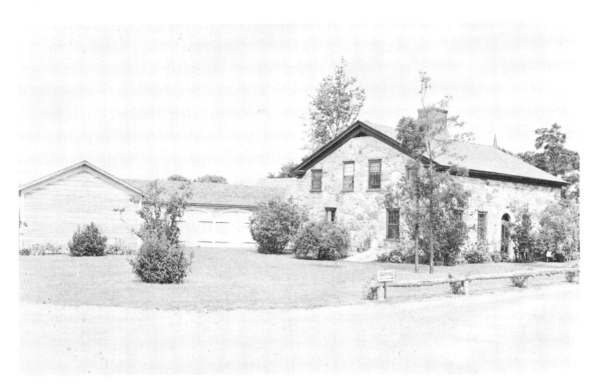

The plan, the frame, and much of the material for this house came from a clapboarded dwelling that had stood since about 1790 in Shelburne Township but was so worn out that both interior paneling and exterior surfacing had to be replaced. The stonework was copied from a contemporary Vermont house. The interior plan is related to that of the salt box, with central chimney, small entrance hall, a room on either side, and long kitchen in back, but the stairs rise from the kitchen instead of the hall and there is, surprisingly, a fireplace facing the front door. The lower rooms are furnished as the home of a sea captain of some means who retired to the Vermont hills in the late 1700's.

The Vermont House

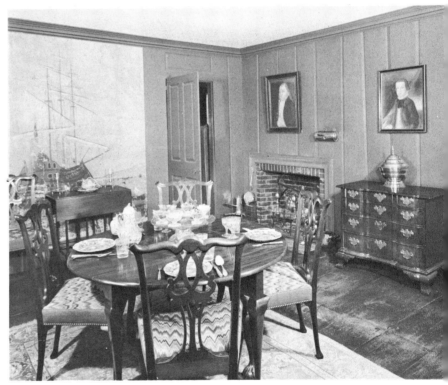

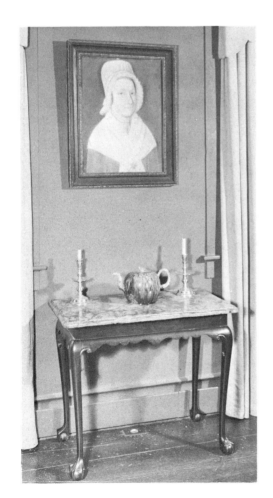

The feather-edge sheathing of the fireplace wall in the dining room is painted a soft brown, offsetting the bright blues of pastel portraits and painted wall paper. Massachusetts Chippendale chairs with flame-stitch seats are used with the Queen Anne drop-leaf table, which is set with Whieldon-type earthenware, an unusual glass Lazy Susan, and English drinking glasses, cut and engraved. The mahogany spider-leg table against the papered wall is one of very few known in American furniture. Throughout this house, as in the other at Shelburne, lighting devices and fireplace equipment are of special interest.

Above a fine New England slab-top serving table (c. 1760) in the dining room hangs a pastel portrait, one of three here attributed to the eighteenth-century Salem artist Benjamin Blyth.

The fine arched and fielded paneling of the parlor came from a house near Essex, Connecticut. Painted blue-green, it provides a pleasing background for rare pieces of eighteenth-century New England furniture. Outstanding among these is the chair at right, whose arms terminate in carved parrot heads, apparently a unique feature; the stopped fluting of its sturdy legs indicates Newport origin. Also of Newport make is the octagonal tea table whose legs have the "collar" seen on a few examples ascribed to the Goddard-Townsend group and terminate in curious paw-and-pad feet. The slipper-foot chair with flaring crest is of walnut; the stool is a rare form in American furniture.

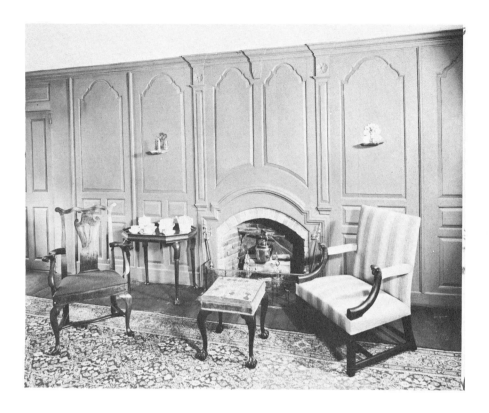

Facing the parlor fireplace is a notable Queen Anne cherry secretary ascribed to the Connecticut craftsman Benjamin Burnham. Its closed bonnet top curves boldly above arched paneled doors with handsome brass hinges, the interior has molded drawers and vine carving of Connecticut type, and the frame stands on short cabriole legs with pad feet. Beyond, New England Queen Anne chairs are drawn up to a contemporary games table. A japanned Queen Anne mirror hangs above a most unusual Connecticut lowboy of cherry, with leaf and flower carving on frieze, legs, and widely overhanging top.

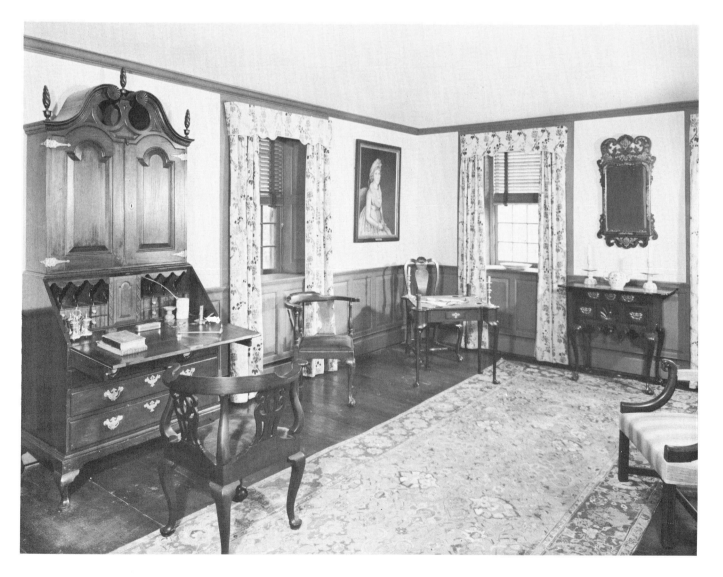

In the kitchen, household objects in wood, pottery, metal, and wool show individuality and rarity in country antiques. Windsor and banister-back chairs may be pulled up to the well-scrubbed pine table, whose pad feet stand on a colorful rag carpet, and a writing-arm windsor fills the corner. The two-drawer Hadley chest (No. 94 in Luther, *The Hadley Chest*) is initialed *MW*. Homespun wool curtains hang at the windows, while colorful pottery and gleaming pewter brighten table and shelves. The picture of a cat on the wall is composed of purple delft tiles; delft tobacco jars and posset pot rest on the window sill.

The big brick kitchen fireplace is fully equipped with pots, pans, trivets, peels, spit and clock jack, oven, strainers, and all the other necessities of iron, brass, and tin. American pewter shines against the red-painted wall; interesting pieces of treenware on the octagonal hutch table include a brose spoon of about 1750 (brose is a Scottish porridge). A pine settle made of enormously wide boards separates this part of the kitchen from the end shown above.

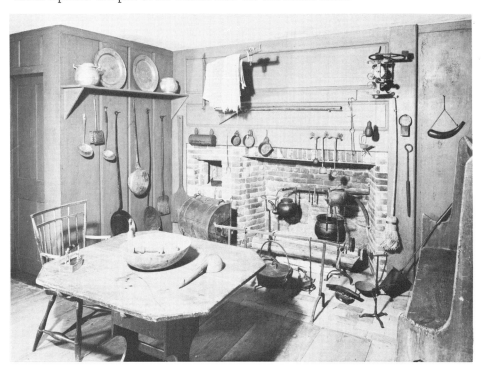

The Stencil House, built in Sherburne, New York, about 1790, is a small, frame, slate-roofed structure. Its distinction lies in the stenciled decoration which was profusely applied, probably about 1820, directly on the board walls of the small entrance hall and the two rooms on either side of it. While stenciling on the plaster walls of old houses is not uncommon, few examples on wooden walls survive, and even fewer that show such a variety of motifs and borders as are seen here. Some elements of these designs, but not all, may be identified with the patterns of Moses Eaton (1753-1833), one of the most prolific of the itinerant artists of his day, whose work has been found in New England, New York, Ohio, and Indiana.

Most of the furnishings of the house are country-made, but a few more sophisticated items reflect the aspiration to elegance which is so clearly expressed in the stenciling—a substitute for expensive wallpaper. The taste for painted decoration is apparent too in much of the furniture, which displays simulated graining, tortoise-shell markings, floral motifs, or at the least solid color in green or old red. All the furnishings have been selected to complement rather than compete with the elaborate wall decorations.

The Stencil House

The stenciled motifs in the parlor (Color Plate Page 288) include a bird on branch, rising run, flowering tree, flowers in vases, and conventionalized designs, with four different borders, all painted in red, green, and brown on a soft green background. Stenciling also decorates the marble-top Hepplewhite table which is painted brown and gilded (Boston, c. 1800); the chalkware owls on it stand 13½ inches tall. The Connecticut writing-arm chair and the high chair are unusual windsors. A Bilbao mirror, marble-veneered and gilded, adds the note of elegance.

A view through doorways, from the dining room across the entrance hall to the parlor, shows the fascinating variety of stencil patterns and the skill with which they have been composed. The dwarf tall clock, with case of strongly figured maple and painted dial, stands 55 inches high.

As in the Vermont House, the entrance hall of the Stencil House is square, without stairs, and with a fireplace directly facing the front door. The fireplace wall is stenciled with American eagle, floral bouquet, bird on branch, and bird in tree motifs disposed around a larger tree in the center. Both side walls are decorated as well, and all are framed with ornamental borders.

The room to the right of the hall (Color Plate Page 289) is arranged for dining and for reading and writing as well, with a variety of tables and chairs and a red-painted desk, on which poses a remarkable bust of Washington in tin. This bust, the basket on the butterfly table, and the numerous candlesticks here are among the many unusual pieces of tin, shiny or painted, placed throughout the house. The stenciling is on an ocher ground and repeats motifs seen in the hall, though with different borders. Handwoven wool curtains and woven rag carpet are suitably unpretentious.

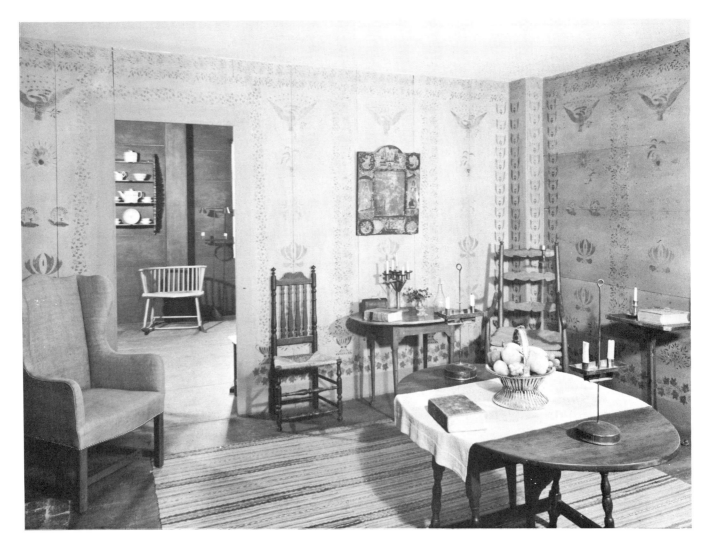

Across the back of the house is the long green-painted kitchen, from which steep stairs lead to the two bedrooms, weave room, and children's playroom above. The blanket chest, of about 1700, received its painted decoration somewhat later. The hanging shelves, displaying cream-ware, are sponge-painted. On the scrubbed pine top of the center table are an unusually large pewter bowl and an eighteenth-century wine bottle in a leather holder. Oval reflectors rise above the six branches of the tin chandelier.

Two beds in the children's bedroom under the eaves have their old red paint and quilted wool coverlets. The small bed, with scalloped head, foot, and sides, is 56 inches long. Curtains are handwoven wool. The walls are blue-green.

The sheathed walls of this bedroom are painted blue-green. An eighteenth-century wing chair with turned legs and stretchers of maple is up-holstered in brown linsey-woolsey, and the straight chair with turned legs and stretchers, probably Canadian, is painted green. At the small fireplace is an unusual fender of heavy iron. Woven rag rug, carpet slippers and Paisley shawl, pieced wool quilt on the red-painted bed, all add warmth and color. Visible beyond the door is a four-drawer chest painted with simulated wood graining.

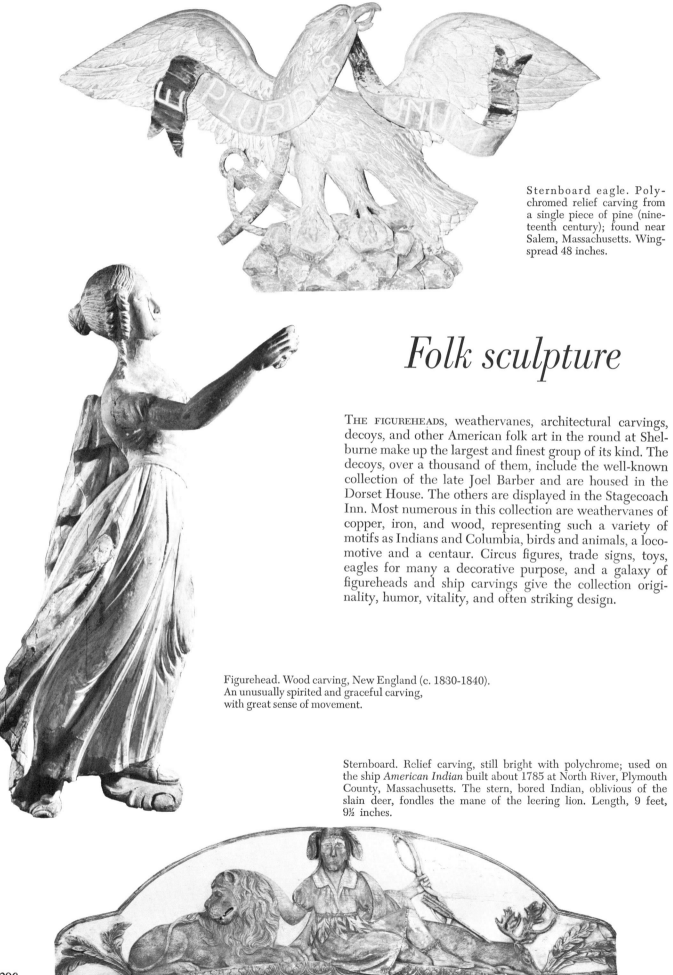

Sternboard eagle. Poly-
chromed relief carving from
a single piece of pine (nine-
teenth century); found near
Salem, Massachusetts. Wing-
spread 48 inches.

Folk sculpture

THE FIGUREHEADS, weathervanes, architectural carvings,
decoys, and other American folk art in the round at Shel-
burne make up the largest and finest group of its kind. The
decoys, over a thousand of them, include the well-known
collection of the late Joel Barber and are housed in the
Dorset House. The others are displayed in the Stagecoach
Inn. Most numerous in this collection are weathervanes of
copper, iron, and wood, representing such a variety of
motifs as Indians and Columbia, birds and animals, a loco-
motive and a centaur. Circus figures, trade signs, toys,
eagles for many a decorative purpose, and a galaxy of
figureheads and ship carvings give the collection origi-
nality, humor, vitality, and often striking design.

Figurehead. Wood carving, New England (c. 1830-1840).
An unusually spirited and graceful carving,
with great sense of movement.

Sternboard. Relief carving, still bright with polychrome; used on
the ship *American Indian* built about 1785 at North River, Plymouth
County, Massachusetts. The stern, bored Indian, oblivious of the
slain deer, fondles the mane of the leering lion. Length, 9 feet,
9½ inches.

296

Spread eagle. Wood carving by Wilhelm Schimmel (1817-1890); painted black and green. A native of Germany, Schimmel came to Carlisle, Pennsylvania, after the Civil War and, according to his obituary, "for many years tramped through [the region], making his headquarters in jails and almshouses. . . . His only occupation was carving heads of animals out of soft Pine wood. . . ." (ANTIQUES, October 1943, p. 164). His only tool was a sharp penknife, with which he whittled his distinctive figures—birds as well as animals, especially eagles, and sometimes humans—in sizes from a few inches up. This eagle has a wingspread of 35 inches.

George Washington in unusual materials. *Left:* life-size terra-cotta bust, found near Trenton, New Jersey, and believed to have been made in the vicinity in the early 1800's; height 26 inches. *Right:* tin bust, gilded; possibly made at the time of the Centennial Exposition, 1876; height 15½ inches.

Cigar-store Indian. Wood carving, painted in polychrome (c. 1880). This bust, with its handsome eagle head-dress, is much rarer than the full-length Indian figures; used probably as an over-door or on-the-counter trade sign. Height 28 inches.

Christopher Columbus (c.1855). Carved wood figure, originally painted and gilded, which once rode on a circus wagon. Height 58½ inches.

Goose in flight. Weathervane (nineteenth century). Body carved of laminated wood; feet and wings of wood, carved separately; tail of tin; remnants of gray and white paint, with black head and yellow bill. Length 84 inches.

Butterfly. Weathervane (late nineteenth century). Sheet copper cut in silhouette, hammered and pierced to suggest color pattern; mounted on horizontal and vertical rods. Height 19 inches.

Centaur. Weathervane (nineteenth century). Made up of two sheets of copper, hammered in the quarter round and soldered together; bow and arrow and tail in flat silhouette. Originally covered with gold leaf, now coated with verdigris. Found near New Haven, Connecticut. Length 37 inches.

Mermaid. Weathervane, carved of one piece of pine, with separate arms and metal mirror. Combing her flowing tresses and gazing forever into her glass, this mermaid originally floated over a barn in Wayland, Massachusetts. Length 52 inches.

Lion. Carrousel figure (detail), one of forty wooden animals which make up the full complement of a merry-go-round to be installed at Shelburne. Found in upstate New York, the figures are believed to have been carved for a carrousel made for the Centennial celebration in 1876.

Havre de Grace swan. Decoy, carved of wood by Samuel T. Barnes, a well-known gunner and decoy maker of Havre de Grace (c. 1890). From the collection of Joel Barber, who referred to it in his book *Wild Fowl Decoys* as the "superb and incomparable wild swan." Exhibited at the Brussels world's fair, 1958. Length 25½ inches.

Design in decoys: a rare crane (*center*) and a sea gull (*right foreground*), equally rare.
The long-legged shore birds, pintail duck (*left*), and canvasback are part of the Barber collection.

The paintings

THE COLLECTION OF PAINTINGS at Shelburne started with American primitives—counterparts in paint of the folk sculpture in wood and metal. It has grown beyond those limits, however, to include academic works as well, and to cover a long period. Significant artists from John Singleton Copley to Winslow Homer are already represented, and additions continue to be made. In time this collection, housed in a new, well-equipped art gallery, will provide a cross section of American painting in all its aspects through the eighteenth, nineteenth, and twentieth centuries.

Portrait of John Scollay (1712-1790),
painted about 1760 in Boston
by John Singleton Copley (1738-1815).
(See Parker and Wheeler,
John Singleton Copley, American Portraits,
p. 178 and pl. 22).

John Couenhoven. Pastel on paper by John Mare, inscribed on back *John Mare, pinxt, 1774.* Born in New York in 1739, Mare is known to have painted portraits in oil in New York, Albany, and Boston between 1760 and 1774. No other pastel from his hand has thus far been recorded.

Portrait in oil on canvas attributed to John Durand (ac. 1766-1782). Inscribed on back of canvas, *1766 18 years.* The subject is believed to be Elizabeth Bancker, first wife of Samuel Blachley Webb.

John B. de Peyster. Charles Willson Peale painted two portraits of his second wife's brother, this one apparently in New York June 6-17, 1792. The other is in the New-York Historical Society. (See Charles Coleman Sellers, *Portraits and Miniatures by Charles Willson Peale,* No. 206.)

Lady with black lace cape (c. 1800), attributed to William Jennys. In original frame, painted red with gilded molding.

Demaris Leeds (Mrs. David Leeds). Pastel on paper mounted on canvas (early 1800's). Unidentified artist.

David Leeds of Mystic, Connecticut. Pastel on paper mounted on canvas (early 1800's). This and the companion portrait are in their original black-painted frames.

Almira Dodge Bassett (1802-1838).
This and the companion portrait (c. 1830) attributed
to Erastus Salisbury Field (1805-1900).

Joseph Bassett (1801-1873)
of Lee, Massachusetts.

Red Jacket (c.1758-1830).
Oil on panel, painted about 1825-1830
by unidentified artist.
The Seneca chief is shown wearing the
silver peace medal given him by Washington.

Lion in landscape. Inscribed *Executed with
the pen By A. J. Taylor* and dated *Aug.
1855.* Calligraphic drawing of unusual
vigor, in black ink with touches of red at
mouth and blue at eye, on paper glazed
with a wash.

The edict of William the Testy against tobacco. Oil on canvas by John Quidor (1801-1881), illustrating an episode in Washington Irving's *Knickerbocker's History of New York:* "William the Testy" was William Kieft, Dutch governor of New Netherland, whose arbitrary rule included prohibition of smoking in the colony.

Winter Scene (1841), by Thomas Birch (1779-1851).

Still life with peeled orange (1852). Oil on canvas by Severin Roesen (?-c. 1871), who came to America from Germany about 1848. Signed and dated in lower left corner.

303

Other collections

In the Hat and Fragrance Unit, which houses some of the most feminine objects in the museum, is the outstanding collection of textiles. There are examples of crewelwork, blue-resist, and printed cottons, wool-on-wool coverlets, samplers, and a brilliant display of quilts including appliqué, pieced, and all-white specimens. Here too is the rug collection, whose rare examples in needlework include one in fine crewels and one in silk, and an outstanding group in the hooked technique. Another display shows the colorful bandboxes used for women's hats and bonnets in the 1800's, some intact and some cut open and spread flat to show the full pattern of their block-printed paper coverings.

Finest of the American crewelwork is this early eighteenth-century bedspread, colorful, well composed, and exquisitely worked in a variety of stitches. The design is more intricate than was usual in America, though still not so compact as in much English work.

Among the many hooked rug designs is this engaging lion, worked in tawny shades against a butternut brown. The initials *JJ* are faintly discernible at the left. The rug is believed to have been made in New England about 1830.

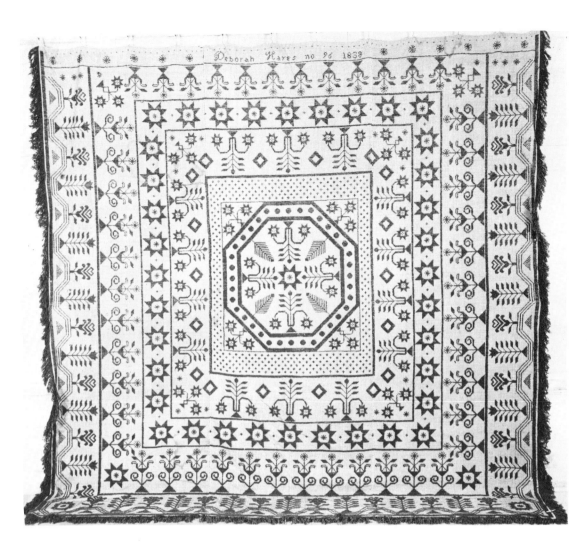

Handwoven bedspread, 1838. The date and *Deborah Hayes no 96* are woven in top border; another example in the same pattern, with owner's name, *no 177*, and date *1859*, has also the initials *HW*, probably those of the professional weaver. Made in three strips, natural color with woven loop design (*boutonné*) in green wool, fashioned by looping yarn over a rod or reed. Size, 97 by 103 inches; 3-inch wool fringe on three sides.

Many of the bandboxes at Shelburne bear the label of Hannah Davis (1784-1863) of Jaffrey, New Hampshire, one of the few makers of whom anything is known. She invented a machine for cutting a spruce log into slices one eighth of an inch thick, and these she bent for the oval sides of box and lid. Bottom and top were of pine. The outside was covered with block-printed paper, the inside lined with newspaper. Dates of the newspapers, which give a clue to the dates of the boxes, range from 1825 to 1855. "Aunt Hannah" began disposing of her wares by barter, then sold them to local merchants, and finally took to driving a load of boxes periodically to sell to girls working in the textile mills at Lowell, Nashua, and Manchester. *Right:* Bandbox by Hannah Davis, c. 1825; paper covering printed in red, white, and green varnish on blue ground; duck shooting scene; depth 16 inches. *Below:* Davis bandbox, c. 1840; fruit-basket design in yellow, pale green, and white on unusual brown ground; depth 15 inches.

305

Greatest rarity in the collection is the pair of Chelsea porcelain tureens in the form of life-size swans (English, c. 1755). Probably a unique pair, superbly and accurately modeled to represent the mute swan; feathers white with tufts of grayish-pink, indicating birds not yet fully grown. Large red-anchor mark on base of one. Sage-green leaves and a few blossoms are painted inside the tureens. (ANTIQUES, June 1954, p. 464.) Height of male (cob), 18¾ inches; height of female (pen), 11¾ inches.

BESIDES THE POTTERY AND PORCELAIN appropriately placed in the furnished houses, ceramics are exhibited in the Variety Unit at Shelburne. They include transfer-printed Staffordshire and Liverpool, luster, spatter and gaudy Dutch ware, Rockingham glaze, English creamware and delft, jasperware and a colorful group of toby jugs. There are minature tea services in English earthenware and China-trade porcelain, and, for contrast, mammoth creamware pitchers over two feet tall which were used as trade signs.

Toby jug, attributed to Thomas Whieldon, Staffordshire, c. 1760. Translucent glaze in rich brown tortoise shell and yellow. Model called *The Squire*, with brimming jug and no pipe. Height 10½ inches.

English delft two-handled posset pots with high domed covers and floral decoration in blue, a rare pair (late 1600's). Such pots were used for a drink consisting basically of milk and gruel curdled with wine, though there are many variants of the recipe in old cookbooks; this form became obsolete in the eighteenth century and was replaced by the punch bowl.

THE DOLLS AND TOYS at Shelburne are, appropriately, exhibited in the Variety Unit. There are dolls of all sizes, ages, and materials—bisque, china, and papier-mâché dolls, wax dolls, wooden dolls, shell dolls. There are amusing peddler dolls and amazing automata, and enchanting doll houses too. The toy collection is even more varied, ranging from home-made wooden playthings to penny banks and mechanical vehicles of iron and tin, and culminating in a gorgeously complete electric train that visitors may see in operation.

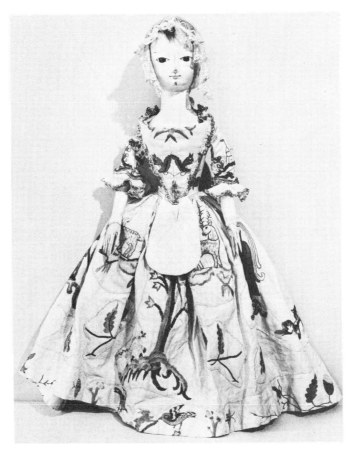

Queen Anne wooden doll, English, early 1700's. Head and neck glazed white; black hair and eyes. Dress of white muslin embroidered in silk in crewelwork designs; knitted stockings; two cotton petticoats; lace cap. Height 22½ inches.

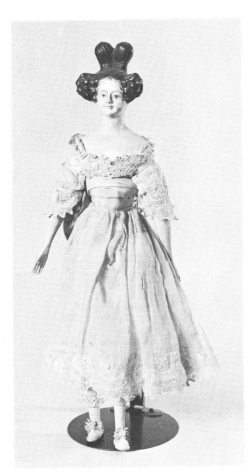

Papier-mâché doll, English, c. 1810. Head of papier-mâché with hair in elaborate "Apollo knot"; kid body; wood arms, hands, and legs. Dress of embroidered white mull; pink satin sash; pink kid shoes. Height 15 inches.

Peddler doll, English, c. 1800. Wax face and hands. In his basket this little peddler displays an extraordinary variety of minute wares: bottles, books, sheet music, bellows, pocketknife, mirrors, watch. Height 9 inches.

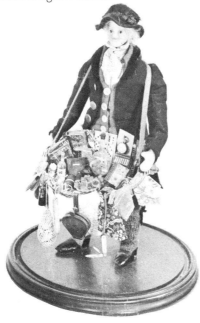

Automaton, French, c. 1860-1870. The gaily dressed clown dances atop the papier-mâché globe as the music plays. Height 45½ inches.

307

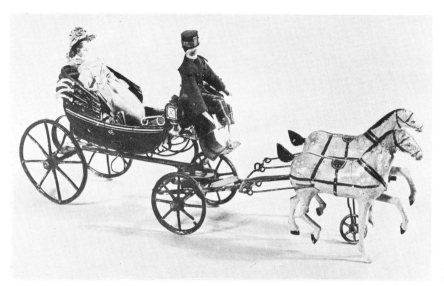

Toy calèche drawn by white horses, French, late 1800's. The tin formal carriage is painted brown and white. Both lady and coachman are fashionably dressed. Length, 10¾ inches.

ALMOST OVERNIGHT horse-drawn vehicles became obsolete, and products of the coachmaker's art that yesterday were commonplaces are today museum pieces. The great collection of these displayed in the big Horseshoe Barn at Shelburne shows the remarkable variety of carriages and sleighs of the latter nineteenth century, some of which were most skillfully built and richly appointed, and it also includes representative farm and commercial wagons of types now forgotten. Here the benighted twentieth-century visitor may learn the difference between a brougham and a landau, a curricle and a cutter, and he may also see a stagecoach, a dog cart, an Irish jaunting car, or a one-horse chaise.

Driving cutter; a light, graceful sleigh made by the French Carriage Company of Boston in the late 1800's. Gilt striping lightens the effect of the dark olive-green body. The curved ironwork bracing is both functional and ornamental.

George IV phaeton, built for Mrs. W. Seward Webb about 1882 by Brewster and Company of New York. A graceful vehicle, and flattering to the occupants; considered the most distinguished for ladies to drive in the park.

Formal coach, late 1800's. The coach form—a closed body with doors and separate driver's seat in front—dates from the sixteenth century. Improvements made in England in the early 1800's culminated in an elliptical spring to support the body and made the coach a lighter, shorter, easier-riding vehicle. The formal or dress coach carried four persons inside, and was drawn by two, four, or six horses.

How to see the museums

THOUGH THE FOLLOWING INFORMATION is correct at date of publication, it is subject to change, and prospective visitors are advised to make inquiries in advance. All the museums listed charge an admission fee.

THE HENRY FRANCIS DU PONT WINTERTHUR MUSEUM (Winterthur, Delaware). Open Tuesdays through Saturdays. *Regular tours* (except April 15–June 1): full-day tour of entire museum; half-day tours, morning or afternoon, with approximately half the museum shown on each; advance appointment necessary; write Reservations Office, Winterthur Museum, Winterthur, Delaware. *Special short tour:* some twelve recently installed rooms and exhibition areas; no advance appointment necessary. *Museum-Garden Tour* (last week of April through first four weeks of May): twenty of the museum's most important rooms and Mr. du Pont's gardens open without advance appointment; gardens only open Sunday afternoons. Museum closed New Year's Day, February 22, May 30, Thanksgiving, Christmas, and first two weeks of July.

COLONIAL WILLIAMSBURG (Williamsburg, Virginia). Exhibition buildings open daily except Christmas. April through October, 9 to 5; November through March, 10 to 5. Single or combination tickets; rates for students, military, and children.

OLD STURBRIDGE VILLAGE (Sturbridge, Massachusetts). Open daily April 1–December 1, 9:30 to 5:30. Open Saturdays and Sundays, December 1–April 1; also Christmas week and Washington's Birthday week. Closed Christmas Day and New Year's Day. Guided tours may be arranged for weekdays during winter months. Rates for students, children, and groups.

THE HENRY FORD MUSEUM AND GREENFIELD VILLAGE (Dearborn, Michigan). Open daily; 9 to 6:30, June 15 through Labor Day; 9 to 5 the rest of the year. Separate tickets for Museum and Village; rates for children and groups.

THE NEW YORK STATE HISTORICAL ASSOCIATION (Cooperstown, New York). Farmer's Museum open daily May 1–October 31, 9 to 6; Village Crossroads open daily except Monday, 9 to 5, the rest of the year as well. Fenimore House open daily May 1–October 31, 9 to 6; November 1–April 30, 9 to 5. Museums closed Thanksgiving, Christmas, and New Year's Day. Single or combination tickets; rates for children.

DEERFIELD (Deerfield, Massachusetts). Six exhibition buildings open weekdays May 1–November 30, 9:30 to 12; 1:30 to 4:30; Sundays, 1:30 to 4:30. Single or combination ticket. Memorial Hall open Monday, Wednesday, Saturday, 9:30 to 12, 2 to 5; Tuesday, 10 to 12, 2 to 4; Sunday, 2 to 5.

THE SHELBURNE MUSEUM (Shelburne, Vermont). Open daily May 25–October 20, 9 to 5; July and August, 9 to 6.

Chronology of crafts

Artists, artisans, and antiques in their historical setting

BY HELEN COMSTOCK

	EVENTS	ARCHITECTURE	FURNITURE	SILVER
1600– 1625	JAMES I, 1603–25; LOUIS XIII, 1610–42. English settlers come to Jamestown, Plymouth, N. H. Dutch at New Amsterdam, French at Quebec. Tobacco and cotton grown in Va. Negro slaves brought to Va. Captain John Smith's *The Generall Historie of Virginia, New-England* ..., 1624.	ENGLAND: EARLY STUART, PALLADIAN STYLE; symmetrical façades. Introduced by Inigo Jones in Queen's House, Greenwich, begun 1616. Based on work of Italian Renaissance architect Andrea Palladio.	ENGLAND: 1600, JACOBEAN STYLE. Oak. Turning, joining, paneling. Chest; court, press cupboards; draw, joined tables; joined stools; wainscot, turned chairs.	ENGLAND: 1600, EARLY STUART (JAMES I). Late Renaissance forms motifs; German influence. Beaker, ewer, rosewater dish; cylindrical flagon; bell, standing, trencher salts steeple cup; cylindrical tankard spreading base; wine cup, baluster stem; slip-end, knopped spoons; fig-shape bowl. Relief decoration, fruit flowers, masks; engraved strapwork scrolls; fluting; chasing.
1625– 1650	CHARLES I, 1625–49; LOUIS XIII. Settlements in Conn., Md., R.I., Del., N.J. and Pa. (Swedes). Harvard College founded. Local post office in Mass.; law requires supervision of schooling and apprenticeship in Mass. Stephen Daye Press, Cambridge, prints *Bay Psalm Book.*	AMERICA: New England clapboard-covered frame house developed from Elizabethan half-timbered: Fairbanks House, Dedham, Mass. Dutch shingled houses on Long Island and in Conn. Brick used in the south: Adam Thoroughgood House, Va. Log cabin introduced by Swedes in Del. ENGLAND: Jones introduces box-like type of country house, large interior wall panels.	AMERICA: JACOBEAN STYLE. Oak and pine. Forms as in England; Brewster, Carver chairs; trestle table. ENGLAND: JACOBEAN STYLE.	ENGLAND: 1625, EARLY STUART (CHARLES I). "Puritan" silver: Little applied decoration. Spoon bowl oval standing salt, scrolls on rim; flat-top tankard.

THE CHART ON THESE PAGES correlates a great deal of information about antiques on a chronological basis. Reading it horizontally, one can see at a glance what styles were current, what monarchs were reigning, and what was going on in each of several crafts in any given quarter-century between 1600 and 1825. Reading it vertically, one can trace the development of styles, techniques, designers, and artisans in a single craft over the entire period.

In compressing so much information into so small a space many short cuts were necessary, and selections and omissions had to be made quite arbitrarily. The chart as a whole is focused on American antiques—the kind of things shown in the museums represented in this book. Pertinent data are included, where space permits, regarding the English arts, to which the American are most closely related, and in some fields regarding those of the Continent. The *Events* cited are convenient historical milestones, not only political but cultural.

All dates are given without that useful and important little prefix *circa*, but most of them should be understood to be approximate rather than exact. Styles are named at approximately the years when they first appeared; it should be remembered that they continued long enough to overlap those that followed. The same is true of new forms, decorative details, and techniques, which are named only at the time they became significant. Craftsmen's life or working dates are usually omitted but their names are listed in the quarter-centuries of their major activity; the dates of most are available in standard works of reference.

OTHER METALS	CERAMICS	GLASS	PAINTINGS & PRINTS	
AMERICA: IRON: 1621–22, ironworks at Falling Creek, Va. ENGLAND: BRASS: lantern clock; many items in latten (sheet brass, largely imported from Flanders). IRON: firebacks, armorial designs; rushlight holders; steel knives, Sheffield. PEWTER: tapering flagon; bellbase, mid-drip candlestick; slip-end (slipped in the stalk) spoon.	ENGLAND: *Delftware* (generic term for English and Dutch tin-glazed earthenware): Aldgate from 1571; Southwark probably 1620–25. HOLLAND: *Delftware:* made since 16th cent.; at Delft only after 1600.	AMERICA: Glass made at Jamestown, 1608. CONTINENT: FRANCE: *Verre de Nevers* (small glass figures and toys) made at Nevers. GERMANY & NETHERLANDS: *Waldglas* (humpen, römer, passglas); raspberry prunts; enameling, engraving, *façon de Venise.* Cutting, engraving: Caspar Lehman, Georg Schwanhardt, at Prague, after 1622 at Nuremburg. VENICE: foremost glass producer of Europe. Colored, clear, milk glass; gilding, enamel "jeweling," threading, latticinio, engraving, applied decoration, elaborate stems. Antonio Neri's *L'Arte Vetraria,* 1612. ENGLAND: *"Venetian" (soda) glass, diamond-point engraving:* Verzelini 1575 patent taken over by Bowes. Sir Robert Mansell's patent, 1623.	AMERICA: Champlain, *Voyages,* 1613. John Smith, *Description of New England,* 1616, map of N.E.	**1600–1625**
AMERICA: PEWTER: *Salem:* Richard Graves, pewterer, recorded 1635. ENGLAND: PEWTER: cylindrical flagon, spreading foot, finial.	AMERICA: *Lead-glaze earthenware:* at Jamestown, Va., from 1625. *Redware* in N.E.: William Vincent (Vinson) and John Pride, Salem; Philip Drinker, Boston. FRANCE: *Faïence* (French tin-glaze earthenware): Nevers & Rouen before 1650.	AMERICA: Glass made at Salem, Mass., 1641. ENGLAND: Glass-Sellers' Co. chartered, 1635. Glaziers & Painters of Glass chartered, 1638.	AMERICA: Hartgers view of New York, 1626. ENGLAND: Van Dyck court painter to Charles I, 1632–41; Samuel Cooper, miniaturist.	**1625–1650**

EVENTS	ARCHITECTURE	FURNITURE	SILVER
1650–1675 COMMONWEALTH, 1649–59 (Oliver Cromwell, 1653–58); CHARLES II, 1660–84; LOUIS XIV, 1661–1715. N. C. and S. C. settled, New Netherland surrenders to British. Tea drinking introduced in England. *The Tenth Muse* by Anne Bradstreet, New England poet. Judge Samuel Sewall, Boston, begins his *Diary*. Navigation Acts put limits on colonial trade.	AMERICA: Frame "salt box" in New England, pine sheathing on interior walls: Scotch-Boardman House, Saugus, Mass. Dutch brick and stone buildings in N.Y. and Middle Colonies: Van Alen House, Kinderhook, N.Y. Bacon's Castle in Va., Tudor Gothic style. ENGLAND: LATE STUART, Dutch influence: pedimented façade. Sash windows introduced, not general until early 1700's. Eltham Lodge.	AMERICA: JACOBEAN STYLE. ENGLAND: 1650, CROMWELLIAN (COMMONWEALTH) STYLE; 1660, CAROLEAN (RESTORATION) STYLE. Walnut; Oriental lacquer; beech, painted. Marquetry. Chest of drawers; gateleg table; tall-case clock; 1670's upholstered wing chair.	AMERICA: STUART ("PURITAN"). *Boston:* John Hull & Robert Sanderson (Hull mint master of Bay Colony, 1652). ENGLAND: 1650, COMMONWEALTH. Much domestic silver melted down. 1660, LATE STUART (RESTORATION). Dutch influence. Gourd-shape caudle cup; caster; tea, coffee, chocolate pots; punch bowl; monteith; sugar box; tapered cylindrical tankard; circular-foot salver. Matted ornament; floral embossing; engraved chinoiserie.
1675–1700 JAMES II, 1684–88; WILLIAM AND MARY, 1689–94; WILLIAM III, 1694–1702; LOUIS XIV. La Salle explores Mississippi and names valley Louisiana. Rice planted in S. C. Bacon's Rebellion in Va. Increase Mather, *Brief History of the War with the Indians*, 1676; Burke and Howe, *The New England Primer*, 1690. Cotton Mather, *Memorable Providences Relating to Witchcrafts and Possessions*, 1689. Witchcraft superstition in New England. William Penn comes to Philadelphia, 1682. Rittenhouse establishes paper mill near Germantown. William and Mary College founded. Triangular slave trade develops between New England and West Indies. Revocation of the Edict of Nantes, 1685; Huguenots flee France. Palatine Germans settle in Pa.	AMERICA: William and Mary College, Va. (style of Wren). Senate house, Kingston, N.Y.: stone walls, gabled roof, Dutch style. Jethro Coffin House, Nantucket—"Cape Cod house" (one-story salt box). Old Ship Meeting House, Hingham, Mass. ENGLAND: BAROQUE STYLE based on 17th-cent. Italian architecture: twisted columns, broken pediments, curved entablatures. Greenwich Hospital, Christopher Wren. London churches by Wren after great fire in 1666 a blend of baroque and classical: St. Paul's. Grinling Gibbons, wood carver.	AMERICA: JACOBEAN STYLE. 1680's, maple. Hartford, Hadley chests; butterfly, stretcher tables; chest of drawers. Ball, vase-and-ring turnings. *Hartford:* Nicholas Disbrowe. *Ipswich:* Thomas Dennis. ENGLAND: CAROLEAN STYLE. English lacquer; Stalker and Parker, *Treatise*, 1688. 1690, WILLIAM AND MARY STYLE. Dutch influence: Flemish scroll; ball, bun, Spanish foot; cup, trumpet turnings. Daniel Marot, designer, 1662–1752, in England 1694–98.	AMERICA: STUART; 1685, WILLIAM AND MARY STYLE. Beaker; caudle cup; standing cup; sugar box; flat-top, tapering cylindrical tankard. Repoussage; engraving; gadrooning; cast details. *Boston:* Hull & Sanderson; John Coney; Jeremiah Dummer; Timothy Dwight; Edward Winslow. *N.Y.:* Jurian Blanck; Jacob Boelen; Jesse Kip; Bartholomew LeRoux; Gerrit Onckelbag; Cornelis van der Burgh; Jacobus van der Spiegel. *Philadelphia:* Cesar Ghiselin; Johannis Nys. ENGLAND: LATE STUART; 1685, WILLIAM AND MARY. Fluting, gadrooning. French influence; immigration of Huguenot smiths (*e.g.* Pierre Harrache, Pierre Platel). 1697, Britannia Standard enforced.
1700–1725 WILLIAM III; QUEEN ANNE, 1702–14; GEORGE I, 1714–28; LOUIS XV, 1715–74; REGENCY OF DUKE OF ORLÉANS, 1715–23. Detroit and New Orleans founded by French. Queen Anne's War, 1701–13, involves New England (Deerfield Massacre), N.Y., S.C., ends in Peace of Utrecht; England gains Nova Scotia and Newfoundland. Offshore and distant whaling begins. Yale founded. Madame Sarah Knight's *Journal* of trip from Boston to New York, 1704. *The Boston News-Letter*, *American Weekly Mercurie*, Philadelphia, established. Addison's *Spectator*, London. Age of the Grand Tour. Bursting of the "Mississippi Bubble."	AMERICA: Interiors more elaborate: raised and fielded panels, stiles and rails, bolection moldings on fireplace. Style of Wren: Old North Church, Boston; Governor's Palace, Williamsburg, Va. William Trent House, Trenton, N.J. (Queen Anne). ENGLAND: BAROQUE replaced by PALLADIAN REVIVAL of Lord Burlington and his followers, Colen Campbell and William Kent, architect, designer. Campbell, *Vitruvius Britannicus*, 1716. Leoni edition of Palladio, 1715. PALLADIAN: Burlington House (1717), and Chiswick (1720). BAROQUE: Blenheim (1705) by John Vanburgh. James Gibbs continues style of Wren.	AMERICA: 1700, WILLIAM AND MARY STYLE. Walnut. Highboy; lowboy; desk-on-frame; slate-top table. Trumpet turnings; Spanish foot. Painted decoration, scenic and floral. *Boston:* Nehemiah Partridge; William Randle (japanners). *Portsmouth:* John Gaines. ENGLAND: 1700, QUEEN ANNE STYLE. Walnut. Card, dressing, side, tea, tilt-top, tripod tables; pier glass; knee-hole desk; hoop-back chair; secretary. Cabriole leg, pad foot; bracket foot; domed pediment; vase splat, yoke crest. Veneer; carving. 1715, EARLY GEORGIAN. Walnut. Lower chair back, pierced splat; cabriole leg, claw-and-ball foot. Carving. 1721, repeal of duty on mahogany.	AMERICA: 1700, WILLIAM AND MARY STYLE continued by 17th-cent. silversmiths. Standing salt; punch bowl; monteith; sugar box; trumpet-foot salver. Gadrooning; fluting; embossing; castings. 1715, QUEEN ANNE STYLE. Pear-shape teapot, coffeepot, creamer; globular teapot; porringer; trencher salt; chocolate pot; chafing dish; bell-shape cup; grace cup. Engraving; cut-card work. *Boston:* John Allen; John Burt; William Cowell; John Edwards; John Noyes. *N.Y.:* Cornelius Kierstede; Charles LeRoux; Bartholomew Schaats; Simeon Soumain; Peter van Dyck; Benjamin Wynkoop. *Newport:* Samuel Vernon. *Philadelphia:* Francis Richardson; Philip Syng Sr. ENGLAND: 1700, QUEEN ANNE STYLE. Cylindrical coffeepot; globular teapot; tea caddy; teakettle-on-stand; domed-lid tankard; cruet frame; two-handled cup and cover; wavy-end spoon. Engraving; gadrooning; cut-card work. 1720, Britannia Standard abandoned. Guillim, *Display of Heraldry*, 6th ed. 1724. *London:* Paul de Lamerie, first mark 1712; Augustin Courtauld; Harrache; Louis Metayer; Anthony Nelme; Simon Pantin, Platel.

OTHER METALS	CERAMICS	GLASS	PAINTINGS & PRINTS	
ENGLAND: BRASS: concave-foot, knopped candlestick; Dutch-type chandelier, baluster shaft. 1658, pendulum clock by Fromanteel. 1660, English importation of Flemish latten prohibited. IRON: pictorial firebacks, superseding armorial. PEWTER: triple-reed rimmed plate; oval-bowl, trifid-end spoon; square-pillar candlestick.	ENGLAND: *Delft forms:* posset pot & cover, dated wine bottle, blue-dash charger, political subjects, Merryman plates. *Delft:* Bristol, nearby Brislington, & Lambeth. *Slipware:* Thomas Toft (d. 1689), Staffordshire. John Dwight's *Fulham stoneware:* Middlesex, 1671. FRANCE: *Faïence:* St. Cloud patent, 1664.	AMERICA: Glass made in New Amsterdam. CONTINENT: *Tall goblets,* multi-collared stems: Georg Schwanhardt and sons, Nuremburg. *Opaque enamel* most popular German decoration. ENGLAND: *L'Arte Vetraria* translated, 1662. Duke of Buckingham's plate glass factory, Vauxhall, 1663. John Greene's drawings sent to Venice, 1670. *Flint (lead) glass:* George Ravenscroft's Savoy factory, 1673.	AMERICA: *Portrait of Richard Mather,* American engraving by John Foster, 1670. *New England:* Mason and Gibbs family portraits; Freake family portraits. ENGLAND: Wenceslaus Hollar, London engraver.	**1650–1675**
AMERICA: IRON: 1685, Ironworks at Saugus, Mass. PEWTER: *Boston:* Dolbeare family, 1671. *Chuckatuck, Va.:* Joseph Copeland (marked spoon dated 1675). ENGLAND: BRASS: latten improved. 1680's, "Prince's metal" (brass alloy) used for ornamental castings. 1690's, brass casting techniques improved. Candlesticks cast in separate hollow halves; no drip pan, saucer on socket, baluster stem. 1690's, Dutch-type andirons; baluster shaft, urn or flame finial; brass or steel on iron base. PEWTER: round-pillar candlestick; capstan salt; flat-top tankard. Engraving; wriggle work.	AMERICA: *Stoneware* made in N.Y. and Pa. before 1700. Earliest potter whose name and work are known: James Kettle (Kettell), Danvers, Mass., 1687–1710. *Delft:* Dr. Daniel Coxe, Burlington, N.J. ENGLAND: *Red stoneware* by Elers. FRANCE: *Faïence:* Moustiers. *Soft paste* (clay & glass or frit): Poterat at Rouen.	AMERICA: Glass made at Philadelphia, 1683. CONTINENT: BOHEMIA: *cut glass,* intaglio or relief. GERMANY: *ruby glass,* Johann Kunckel, Brandenburg. VENICE: glass-making declines. ENGLAND: New forms in tableware; wine glass with solid *baluster stem; coin knop. Crizzled glass* (excessive alkali in early Ravenscroft formula). *Sealed glasses* bearing maker's mark or seal, as raven's head for Ravenscroft. *Verre églomisé* used in looking-glass frames.	AMERICA: *Portrait painters:* Capt. Thomas Smith, New England; Gerrit Duyckinck, N.Y.; early Va. portraits. ENGLAND: Kneller court painter from James II to George I.	**1675–1700**
AMERICA: BRASS: *Philadelphia:* Caspar Wistar (cast brass), 1717. PEWTER: *N.Y.:* Francis Bassett I; John Bassett I; Joseph Leddel Sr. *Philadelphia:* William Cox; Simon Edgell. ENGLAND: BRASS: baluster-stem candlestick, round or octagonal base; andirons, baluster form; BRASS, STEEL fenders, pierced and engraved; 1720's, arched clock dials. IRON: firebacks show Dutch influence in design, thinner construction. PEWTER: two-handled covered cup; baluster measure, volute thumbpiece; Scottish pot-belly measure; acorn flagon; domed-top cylindrical tankard; mid-band on tankard.	*China-trade porcelain:* including armorial, exported to Europe. AMERICA: *Dutch tiles* advertised in Boston, 1716. ENGLAND: *Delft:* begins to show Chinese influence. Blue, purple, red, and green used; sponged decoration. Liverpool, 1710. *Staffordshire:* lead-glaze earthenware with trailed slip; combed ware; brown stoneware; sgraffito; salt glaze (thin white stoneware with calcined flint), "scratch-blue" decoration. Superior *stoneware:* Nottingham. FRANCE: *Faïence:* Marseilles, 1700; Strasbourg, 1721. *Soft paste:* St. Cloud, patent 1702. GERMANY: *Dresden:* Böttger (d. 1719) red stoneware 1708–19; 1709, Böttger produces first European hard paste; 1710, *Meissen* founded, under Böttger, Herold director, 1720 (chinoiserie decoration). *Hard paste:* Vienna, Du Paquier patent 1718.	AMERICA: No record, but *bottle* and *window glass* probably made at glass-houses established earlier. CONTINENT: Bohemia takes lead in production of fine glass; enameling. *Wheel engraving:* Bavaria, Brandenburg, Silesia. G. F. Killinger, Nuremburg engraver. ENGLAND: Heavy, dark, "oily" flint glass with increased ratio of lead. *Goblets:* heavy baluster knopped stem, "tears." *Other forms:* monteith; punch bowl; cordial glass; dram glass; decanter.	AMERICA: Schuyler family portraits, Hudson Valley, 1700–10. John Emmons, 1704–40, Boston, American-born painter. Henrietta Johnson, pastellist, settles in Charleston, S. C.; Justus Engelhardt Kühn, Annapolis; Gustavus Hesselius, Philadelphia; John Watson, Perth Amboy. *Engravings: New York,* William Burgis, 1716–17; eng. 1719–21; *Bonner Map of Boston,* eng. by Dewing, Boston, 1722; *View of Boston,* Burgis, London, 1723. *Paintings:* Portrait of Elsje Vas, Pieter Vanderlyn, 1723. *East Prospect of the City of Philadelphia,* 1718–20, oil by Peter Cooper. ENGLAND: Kneller continues portrait painting. John Wootton, sporting painter.	**1700–1725**

1725–1750

EVENTS

GEORGE I; GEORGE II, 1727–60; LOUIS XV.

Settlement at Oglethorpe, Ga. Paper mill in Mass. First stage between Boston and New York. Religious community at Ephrata, Pa.; paper mill and printing press there. Moravians at Bethlehem, Pa. Benjamin Franklin establishes public library, Philadelphia; American Philosophic Society; *Poor Richard's Almanack*, 1732; fire insurance company. Series of wars between Spain, France, England involve colonies and West Indies. Dr. Alexander Hamilton, *Itinerarium*, 1744, trip from Annapolis to New England. Indigo grown in Carolina. Ruins at Herculaneum and Pompeii stimulate revival of classic art in Europe and England.

ARCHITECTURE

AMERICA: EARLY GEORGIAN, a modified PALLADIAN: sash windows, carved wood paneling, architectural overmantels, paint and plaster, wood graining and marbleizing. Stenton, Germantown, Pa.; Westover, Va.; Royall House, Medford, Mass.; Independence Hall, Philadelphia; Redwood Library and Old Colony House, by Peter Harrison, Newport, R.I.

ENGLAND: GEORGIAN country houses: stucco replaces wood paneling, velvet, damask, Chinese papers, painted scenic papers for wall covering. William Kent, *Designs of Inigo Jones*, 1727. James Gibbs, *A Book of Architecture*, 1728. Batty Langley, *The Builder's Jewel*, 1741. Romanticism in 1740's: Batty Langley's two books on "Gothick Mode," 1742 and 1747. Walpole's gothic Strawberry Hill, 1750. Rococo interior, Kirtlington Park.

FURNITURE

AMERICA: 1725, QUEEN ANNE STYLE. Walnut, maple, cherry, bilsted (gumwood); little mahogany before 1750. Slant-top desk; card, tea, tripod tables. Vase splat; cabriole leg; pad, slipper foot. Carving; painting; japanning. *Boston:* John Pimm. *Charleston:* Thomas Elfe. *Newport:* Job Townsend. *Philadelphia:* William Savery. *Portsmouth:* Gaines. Clockmakers: *Boston:* Benjamin Bagnall. *Newport:* William, Thomas Claggett. *Philadelphia:* Peter, Thomas Stretch.

ENGLAND: EARLY GEORGIAN. William Kent, designer. 1730, MID-GEORGIAN. Mahogany supplants walnut. Commode; bureau; console. Claw-and-ball, paw, ogee bracket foot; mask; shell. Carving; gilt gesso; parcel gilding. Matthias Lock, *New Drawing Book*, 1740, illustrating rococo details. 1740's, ROCOCO (CHIPPENDALE) STYLE, combining French, chinoiserie, Gothic elements. Thomas Chippendale, 1718–79.

SILVER

AMERICA: QUEEN ANNE STYLE continued by early 18th-cent. silversmiths. *Albany:* Jacob, Barent Ten Eyck. *Boston:* Jacob Hurd; Knight Leverett; John Potwine; Paul Revere Sr. *Conn.:* Kierstede; Potwine. *N.Y.:* Adrian Bancker; Henricus Boelen; Peter Quintard; Peter Vergereau. *Philadelphia:* Elias Boudinot; Philip Syng Jr.; William Vilant.

ENGLAND: QUEEN ANNE STYLE; 1730 EARLY GEORGIAN. Sympson, *New Book of Cyphers*, 1732. 1740, ROCOCO STYLE. Huguenot influence continues. Pear shape tea, coffee pots; bulbous tankard, domed lid; footed salt; sauce boat; epergne. Scrolls; dolphin; scallop shell; embossed chinoiserie; mythological figures. Engraving, piercing; cast details. *London:* Lamerie dominant; Peter Archambo; Courtauld; William Fawdery; Pantin. 1743, Sheffield plate invented by Thomas Boulsover.

1750–1775

EVENTS

GEORGE II; GEORGE III, 1760–1820; LOUIS XV; LOUIS XVI, 1774–89.

French and Indian War, 1756–63: Braddock's defeat, fall of Quebec to General Wolfe, war ends in Treaty of Paris. England gains Canada and territory to the Mississippi. Stamp Act unites colonial opposition to taxation without representation: Stamp Act Congress, Sons of Liberty, repeal of Stamp Act. Boston Massacre, Boston "Tea Party," First Continental Congress. Daniel Boone explores Ky. Fort Pitt at Pittsburgh. Survey of Mason-Dixon line. New calendar adopted (Gregorian) 1752. Franklin experiments with electricity; begins *Autobiography* [1771–89]. Royal Academy, London, founded. Theater in New York City. Princeton, Dartmouth, Columbia, Brown, University of Pa., Philadelphia Medical School. Shakers in New York.

ARCHITECTURE

AMERICA: MID-GEORGIAN: paneled doors, arched fanlight, balustraded roof, rustication, dado with wallpaper, broken pediments, rococo and Chinese motifs. Kenmore, Gunston Hall (William Buckland), Mount Airy, Va.; Tryon Palace, N.C.; Miles Brewton House, S.C.; Hammond-Harwood House, by Buckland, Md.; Mount Pleasant, Pa.; Jeremiah Lee House, Richard Derby House, Mass. First building at Monticello.

ENGLAND: Architectural books: Robert Morris, *Rural Architecture*, 1750; John and William Halfpenny, 1750–67; Robert Wood, *Ruins of Palmyra*, 1753; Isaac Ware, *A Complete Body of Architecture*, 1757; Abraham Swan, *Collection of Designs in Architecture*, 1757; William Chambers, *Designs of Chinese Buildings*, 1757; James Paine, *Plans . . . of Gentlemen's Houses*, 1787. Capability Brown creates natural parks for country houses. NEOCLASSICISM introduced by Robert Adam, architect, designer. Adam, *Ruins of Spalatro*, 1764; *Works in Architecture of Robert and James Adam*, 1773. James Stuart and Nicolas Revett, *Antiquities of Athens*, 1762. Syon House, Kedleston, Luton Hoo decorated by Adam.

FURNITURE

AMERICA: 1750, CHIPPENDALE STYLE. Mahogany, maple, cherry. Camel-back sofa; kettle stand; pembroke, piecrust tables. Cabriole leg; claw-and-ball, ogee bracket foot. Carving. *Boston:* John Cogswell; Benjamin Frothingham. *Charleston:* Elfe. *Conn.:* Benjamin Burnham; Eliphalet Chapin. *N.Y.:* Gilbert Ash; Thomas Burling; Joseph Cox; Samuel Prince. *Newport:* Job, John Townsend; John Goddard. *Pa.:* John Bachman II. *Philadelphia:* Thomas Affleck; Edward Duffield (clocks); John Elliott (mirrors); James Gillingham; Jonathan Gostelowe; Benjamin Randolph; Savery; Thomas Tufft.

ENGLAND: ROCOCO (CHIPPENDALE) STYLE. Mahogany. China, library, pembroke tables; breakfront; "ribband"-back chair. Cabriole leg, scroll toe. Gadrooning; fret carving. 1755–65, Vile and Cobb dominant. Design books: Lock and Copland, *New Book of Ornaments*, 1752; Edwards and Darly, *New . . . Chinese Designs*, 1754; Chippendale, *Director*, 1754, 1755, 1762; Johnson, *New Designs*, 1756–58; R. Dossie, *Handmaid to the Arts*, 1758; Ince and Mayhew, *Universal System*, 1759–63; Manwaring, *Cabinet and Chair Makers' . . . Companion*, 1765. 1765, LATE GEORGIAN: NEOCLASSIC STYLE; Adam influence (Robert Adam, 1728–92). Satinwood. Tapering leg. Inlay, carving; classical forms, motifs. Painted furniture, influenced by Angelica Kauffmann, Pergolesi. Lock, *Pier Frames* and *Foliage*, 1769, illustrating classic details.

SILVER

AMERICA: 1750, ROCOCO STYLE, adopted by many Queen Anne silversmiths. Pear and inverted-pear shapes; domed covers; scroll handles. C-scrolls; cast shells. Engraving; piercing. *Boston:* Zachariah Brigden; Benjamin Burt; John Coburn; Daniel Henchman; Benjamin Hurd; Samuel Minott; Paul Revere (Sons of Liberty bowl 1768). *N.Y.:* Cary Dunn; Daniel Christian Fueter; William Gilbert; Thomas Hammersley; John Heath; Myer Myers; Elias Pelletreau; Pieter de Riemer. *Philadelphia:* Daniel Dupuy; William Hollingshead; Edmund Milne; Joseph Richardson Sr.; Thomas Shields. *R.I.:* Samuel Casey.

ENGLAND: ROCOCO STYLE. *London:* John Cafe; William Cripps; William Grundy; Richard Gurney; Nicholas Sprimont; Edward Wakelin. 1760's, Sheffield plate developed by Joseph Hancock, Sheffield; by Matthew Boulton, John Fothergill, Birmingham. 1770, NEOCLASSIC STYLE; Adam influence. Urn shapes. Classical (Pompeiian) motifs; swags; husks; oval shields. Bright-cut engraving.

1725–1750

OTHER METALS

AMERICA: BRASS: native work advertised. *Salem:* Jeffrey Lang, 1736. IRON: 1740's, Franklin stove. PEWTER: *Boston:* John Carnes; David Cutler; Thomas Simpkins. *Conn.:* Thomas Danforth I. *N.Y.:* Peter Kirby; Joseph Leddel Jr. *Philadelphia.:* Thomas Byles.

ENGLAND: Improved techniques: 1725, George Moore patent for process of refining and purifying COPPER; 1728, Hawksbee-Lund patent further improves COPPER process; 1728, John Cook patents rolling machine for IRON, COPPER, BRASS. BRASS: chandeliers, gadrooned and fluted vase-shape stem replaces globe; hall lantern with glazed sides; lobed-foot candlestick. PEWTER: plates, narrower rims, double and triple reeding, wavy edge; sadware (flatware) cast and turned. JAPANNED TIN PLATE: developed in Wales at Pontypool, Monmouthshire, by Hanburys, Allgoods. *Birmingham:* John Baskerville, 1742.

CERAMICS

AMERICA: *Stoneware:* Crolius, John Remmey I, N.Y.; Adam Staats, N.J. Pa.-German dated *sgraffito ware. Porcelain:* Andrew Duché, 1738–43, Ga. *Redware:* many N.E. makers before 1750.

ENGLAND: *Delft forms:* tea ware, punch bowl, puzzle jug, "bricks"; powder grounds. *"Astbury-type"* earthenware: sprigged decoration, "image toys." *Delft:* Wincanton, 1737. *Salt glaze:* pew groups, molded, polychrome; Staffordshire. *Agateware, tortoise shell:* Thos. Whieldon at Fenton Low, 1740. *"Astbury-Whieldon"* wares. *Soft paste:* Chelsea, 1745; Bristol, 1748.

FRANCE: *Soft paste:* Chantilly, 1725; Mennecy-Villeroy, 1734; Vincennes, 1745.

GERMANY: *Hausmaler* decoration important to 1760. *Hard paste:* Höchst, 1746; Nymphenburg, 1747. Kändler at Meissen, 1731.

ITALY: *Soft paste:* Capo di Monte, 1743.

GLASS

AMERICA: Glasshouse recorded in N.Y., 1732. Caspar Wistar, South Jersey, 1739: *lily-pad* technique.

CONTINENT: *Diamond-point engraving:* Frans Greenwood, Rotterdam.

ENGLAND: Molded, four-sided, or polygonal wine-glass stems. *Wheel engraving, cutting,* and *diamond-point engraving* brought from Germany with Hanoverians. *Forms:* ratafia (cordial glass); champagne glass; onion-shape decanter; syllabub, sweetmeat glass; "pyramid." "Drawn-," air-, enamel-twist stem; *wheel-engraved "flower'd glass." Newcastle glass. Jacobite,* including *Amen* glasses. *Cut-glass chandeliers,* form based on brass examples; *candelabra; sconces.* Excise by weight, 1745, leads to lighter glass.

PAINTINGS & PRINTS

AMERICA: Peter Pelham, mezzotint-engr., Boston; Gustavus Hesselius, Pa., Del., Md., Va.; John Smibert, Boston; Jeremiah Theus, Charleston; Robert Feke, Newport, Boston, Philadelphia; Joseph Badger, New England; John Greenwood; William Dering, Va. Mark Catesby, *Natural History of the Carolinas,* 1731–43; Carwitham views of *Boston, New York, Philadelphia,* 1731–36; Roberts, *View of Charleston,* 1739; *Bodleian Plate,* Williamsburg bldgs., 1740; *View of Yale,* 1749, by Johnston after Greenwood.

ENGLAND: William Hogarth completes apprenticeship as engraver, 1728; period of the conversation piece, 1730–40's: Marcellus Laroon, Gawen Hamilton, Hogarth, Arthur Devis, Charles Phillips. Thomas Gainsborough active by late 1740's. *Marriage á la Mode,* 1743–45, Hogarth.

1750–1775

OTHER METALS

AMERICA: IRON: *Pa.:* Elizabeth Furnace (Jacob Huber, H. W. Stiegel); Charming Forge (Stiegel); Carlisle Iron Works. PEWTER: *Conn.:* John Danforth; Jacob Whitmore. *Mass.:* Nathaniel Austin; Thomas Badger; John Skinner. *New England.:* Richard Lee Sr., Jr., (also BRASS). *N.Y.:* Francis Bassett II; Frederick Bassett; Robert Boyle; Peter, William Kirby; Henry, John Will. *Pa.:* Cornelius Bradford; Byles; Johann C. Heyne; William Will. *R.I.:* Samuel Hamlin; Gershom Jones.

ENGLAND: JAPANNED TIN PLATE: 1761, Allgoods at Usk. 1760's, factories at Wolverhampton, Bilston, Birmingham, making urns, kettles, canisters, trays, etc.; 1765, color supersedes gold decoration. ORMOLU: 1762, Matthew Boulton, Birmingham, makes mounts. "WHITE WARE": 1769, soft alloy of tin rivaling pewter, introduced by John Vickers.

CERAMICS

AMERICA: *Redware:* N.C., 1756; Mass., slip-decorated by Daniel Bayley & sons. *Porcelain & creamware:* Bonnin & Morris, Philadelphia, 1771. *Creamware & stoneware:* N.C., 1774.

BELGIUM: *Soft paste:* Tournai, 1751.

ENGLAND: *Transfer printing:* John Sadler, Liverpool, 1750. *Soft paste:* Chelsea, raised anchor, 1750–53; red anchor, 1753–58; gold anchor, 1758–70; Chelsea-Derby (under Duesbury), 1770–84. *Derby* (Duesbury, prop., 1756), 1750; Longton Hall, 1750; Worcester (Dr. Wall period to 1783), 1751; Lowestoft, 1757; Swansea, 1764; Caughley, 1772 (Salopian mark). *Enamels:* Battersea, 1753–56, then south Staffordshire. *Delft:* "Fazackerly" decoration at Liverpool, 1757. *Black-glaze earthenware* (Jackfield). *Whieldon-type* cauliflower ware. *Toby jugs, figures:* Ralph Wood I (1715–72); Aaron Wood (1717–85); Ralph Wood II (1748–95); John Voyez, modeler. *Wedgwood:* colored and salt-glaze wares; creamware 1759 (called Queensware 1765); basalt, 1767; at Etruria, 1769; Bentley partner, 1769–80; caneware, 1770; jasper, 1774. *Creamware:* Leeds, 1760; John Turner, 1762 (also *stoneware*). *Hard paste:* Plymouth, Cookworthy patent 1768.

FRANCE: *Soft paste:* Sceaux, 1763; Sèvres (from Vincennes), 1756. *Hard paste:* Sèvres, 1769.

GERMANY: *Hard paste:* Frankenthal, 1755; Ludwigsburg, 1756; Bustelli at Nymphenburg, 1754.

SPAIN: *Soft paste:* Buen Retiro (from Capo di Monte), 1759.

GLASS

AMERICA: N.Y. glasshouse expanded, 1752. Joseph Palmer, Quincy, Mass., 1752: case bottles, snuff bottles, pickle & conserve jars. Wm. Henry Stiegel at Elizabeth Furnace, Pa., 1763, Manheim, Pa., 1765–74: *soda-lime* (engraved, enameled), *lead-flint* (colored, pattern-molded); *engraved* designs: tulip, flower basket, sunburst with birds; *enameled:* floral with dove, woman in boat, steepled building; *pattern-molded* (blue, purple, emerald green, bottle green): diamond-daisy. Kensington *(flint glass)* works, Philadelphia, 1773.

ENGLAND: *Decoration:* chinoiserie; engraved, enameled; oblique cutting after 1750. *Chandeliers* have canopies, notched candle arms, spires, pendent drops. *Opaque white ("Bristol") glass:* made at London, Bristol, Dublin, Warrington, etc.; Michael Edkins, decorator at Bristol, 1760's. *Beilby glass:* Newcastle glass decorated in enamel (monochrome white, or heraldic in full color) by Wm. & Mary Beilby, 1760.

PAINTINGS & PRINTS

AMERICA: John Wollaston, N.Y., Md., Va., Philadelphia; John Hesselius, Philadelphia, Md., Va.; Joseph Blackburn, New England; John S. Copley, Boston; Thomas McIlworth, N.Y., Albany; Benjamin West, leaves for England, 1759; William Williams, Philadelphia, N.Y. (conversation pieces), 1770's; John Durand, N.Y., Va.; John Mare, N.Y.; Winthrop Chandler, Conn.; Copley goes to London, 1774. Charles Willson Peale. *Battle of Lake George,* 1755, T. Johnston after S. Blodget, historical print; *Nassau Hall,* Dawkins-Tennant, 1763; *View of Harvard,* Revere, 1767; *The American Academy,* ptg., Matthew Pratt, 1765; *Landing of British Troops in Boston,* eng. pub. 1770, Revere; *Boston Massacre,* 1770, Revere; *Death of Wolfe,* ptg., West, 1771.

ENGLAND: Sir Joshua Reynolds; Richard Wilson; George Romney; Joseph Stubbs; John Zoffany; Joseph Wright of Derby; Bartolozzi, stipple eng.; Gainsborough. *The Atlantic Neptune,* 1763–84, J. F. W. Des Barres.

1775–1800

EVENTS

GEORGE III; LOUIS XVI; DIRECTOIRE, 1795–1802.

Presidents: Washington, 1788–96; John Adams, 1796–1800.

American Revolution, 1775–83 Thomas Paine, *Common Sense*, 1776. U.S. flag, 1778. Great Seal adopted, 1782. Constitutional Convention, capital moved from New York to Philadelphia. Congress orders frigates *Constitution, Constellation, United States;* Navy Department and General Post Office established. Bank of North America, Society of the Cincinnati, 1783. French Revolution ends monarchy 1793, rise of Napoleon. China trade begins with *Empress of China* (1785) New York, and *Grand Turk* (1787) Salem. Northwest Ordinance opens territory north of Ohio River. Slater opens spinning mill in R.I. and Eli Whitney invents cotton gin, 1793. *Pa. Evening Post and Daily Advertiser,* 1783, Philadelphia. U.S. census. Alien and Sedition Acts. Death of Washington. States admitted to Union: N. H., 1788; Vt., 1791; Ky., 1792; Tenn., 1796.

ARCHITECTURE

AMERICA: simplified Adam NEOCLASSICISM basis for FEDERAL STYLE: Peirce-Nichols House, Salem, by carver-designer Samuel McIntire. Asher Benjamin, *Country Builder's Assistant,* 1797. Governor John Langdon Mansion, Portsmouth, N.H. Capitol, Washington, D.C., after designs of Thornton, Hallet, Latrobe, Bulfinch. State House, Boston, by Bulfinch. Monticello rebuilt. Bank of Philadelphia by Benjamin Latrobe in GREEK REVIVAL style.

ENGLAND: Reaction to Adam style favors simpler Greek forms: Carlton House, Henry Holland. James Wyatt uses Greek and Gothic. French influence. Romanticism develops: cult of the picturesque introduces Turkish, Chinese, Gothic, in landscape architecture of Capability Brown and Humphry Repton.

FURNITURE

AMERICA: CHIPPENDALE STYLE continued by pre-Revolutionary cabinetmakers. 1785, NEOCLASSIC STYLE; Adam-Hepplewhite-Sheraton influence. Mahogany; satinwood. Classical forms, motifs. Tapering leg, spade foot; turned, reeded leg. Inlay; carving; reeding; painting; veneer. *Annapolis:* John Shaw. *Boston:* Stephen Badlam; John, Thomas Seymour. *Conn.:* Aaron, Eliphalet Chapin; Kneeland & Adams. *N.H.:* Samuel Dunlap II. *N.J.:* Matthew Egerton, Sr., Jr. *N.Y.:* Elbert Anderson; Duncan Phyfe; Mills & Deming. *Newport:* Edmund Townsend; Holmes Weaver. *Philadelphia:* John Folwell; Adam Hains; Daniel Trotter. *Salem:* Edmund Johnson; William Lemon; Elijah Sanderson. Carvers: *Boston:* John, Simeon Skillin. *Salem:* Samuel McIntire. Chest decorators: *Pa.:* Johannes Rank; Christian Selzer.

ENGLAND: NEOCLASSIC STYLE; 1775, Hepplewhite influence (George Hepplewhite, d. 1786); 1790, Sheraton influence (Thomas Sheraton, 1751–1806); 1795, French Directoire influence. Exotic woods: kingwood, harewood, tulipwood, amboyna, rosewood veneer, some solid satinwood. Turning, caning, japanning revived. Design books: Hepplewhite, *Guide,* 1788; Shearer, *Cabinet Maker's London Book of Prices,* 1788; Sheraton, *Drawing Book,* 1791–94.

SILVER

AMERICA: ROCOCO STYLE continue by pre-Revolutionary silversmith: 1785, NEOCLASSIC (FEDERAL) STYLI Urn shapes; elliptical teapot; helme creamer; flat-top, cylindrical tankar matching tea service. Reeded mold ings; beading; fluted sides; bright-c engraving. *Boston:* Benjamin Bur Coburn; Joseph Loring; Minott; Re vere. *N.Y.:* Ephraim Brasher; Willian G. Forbes; Lewis Fueter; Samu Johnson; John Vernon; Hugh Wishar *Philadelphia:* Joseph Anthony Jr.; J seph Cooke; Abraham Dubois; Rich ard Humphreys; Joseph Lownes; J seph & Nathaniel Richardson; Josep Richardson Jr. (Indian medals).

ENGLAND: NEOCLASSIC STYLE. Matcl ing tea, coffee service, with matchin flatware; cylindrical teapot; argyl 1785, sovereign's head added to ha marks. *London:* George Baskervill Hester Bateman; Jonathan, Peter Ann Bateman; Henry, William Chav ner; Robert Cruickshank; Paul Stoi first mark 1793.

1800–1825

EVENTS

GEORGE III; REGENCY OF PRINCE OF WALES, 1811–20; GEORGE IV, 1820–30; DIRECTOIRE, 1795–1802; CONSULATE, 1802–04; NAPOLEON I, 1804–14; LOUIS XVIII, 1814–24; CHARLES X, 1824–30.

Presidents: Thomas Jefferson, 1801–08; James Madison, 1809–16; James Monroe, 1817–24.

Capital moved to D.C. Pres. John Adams in President's House, 1800. War with Tripoli, frigate *Philadelphia* lost. U.S. Military Academy at West Point. Louisiana Purchase, 1803, doubles area of U.S. Lewis and Clark explore Northwest to Pacific, 1803–05; Zebulon Pike explores Southwest, 1805–07. Noah Webster, *Compendious Dictionary,* 1806. Fulton's steamboat, *Clermont,* on Hudson, 1807 (steamboat on Mississippi, 1811; on Great Lakes, 1816; crosses Atlantic, 1819). Long Embargo limits U.S.-British trade. War of 1812; victory of *Constitution* over *Guerrière;* Perry's victory on Lake Erie; Battle of New Orleans, 1815. Gas for lighting at Peale Museum. Cumberland road national highway west. Monroe Doctrine, 1823. Lafayette's visit, 1824–25. Erie Canal opened, 1825. States admitted: La., 1812; Ind., 1816; Miss., 1817; Ill., 1818; Ala., 1819; Me., 1820; Mo., 1821.

ARCHITECTURE

AMERICA: FEDERAL and GREEK REVIVAL. John Haviland, *Builder's Assistant,* 1819–21. Government buildings in Greek style by Benjamin Latrobe. FEDERAL: Asher Benjamin author and builder in Conn. River Valley; Pingree House, Salem, by McIntire; New York City Hall by McComb and Mangin (French influence). GREEK REVIVAL: University of Virginia by Jefferson; Second Bank of U.S., Philadelphia, by William Strickland. REGENCY houses in Savannah by William Jay.

ENGLAND: REGENCY STYLE: Bank of England remodeled; Soane Museum founded by Sir John Soane. Royal Pavilion, Brighton, and Regent Street façades, John Nash. John Plaw, *Sketches for Country Houses,* 1800 (picturesque).

FURNITURE

AMERICA: NEOCLASSIC (FEDERAL) STYLE continued by post-Revolutionary cabinetmakers; 1800, French Directoire influence. "Grecian" forms, motifs; klismos chair; Récamier sofa; sofa table; dressing table, attached mirror; wardrobe; Sheraton fancy chair; extension dining table. Saber leg. *Boston:* Seymours dominant to 1816. *New Orleans:* François Seignouret. *N.Y.:* Phyfe dominant; Michael Allison; Charles Honoré Lannuier. *Philadelphia:* Henry Connelly; Ephraim Haines. *Salem:* McIntire dominant to 1811; Nathaniel Appleton. Clockmakers: *Conn.:* Silas Hoadley; Joseph Ives; Eli Terry; Seth Thomas. *Mass.:* Lemuel Curtis; Simon Willard (banjo clock patented 1802); Aaron Willard; David Wood. 1815, EMPIRE STYLE. Roman inspiration; scrolls; coarsened classic forms, motifs. *Baltimore:* John & Hugh Finlay. *New Orleans:* Seignouret. *N.Y.:* Allison; Phyfe.

ENGLAND: NEOCLASSIC STYLE; 1810, REGENCY. Mahogany; rosewood; exotic veneers. Roman and Egyptian forms, motifs. Brass inlay, mounts, feet. Thomas Hope, designer 1770–1831. Design books: Sheraton, *Dictionary,* 1803; Hope, *Household Furniture,* 1807; George Smith, *Household Furniture,* 1808; Percier & Fontaine (designers to Napoleon), *Recueil de décorations,* 1812.

SILVER

AMERICA: NEOCLASSIC (FEDERA STYLE continued by post-Revolutio ary silversmiths. Barrel-shape pitche cake basket; coffin-end spoon; fiddl handle spoon with floral basket, whe sheaf, shell. *Albany:* Isaac Hutto Shepherd & Boyd. *Baltimore:* Stan ish Barry; John Lynch. *Boston:* R vere to 1804; Loring; Ebenezer Mou ton. *N.Y.:* Forbes to 1809; Brashe George Carleton; Vernon; Wisha *Philadelphia:* Joseph Lownes to 181 Anthony; Philip Garrett; Harv Lewis; Edward Lownes; John M Mullin; Christian Wiltberger. 181 30, Baltimore hall marks. 1820, EI PIRE STYLE adopted by many Fede silversmiths. Boat shapes. Broad ga rooning; applied bands of laur waterleaf, grapevine; ball, winge paw foot. *Baltimore:* Samuel Kii *N.Y.:* Frederick Marquand.

ENGLAND: NEOCLASSIC STYLE; 18] REGENCY. Boat shapes; oblong tra foxhead stirrup cup. Greco-Roma Gothic, Egyptian, Chinese, Indi motifs. Cast decoration. Designe John Flaxman, for Storr, Runde Thomas Stothard. Charles H. Tatha *Designs for Ornamental Plate,* 18(*London:* Storr dominant to 18: Peter, Ann, William Bateman; Rob Garrard; Rundell, Bridge & Run (royal goldsmiths); John Wakeli

1775–1800

OTHER METALS

...RICA: BRASS, COPPER: Bos-...Bolton & Grew; Paul Re-...N.Y.: James Kip; Abram...tayne; R. Wittingham...rons). IRON: Pa.: Carlisle...ace, Cumberland Furnace,...el Forge, Mt. Holly, Pine...e (Ege family); ten-plate...s. PEWTER: Conn.: Ed-..., John, Joseph, Samuel,...nas II, Thomas III, William...orth; Jacob Eggleston;...ezer Southmayd. Mass.:...rd Austin; Badger; Sam-...reen; Samuel Pierce; Skin-...N.Y.: Francis, Frederick...ett; George Coldwell; Wil-...Kirby; Henry Will; Peter...g. N.C.: Jacob Eggleston...William Billings; Parks...; John Andrew Brunstrom;...nas Danforth III; William...R.I.: William Billings;...lin; Jones; David Melville.

...AND: PAKTONG (TUTENAG),...of zinc, copper, nickel:...ney furniture; candle-...s. PEWTER: Britannia metal...duced by John Vickers.

CERAMICS

China-trade porcelain for American market, 1785.

AMERICA: *Stoneware:* Cheesequake Creek, N.J., dated; William Crolius II, N.Y. *Pa.-German sgraffito:* dated, Georg Hübener. *Creamware:* John Curtis, Philadelphia, 1791. *Bennington:* earthenware and stoneware, John Norton, 1793.

ENGLAND: *Wedgwood:* Flaxman models reliefs, from 1775; pearlware, 1779; first edition Portland Vase, 1786–90. *Soft paste:* Flight period at Worcester, 1783; Chamberlain's Worcester, 1792; Minton, 1798; Caughley amalgamated with Coalport, 1799. *Hard paste:* New Hall, 1782; bone china by Spode after exp. of Cookworthy's patent, 1796. *Earthenware:* Herculaneum Pottery, Liverpool, 1793; Prattware (lead glaze, relief decoration, high temperature colors). *Creamware:* Neale & Co., 1786; Castleford, 1790; Davenport, 1793. *Anglo-American historical ware:* Staffordshire & Liverpool transfer printed, 1790.

FRANCE: *Creamware:* Creil, 1794.

GERMANY: *Creamware:* Magdeburg, 1786.

GLASS

AMERICA: New Bremen Glass Manufactory, John Frederick Amelung, near Frederick, Md., 1785–95: *crown window* glass, *soda-lime* table wares; engraved decoration. *Pitkin flasks* (swirled ribbing), East Hartford, Conn., 1780.

CONTINENT: *Eglomisé decoration:* Zeuner, Amsterdam. *Zwischen-goldglas* (cut, engraved, gilded & enameled): J. J. Mildner, Austria; 1787. *Stippled diamond-point engraving:* David Wolff, The Hague. *Enameled glass figurines* (verre-de-Nevers type), C. F. Hazard, Paris.

ENGLAND: Excise acts stimulate Irish glassmaking, 1777–81–87. *Forms:* rummer (short-stemmed goblet); barrel-shape decanter (earliest with disc stopper, mushroom stopper, 1790); faceted-stem wineglass. *Adam chandeliers* with plain arms, urn shafts, festooned pear-shape drops. *Relief-diamond-cut* decanters.

IRELAND: Trade freed 1780; exports increase; English workers emigrate. *Waterford factory,* 1783, extensive exports to America from 1786. *Cutting in deep relief,* 1790's: hobnail diamond & strawberry diamond.

PAINTINGS & PRINTS

AMERICA: Gilbert Stuart, London, 1775; Charles Willson Peale begins museum, 1784; Robert Edge Pine, Philadelphia; Ralph Earl, London, 1778–85; Christian Gullager; Reuben Moulthrop, Conn.; Archibald Robertson; Alexander Robertson, New York; Stuart returns, 1793; Joseph Wright; James Peale, miniatures; Edward Savage; James Sharples, pastels; Edward G. Malbone, miniatures; Francis Guy; William Groombridge; William Winstanley; George Beck; C. B. J. Fevret du Saint-Mémin; Michel Felice Corné, Salem, Boston. *Battle of Lexington and Concord,* 1775, eng. by Amos Doolittle after Ralph Earl; Bernard Romans, *Late Battle at Charlestown,* 1775; Abell Buell, *Map of U.S.,* 1783; Larcour-Doolittle, *Federal Hall, New York,* eng., 1789. Primitive painting.

ENGLAND: Paul Sandby introduces aquatint, 1775; Sir Henry Raeburn; William Morland; Sir Thomas Lawrence. Wheatley, *Cries of London,* 1793.

1800–1825

OTHER METALS

...RICA: BRASS, COPPER: Bos-...re. N.Y.: Isaac, Richard,...ard Jr. Wittingham. Pa.:...r, Arnold & Co.; William...er; W. O. Hickok. JA-...ED TIN PLATE: Conn.:...son family; Mygatt; Hub-...; Francis; North. Me.:...ariah Stevens; Oliver,...Ann Buckley. N.Y.: Au-...us Filley. Pa., Vt.: Oliver...y. PEWTER: Britannia met-...troduced. Conn.: Thomas...forth Boardman and part-...; Samuel, William Dan-...a; Ashbil Griswold; Jehiel...son. Mass.: R. Austin;...n; Pierce. Md.: Samuel...ourn. N.Y.: Timothy Brig-...Pa.: Boyd; Robert Pale-...p Jr. R.I.: William Calder;...uel E. Hamlin.

...LAND: JAPANNED TIN...CE: 1812, bronze powders...oduced.

CERAMICS

AMERICA: *Redware & stoneware:* Bell family, Shenandoah Valley, 1800; Thomas Crafts, Mass. (grotesque jugs); Xerxes Price, N.J.; Peter Cross, Conn.; Paul Cushman, N.Y. *Pa.-German sgraffito:* David Spinner. *Bennington:* L. Norton & Co. from 1823, earthenware & stoneware. *Porcelain* attempted: Dr. Henry Mead, N.Y.

ENGLAND: *Ironstone:* Spode, Mason. *Lusterware* (pink, silver, copper): Staffordshire, Sunderland, Swansea, etc. *Rockingham glaze:* Rockingham, Swinton. *Gaudy Dutch:* for Pa. market, Staffordshire, 1810. *Spatterware:* Staffordshire 1820. *Soft paste:* Nantgarw, 1813. *Dr. Syntax series:* Clews, Chamberlain's Worcester. *Anglo-American historical wares:* Staffordshire esp. 1800–50; E. Wood, J. & R. Clews, J. & W. Ridgway, Ralph Stevenson, Andrew Stevenson, Thomas Mayer, William Adams, Joseph Stubbs; Liverpool esp. 1800–25.

FRANCE: *Vieux Paris:* porcelain by independent Paris factories. *Sèvres:* hard paste only.

SPAIN: *Hard paste:* Buen Retiro.

GLASS

AMERICA: *South Jersey type:* off-hand blown, N. J., N. Y., N. E.; lily pad; threading; rigaree (pinched trailing); tooling; bird finials; prunts. *Flint glass:* Bakewell & Co., Pittsburgh, 1807; Mt. Vernon Glass Co., Oneida Co., N.Y., 1810; Thomas Cains, South Boston, 1811. *Blown three mold:* geometric, arch, baroque. *Stiegel type, Midwestern houses* (Zanesville, Mantua): off-hand work, pattern molded, ribbing, fluting, expanded diamond, broken swirl; 1815. *Cambridge:* New England Glass Co., 1818. *Pictorial & historical flasks,* 1820.

CONTINENT: *Cameo incrustations* (sulphides): France, 1815.

ENGLAND: *Cameo incrustations:* Apsley Pellatt patent, 1819. *Blown molded,* geometric: 1820. *Colored:* Bristol, Nailsea; "witch balls," 1820.

IRELAND: *Glasshouses:* Waterloo Co., Cork, 1815; B. Edwards, Belfast. *Blown molded,* geometric, 1820. *Cut glass:* pillared fluting, scalloped border.

PAINTINGS & PRINTS

AMERICA: Washington Allston; Ezra Ames, Albany; Thomas Birch; James Eights (*Views of Albany,* 1805, pub., 1847); Baroness Hyde de Neuville, in U.S. 1807–14; J. W. Jarvis; William Jennys, Conn. River Valley; Rembrandt Peale; Raphaelle Peale; Joseph Steward; P. P. Svinin, in U.S. 1811–12; John Trumbull; John Vanderlyn; Edward Hicks; William Jewett; Thomas Sully; J. L. Krimmel, Philadelphia; S. F. B. Morse; Bass Otis, American lithographs; Alvan T. Fisher. W. R. Birch, *Views of Philadelphia,* 1800; *Hudson River Portfolio,* 1824, after W. G. Wall. Primitive painting.

ENGLAND: John Constable; J. M. W. Turner; Ben Marshall; John Ferneley; James Pollard. Rowlandson, *Microcosm of London,* 1810; Alken, *National Sports of Great Britain,* 1821.

317

Index

Index to the museums, their buildings and rooms; to the craftsmen and artists named; and to the antiques treated as separate categories (i.e., Ceramics, Furniture, Glass, etc.; for these the reader is also referred to the interior views throughout).